BOWDOIN COLLEGE LIBRARY
WITHDRAWN
BRUNSWICK, MAINE

Measured Words

Computation and Writing
in Renaissance Italy

ARIELLE SAIBER

Measured Words

Computation and Writing
in Renaissance Italy

UNIVERSITY OF TORONTO PRESS
Toronto Buffalo London

© University of Toronto Press 2017
Toronto Buffalo London
www.utorontopress.com
Printed in the U.S.A.

ISBN 978-0-8020-3950-7

Printed on acid-free, 100% post-consumer recycled paper
with vegetable-based inks.

Toronto Italian Studies

Library and Archives Canada Cataloguing in Publication

Saiber, Arielle, author
Measured words : computation and writing in Renaissance Italy/Arielle Saiber.

(Toronto Italian studies)
Includes bibliographical references and index.
ISBN 978-0-8020-3950-7 (hardcover)

1. Mathematics – Italy – History – 15th century. 2. Mathematics – Italy – History – 16th century.
3. Mathematical literature – Italy – History – 15th century. 4. Mathematical literature – Italy –
History – 16th century. 5. Science and the humanities – Italy – History – 15th century.
6. Science and the humanities – Italy – History – 16th century. 7. Italy – Intellectual life –
1268–1559. 8. Italy – Intellectual life – 1559–1789. I. Title. II. Series: Toronto Italian studies

QA27.I8S25 2017 510.945 C2017-905118-0

This book has received the Weiss-Brown Publication Subvention Award from the Newberry Library.
The award supports the publication of outstanding works of scholarship that cover European
Civilization before 1700 in the areas of music, theatre, French or Italian literature, or cultural studies.
It is made to commemorate the career of Howard Mayer Brown.

This book has been published with the assistance of Bowdoin College and an Aldo and Jeanne
Scaglione Publication Award from the Modern Language Association.

University of Toronto Press acknowledges the financial assistance to its publishing program of
the Canada Council for the Arts and the Ontario Arts Council, an Ontario government agency.

Canada Council Conseil des Arts
for the Arts du Canada

ONTARIO ARTS COUNCIL
CONSEIL DES ARTS DE L'ONTARIO
an Ontario government agency
un organisme du gouvernement de l'Ontario

Funded by the Financé par le
Government gouvernement
of Canada du Canada

Canada

Contents

Contents

Figures

Acknowledgments

It is difficult to measure – numerically or verbally – the depth and breadth of my gratitude to the many people and institutions who generously supported the production of this book. I'll start by thanking my home institution, Bowdoin College, which has offered me generous research grants and dedicated research time, as well as access to wonderful, catalytic colleagues and students. I am also grateful to Bowdoin, and to the many people I mention below, for their patience during the years that I put this Renaissance book project on hold to *carpe diem* in the world of science fiction, and to pursue myriad Dante-related projects.

Harvard University has also been a major power source for this book, granting me two separate fellowships at key stages of the project: I was fortunate to begin my exploration of Renaissance computers and writers at The Radcliffe Institute for Advanced Study in 2003–4, and to complete the bulk of research and writing several years later at Villa I Tatti (2008–9). I am incalculably grateful to both residential fellowships for the opportunity to pursue transformative conversations and form lasting bonds with fellow scholars from across the arts and sciences – and to stretch my thinking via exposure to projects ranging from computation in molecular biology, to Renaissance translations of mathematical treatises from Arabic into Latin. While my choice of Villa I Tatti for 2008–9 meant I was not able to accept an NEH Research Fellowship for that year, I am honoured to have been offered NEH support.

I also wish to thank the Society for Literature, Science, and the Arts (SLSA) – and its members – for years of stimulating conferences and publications, and for its commitment to modelling rigorous interdisciplinary scholarship as the thoughtful, careful, and humbling business it necessarily is. *Measured Words* owes its genesis and scope to SLSA-facilitated exposure to and exchanges with

philosophers, mathematicians, physicists, art historians, historians, architects, artists, and scholars of diverse national literatures and periods.

I could not have written a book about Renaissance mathematics and literature without the many libraries and library staff members who facilitated access to manuscripts, early printed books, and other research resources. I owe particular thanks to Harvard's Houghton, Widener, and I Tatti; Florence's Biblioteca Nazionale, Istituto e Museo di Storia della Scienza (Museo Galileo), Laurenziana, Marucelliana, Riccardiana, and the "Matematica antica" project of the Giardino di Archimede: Museo per la Matematica; and Rome's Biblioteca Vaticana. Closer to home, I'd also like to thank the Bowdoin College Library, whose staff deserve particular mention for their herculean efforts on my behalf over the years.

I would like to express my gratitude to a long list of people, and I will do my best to include them all here. Others, who helped my work without my knowledge or even without their own knowledge, I am apt to miss. But to those stealth helpers, a stealthy thank you.

To the many extraordinary classical, medieval, and Renaissance colleagues – brilliant, generous, inspirational scholars in diverse fields – who have supported me through a decade of "Measured Words" brainstorms, research dilemmas, insights, and an enduring preoccupation with the whys, hows, and present value of doing pre-modern scholarship, thank you. Particular thanks go to David Albertson, Marco Arnaudo, Albert Ascoli, Stefano Baldassarri, Lydia Barnett, Teodolinda Barolini, Susanna Barsella, Daniela Boccassini, Erika Boeckeler, James Bono, Barbara Boyd, Margaret Boyle, Nina Cannizzaro, Angela Capodivacca, Mario Casari, Christopher Celenza, Claudia Chierichini, Kathleen Christian, Elizabeth Coggeshall, Matthew Cohen, Lucida Cole, James Coleman, Tom Conley, Joseph Connors, Alison Cornish, Paolo d'Alessandro, Katherine Dauge-Roth, Bianca De Divitiis, Brenda Deen-Schildgen, Dallas Denery, Christian Dupont, Elsa Filosa, Menso Folkerts, Maggie Fritz-Morkin, Hilary Gatti, Veronica Gavagna, Laura Giannetti, Enrico Giusti, Fiona Griffiths, Crystal Hall, George Hersey, Nathalie Hester, Peter Hawkins, Ronald Herzman, Jason Houston, Olivia Holmes, Jens Høyrup, Wendy Hyman, Fredrika Jacobs, Rachel Jacoff, Christiane Joost-Gaugier, Minsoo Kang, David Kertzer, Ann Kibbie, Timothy Kircher, Victoria Kirkham, Aaron Kitch, Jennifer Knust, Sergius Kodera, Richard Lansing, Anne Leader, Dennis Looney, David Lummus, Joseph Luzzi, Roy MacLeod, David Marsh, Ronald Martinez, Carla Mazzio, Giuseppe Mazzotta, Martin McLaughlin, Christian Moevs, Caterina Mongiat, Robert Morrison, Andrea Moudarres, Pier Daniele Napolitani, Elio Nenci, Reviel Netz, Scott

Acknowledgments

Newstok, John Paoletti, Katherine Park, Deborah Parker, Lino Pertile, Kristin Phillips-Court, Arkady Plotnitsky, Alessandro Polcri, Alfonso Procaccini, Gina Psaki, Guy Raffa, Eileen Reeves, Denis Ribouillaut, Meghan Roberts, Daniel Rosenberg, Sherry Roush, Camilla Russell, Guido Ruggiero, Darrel Rutkin, Yulia Ryzhik, Thomas Settle, Deanna Shemek, Marcello Simonetta, Ingrid Skipnes, Janet Smarr, Matteo Soranzo, Justin Steinberg, Walter Stephens, Dana Stewart, Nick Terpstra, Francesca Trivellato, Henry Turner, Jane Tylus, Nancy Vickers, Adrienne Ward, William West, Jessica Wolfe, and Leslie Zarker Morgan.

For generously reading chapter drafts and offering precious time and feedback, my greatest thanks go to Albert Ascoli, Dallas Denery, Veronica Gavagna, Timothy Kircher, Martin McLaughlin, Mark Peterson, Guy Raffa, Sherry Roush, and Deanna Shemek. The value of their suggestions is incalculable. Any ill-measured words or computational slips that remain are my own.

For their incommensurate expertise, generosity, and camaraderie, I offer exponential thanks to historians of mathematics Veronica Gavagna and Pier Daniele Napolitani; I am particularly indebted to their work on Giambattista Della Porta, to Gavagna's work on Niccolò Tartaglia and Luca Pacioli, and to Napolitani's work on Archimedes and Federico Commandino. I would also like to thank the many mathematicians working in fields ranging from combinatorics to topology who have been invaluable interlocutors – in some cases unwittingly, in others holding me accountable with uncompromising integrity. Special thanks to Charles Cunningham, Jordan Ellenberg, Jonathan Farley, Sarah Glaz, Fernando Gouvêa, Kellie Gutman, Matthew Kleban, Sonja Mapes-Szekelyhidi, George Markowsky, Barry Mazur, Aba Mbirika, Mark Peterson, and Bonnie Shulman.

I would also like to convey my thanks to a scholar with whom I only exchanged a few brief emails, but whose work was the primary inspiration for this project: the late Professor of History at Pennsylvania State University, Paul Lawrence Rose. He had kindly and generously offered to read this manuscript but passed away before I completed the full draft. I remain indebted to his seminal work on mathematics and humanism in the Renaissance; *Measured Words* is but a small addition onto the mansion he built in the 1970s.

To Julia Boss, sage adviser on beautiful writing, and to Amyrose McCue Gill and Lisa Regan, who worked wonders to obtain image reproductions and reprint permissions, my thanks are countless. Thanks also to my magnificent Bowdoin research assistants Kyra Babakian, William Doak, Paige Gribb, Michael Hannaman, Victoria Rea-Wilson, Mary Ridley, Raisa Tolchinsky, Gretchen Williams, and Aisha Woodward; to Ariel Franklin-Hudson for combing through

my bibliography and footnotes and untangling the knots; Matthew Collins for helping me to obtain a number of important images and information about those images at the Houghton Library; Piera Deglinnocenti, Lorenza Camin, and Eleonora Buonocore for their help in obtaining the photo of Donatello's Pecci Tomb in Siena; Camilla Russell and Mario Casari for their capture of the lapidary inscription at the base of Trajan's Column; Francesca Marini for the photographs of the Cappella Rucellai; Anthony Oldcorn, Rita De Tata and Andrea Cristiani for help acquiring the pages from an early copy of Pacioli's *De viribus quantitatis* held at the Università di Bologna; Robert Saslow for his extensive knowledge of calligraphic and typographic letterforms; and my Italian program colleague extraordinaire Davida Gavioli for the know-how and humour that keep me and the program alive and well. Hyperbolic thanks to Suzanne Rancourt, editor at the University of Toronto Press, whose vision, patience, wisdom, and exceptional editorial instincts helped me to complete this project.

To the many, many dear friends, and to my wonderful families – the Saibers, Grosses, Heymans, and Montanaros – who have walked with me literally and figuratively for years as I grappled with the puzzles this book presented, my love and thanks know no bounds.

Finally, to my husband, Kavi Montanaro: there is no measure to my gratitude for all you do and are, no way to compute or words to describe the magnitude of the love and joy you bring to my life. This book is dedicated to you.

Parts of chapter 3 were published in "Niccolò Tartaglia's Poetic Solution to the Cubic Equation" in the *Journal of Mathematics and the Arts* 8 (2014): 68–77. Parts of chapter 4 were published in "Flexilinear Language: Giambattista Della Porta's *Elementorum curvileorum libri tres*" in *Annali d'italianistica* 23 (2005): 89–104.

Measured Words

Computation and Writing
in Renaissance Italy

Introduction:
Well-Versed Mathematics

The union of the mathematician with the poet ... this is surely the ideal.

— William James[1]

There were computers in Renaissance Italy. Excellent and varied computers: they were the people who calculated quantities, formulated algorithms, proposed new mathematical objects and equations, tested proofs. These *matematici, aritmetici, computisti, contisti, geometri, misuratori,* and *pesatori*[2] worked in tandem with writers – some of them also exceptional computers – who took calculated risks, formulated rules for good lettering (calligraphic, epigraphic, and typographic) and textual style, proposed new ways of thinking about alphabets and language, tested their mathematical ideas in words. In this period of Italy's history, both computation and writing were in a dynamic process of identity conjuring. Like others among Italy's increasing number of upwardly mobile citizens, Renaissance computer-writers were not only calculating and measuring their words: they were actively seeking to demonstrate their value to society and to showcase their contributions to the larger search for knowledge. As Neil Rhodes, Jonathan Sawday, and the contributors to their 2000 edited volume, *The Renaissance Computer: Knowledge Technology in the First Age of Print,* have shown, the fifteenth and sixteenth centuries experienced an information explosion much like the end of the twentieth and the beginning of the twenty-first centuries. Then, as today, writers and "computers" were faced with radically new, powerful ways to produce knowledge, circulate it, and understand it. Some might say that "information theory" and the digital humanities began hundreds of years ago.

Tomaso Garzoni, in his encyclopedic 1585 study *Piazza universale di tutte le professioni del mondo* [Universal Piazza of All the World's Professions], spoke for many of his contemporaries when he pronounced, "without mathematics it would be hard to arrive at the perfect philosophy."[3] Leon Battista Alberti, in a brief piece he titled "Paintings" (c. 1430–40), described Mother Humanity (*Humanitas Mater*) as a woman with "numerous hands [that] extend from her shoulders, some holding pens, others lyres, some a highly polished gem, others a painted or carved emblems, some [holding] various mathematical instruments, and others books."[4] The Renaissance *studia humanitatis*, based on classical models for educating the liberal ("free") man, approached human nature via the three arts of the *trivium* (grammar, rhetoric, logic), and the related arts of history, literature, and moral philosophy. Yet Renaissance humanists like Alberti and Garzoni knew that to study human nature through words alone was to study humanity only in part. On the flip side – or, rather, the other side of the equation – were the arts of the *quadrivium* (geometry, arithmetic, astronomy, music), natural philosophy (fields we would now call sciences, such as physics, biology, and medicine), and other arts that required empirical study and computation. Through translations by Leonardo Bruni and Marsilio Ficino, predominantly, and numerous commentaries, Renaissance humanists knew the theory that the Egyptian god Thoth (or Theuth, or the Greek Hermes) was the originator of *both* numbers and letters.[5] And many humanists paired Protagoras's concept of "man as the measure of all things" together with Lorenzo Valla's alternate "rhetoric as the measure of all things."[6]

From the early 1400s through the early 1600s, Italy nurtured an especially large cast of imaginative thinkers who esteemed all the arts, and these artists borrowed from one another with great freedom. Italy was, at this time, Europe's centre for mathematical study. Universities like Padua's attracted foreigners including Copernicus, Regiomontanus, Albrecht Dürer, and Nicholas of Cusa. Humanists engaged in the herculean recovery of ancient learning, translating and interpreting codices that Giovanni Aurispa, Francesco Filelfo, and others had brought to Florence from Byzantium. Previously lost ancient works – and works hitherto unavailable in Latin – by Archimedes, Pappus, Apollonius, Hero, and Diophantus became part of the humanist's library, and central to the mathematician's curriculum. Powerful patrons including Cardinal Bessarion and the Farnese in Rome, the Medici in Florence, the Dukes of Urbino, and Popes Pius II, Nicholas V, and Marcellus II encouraged humanists to seek out, translate, and print mathematical treatises as well as literary works. Humanists such as Coluccio Salutati, Pier Paolo Vergerio, and Angelo Poliziano argued that mathematics was a crucial

study for orators, writers, and philosophers, and Bernardino Baldi initiated the history of mathematics with his late sixteenth-century biography of mathematicians, *Vite de' matematici*. Literary academies and scientific academies were emerging – and in some instances, such as the Infiammati in Padua, were merging. Pietro Bembo, Lodovico Castelvetro, Galileo, and many other scholars debated the nature and form of literary expression, and "computers" of all sorts were asking many of the same questions: Whose wisdom is greater – that of the ancients or the moderns? Do I lean towards Plato or Aristotle? Which language – Latin or the vernacular – should I use in my writing? Do I invent or discover ideas? Is novelty a good or a dangerous thing? Is *mimesis* better? The answers to these questions were as varied as their askers. Computation and writing, like the arts themselves, were developing rapidly in this particular place and time, and they were doing so not in isolation, but precisely because they were in dynamic dialogue with one another.

Before going any further, I should define more precisely what I mean by "computation" and "writing." By "computation" I intend calculations both in pure (abstract) mathematics and in applied mathematics – primarily calculations based in arithmetic, algebra, and geometry. The statistical analysis of a letter's frequency in an alphabet; the ratio between a letter's height and the angle of a pen stroke; a solution to a long-unsolved equation; an attempt to square the circle: all are forms of computation. By "writing" I intend production in three general categories: 1) alphabetic letters as the atomic building blocks or symbols of syntax and semantic meaning; 2) the manual act of lettering (handwritten scripts, lapidary inscriptions, and typeface design); and 3) text (its genre, form, style, register, audience, and content). Investigating the convergence in Renaissance Italy of computation and writing (broadly defined as I have suggested here), we come to see how many among the intelligentsia fashioned their work as, necessarily, a merging of number, form, and word.

I have long sought to understand what mathematics and literature have in common, in terms of both practice and ideas. I have often pondered the claim that "mathematics is a language." Over the years, as I have continued reading widely in both early modern literature and early modern mathematics, I have come to think more about the particulars of the relationship between literary and mathematical languages. If mathematics is a language, then what kind of language is it? Are numbers, mathematical objects, and functions equivalent to letters, phonemes, and words? Are equations, operations, and proofs mathematics' counterparts to narrative? As I have increasingly sought to understand what it

means to say that "mathematics is language," I have seen this question addressed, from myriad angles, by mathematicians, philosophers of mathematics, cognitive scientists, neuroscientists, and educators.[7] Some of these scholars have focused on how natural language and counting emerged together and both become symbolic through writing; some have seen the aesthetic qualities of mathematical language as comparable to metaphor, or to a linguistic form like poetry; others have considered natural language's centrality to mathematics' development. We can, in fact, examine the utility of storytelling and word problems in teaching mathematics, compare the similar imaginative processes involved in abstract mathematical thinking and abstract literary thinking. We can, to some degree, trace neural activity in a brain engaged in mathematical thinking, and compare it to the neural patterns that emerge when the brain does the work of reading, writing, remembering, recounting, or inventing a fictional world. These studies, along with many others, have vastly enriched my thinking about – as George Lakoff and Rafael Núñez would say – "where mathematics comes from." I am not in the business of drawing conclusions about how mathematics as a cognitive process *is* or *is not* like those employed in spoken language and writing, although I have devoted some thought to mathematics in its relation to the imagination.[8] My aim here is to bring some awareness of these questions to my present study of the cultural factors and intellectual practices that characterized interdisciplinary exchange in Renaissance Italy.

My questions about language and mathematics first drew me to the connections between Euclidean geometry and rhetorical tropes in the works of Renaissance philosopher-poet-playwright-mathematician Giordano Bruno.[9] In *Giordano Bruno and the Geometry of Language*, I noted the many ways in which Bruno's extensive use of tropes such as circumlocution, hyperbole, and oxymoron (and many others) demonstrates his awareness of the geometric forms and spaces that underpin verbal and written syntax and the production of meaning. Bruno deployed his strategy of what I call "geometric rhetoric" to reinforce his most cherished theories: heliocentrism; the universe as infinite, and containing infinite possible worlds; and his theory that knowledge of divine mystery is approached via *coincidentia oppositorum*. As I articulated the confluence of Bruno's geometry with his philosophical and literary studies, I began to realize that Bruno's was just one voice – albeit a powerful one – in a larger conversation about, and between, the worlds of mathematics and literature. Not only did numerous computers and writers actively borrow from each other during the Renaissance, they also often described explicit relationships between their two modes of expression and inquiry, and the ways those relationships strengthened each field's development.

The nineteenth and twentieth centuries saw extensive scholarly production on connections during the Italian Renaissance between mathematics and the visual arts, between mathematics and architecture, between mathematics and music. The equally notable convergence of mathematical computation and the written word in this period in Italy has been less explored, although early modern Europe as a whole, and especially Northern Europe, has seen a recent upswing in interest in studies such as Timothy Reiss's *Knowledge, Discovery and Imagination in Early Modern Europe: The Rise of Aesthetic Rationalism*; David Glimp and Michelle R. Warren's volume of essays, *Arts of Calculation: Numerical Thought in Early Modern Europe*; Jessica Wolfe's *Humanism, Machinery, and Renaissance Literature*; Henry S. Turner's *The English Renaissance Stage: Geometry, Poetics, and the Practical Spatial Arts 1580–1630*; Tom Conley's *The Self-Made Map: Cartographic Writing in Early Modern France*; and Katherine Hunt and Rebecca Tomlin's edited special issue for the *Journal of the Northern Renaissance, Numbers in Early Modern Writing*.[10]

Paul Lawrence Rose's 1975 historical study, *The Italian Renaissance of Mathematics: Studies on Humanists and Mathematicians from Petrarch to Galileo*, is one of the earliest works, and to date the most in-depth, to track the interactions between mathematicians and humanists in the Italian Renaissance. Any scholar working today on mathematics in the Renaissance is indebted to Rose's findings, particularly his detailed reconstruction of individual humanists' access to and interest in specific mathematical treatises. I have built on Rose's study, but have shifted the focus to examine the intersection of computation and writing in only four texts by four Renaissance Italian authors. I chose these authors after an extensive survey of primary works of mathematics from the period – consulting numerous manuscripts and exemplars in libraries and archives in Florence and Rome. I was also able to benefit from the exceptional digital resources for early mathematical publications now available through the efforts of the "Biblioteca matematica" project of the Giardino di Archimede museum in Florence and the Max Planck Institute for the History of Science in Berlin. While I have ultimately narrowed my study to four texts, my reading of each has been enhanced by the opportunity to consider these sources within the larger context of Renaissance mathematical writing.

Helping me both to focus my vision historically and to expand it conceptually have been studies on the relationship between science and humanism,[11] the state and status of mathematics in the Renaissance,[12] the early print history of mathematical treatises,[13] the history of Renaissance schooling,[14] and discussions in the field of "Literature and Science."[15] While rooted in Renaissance cultural,

literary, and mathematical history, my analyses of the four texts in this study are also the product of close reading: an examination of the use of "writing" within computational works, and the use of "computation" within texts engaging the art of writing.

The Four

The four computer-writers I selected for this study embody the period's spirit of interdisciplinary exchange; their contributions to the world of Renaissance thought unequivocally demonstrate how mutually beneficial conversation between computational arts and writing arts can be. I have arranged the case studies – Leon Battista Alberti (1404–1472), Luca Pacioli (1445–1517), Niccolò Tartaglia (circa 1499–1557), and Giambattista Della Porta (1535–1615) – chronologically, from the mid-fifteenth century to the turn of the seventeenth. This is a century and a half that, significantly for my thinking on this project, sees the birth of the printing press at one end and the beginnings of modern calculus at the other. The aesthetic, commercial, and intellectual uses of the printing press loom large in all four case studies. Calculus, by comparison, is barely present: its development occurred towards the end of the sixteenth century, and that development would eventually shift the mathematical centre of Europe from Italy to the north. The kinds of computation and writing analysed vary between the chapters, as do the authors' reasons for participating in an active exchange between the arts of mathematics and literature, and the socio-economic or biographical factors that complicated their access to or participation in that exchange. There is no question that this period in Italy exhibited a particularly fluid dialogue between computation and writing, but there is also no question, I would argue, that wherever numbers and figures coexist with letters (or characters), there is opportunity for convergence and conversation.

I begin with Leon Battista Alberti's 1466 groundbreaking work on cryptography: *De componendis Cifris*. *De Cifris* was the first known treatise on cryptography in the Western world, and Alberti's revolutionary two-disc "polyalphabetic substitution" system anticipated modern cryptographic techniques by more than four hundred years. Alberti makes it clear that his work was intended exclusively for Vatican use, though his system seems quickly to have travelled to courts in Renaissance Italy and beyond. Notwithstanding the text's relatively rapid dissemination, its coding systems were not widely understood or used until the

1800s. In my discussion of *De Cifris* I explore, among other fascinating characteristics of this text, the subtle autobiographical fingerprints that Alberti left among his calculations and words. An excellent mathematician and expert writer, Alberti studied the shape of language and analysed the letters that constituted its smallest parts. Catalysed by the invention of moveable type and the accompanying promise of quick information diffusion, *De Cifris* teaches its readers intricate systems for manipulating those letters to conceal or reveal meaning. *De Cifris* contemplates what it means to see, to be seen, and to hide – states of awareness that reappear throughout Alberti's writing and in both his personal and professional life.

Chapter 2 likewise focuses on the confluence between mathematics and the atoms of language during the first years following the printing press's arrival in Italy. This time, however, the alphabet is not scrutinized by statistical analysis or combinatorics; it becomes, instead, a carefully developed cast of "characters" that a user can manipulate to project beauty, virtuosity, and power. In the 1509 print version of his *Divina proportione*, Franciscan friar and mathematician Luca Pacioli included specific rules and ratios to construct what he considered the most perfectly proportioned Roman capital letters – letters that could be engraved on stone, inked on paper, worked in gold, cut as punches, or painted in miniature. Pacioli's idealization of geometrically formed letters emblematizes changes in the domains of calligraphy, typography, and literary production in this period. Beyond his choice of the vernacular to describe his letters' "divine proportions," his emphasis on the practical project of re-creating an aesthetic ideal in a range of media demonstrates his commitment to disseminating mathematical knowledge among people of all classes, professions, and trades. For Pacioli, mathematics was the foundation for all the human arts and sciences, and on its foundation was laid the path towards understanding the divine; mathematics guided even language itself. By understanding mathematics' operations and uses, he believed humans might better understand the "characters" of the natural world, ourselves, and the divine.

Chapter 3 considers an algebraic calculation that has a curious connection to poetry. In 1535 (1534 on the Venetian calendar), Brescian mathematician Niccolò Tartaglia discovered a long-sought solution to the cubic equation, and then wove that solution into a poem. Tartaglia's poem was part mnemonic – to help him recall the procedure – and part encryption – to hide the solution from others who wanted it. Renowned mathematician Girolamo Cardano was among those pressing Tartaglia for his method for solving cubics: Tartaglia resisted, fearing that Cardano would publish the solution more quickly than Tartaglia could himself. Eventually,

he gave Cardano the solution embedded in a poem – stalling Cardano's efforts to extract the solution, and demonstrating his own awareness of poetry's ability simultaneously to reveal and to conceal. When read in the larger context of Tartaglia's life and thought, his "poetic solution" comes into focus as a display of an autodidact's pride in his triumphs over adversity, but also of the anxiety he felt as he moved on the periphery of scholarly circles. Tartaglia's poem is a powerful example of literary writing's ability to participate in computational strategies in this period – a period before conventions of symbolic notation were stabilized and most mathematical operations were still written in words.

The final case study operates in a zone far removed from Alberti's and Tartaglia's mathematical innovation, and equally far from Pacioli and Tartaglia's desire to reach as many readers as possible. Neapolitan playwright, natural philosopher, and magus Giambattista Della Porta is a bit of anomaly in the history of Renaissance mathematics, and his 1610 treatise entitled *Elementorum curvilineorum libri tres* [The Elements of Curves in Three Books] is a bizarre text with no connection to the mathematical discourse of its time. It garners no critical response from contemporary mathematicians or otherwise; it simply disappears. And it is its very oddness that makes it fascinating. Della Porta invents neologisms to describe a myriad of curves, clearly revelling in the language and the wonders of geometry: he makes simple operations look difficult, the monstrous appear innocuous, and everything seem marvellous. Although advancing claims to precision and rigour, his text proves itself to be something quite other than a traditional mathematical treatise. Hidden within it is a comedy of errors, colourful coinages, and sensational pronouncements, not unlike a play he might have written for the Neapolitan stage. In Della Porta's hands, geometric computations perform spectacular roles on the printed page.

Alberti, Pacioli, Tartaglia, and Della Porta – with their varied ways of enacting interdisciplinary exchange – form an exemplary slate of early modern computer-writers working and networking across the major intellectual hubs of fifteenth- and sixteenth-century Italy: Florence, Milan, Rome, Venice, Urbino, and Naples. They also offer four different examples of the impact social class had on Renaissance computer-writers, four ways of thinking about the *questione della lingua* (whether to write in Latin or Italian) and audience, and four different writing styles that reveal much about their backgrounds, goals, and thoughts about the uses of both mathematics and language. Most importantly, however, these four authors' works not only display a heightened awareness of the relationship between computation and writing, but also, in the instances I have isolated for study, actually depend on that relationship to achieve their goals and to convey meaning.

As will be noted throughout the chapters that follow, the four at times echo one another and intersect in numerous ways. Pacioli and Alberti – both Tuscans – were friends; and when Pacioli stayed with Alberti in Rome for a short period, he may have served as the aging Alberti's amanuensis and learned much about the construction of Roman capital letters from Alberti's own efforts. Both authors, as *De Cifris* and the *Divina proportione* show, exemplify ways of thinking computationally about writing's smallest parts.

Alberti and Della Porta wrote more frequently in Latin than did Pacioli and Tartaglia. The fact that writers at this time had to make a calculated choice regarding which language to use for the composition of their works, and that the two authors from higher social classes (Alberti and Della Porta) chose to write primarily in Latin, reflects the charged debates around the access to knowledge in this period. Della Porta embraced his elite (minor nobility) status, while Alberti – the illegitimate son of a wealthy Florentine merchant – always felt insecure about his identity; his stellar career and interaction with the highest rungs of Renaissance society did not seem to free him of his angst. Both Alberti and Della Porta wrote cryptographies (in Latin), exploring language's ability to reveal and conceal: an art they both found particularly compelling, albeit for vastly different reasons.

Tartaglia also toyed with language's possible "reveal-conceal" duality with his "poetic solution" to the cubic equation. In this and elsewhere, Tartaglia shows similar social anxiety to Alberti: that of being misunderstood, dismissed, or exploited. Tartaglia's works frequently display defensiveness regarding his lower-class status, poverty, and lack of formal education; but like Alberti, Tartaglia demonstrates pride at having accomplished much, despite myriad challenges.

Pacioli, unlike the other three authors under consideration – even though he was highly connected to a large network of nobility – expresses little concern in his writing regarding his own social status. This is not to say that he was not aware of status and was not an excellent self-promoter. Like Tartaglia, however, he cared deeply about writing in Italian as a means to bridging the education-class gap. Alberti and Della Porta – while they seem to have been less interested in furthering a "universal education" mission – did occasionally write in Italian and often had their works translated into Italian. All four enthusiastically sought to reach large audiences with their publications, although only Pacioli, Tartaglia, and Della Porta were able to make good use of the new printing press technology. Alberti, even if he could have had the press easily at his disposal, did not intend for his cryptographic treatise to circulate beyond the Vatican.

Pacioli and Tartaglia never met, but the connections between the two scholars are nevertheless numerous and deep. Besides the aforementioned commonalities

of lower social status origins and their fervent commitment to writing in the vernacular to reach more readers, both were active, life-long teachers. Tartaglia revered Pacioli, fifty years his senior, citing him constantly in his mathematics, imitating his writing style, even echoing Pacioli's rare but targeted use of poetry and mottoes within mathematical works. Both released Latin editions of Euclid's *Elements*, and both translated the *Elements* into Italian (although Pacioli's translation has never been found). Pacioli met the Bolognese mathematician Scipione Dal Ferro, who found the solution to one case of the cubic equation; Tartaglia would independently discover his own solution for the same case, and for other cases of the cubic.

In an era in which mathematical information was conveyed primarily in natural language, readers of mathematical treatises, it seems, could not resist commenting on the quality of a contemporary, or near contemporary, mathematician's writing. Even if a mathematician's mathematics were elegant and flawless, if his writing in Latin or Italian were poor, he would generally be made quite aware of this by his peers. Of the four authors, one was considered an excellent writer, two terrible writers, and the fourth a powerful writer but problematic computer. The indefatigable historian of mathematics Bernardino Baldi (1553–1617) praised Alberti's Latin mathematical writing as highly eloquent and was a great admirer of Alberti's literary works.[16] In contrast, he condemned both Pacioli and Tartaglia as awful writers, although he considered them great mathematicians.[17] Della Porta does not ever enter into his discussions.

In two cases, members of our four intersect in Garzoni's *Piazza universale di tutte le professioni del mondo*: Alberti and Tartaglia are both in Discorso 107 with the architects, fortress fortifiers, machine makers, and engineers; and Pacioli and Tartaglia are together in Discorso 15 with arithmeticians and calculators. But Della Porta overlaps with none of the other three. Garzoni offered him mixed praise, locating the physician-playwright among professors of secrets (respectable inventors of medicines, cosmetics, consumer goods, and marvels), magicians (a dark, insidious group), and pimps (obviously up to no good). He did, however, include Della Porta with one somewhat computationally oriented group: mirror-workers.[18] Garzoni may not have known Alberti's work in cryptography; he would otherwise likely have grouped him with Della Porta and the other professors of secrets, since he included cryptographers in this category. In Garzoni's assessment, Alberti and Della Porta were far-ranging, supple minds, though curiously he did not discuss in the *Piazza universale* either author's extensive literary production (even though he was certainly acquainted with many of their works). Garzoni presented Pacioli and Tartaglia as much less multifaceted in their talents.

Unlike Garzoni, Baldi did not include even a quick reference to Della Porta in his biographies of mathematicians. Della Porta's *Elementa* is, in fact, a rather unusual mathematical treatise, and Della Porta's only attempt at a purely mathematical work. Della Porta's absence from Baldi's *Vite* and from the major computational groups detailed in Garzoni's *Piazza universale* may, however, reflect chronology rather than a lack of esteem for Della Porta's mathematics: the *Elementa* had not yet been published when Baldi and Garzoni were writing. What we can see that Baldi and Garzoni could not, however, is how Della Porta's interest in curvilinear shapes recalls Alberti's and Pacioli's work on the morphology of letterforms; Della Porta's impulse to catalogue all conceivable curves parallels Pacioli's efforts to catalogue everything mathematical he could find or invent; and Della Porta shared Tartaglia's tendency (as well as Pacioli's and Alberti's to some degree) to seek mathematical opportunities for displays of intellectual pride, with both writers frequently boasting regarding their unique mathematical gifts.

Of the four, only Della Porta and Alberti ventured into literary writing (and, as mentioned earlier, only these two explored cryptography, wrote primarily in Latin, and were of high social status). I chose them intentionally as bookends to this study, where they operate as each other's inverse, although not as one might anticipate. Alberti's 1466 *De Cifris*, with its exasperated critique of man's tendency to deceive one another and its subsequent revolutionary invention of the polyalphabetic cypher, demonstrates powerful, forward-looking thinking; while Della Porta's 1601/10 *Elementa* fundamentally gazes backwards, conveying a nostalgia for the magical power of the circle, and for the comforting, authoritative format of the classical mathematical treatise par excellence, Euclid's *Elements*. Pacioli and Tartaglia fall chronologically between Alberti and Della Porta, and given their many similarities and ideals, they form a kind of unit, both pushing for the preservation, progress, and availability of mathematical knowledge to people of all classes. The nearly hundred and fifty years covered in this study show both the seeds of the Scientific Revolution to come and devotion to notions regarding the marvellous, magical, and divine character of numbers, proportions, and shapes occurring in the world around, and within, us.

Beautiful Minds

Though the chapters that follow will allow me to illustrate the beauty of just four early modern mathematical minds, the Italian Renaissance offers numerous other figures whom I might easily have chosen to be case studies for this book: Leonardo

da Vinci (1452–1519) (who worked closely with Pacioli to illustrate parts of the latter's *Divina proportione*); Antonio Manetti (1423–1497), Alessandro Vellutello (active in the first half of the sixteenth century), and Galileo Galilei (1564–1642), all of whom attempted to calculate the shape, size, and location of Dante's hell; the unknown author of the *Hypnerotomachia Poliphili* (1499), who penned a tragic dream-sequence in exquisite architectural detail; or Francesco Patrizi (1529–1597), who wrote treatises on both poetry and mathematics. I might have included a chapter on Marsilio Ficino (1433–1499), who produced highly regarded Pythagorean, Hermetic, and Platonic translations and studies of the age; or on mathematician Giorgio Valla (1447–1500), who collected a massive library of mathematical texts, translated Aristotle's *Poetics* into Latin, and wrote an encyclopedia (*De expetendis et fugiendis rebus*, published posthumously in 1501) that offered translations of newly discovered fragments from Apollonius, Archimedes, and Hero; or the philosopher Pico della Mirandola (1463–1494), who developed eighty-five mathematical "conclusions," many of which were almost immediately deemed heretical; or Angelo Poliziano (1452–1494), poet and avid collector of mathematical manuscripts; or the physician, mathematician, astrologer Girolamo Cardano (1501–1576), who wrote an intriguing encomium to geometry (and played a key role in the drama around Tartaglia's cubic solution); or Tommaso Campanella (1568–1639), who imagined a utopia that blended the *quadrivium* and *trivium* in equal parts; or the architect Daniele Barbaro (1513–1570), with his commentary on the appropriate Vitruvian proportions to use in building stage sets for tragedies and comedies. That any of these thinkers, and many more, could have illustrated the dynamic, extensive commerce between computation and writing in this period underscores the book's ultimate point: there existed an immense community of Renaissance writers and mathematicians who explicitly sought and celebrated the mutual benefits gained by dialogue between computation and writing.

Bernardino Baldi – poet, linguist, historian, theologian, mathematician, and translator of ancient mathematics – laboured to give an overview of historical and contemporary computer-writers in his immense compendium of mathematicians' biographies, the *Vite de' matematici* (written between 1586 and 1590), and in his more concise *Cronica de' matematici* (written contemporaneously). We might see Baldi's two works as weathervanes, indicating the directions and ways in which computation and writing in the Italian Renaissance were forming and intersecting.[19] And we might see Baldi, further, as the right person in the right place at the right time to author these works: an observer with the expertise to notice – and

celebrate – the evolving dance between literary and mathematical fields at the close of a two-century period when these arts were undergoing rapid change.

Baldi's *Vite* is nearly 2000 manuscript pages in length and presents 200 mathematicians (or 201, depending on how you count them) from Pythagoras to Christopher Clavius (d. 1612).[20] His *Cronica* offers 366 brief notes (not a random number choice, given Baldi's obsession with time) on mathematicians from Euphorbus (seventh century BCE) to Guidobaldo del Monte (d. 1607). Baldi modelled both texts, but especially the *Vite*, on well-known biographies by Diogenes, Plutarch, Petrarch, Boccaccio, and Vasari: by association with these illustrious predecessors, he suggests mathematicians deserve as much admiration as the politicians, rulers, philosophers, and artists profiled in other influential *vite*. In his prefaces, and often throughout the biographies and chronicle entries, Baldi articulates the extensive contributions mathematicians have made to the arts, to society, and to humanity as a whole.

Most of Baldi's *vite* (and *croniche*, albeit in a more condensed fashion) follow a similar format. He begins by indicating where each mathematician was born; his (all Baldi's mathematicians – except Hypatia – are male) religion or philosophical beliefs; which languages he spoke; and in which languages he wrote (a topic of great interest to Baldi, who is said to have known twelve languages, including Arabic and Greek, both of great importance to Renaissance mathematics). Each *vita* would then describe its subject's mathematical texts, his teachers and *studia*, his students and where he taught, his friends, and finally where and how he died. Baldi also often adds further details: where he (Baldi) found his information; what errors a given mathematician made; which mathematicians later improved upon a subject's works, and which mathematicians should have read each other's work (or done so more carefully); when possible, he even describes where texts are available for consultation. Sometimes Baldi mentions where a mathematician's texts were published and who translated and/or commented on them; and occasionally (as in the cases of Alberti, Pacioli, and Tartaglia) he adds his critical opinion on the merit of a given mathematician's writing style.

Peppering his *Vite* are numerous neologisms Baldi devised to name mathematical objects and fields of study – a practice of naming that all four authors in this study followed when they were writing about and doing mathematics. In the sixteenth century, even more than in the fifteenth, scholars from all fields were racing to invent new terms for the new ideas, discoveries, inventions, and knowledge being transmitted more quickly than ever before. Standardized conventions for mathematical operations and functions had not yet stabilized, and most

mathematical texts were still written in natural language. Words, writing, symbolic language, and mathematics were evolving rapidly and, necessarily, together. As historian Warren Van Egmond has written, "[t]he ways in which we write our numbers, calculate with and think about them, the techniques and symbolism of algebra, which provides the basic language of modern mathematics, and our remaining knowledge of classical mathematics – all these are the results of work done by mathematicians in the fourteenth, fifteenth, and sixteenth centuries."[21] I would add that these accomplishments are also the result of the *computisti's* contact with writers – intellectuals who were as committed to seeking new forms, formats, styles, and conventions for their work – and of the Renaissance *computisti's* own experience as highly conscious writers.

While Baldi says little about what writing offered mathematics, he often speaks of mathematics' contribution to humanistic fields such as philosophy, theology, literature, law, and history. As a historian, he particularly sought to demonstrate the importance of mathematics – or, rather, the mathematical approach of objectivity – to the writing of history. In his *Breve trattato dell'istoria* Baldi says, point blank, that a true historian should know mathematics.[22] What kind? He does not specify. But he does explain that the writing of history requires eloquence and objectivity: the historian, he explains in the *Breve,* can give his opinion on the events of the past but "must do so carefully" and "without passion or affect."[23] Baldi admits that historians (and readers) must judge at times, but the ideal historian (and reader) would do so rarely and would try to let facts speak for themselves. Given the context in which he was writing, Abbot Baldi might himself be commended for reserving judgment on the many potentially controversial figures he included in his *Vite*: Arab and Jewish mathematicians, not to mention a few heretics. Even when criticizing certain mathematicians as enemies of the faith or "barbari" [barbarians], Baldi ultimately focuses on their mathematics: if the math is good, he says so. He often employs superlatives to describe a mathematician's "ingegno" [genius], ranging from *eccellentissimo, celebratissimo, sottilissimo,* and *prontissimo* to *curiosissimo*; he excused great mathematicians for making mistakes or having inelegant writing, "as to err is human,"[24] though he did not hesitate, as we know, to chastise those who wrote exceptionally badly.

Still, for modern readers (especially those of us drawn to biopics of mathematicians and scientists like John Nash, Alan Turing, Stephen Hawking, and the women of *Hidden Figures,* such as Katherine Johnson) it is rather disconcerting that a text called "The Lives of Mathematicians" should say so little about its subjects' personhood.[25] Of course, Baldi did not have access to extensive data for the majority of his ancient, medieval, and foreign mathematicians,[26] but even when he wrote

biographies of mathematicians he knew personally, he tended to avoid saying much about their private lives. Readers glimpse tidbits here and there: we learn that Hippocrates of Chios was inept in running a household; that Xenocrates was melancholic and partook of abstinence (although Baldi's *vita* does not specify from what Xenocrates abstained). But a number of *vite* – including the first he wrote, in honour of his beloved teacher Federico Commandino – do offer more insight into the life and humanity of a mathematician. Baldi speaks, for example, of Commandino's physique, his impressive study regime, snappy dressing, despair at losing his wife, weakness for women, and general temperament.[27]

What the *Vite* convey overall, I would argue, is that the *practice* of mathematics and its results are more important than the mathematicians themselves. Despite Baldi's claim, in the Preface to the *Vite*, that the world should know as much about the lives of mathematicians as it does about the lives of other great minds (grammarians, orators, sophists, and painters), his "biographical" collection might as easily have been called "Works of Mathematics." Granted, he organized the entries by the mathematicians and not by their publications. But Baldi's *Vite* give readers a mixed message: on the one hand, the *Vite* exalt mathematicians *because of* their mathematics, and value a person's professional output over his class, race, religion, and education; on the other hand, the *Vite* essentially hold the mathematicians at a remove from the reader, raising them up as heroes somewhere between the human and divine. We might even compare them to the mechanical movers of (forgive the coincidental name) Hero's *Automata*, a text that Baldi translated. Gleefully reversing the human sense of superiority over inanimate objects or machines, Baldi presents the human as frozen in awe, as he witnesses a moving automaton: "O come l'arte imitatrice ammiro / Onde, con modo inusitato e strano, / Movesi il legno, e l'uomo ne pende immoto!" [Oh how I admire art the imitator / where, with a new and strange way / it moves wood, and man hangs before it, immobile!].[28] For Baldi, computational and verbal arts – especially when the fusion of the two is at its best – seemed able to trump even humanity's humanness.

With Ovid in mind, Baldi exclaims in his description of Urbino's Palazzo Ducale that "niuna forza è superiore a quella delle lettere nel far resistenza agli assalti e alle screte e potenti macchine del tempo" [no force is superior to that of letters in resisting the assaults and powerful mechanisms of time].[29] What a meaning-rich statement from a writer who cared about retrieving the past and immortalizing ideas for the future, a computer who studied, most enthusiastically, the physics of force and the dynamics of machines, and a historian who wrote extensively on the practical means to measure and understand time, as well

as accomplishments within time. The very fact that someone decided to compile the lives and works of mathematicians at this point in the Italian Renaissance – someone who was himself an exceptional computer-writer – is indicative of the growing status of mathematicians in this period, as well as the urgency of writers to write about them, and of mathematicians to write in such a way that more people could access their knowledge.

With Measured Words

At the core of both computation and writing are *mathesis* – "knowledge" or "learning" – and *poesis* – an act of making and creating. The *mathesis of poesis*, the knowledge of making, and the *poesis of mathesis*, the making of knowledge: the awareness of these two acts is not limited, of course, to the Italian Renaissance, nor to mathematicians and writers. Yet Renaissance mathematicians were particularly "well versed" in the humanities, and Renaissance writers were drawn to the proportions, harmonies, and objective truths that computation so beautifully narrated.

Early modern computer-writers have, in many ways, paved the way for our present forms of computation, writing, computational writing, and writerly computation. Although the conversation is alive and well between today's writers and today's human computers (and digital computers), the interlocutors are less likely than their Renaissance peers to move as consciously, or as freely, between the worlds of words and mathematics. This involves a loss on both sides. It does not take much, however, to observe how writers today actively construe their production in terms of data: word counts and searches, text mining, digital presentation and delivery, visualizations of networks and other kinds of relationships across space and time, statistical analyses of citations and reviews. Equally, today's computers must use natural language to support and popularize their work through grant writing, blogs, and lectures – and some of the most intractable computational problems in artificial intelligence centre on the acquisition and production of natural language. In the centuries since Alberti, Pacioli, Tartaglia, and Della Porta, interest in the connections between computation and writing has ebbed and flowed. In a post-modern, tech-driven world that increasingly speaks the language of big data, however, such algorithmic-linguistic connections (and the thinkers capable of making those connections) are becoming newly prized. Alberti's calculations on how to mask an alphabet through code, Pacioli's instructions on how to render letters beautiful through geometry, Tartaglia's choice to

place a prized solution to a long-sought equation in a poem, and the physician-magus-playwright Della Porta's foray into the mathematics of curves *are* digital humanities. These four Italian Renaissance computer-writers show us what inter-disciplinary discourse can look like: its challenges, its triumphs, and its remark-able value to all disciplines involved.

By studying examples of the conversation between computation and writing through an author's historic context, opus, personal history, and the meanings with which they endowed their works, we start to see the deep ontological and epistemological bonds that exist between mathematics and letters/words/language. We see how both mathematicians and writers necessarily measure their words: literally and figuratively. And in seeing the remarkable benefits of such concerted interdisciplinary commerce, we may be inspired, or re-inspired, to fur-ther notice and further develop active disciplinary exchanges in our own world.

Cryptographica:
Leon Battista Alberti's *De componendis Cifris*
(1466)

Words are dangerous tools ... The scientist must thrust through
the fog of abstract words to reach the concrete rock of reality.
 – Hermann Weyl[1]

In 1466, Leon Battista Alberti (1404–1472) was in Rome, having recently ended his time as apostolic secretary to Pope Pius II. The renowned Renaissance polymath had already written his famous treatises on painting (*De pictura/Della pittura*, 1435–6), sculpture (*De statua*, c. 1450), and architecture (*De re aedificatoria*, 1452). He had designed exquisite buildings for Florence, Mantua, and Rimini, and consulted for numerous others. He had organized one of the earliest formal poetry contests in Italy (the *Certame Coronario*, 1441), and he had written over forty works on a wide variety of topics, in both Latin and Italian. While still in law school, he had produced a comedy (*Philodoxeos*, 1424) that he passed off as recovered from ancient Rome. Later came a discourse on the pros and cons of studying literature (*De commodis litterarum atque incommodis*, 1428–30), a dialogue on escaping bad relationships (*Deifira*, 1429–34), and two discourses on love in good ones (*Amator* and *Ecatonfilea*, 1429–30?). Alberti had also reflected on the hardships of priestly life (*Religione*, 1428–30), collected fables (*Intercenales*, 1430–40), written a Tuscan grammar textbook (*Grammatichetta*, 1434–41?), offered advice on how to run a family (*I quattro libri della famiglia*, 1433–44), and called readers to civic duty and moral virtue (*Theogenius*, 1439–41). He had surveyed Rome in *Descriptio urbis Romae* (c. 1450), produced an autobiography (1438–43/4), a study on law (*De iure*, 1437), a collection of mathematical divertissements (*Ludi rerum mathematicarum*, 1450–2), a treatise on horses (*De equo*

animante, 1441), a eulogy for his deceased dog (*Canis*, 1438), a satire of nearly everything in his proto-novel, *Momus* (1443–50), and a paradoxical encomium to the house fly (*Musca*, 1442–3).

One day in 1466, perhaps on a break from his wildly prolific writing program, Alberti took a stroll in the Vatican gardens with his friend and fellow papal secretary Leonardo Dati. He and Dati, he recounts, had a rather memorable conversation that flowed from thinking about Gutenberg's powerful new tool:

> we happened to praise in the most enthusiastic terms the German inventor who has recently made it possible, by means of a system of moveable type, to reproduce from a single exemplar more than two hundred volumes in one hundred days with the help of no more than three men. This makes it possible to obtain an entire, large format page from a single impression. That having brought us to similar appreciations of the brilliant discoveries in the most diverse areas, Dati fervidly admired those who, faced with strange characters with unusual meanings known only to the writers and receivers, called ciphers, have the skill to read and interpret them ...[2]

So begins one of Alberti's most curious and least-studied works: his Latin treatise on cryptography, *De componendis Cifris* [On Devising Ciphers]. Alberti wrote *De Cifris* at Dati's request,[3] and did not intend for it to be made public, although the text quickly found its way to Venice, London, and other important courts across Europe.[4] It was not until nearly a century after Alberti's death that the treatise was published, and then only in Italian translation by Cosimo Bartoli in a compilation of Alberti's works he entitled *Opuscoli morali* [Moral Works] (Venice: Franceschi, 1568) – an odd designation for works that ranged from mathematical games to his famed treatise on painting.[5] The complete, original Latin *De Cifris* was not printed until the early twentieth century, and the first critical edition did not appear until 1994.[6] Alberti's original autograph has not been found, but thirteen manuscript copies have been located thus far.[7]

De Cifris is one of the earliest treatises on coding in the Western world, and Alberti has accordingly been dubbed the father of Western cryptography. With his invention of polyalphabetic substitution (a cipher system that encodes through the use of multiple alphabets and changing indexes), he shaped the most difficult encipherment system to crack (and also to create) for the next four hundred years. No cryptographic system developed in the Renaissance – not the renowned works of Giovanni Soro, Johannes Trithemius, Giovan Battista Bellaso, and Blaise de Vigenère, nor the lesser-known projects of Girolamo Cardano and Giambattista Della Porta – was as revolutionary as Alberti's.[8]

The rapidly developing Italian city-states of the fifteenth century – and the political imperative for secret communication – partially explain the pre-eminence of Italian cryptanalysis in this period. But it was the humanists' gaze back to antiquity – to its mathematics and to its language and literature – that gave Italy an edge over countries that had yet to be seized by this particular craze for ancient learning. Even though the Arab world had developed sophisticated cryptographic systems before and during the Middle Ages, most of the Arab scholars' writings remained inaccessible to early Renaissance Italians. Cryptanalysis had been relatively stagnant in the European Middle Ages, perhaps most curiously because coding was associated with theoretical mathematics, which in turn was believe to be linked to the dark arts.[9]

Where, then, did Alberti find inspiration for his brilliant cipher system? Perhaps the idea of moveable type – and his conversation with Dati that day in the Vatican gardens – triggered something in his imagination. Alberti may, in fact, have seen the new press in action, as the German printers Konrad Sweynheim and Arnold Pannartz brought a press to Subiaco, outside Rome, around 1464, just before Alberti penned *De Cifris*.[10] Others have pointed to classical sources that talked about secret writing, such as Ovid or Suetonius,[11] and the "wheels" for generating orations and recalling them in Ramón Llull's *Ars inventiva veritatis* (1289) and Giovanni Fontana's *Secretum de thesauro experimentorum ymaginationis hominum* (c. 1430).[12] The topic of coding may have arisen in conversations with mathematician friends, such as Paolo dal Pozzo Toscanelli, the great Florentine mathematician, astronomer, and reviver of ancient mathematics to whom Alberti dedicated an entire book of the *Intercenales*; or Pacioli, whom Alberti is said to have hosted in Rome, and with whom he may have explored the geometric proportions of ancient lapidary inscriptions. M.D. Feld proposes that Pacioli may even have been Alberti's amanuensis in the last few years of Alberti's life,[13] and Alberti may have been a primary source of inspiration for Pacioli's Roman capital letters, as we shall see in the next chapter. The modern printing press, ancient wisdom, the art of writing, medieval "wheels," and Florentine mathematicians – these may all have played a part in Alberti's inspiration.

Few literary scholars and Renaissance historians have discussed *De Cifris* at all, much less at any length.[14] Historians of cryptography have primarily focused on the text's cryptographic originality, and the few mathematicians who have explored *De Cifris* have looked principally at Alberti's statistical analyses of letter frequency.[15] The social, cultural, and biographical implications of this fascinating treatise have remained unexplored. What happens, then, if we investigate *De Cifris* as the meeting place for Alberti's mathematical expertise

and his literary / linguistic imagination? Alberti's deep knowledge of mathematics made him a perceptive observer of patterns and builder of systems. His training in the *studia humanitatis* – as well as his interactions with high nobility, scholars, clerics, and artisans – gave him insight into the very human art of communication (and deception), rhetoric, and language's syntax and grammar. From unmasking and cataloguing language's patterns, he moved easily to devising systems to masterfully mask those patterns. *De Cifris* – a remarkable piece of interdisciplinary thinking – reveals something further about its author: while many of his contemporaries were attempting to impose ideal patterns onto the world around them, Alberti fashioned himself as an empirical *decoder* seeking to unlock data patterns hidden within the natural and human worlds around him.

Deciphering *De Cifris*

Often bound together in fifteenth- and sixteenth-century codices with his *Elementa*, *De statua*, and *Trivia senatoria*, Alberti's *De Cifris* is a mere twenty-five manuscript pages in length, comprising nineteen brief chapters, a diagram of the polyalphabetic cipher wheel (figure 1.1), and a numeric table (figure 1.2).[16]

The initial three chapters introduce the nature and importance of codes; the following four analyse statistically and structurally the frequencies of vowels, consonants, syllables, and letter pairs in Latin. Alberti notes almost immediately that in any given page of Latin text – verse or prose – there are more consonants than vowels, but Latin verse has fewer consonants per page than prose does. He then goes on to reveal that there are 2:1 more consonants than vowels per page of verse, and 4:3 more consonants than vowels in prose.[17] Interpretations of his calculations and his terms "octava" and "sesquitertiam" have been varied and contradictory, but Bernard Ycart's recent statistical investigation of Alberti's letter counts confirms Alberti's claim that there are approximately one-eighth more vowels (especially *a*, *e*, and *y*, with *i* and *u* varying in their use as vowel or consonant) in classical Latin poetry than in classical Latin orations.[18] Ycart hypothesizes that the higher frequency of "y's" in classical Latin poetry indicates a more consistent use of Greek words, and that "a's" and "e's" have a more open sound, which would be more appealing to the poetic ear.[19]

The next four chapters of *De Cifris* (beginning with Chapter 8) consider the encrypted message's visual appearance. After a few sentences in Chapter 12 dismissing the ineffectiveness of steganographic techniques – such as using invisible

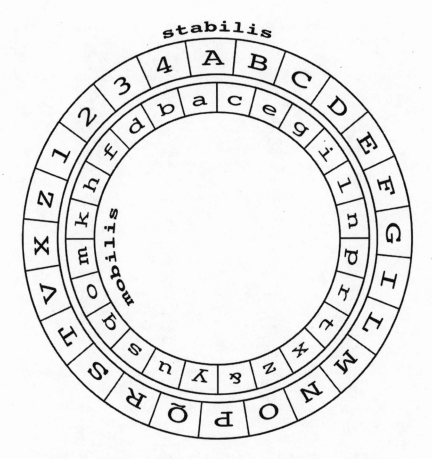

1.1 Visual representation of Alberti's two-disc encipherment system (as described in his *De Cifris*), which he called the *formula*. Image by Kavi Montanaro, based on the drawing in Leon Battista Alberti, *Opuscoli morali*, ed. Cosimo Bartoli (Venice: Franceschi, 1568), 213.

ink to hide a message – Alberti discusses in detail how the encrypter must be careful not to use visual "giveaways": recognizable punctuations, familiar spacing between words, normal spelling (especially with common letter sequences like "qu"). He extols the value of "nulls" (characters or symbols not actually part of the cypher text); exalts the use of homophones; recommends using fake words or words without vowels, or using symbols that resemble neither Greek nor Roman letters nor the objects they are meant to represent. He notes that often words

1.2 Page of Alberti's numeric tables. Leon Battista Alberti,
De componendis Cifris (1466). Miscellanea Correr 47 2130, fol. 7r. 2016
© Biblioteca Correr – Fondazione Musei Civici di Venezia.

have two vowels, one after another, and that infrequently will a word have more than two successive consonants.

In Chapters 13 through 18, Alberti reveals his ingenious polyalphabetic system and numeric nomenclator chart. Alberti's two-disc system, which he called the *formula*, consisted of forty-eight total houses, or cells. The outer, fixed (*stabilis*) wheel had twenty capital "plaintext" letters of the Latin alphabet and numbers 1 through 4. These are the letters that spell out the actual message to be communicated. The inner, mobile wheel had twenty-three "cipher-text" letters, an ampersand, and no numbers. The discs were, incidentally, intended to be cast in *aeneus* (copper or bronze).[20] Cosimo Bartoli, the 1568 editor of *De Cifris*, organized the inner wheel's cipher-text letters in a zigzag manner in his image (see figure 1.1), and I have followed suit, although Alberti makes it clear that these letters can be organized in any order. Per Alberti's wishes, the outer wheel – the plaintext wheel – lacks not only the letters "J," "K," "W," and "Y" (which, besides the "J" in Latin, are not used in either the Latin or Italian alphabet),[21] but also the letter "H," which is used in both alphabets. Although Alberti does not tell us the reason for the absence of the letter "H," it is likely because the "H" is silent in Latin, and plaintext words can be understood without it; for Italian words, on the other hand, a missing "H" can change the word entirely. The missing "H" might be considered a bonus obfuscator. Also of note, but not explained, is that the inner cipher-text wheel contains "h," "k," "x," "y," and an "&" ("k" and "y" used for Greek, and the "x" often used in Alberti's Italian, and a letter he includes in his Tuscan alphabet in the *Grammatichetta*), but no "j" or "w." Alberti mentions, moreover, that the capital plaintext letters on the outside wheel are meant to be in red – but not the numbers, which are meant to be in black, as are the lowercase cipher-text letters. Historian of cryptography David Kahn has argued that the use of black and red indicates only that Alberti "liked colors."[22] While I am sure Alberti did like colours, I would suggest that he may also have intended these colours to add another dimension of obfuscation, which scholars have not yet been able to identify.

At first glance, the use of these wheels could seem quite simple: just line up a letter of the outer wheel against a letter of the inner wheel, and then encode and decode through substitution based on that calibration. If, for example, you set the lowercase "b" of the inner, mobile wheel to the capital "A" (this b-to-A setting would be called the *index*), you would then encode the word "NO" (N-O) as "tx" (figure 1.3).

As long as the person to whom you sent your encrypted note had the same two wheels and was told the "key" (how to set the index), you would have a simple, monoalphabetic code with the twist of a scrambled cipher-text alphabet. But if

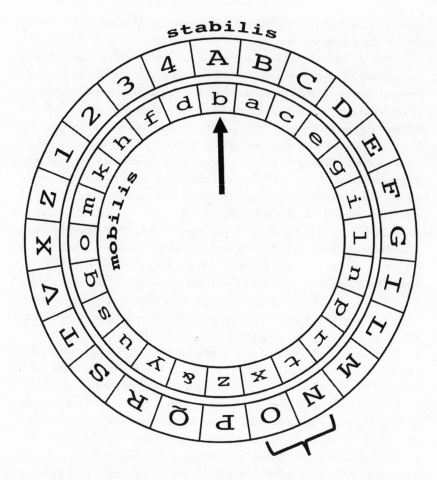

1.3 Calibrating a cipher text with Alberti's two-disc encipherment system.
Image by Kavi Montanaro.

your encrypted letter were intercepted – even by a villain without your wheel system and your key – your message could be easily deciphered based on word and letter frequency. The brilliance of Alberti's system comes from its "polyalphabetic" design: Alberti proposes that the index be changed every few words, or every word – and even, if you can imagine it, every letter. An encoder, then, could go about encoding a message as follows: First, he might communicate to the recipient that the index should be set to the outer-wheel A. Then he would

convey the key – for example, one in which each capital letter in the ciphered message indicated the new letter to which the outer-wheel A should be set. Or he could randomly place numbers 1–4 within the text and say that every time the recipient reached a number, he should recalibrate the inner wheel to the outer wheel according to a given set of pre-established rules.[23] Or, he could give his recipient a word or short phrase and a rule: recalibrate the index according to the letters of this word (or phrase) with each new word in the ciphered message. For example, if the message to be conveyed were five words long, the key word would be five letters long and could look like figure 1.4.

Even more difficult to crack are codes that polynumerically associate the four numeric cells on the fixed wheel with words, names, and phrases. In this super-encryption system, code-words, names, or phrases can be used and combined in groups of 2, 3, or 4. With a pairing of 2 numbers (a bigram) you could have 16 phrases at your disposal; with groups of 3 numbers (a polygram) you could have 64 phrases; and with 4 numbers, 256. Figure 1.5 shows how this system works. While this polyalphabetic cipher system may seem rather simple to us now, post–Enigma Machine and advanced computing, in its time it was a truly remarkable achievement, one that resulted directly from Alberti's interdisciplinary thinking.

Writing in Code

Historian Paul Lawrence Rose posited that Alberti was one of the thinkers in the Renaissance for whom mathematics was central to how he viewed life and the world, as mathematics gave him "a certainty and contentment lacking in the arbitrary vexations of human affairs."[24] Alberti's extensive writings – both technical and literary – show just how varied was his application of mathematics to the world. For Alberti, mathematics had its roots in nature itself, not – as many other fifteenth-century thinkers believed – in the divine.[25] I would even venture to say that, unlike Galileo, he saw mathematics as a system derived from phenomena in the natural world and the human mind, rather than seeing mathematics *as* the language in which the world was written. Mathematics was more than just a tool Alberti used to describe and understand the world around him. It was more than a way to "[exercise] his intelligence" rather than tax his memory, as he explained in his *Vita* the choice of mathematics and physics over his earlier legal studies.[26] For Alberti, mathematics was ultimately a companion in his search for certainty, contentment, unity, and harmony.

If the key is
felix

word 1 at A-f
word 2 at A-e
word 3 at A-l
word 4 at A-i
word 5 at A-x

plaintext
Go to Rome at once

cipher text
gr my kqut ih fh&u

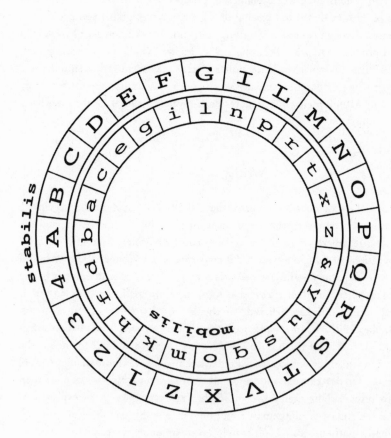

1.4 An example of a five-word message using Alberti's two-disc encipherment system. Image by Kavi Montanaro.

stabilis

mobilis

plaintext
It is not possible for the
ship to arrive in port
Saturday morning.

key
11 = Saturday morning
12 = in port
13 = soldiers
14 = not possible
21 = to arrive
22 = the ship
23 = for

cipher text phase 1
14 23 22 21 12 11

cipher text phase 2 (the index is A-b)
kd hf hh hk kh kk

1.5 An example of a coded message using Alberti's numeric tables and two-disc encipherment system. Image on right by Kavi Montanaro.

Alberti's mathematical expertise was vast, as we can see by the topics of his writing, his art and architecture, and the texts present in his personal library.[27] Many were the circles of mathematically interested and/or mathematically minded people with whom Alberti associated, such as the Florentine humanists bringing ancient Greek mathematics to Florence for study, Greek scholars and translators (Theodorus Gaza), mathematicians (Paolo Toscanelli, Regiomontanus, and Pacioli), fellow engineer-architects (Filippo Brunelleschi), and the collectors of these mathematical treatises (Bessarion and Nicholas V).[28] Alberti certainly knew his Euclid,[29] as we can see from his extensively annotated copy of the Campanus translation of the *Elements*,[30] and he knew some Archimedes,[31] Hero of Alexandria, Nicomachus (more for his music theory than for his number mysticism), and Fibonacci (Leonardo of Pisa). He frequently cites texts such as Pseudo-Pythagoras's *Aurea praecepta* and *Symbola* (Ficino's translations), Plato's *Timaeus*, Strabo's *Geographia*, Diogenes Laërtius's *Vitae* (Thales, Anaxagoras, Pythagoras), Vitruvius's *De architectura*, Marcus Manilius's *Astronomica*, Lucius Columella's *De re rustica*, and Pomponius Mela's *De cosmographia*.[32] And although it is unlikely that he would have had access to the new translations of the Greek mathematical works Giorgio Valla was to include in his encyclopedia *De expetendis et fugiendis rebus* (published posthumously in 1501 by Aldo Manuzio), he may have known about the translations being done of geometric work by Apollonius, Pappus, Proclus, Serenus, and others.

With the notable exception of *De re aedificatoria*, where Alberti sustains a long commentary on Vitruvius, he did not take part in the standard humanist activities of recovering, translating, or commenting on ancient mathematical treatises; nor did he write treatises on trigonometry, algebra, geometry, or number theory. Though little of his writing shows an interest in classical, religious, or Neoplatonic number symbolism,[33] scholars have argued that his architectural designs reveal, at times, an interest in sacred geometry and numerology.[34] Alberti's relationship to mathematics was, however, as deep as it was broad. He explored mathematics' practical applications, and used mathematical tools to develop new devices and techniques for understanding the world: explaining and codifying artificial perspective, developing the camera obscura and the anemometer, and of course, inventing the polyalphabetic cipher.

Of his purely mathematical works, the *Ludi matematici* (1450–2), which Alberti wrote for Meliaduse d'Este at the latter's request, best shows Alberti's passion for applying mathematical knowledge to everyday human situations – mechanical and physical situations that require problem solving, similar in many ways to the art of decoding. This book of mathematical diversions was written in

an informal Italian and aimed at a layperson who wished, essentially, to play with mathematics. It covered an array of "games," such as how to measure the height of towers, the width of rivers, and the depths of wells; how to make a gravity-powered fountain; how to calculate time by means of the sun or the stars; and how to construct devices to level surfaces, weigh objects, measure distances and create maps, assess the speed of a ship, or measure the weight of solids displaced by water. Euclid is everywhere in this particular book; word problems from abacus treatises appear; Hero of Alexandria looms large in the *ludo* of the gravity-powered fountain; and Archimedes (perhaps via Vitruvius) is present as Alberti explains how to measure solids through water displacement. Alberti refers directly to the fifteenth-century artist and engineer Mariano di Jacopo, known as Taccola (*De ingeneis* and *De machinis*); the twelfth-century Spanish mathematician and astronomer Abraham bar Ḥiyya, known as Savasorda (*Liber embadorum*); and the first-century agronomist Columella (*De re rustica*). Alberti's practical application of mathematics to real-world problems shows the power he saw in mathematics as part of the natural world – a power that needed to be understood and cultivated.

The brief *Elementi di pittura* (1432–5), written before the seminal *De pictura / Della pittura* (1435–6), shows off Alberti's understanding of Euclid and Fibonacci's *De practica geometrie*. The even briefer (single-page) *De lunularum quadratura*, which has not been definitively attributed to Alberti,[35] reveals a familiarity with proposed methods for solving the classical problem of squaring the circle, such as Hippocrates of Chios's method of using lunes, and Archimedes' method of exhaustion. Alberti did, in fact, transcribe a passage from Archimedes' *De mensura circuli* in his copy of Euclid's *Elements*,[36] and he must have known Llull's attempted solutions to the problem (he owned a copy of the Catalan's *De quadratura et triangulatura circuli*).[37] He may also have known Nicholas of Cusa's work on how to square the circle, as he would have had opportunity to meet Cusa through their common friend, the mathematician Paolo Toscanelli.[38]

Yet the groundbreaking *De Cifris* – though it would have been well served by an algebraic system – does not employ algebra. (Algebraic cryptography would be introduced decades later by mathematician François Viète, 1540–1603.)[39] Alberti was familiar with Fibonacci's 1202 *Liber abaci*, and had access to the work of some medieval Arab algebraists in Latin translations, such as al-Khwārizmī's *Algebra*, translated by Robert of Chester (*Liber algebrae*, 1145), and Savasorda's *Liber embadorum*, translated by Plato of Tivoli in 1145. Alberti would likely also have known, at the very least, some of the algebra Pacioli would include in his 1494 *Summa de arithmetica* (a compilation of European mathematical knowledge),

and he may have been aware of Regiomontanus's discovery of Diophantus's *Arithmetica* in Venice in 1463–4.[40] Alberti's brilliance and far-reaching interests notwithstanding, he was not an avid explorer of the algebra of his time. Of unlikely attribution to Alberti is a small text on algebra called *Algorismus proportionum*, which appears after four of his works (*Elementa picturae, De statua, De Cifris,* and *Trivia senatoria*) in a codex in Florence, but is written in a different hand.[41] He probably did not write the brief *Algorismus*, as he makes no reference to it elsewhere in his opus.

Yet even without a deep interest in algebra, Alberti's mathematical knowledge was vast, and his expertise – especially in the realms of geometry and engineering – was impressive. His talent for applied mathematics, together with his love for and facility with words, primed Alberti to perceive quickly that the operation of Gutenberg's press would require calculating letter frequencies, making him, as Friedrich Kittler has observed, "the first among Gutenberg's contemporaries to grasp the mathematicization [of words]."[42] Much earlier, Giorgio Vasari had also linked Gutenberg and Alberti (when discussing the latter's work in linear perspective), heralding both as inventors who gave the world techniques for "enlarging small things and reproducing them on a greater scale."[43] When Bernardino Baldi included Alberti in his *Cronica de' matematici*, he described him as "of the sharpest intellect and equally predisposed to all forms of study" – highlighting precisely the polymath quality that would predispose Alberti to systematize the mathematicization of language in *De Cifris*.[44]

Number and word converged in Alberti's cryptographic endeavour, as we know they did in many of his other written and architectural works. Perhaps he even – albeit incorrectly – connected the Hebrew word for "text" or "book" (רפס: *sefer*) to the Italian word *cifra*, which in fact derives from the Arabic word (ر.فص: *ṣifr*) meaning "zero" but by Alberti's time had come to mean "number" in general. Word and number. Although he was unlikely to have been familiar with or have had access to Arabic cryptographic treatises, there is a prominent aspect of Arab cryptography that may have intrigued Alberti: its explicit and intimate connections to grammar (not just to questions of letter and word frequency, which is central to all coding and decoding).[45] Alberti himself wrote a grammar textbook, the *Grammatichetta*, or *Della lingua toscana*, between 1434 and 1441, either contemporaneously with or shortly after the Certame Coronario – an event that spotlighted the vernacular. We know that he valued the vernacular in all areas of learning; he was also the first to write eclogues in Italian, and to follow classical hexameter rhythm in the vernacular. As Martin McLaughlin has rightly noted, Alberti was more committed to assimilating classical texts into contemporary

Italy, writing modern versions of ancient texts and building original theories on ancient thought, than he was to philological recovery and restoration.[46] Alberti's *Grammatichetta*, the Tuscan version of Priscian's *Institutiones grammaticae*, demonstrates precisely this commitment.

The *Grammatichetta*, moreover, demonstrates an early interest in patterns and letters that Alberti would develop a few decades later in *De Cifris*. In an original move that departed strikingly from his Latin model, he arranged his Tuscan alphabet *non-alphabetically* (figure 1.6). Carmela Colombo has convincingly demonstrated that Alberti intended this alphabetical arrangement for his *Grammatichetta*: she found a surviving copy of the alphabet, in Alberti's hand, written on a single sheet of parchment, in Florence's Riccardiana's Cod. Moreni 2.[47]

Some scholars believe that Alberti organized these letters – notably, in a chancery, humanist hand as opposed to a blackletter script – according to the number and kinds of pen-strokes needed to make them;[48] others think he organized the letters in terms of their overall forms, from the simplest to the most complex.[49] A third group sees the organization as an early attempt at an alphabet arranged according to phonetic principles.[50] While Alberti does use verbs such as *dire* and *pronuntiare* (*sic.*) much more often than *scrivere* in the text,[51] I think the importance of visual form to Alberti should not be discounted: he may well have looked at the alphabet as a series of letter shapes/building blocks. Alberti does not explain the organization of the *Grammatichetta*'s alphabet, leaving his readers to wonder what his exact thinking was on these shapes.

The most commonly reproduced *Grammatichetta* is the Vatican's Reginense 1370, which is by a fifteenth-century hand. The alphabet chart in this manuscript copy slightly alters the order of the Riccardiana's autograph version. The third and fourth lines of letters are reversed ("c-e-o" now comes above "l-ʃ-f"), and the "b" and "d" in the fifth line are inverted. Colombo and Paolo Bongrani see the reversal of lines 3 and 4 to be intentional on the copyist's part, and believe he (the copyist) was simplifying the orthographic system Alberti posed, with the long strokes (ascenders) of "l-ʃ-f" more closely linked with those of "b-d" and a particularly long-swashed "v" (although the copyist shortens that arm).[52] One could further argue that the round bodies of "c-e-o" link closely with those of the bowls of "b-d." The precise logic for Alberti's, as well as the copyist's, letter groupings and ordering is still not entirely clear, but shape is undoubtedly part of the formula, as it is in *De Cifris* where Alberti speaks directly to letter shapes when discussing the confusion that "u's" and "v's" can create for someone trying to decode a letter (hence the value in switching them on purpose or using only one shape for both).[53]

1.6 Autograph page from Leon Battista Alberti, *Grammatichetta* (c. 1440).
Codice Moreni 2, carta IV. Biblioteca Moreniana, Florence.

If Alberti's *De Cifris* was partly inspired by the mathematical implications of Gutenberg's printing press, its coding system remains informed by the conventions and considerations of manuscript production: a meeting of print and manuscript, as well as a meeting of mathematics and grammar. Alberti knew how easily letters and numbers, like images (of which there are few in Alberti's works), could be miscopied by scribes in the pre–printing press world. What is more, in his autobiography he describes a reading experience when the his tired eyes see letters on the page reorganize themselves from fragrant flowers into scorpions:

Sibi enim litteras, quibus tantopere delectaretur, interdum gemmas floridasque atque odoratissimas videri, adeo ut a libris vix posset fame aut somno distrahi; interdum autem litteras ipsas suis sub oculis inglomerari persimiles scorpionibus ...

For letters sometimes delighted him so much that they seemed like flowering and fragrant blossoms from which hunger or weariness could hardly distract him; yet at other times they would seem to be piling up under his eyes, looking like scorpions ...[54]

Letters written or printed in blackletter were certainly guilty of tiring the eye more than the older Carolingian and the newer humanist scripts and fonts.

As Guglielmo Gorni stated, "within [Alberti] the literary scholar [there] surfaced the artist, who was inclined to acknowledge the alphabetical sign for what it is: a stylized occasion of geometrical representation."[55] Alberti was, in fact, among the early humanists interested in Roman epigraphy and in reproducing the capital letters found on lapidary inscriptions – as can be seen, for example, in the lettering he and Matteo de' Pasti designed for the Cappella Rucellai in Florence (1467) (see figure 2.34). He may even have inspired Pacioli's geometrically produced alphabet (which will be treated in the next chapter within a larger discussion of letters' ideal geometric proportions as a popular exercise in the later fifteenth and sixteenth centuries). The advent of moveable type and the printing press in the 1450s, and especially Sweynheim and Pannartz's inaugural use of Roman typeface during the next decade, furthered work on "ideal" letter shapes, and subsequently helped to stabilize fonts, many of which we still use today.

Alberti considered language as composed of form and patterns. And from what we see in the *Grammatichetta* and *De Cifris*, he believed the vowel functioned as language's nucleus ("without vowels there are no syllables")[56] – the centre around which consonants attached themselves to create syllables, words, and sentences. It may be Alberti's conception of the syllable as expanding outward from a central vowel point that gave him the idea to create a cipher

wheel as opposed to using a linear, two-alphabet slide, like the Caesar Cipher (a shift cipher).

It seems safe to say that Alberti liked circles, as much as if not more than his contemporaries. Circles and wheels appear frequently in his work: there is the *finitorium* for measuring the proportions of a statue (figure 1.7); the large disc (a diameter of approximately ten feet)[57] that Alberti called the *horizon*, which was used to survey the topography of a city (figure 1.8); and even a rhetoric wheel to help an orator compose and remember a speech by combining together elements from categories assigned to separate cells (figure 1.9). Circles also are present in Alberti's architecture, the façade of Santa Maria Novella and the entire Capella Rucellai in Florence being excellent examples.

The idea of language as wheel – engendered from a point and radiating outwards, like the spokes that bring a zero-dimensional point into one-dimensional lines – recalls Alberti's notion of the centric point in perspectival drawing and painting, or his idea that a painting's *istoria* – that is, the story it tells – is built out of, or around, a particular notion or meaning. The circular and the linear unite, almost like the impossible-to-square circle, a problem that we have seen interested Alberti. The shape of language – its grammatical structure, its recurring patterns, its inherent and crafted symmetries – like the shape of perspective, gives *order* to a composition; language's shape provides *concinnitas*, harmonizing the parts and endowing both the parts and the whole with communicative power. "Everything," Alberti wrote in *De re aedificatoria*, "should be so defined, so exact in its order, number, size, arrangement, and form, that every single part of the work will be considered necessary, of great comfort, and pleasing in harmony with the rest."[58]

Alberti searched hard for the *artifex*, for the "key" that would unlock harmonies. This "key" may have been, for him, embedded in language, or in the language of mathematics itself. Nothing seemed to please Alberti more than mathematics, as he wrote in the conclusion to the *Profugiorum ab aerumna libri III* (On the Tranquillity of the Soul, 1441–2),[59] as "the same numbers by means of which the agreement of sounds affects our ears with delight, are the very same which please our eyes and our mind ..."[60] Mathematics and language can be stirred together into a powerful cocktail, one that can help us *read* both the natural world and communication strategies themselves, as well as *write* the world by putting the decoded parts together in a form that helps us articulate, and understand, what is there. In some ways, Alberti anticipates Vigenère's notion that "all the things in the world constitute a cipher ... all nature is merely a cipher and a secret writing."[61] But in other ways, Alberti departs from this view – as he would have from Galileo's that the universe is written in mathematics – in his attempt to see the

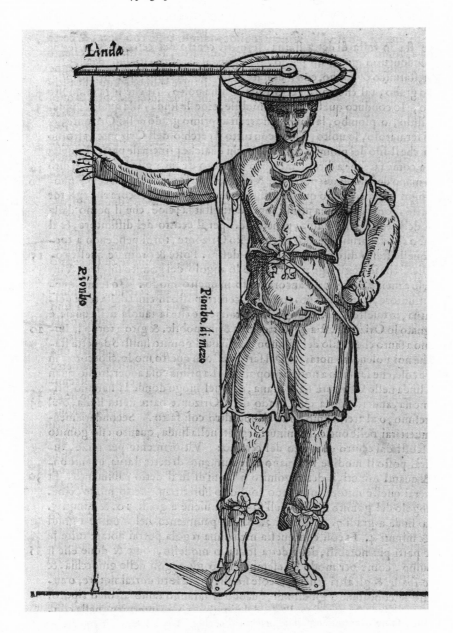

1.7 The *finitorium* in Alberti's *De Statua* (c. 1450). Alberti, *Opuscoli morali*,
ed. Cosimo Bartoli (Venice: Franceschi, 1568), 299. Ital 7302.5.
Houghton Library, Harvard University.

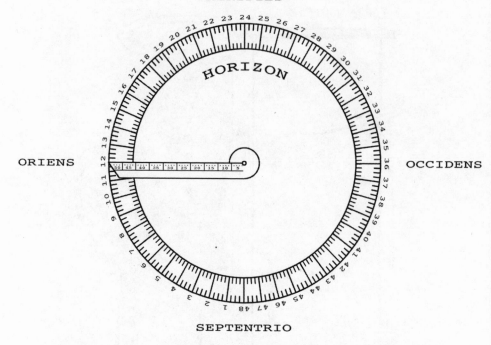

1.8 The *horizon* from Alberti's *Descriptio urbis romae* (1447). Image by Kavi Montanaro, based on a number of illustrations in Alberti, *Descriptio urbis Romae/Delineation of the City of Rome*, ed. Mario Carpo and Francesco Furlan (Tempe: Arizona Center for Medieval and Renaissance Studies, 2007), 37–8, 78–9.

world for what it is, not assuming or imposing ciphers, mathematics, and meaning where they might not be.

We know Alberti revelled in the harmonies and proportions he found in nature, art, music, language, and society; that he attempted to reproduce them; and that he was distressed when he saw them broken, or faked. In one of his *Apologhi* a dove says to a blackbird, who is attempting to sing well, "Oh be quiet! Or sing something harmonious!" The blackbird replies, "You are crazy if you always express yourself in the most artistic of ways! Today, it is not he who truly knows who is held as a great wise man, but he who only seems to know."[62] Alberti's cynicism vis-à-vis many of the intelligentsia and educated of his day runs throughout

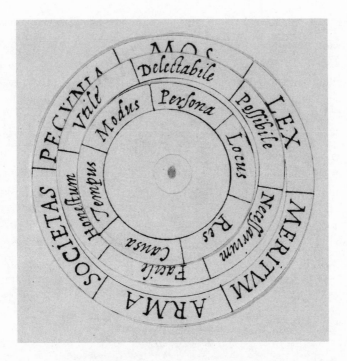

1.9 The rhetoric wheel in Leon Battista Alberti, *Trivia senatoria* (1460). Ms 927, fol. 67r. Biblioteca Riccardiana, Florence.

his works; the celebration of "seeming to know" particularly pained him, even though he, too, admits at times to wearing masks and engaging in various forms of dissimulation.[63]

Although Alberti was, in fact, a stunningly accomplished "polyhedric"[64] writer who *seemed* to have a whole set of "keys" at his disposal, his autobiography reveals how difficult even he found it to encode himself – a Florentine born in exile, of illegitimate birth, rejected by the Alberti family after his father died, and sensitive to the critique and disdain of the people around him.[65] Martin McLaughlin has explored Alberti's fierce commitment to hard work and to friendship, and his deep dismay when seeing, or experiencing, betrayal of any sort.[66] Mark Jarzombek has suggested that Alberti might have seen himself as a kind of martyr, sketching his self-portrait in the pose of a humble saint, and writing his autobiography as auto-hagiography (figure 1.10).[67] And many are the affinities Alberti shared with

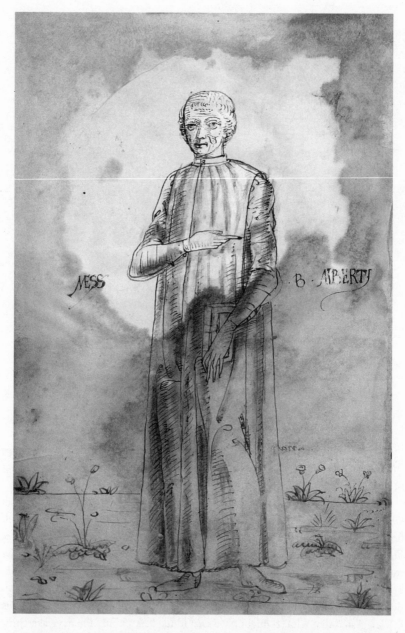

1.10 Alberti's self-portrait. Ms V.E. 738, fol. iv. Biblioteca Nazionale Centrale di Roma (BNCR). No reproduction is permitted without authorization from the BNCR.

exceedingly caustic, pessimistic philosophers who heaped criticism on the motives of humankind, such as the iconoclastic Bion of Borysthenes, the Cynics Diogenes and Menippus, the Sceptic Pyrrho.[68] For Alberti, *De Cifris* was more than a mathematical *ludo*, or just an intellectual exercise in the mathematicization of language. In creating *De Cifris*, Alberti tacitly acknowledges that, while humans encounter the universe as readers potentially capable of unlocking its secret codes, they meet each other as writers and speakers capable of hiding themselves, or even deceiving those who would seek to interpret them.

It is unsurprising that such a sharp observer of humanity would note how difficult it was to decode the human world, "given," as he wrote in *De Cifris*, "the tendency of man to betray one another."[69] Did Alberti see not only others, but *himself*, in his unsavory protagonist Momus – the dreaded Roman god of criticism, mockery, and dissimulation who cries, "oh what an excellent thing it is to know how to cover and cloak one's true feelings with a painted façade of artificiality and studied pretense!"[70] In a moment of self-chastisement, Momus even cries, "I cannot *not* be Momus, and I cannot *not* be who I have always been without sacrificing my freedom and my consistency. Well, let it be so: keep the real you, the man you want to be, deep inside your heart, while using your appearance, expression and words to pretend and feign you are the person whom the occasion demands."[71]

Alberti was certainly disturbed by his own limits in encoding and decoding his role in society; from a young age he worked to show that one could rise to greatness even if not of high birth or wealth. Yet he left many of his texts unsigned, which raises questions about his relationship to his own authority. Anthony Grafton and Martin McLaughlin point out that many scholars have kindly refrained from peeking behind Alberti's cloak, willingly reading only his cipher text of himself: a model, Burckhardtian Renaissance man.[72] Yet Alberti's vast eclecticism, his promotion of the vernacular and texts that communicate their ideas clearly, and his mobility between classes (he claimed to be as comfortable working with artisans as he was interacting with princes and popes)[73] show that he was a radical form of early modern intellectual.

Alberti's friend Cristoforo Landino famously called him a "chameleon,"[74] and scholar Roberto Cardini has called him a "mosaic" and "mixed salad," given his variety of interests and expertise, and his ability to be many things at once, not just a shifter of identity.[75] Alberti did, in fact, find the mosaic a compelling image for writers of his day, himself included, who could do nothing but gather the pieces of antiquity's great production and arrange them into a new design.[76] Yet even with his demonstrated and stated humility, we know he – in his adopted

identity as Leo (Leon) – identified with the prideful, ambitious, regal (and Florentine) lion,[77] and delighted in creating, or at least collecting, new inventions and new ideas.

And, *quid tum?* Scholars have pointed to the eagle in Alberti's emblem as the symbol of sight and flight (see below), and to the lion (whose eyeballs, legend had it, lived on after the lion's death).[78] But perhaps Alberti also saw himself in the house fly: modest, always curious, independent, seemingly omnipresent, stealthy, relentless, ecumenical, and social. Inspired by Lucian's comic encomium of the fly, Alberti's *Musca* highlights the fly's ability for flight and its huge eyes, which "easily see what is hidden beyond the sky, in the most profound depths, and outside the confines of lands and horizons."[79]

Alberti consciously and consistently presented himself as a reader – of the world, of people, of himself – and repeatedly asked his contemporaries to do the same: stay vigilant and always be aware of what needs decoding. Even his personal emblem and motto reflect his challenge to himself and to his readers/viewers/interlocutors to *see* the world truthfully. His emblem is a winged eye (figures 1.11–1.14), wide open, with optic nerves (or blood vessels, or lightning bolts, or light, or vision) reaching out in all directions and encircled by a laurel wreath. In the short piece entitled "Anuli," which is of uncertain attribution but likely by Alberti, he describes the symbol of the eye as follows:

> … an emblem of gladness and glory. There is nothing more powerful, swift, or worthy than the eye. In short, it is the foremost of the body's members, a sort of king or god. Didn't the ancients regard God as similar to the eye, since he surveys all things and reckons them singly? On the one hand, we are enjoined to give glory for all things to God, to rejoice in him, to embrace him with all our mind and vigorous virtue, and to consider him as an ever-present witness to all our thoughts and deeds. On the other hand, we are enjoined to be as vigilant and circumspect as we can, seeking everything which leads to the glory of virtue, and rejoicing whenever by our labor and industry we achieve something noble or divine.[80]

Some scholars have held that Alberti intended to associate his flying eye and his description of it in the "Anuli" with God's scrutiny and judgment of mankind – rather than with Alberti's own eye. But most have seen the Albertian eye as a nuanced symbol of vision, linking the watchful eye of divine justice together with Alberti's observation of the world, and Alberti's encouragement to all men to be like eagles (and lions), watchful of their world and their works.[81] Clearly, sight and flight – observation, judgment, freedom, and the desire for terrestrial glory /

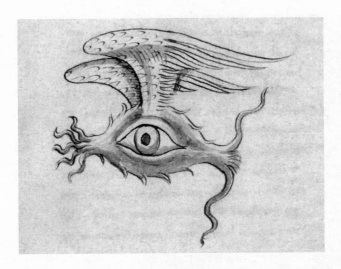

1.11 Autograph drawing in Leon Battista Alberti, *Philodoxeos fabula* (c. 1436/7). Lat. 52 = alfa.O.7.9, fol. 6v. Biblioteca Estense, Modena. Su concessione del Ministero dei beni e delle attività culturali e del turismo.

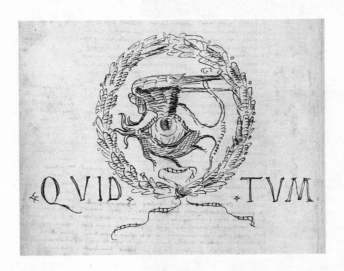

1.12 Autograph drawing placed before the dedication to Brunelleschi in Leon Battista Alberti, *De pictura* (1436). Nazionale II.IV.38: fol. 199v. Biblioteca Nazionale Centrale di Firenze (BNCF). Su concessione del Ministero dei beni e delle attività culturali e del turismo/BNCF. No reproduction or duplication of this image by any means is permitted.

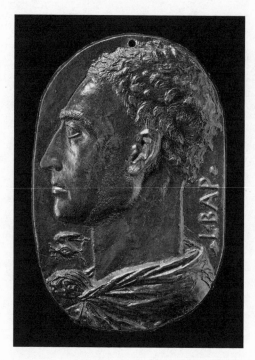

1.13 Note the small winged eye
beneath Alberti's chin.
Leon Battista Alberti, *Self-portrait*
(c. 1435–8). Bronze, 20.1 × 13.6 cm.
Courtesy National Gallery of Art
(Samuel Kress Collection),
Washington.

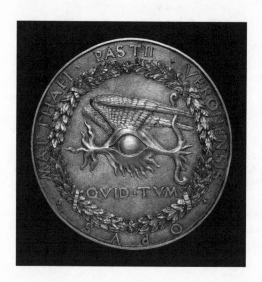

1.14 Medal designed by Alberti
and made by Matteo de' Pasti
(1446–54).
Paris, Bibliothèque nationale de
France, Méd. ital. 580 (revers).

fame (the laurel crown) – were central to Alberti's sense of self. The potential implications of the symbolic eye (especially one that flies at a great height) are many: that eye has been connected to the art of perspective; to the hubris Alberti notes in "Icaromenippean" philosophers;[82] even to the mysterious and monstrous he develops in his use of figures like Argos, Fame, and Polyphemus. And what about the wavy branches streaming from the eye? Are they lightning bolts of divine judgment, or just the far reach of excellent vision? Might the seven branches radiating from the *Philodoxeos* eyeball's left side represent the liberal arts? Why do those branches diminish in number in subsequent versions – because Alberti focused his interests as he aged? He did, in fact, reject Vitruvius's belief (shared by many others in the ancient past, the Middle Ages, and the Renaissance) that the architect must have training in all the liberal arts.[83] But I would hesitate to assume proposed limits on knowledge and study when considering Alberti, a multifaceted scholar who chose as his motto "Quid tum."

Quid can be translated as "what, how, to what extent, why" and *tum* as "then, at that time, next, or so." Based on how you wish to interpret it and from whence you think Alberti (or de' Pasti) drew the motto (Virgil's *Eclogues* 10.38; *The Aeneid* 4.543; Cicero's *Tusculan Disputations* 2.11.26 and 5.37.107),[84] the phrase might be interpreted as meaning "*So what?*" or "*What of it?*" – echoing the shepherd Amyntas, who in Virgil's *Eclogue* shrugs off his swarthy colouring (Alberti's response, perhaps, to his illegitimate origins?) with those exact words. But it could also mean "*So, what's next?*" or "*What now?*" or "*Then what?*" What else can I discover and decode? What else can I build and encode? *Quid tum* could go either way and both ways simultaneously: what's next for me, and who cares what you think about me! In a sense, the motto indicates a desire for forward momentum, a sort of "Let's move on!" *modus operandi*.

Alberti was always looking around him, behind surfaces, around corners, into the heart of Mother Nature's nature. But he was neither solely a student of nature, nor solely one of ancient wisdom; as Cecil Grayson wrote, Alberti was "never servile to this or that tradition of antiquity, but constantly striving to extend the bounds of knowledge, to find and explore those fields in which the ancients studied inadequately or not at all."[85] As Alberti explored the mysteries of the world around him, he experimented with his identity, constructing a "polyphonic song of self."[86] His delight in being the spirited "Lepidus" (the name meaning "witty") or in unveiling *convelata* (veiled sayings) in his fables was equalled, perhaps, by the esoteric numeric permutations and symbolism that some architectural historians believe Alberti hid in his architecture.[87] "It is the duty of the writer," Alberti wrote in the preface to the *Momus*, "to write nothing that his prospective readers

will find familiar and obvious."[88] Cipher systems, too, he writes, "must be a mode of writing that has never before been seen."[89] To write a good code, one must first dissect a given language in order to understand its recognizable letter and word patterns, and then build a structure that hides those patterns. The familiar must dissimulate as unfamiliar. The better one knows the known, the better one can cloak it, simulate it, dissimulate, or create something new and unknown. Alberti's deep knowledge of both mathematics and language patterns gave him a powerful key that let him see things, which he could then tightly encrypt.

The code writer's and breaker's arts are those of finding recurring relationships and behaviours – meetings, associations, pairings, and twinings within a natural language and within a coded text, respectively. To encrypt is to utilize an order to make something look disordered, as Alberti writes in *De Cifris*, like "a bunch of leaves blown by the wind that you have gathered and put in a pile."[90] The cryptographer scrambles information to create what looks like a "semantic storm," but one that is so eminently ordered that a key can unlock "the calm of transparent meaning."[91] And calm is something we know Alberti looked for, whether he was avoiding romantic relationships and confrontations, celebrating steady friendships and home life, or considering the ways to find peace, as he did in numerous of his works.

Many Renaissance authors seemed more intent on writing worlds into reality than on breaking reality's codes – that is, more intent on imposing certain forms of language, certain orders, and certain proportions onto the human and natural worlds than on reading the codes written in nature, by nature. But Alberti – perhaps because of his pessimism about the potential for harmony in society, or perhaps being "ever-devoted to the investigation of the occult arts and the mysteries of nature,"[92] as Dati described him during their stroll that day in 1466 – was, even as a master writer, ultimately devoted to being one of early modern Europe's very best readers.

—— *Two* ——

The Calculated Alphabet:
Luca Pacioli's "degno alphabeto Anticho"
(1509)

*Someone asked the compass why, in tracing a circle, it held one
leg firm but moved the other. The compass replied: "It's impos-
sible for you to make anything perfect unless constancy guides
your effort."*

— Bernardino Baldi[1]

Prelude: Pacioli Portrait

The chapter that follows will focus on the calculated "divinity" of the "degno al-
phabeto Anticho" [worthy/virtuous Ancient alphabet] that Luca Pacioli so care-
fully computes in the 1509 printed edition of his *Divina proportione*.[2] But before
doing so, I would like to consider his most famous portrait (figure 2.1) – a paint-
ing of c. 1495, attributed to Jacopo de' Barbari, which now hangs in Naples's
Museo di Capodimonte – as an introduction to the author and his works and
to some of the more debated points in Pacioli scholarship. This depiction of
the Franciscan mathematician, also known as Fra Luca dal Borgo (c. 1446/8–
c. 1517), offers fascinating hints about confluences of computation and writing
within Pacioli's production as a whole, and it can lead us to look more closely for
the themes, symbols, and teachings that Pacioli held most dear. As we shall see,
Pacioli's letterforms are connected to the geometry he used to compute the pro-
portions of things "divine," from the human head to an architectural façade. The
capo [human head] is linked to both the capital (the architectural element on the
top of a classical column) and the capital letter (the head of a word), and all three
take on a kind computational character within Pacioli's writing.

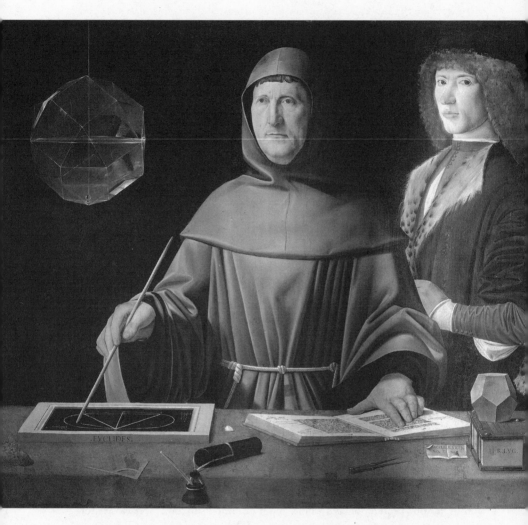

2.1 Jacopo de' Barbari (?), *Fra Luca Pacioli* (c. 1495). Museo Nazionale di Capodimonte, Naples. Photo Credit: Scala/Ministero per i Beni e le Attività Culturali/ Art Resource, NY.

In the portrait, a serene Pacioli, gazing outward towards an indefinite beyond, is accompanied by a well-dressed young man, a student or patron, who turns a direct gaze on the viewer. Art historians have suggested this young man might be Guidobaldo da Montefeltro of Urbino, or Galeazzo Sanseverino, or Ludovico Sforza (Il Moro), or even one of his sons. One scholar has proposed Albrecht Dürer; another has suggested that the young man may be the artist (de' Barbari?) himself.[3] Whoever he may be, the man is dressed to signify high social status. His direct, confident – verging on superior – gaze outward at the painting's viewers reinforces our sense of his importance, as do his physical stature and his apparent equal footing with Pacioli. But adding to the mystery of the young man's identity – and complicating the attribution of the portrait – is the man's grey glove, which is not shadowed as it should be by the figure of neighbouring Pacioli. This may have been a *pentimento* of the original artist, or it may be an indication that the young man (or perhaps just his glove) was added later by an artist of lesser expertise.[4]

The two men stand in front of a table, in a nondescript room illuminated from their right. To Pacioli's right hangs a large, transparent rhombicuboctahedron (a polyhedron with twenty-six faces, forty-eight edges, and twenty-four vertices), one of the thirteen semi-regular polyhedra, also known as the Archimedean solids (figure 2.2). The polyhedron is half-filled with water and seems to reflect a bright sky; and a tiny shadow – perhaps of a man – hovers just below the waterline near the figure's centre. The glass polyhedron registers to the viewer's eye as ethereal – appended as it is to an indeterminate ceiling above – and yet its water-containing capacity signals it as decisively material. It is suspended from a string or wire attached (perhaps, we imagine, because of the water's weight) to the polyhedron's bottom-most vertex. This mode of suspension differs from the drawings of polyhedra for the Geneva and Milan manuscript copies of Pacioli's *Divina proportione* (figures 2.3 and 2.4) – the two remaining manuscript versions of this text[5] – where the figures hang from strings attached to their tops (the 1509 print versions of the polyhedra lack suspension strings; see figure 2.5), similar to the hanging polyhedra of Federico da Montefeltro's *studiolo* intarsia in Gubbio and in his Urbino *studiolo* intarsia (both made in the 1470s or early 1480s).

In the portrait, to Pacioli's left, there is an elegantly bound book, with a red cover. The book is closed, but the letters LI.R.LVC.BVR are painted onto the fore-edge (figure 2.6). In order for the viewer to be able to read them, the letters are printed upside down with respect to the way they usually would be for a book in this position.[6] This abbreviation – oriented for the portrait viewer's, not a book reader's, reading convenience – could indicate *Liber reverendi Lucae Burgensis*,

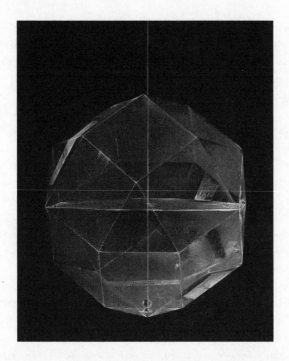

2.2 Detail of the glass rhombicuboctahedron (26 faces, 48 edges, and 24 vertices),
filled halfway with water, and its suspension string. Jacopo de' Barbari (?),
Fra Luca Pacioli (c. 1495). Museo Nazionale di Capodimonte, Naples. Photo Credit:
Scala/Ministero per i Beni e le Attività Culturali/Art Resource, NY.

"The Revered Book of Luca of the Borgo"; in that case, the book might be Pacioli's famed *Summa de arithmetica geometria proportioni et proportionalita*, dedicated to Guidobaldo da Montefeltro and published in 1494, a year before this portrait was likely painted. Or the "R" might refer to "Regularum"; at least one scholar has thus argued that the red-bound book would then be the *Divina proportione*.[7] In the miniature he painted in the Geneva manuscript *Divina proportione*, Giasone del Maino (Maestro dell'Epitalamio) depicted a Pacioli on bended knee offering a red-and-gold-bound copy of the book to his patron Ludovico Sforza[8] (figure 2.7). The *Divina proportione* was not completed until 1497/8, although Pacioli may have begun working on it earlier than 1496 (the date most scholars have assumed he began writing his treatise) – or, alternatively, the portrait might have been painted later than 1495 (the date art historians have usually assigned

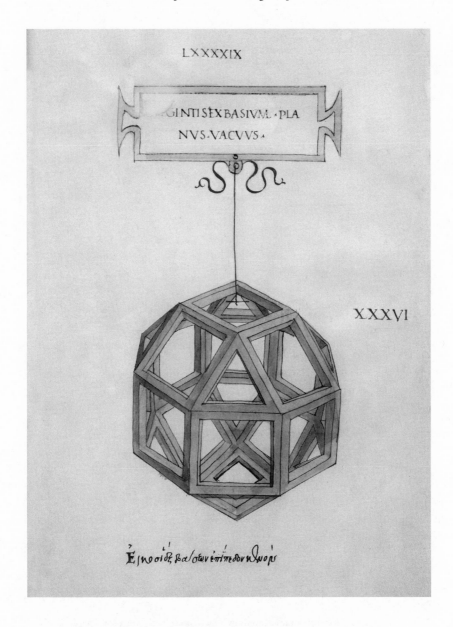

2.3 The rhombicuboctahedron drawn by Leonardo da Vinci for Pacioli's *Divina proportione*, from the Geneva manuscript, which was given to Ludovico Sforza (Il Moro). Bibliothèque de Genève, ms l. e. 210, fol. 99.

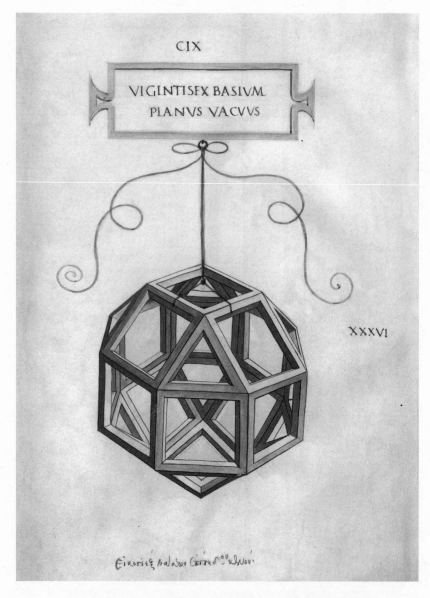

2.4 The rhombicuboctahedron drawn by Leonardo da Vinci for Pacioli's *Divina proportione*, from the Milan manuscript, which was given to Galeazzo Sanseverino. VB002571, plate 36, fol. 109r. © Veneranda Biblioteca Ambrosiana – Milano/De Agostini Picture Library.

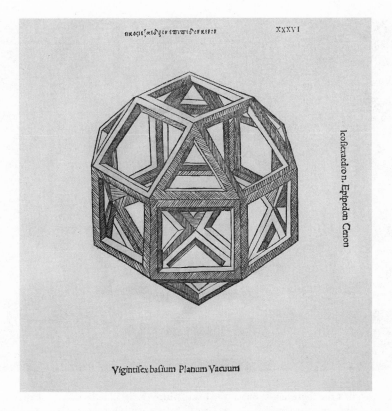

2.5 The rhombicuboctahedron. Woodcut from Luca Pacioli, *De divina proportione* (Venice: A. Paganini, 1509), plate 36. Typ 525.09.669a. Houghton Library, Harvard University.

to it). De' Barbari's portrait includes more details pointing to Pacioli's work in geometry than references to his expertise in arithmetic, abacus, and accounting, although the artist does present a simple calculation (three numbers added together) on the slate in the lower left of the painting (figure 2.8).

In either case, the large red volume is placed at the remote edge of the foreground, perhaps to imply humility on the friar's part. Its lavish binding indicates that it belongs to a wealthy patron (possibly the young man by his side), and the clean-cut, tightly bound pages make the book appear new (or rarely read). Its closed state may imply that this is a text already read by his patron, or a text his viewer should already have read and know well.

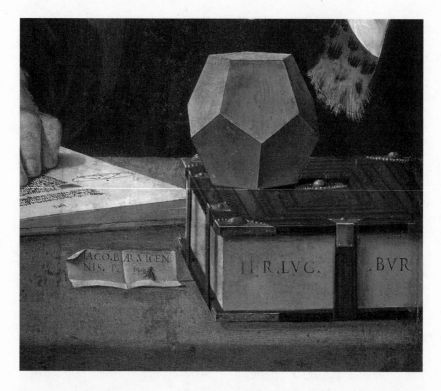

2.6 Detail of the abbreviation on the red book, which reads: LI.R.LVC.BVR. Jacopo de'
Barbari (?), *Fra Luca Pacioli* (c. 1495). Museo Nazionale di Capodimonte, Naples.
Photo Credit: Scala/Ministero per i Beni e le Attività Culturali/Art Resource, NY.

On the closed book rests a solid-looking dodecahedron (twelve faces, thirty
edges, and twenty vertices). This geometric solid is one of the five regular polyhe-
dra described by Plato in the *Timaeus*, as symbolic of the fifth element, ether –
and it is one of the central "characters" in the *Divina proportione*. The polyhedron
conveys weight and sturdiness: it is the inverse of the floating, crystalline rhom-
bicuboctahedron to Pacioli's right. Its twelve faces are pentagons, each diagonal of
which is in golden ratio (φ) to its sides. It is perhaps an example of the wooden
polyhedra that Pacioli used in teaching: in the *Summa*, Pacioli reminds Guido-
baldo – his student, patron, and the book's dedicatee – of the wooden polyhedra
they have used together in the past.[9]

2.7 Miniature by Giasone del Maino (Maestro dell'Epitalamio) of Pacioli offering his *Divina proportione* to Duke Ludovico Sforza (Il Moro) in the Geneva manuscript copy of the same text, which was a gift to the Duke. Bibliothèque de Genève, ms l. e. 210, fol. 1r.

To the left of the large red book is a small piece of folded paper containing an abbreviated name, likely the artist's signature: IACO.BAR.VIGEN/NIS. P. (figure 2.9).

Scholars continue to debate the identity of the portrait's artist. Theories have ranged from Jacopo de' Barbari of Venice (the P indicating "pinxit," painted) – perhaps claiming to be twenty years old at the time of painting (VIGEN/NIS [vicennis]), though the "Barbari" known as The Master of the Caduceus would have been near fifty in 1495[10] – to multiple artists of Leonardo's school, to Leonardo himself (in his forties at the time of painting). Perhaps VIGENNIS should have been spelled "VIGENTIS," implying "flourishing." Current scholarship continues

2.8 The tiny numbers – three-column addition – are on the bottom left of the slate, upside down to the viewer of the painting. Jacopo de' Barbari (?), *Fra Luca Pacioli* (c. 1495) (detail). Museo Nazionale di Capodimonte, Naples. Photo Credit: Alfredo Dagli Orti/The Art Archive at Art Resource, NY.

2.9 Detail of the creased paper beside the red book, which contains an abbreviated name, likely the artist's signature: IACO.BAR.VIGEN/NIS. P. The last number of the date is covered by a fly, which could indicate later alterations to the painting by the original artist or another hand. Jacopo de' Barbari (?), *Fra Luca Pacioli* (c. 1495). Museo Nazionale di Capodimonte, Naples. Photo Credit: Scala/Ministero per i Beni e le Attività Culturali/Art Resource, NY.

to favour de' Barbari – and supports the theory that Pacioli was directly involved in selecting the items included in his portrait. Renzo Baldasso notes that this portrait may have been based on a similar painting, now lost, by Piero della Francesca.[11] Mathematician and historian Bernardino Baldi, in his late sixteenth-century *Vite de' matematici*, noted in Piero's painting the inclusion of Pacioli's *Summa*, as well as several crystals in the form of regular solids suspended from above, suggesting a composition similar to the portrait by de' Barbari.[12]

Next to the signature are a date (1495?), and a housefly (figure 2.9), the latter as symbol and trompe-l'oeil often used in Quattrocento and early Cinquecento Flemish and Italian paintings – especially in Italian works from the Veneto. The fly would be placed near a signature,[13] on a painting's frame, or in some other unexpected location, to signal the artist's ability to render a natural creature so real as to convince viewers it was *not* part of the painting. The tradition harks back to the legend of Zeuxis and Parrhasius, retold by Filarete in his *Trattato d'architettura* (1460–4) with new characters. In Filarete's version, the young artist Giotto tricks his master, Cimabue, into thinking a fly has landed on a painting in progress: the student has superseded the master.

That the fly covers most of the date's final number (a 5?) could indicate that the fly was added later by de' Barbari, or by some later artist who contributed to the painting – in either case, someone hoping to obfuscate the painting's date. If a later hand added to this painting, that later artist may also have added the unidentified young man, with his *pentimento* glove, at Pacioli's side. Yet obscuring the number five may have another meaning. For Pacioli and other Renaissance Platonists, five was a number rich with mysteries: we shall see, later in this chapter, the unique character of the number five in Pacioli's *Divina proportione*; we may see hints of five's mysteries in this painting, with its dodecahedron placed on top of its red book: twelve symmetrically arranged *penta*-gons, in close proximity to the date's semi-obscured final digit "5."

Behind the signed and dated scrap of paper is an open book with geometric figures in the margins. The book is Euclid's *Elements*, and Pacioli's left hand points to what Nick Mackinnon thinks may be Proposition 12 of Book 13,[14] or the proof from Book 14.8, which Pacioli believed to have been created by Euclid, though it was likely written by Hypsicles.

Pacioli's right hand diagrams a proof on a slate board framed with wood and stamped or engraved with "Euclides" on the side facing us (see figure 2.8). Given the diagrams the viewer glimpses in its margins, the portrait-Pacioli may be consulting the 1482 Campanus translation of the *Elements* (the first printed version of this text in Western Europe) published in Venice by Erhard Ratdolt, or the 1491

edition published in Vicenza by Leonardus of Basel and Guglielmus of Pavia.[15] Some scholars, however, have argued that the artist did not copy this page from either edition.[16] If so, then the open book may be a nod to the Italian translation of the *Elements* (now lost) that Pacioli himself claimed to have produced, or to an early draft of the Latin edition he would publish in 1509 with Paganini. The geometric figures in both the 1482 Venice and 1491 Vicenza editions contain numerous errors, while the painting's Euclid is open to pages displaying correct drawings of these figures, as well as marginalia, presumably in Pacioli's hand. Pacioli is depicted pointing to two such problematic figures on his slate;[17] he seems to invite the viewer to resolve them, including that viewer in the select group of mathematicians with sufficiently advanced knowledge of geometry to do so. On the title page of his 1509 edition of the *Elements*, Pacioli describes himself as a

> famous theologian with the most uncommon quality of having advanced knowledge in the mathematical sciences, on the most careful examination clarified and corrected one hundred and thirty figures which in other books were reversed and imprecisely drawn, redrawing them to the correct composition while also adding many necessary ones.[18]

As Baldasso has observed, the portrait presents Pacioli not just as a mathematician but as a humanist, interested in the accurate understanding and transmission of ancient knowledge and in the power of images and practice to help with the recovery and dissemination of such knowledge.

In front of the Euclidean demonstration is a right-angle tool (a try square), and to the try square's right, an inkwell and pen (complete with carrying case). Baldasso has proposed that the pen and ink are placed so close to the edge of the foreground, and outside the area where the light falls, to imply an invitation (from the artist, from Pacioli himself) that the viewer take notes during the lesson.[19] Behind the pen is a piece of chalk. To the right of the pen is a compass or calipers. And on the painting's far left – very near the slate tablet – is a sponge eraser.

Scholars have noted a great many details and symbols in this painting, and yet one component has been almost entirely overlooked: the letterforms used on the large red book (figure 2.6), on the scrap of paper with the date and the resting housefly (figure 2.9), and on the wooden frame of the chalkboard (figure 2.8). The text that appears on these items is expressed in characters closely resembling Pacioli's geometrically constructed alphabet of Roman capital letters,[20] the characters Pacioli would call his "degno alphabeto Anticho"[21] when he included them in the 1509 print edition of his *Divina proportione* (the *degno alphabeto Anticho* does

2.10 Cartouche with dedication to Ludovico Sforza (Il Moro) with Roman capital lettering and some inserted small majuscules. Luca Pacioli, *De divina proportione*, Bibliothèque de Genève, ms l. e. 210, fol. 1r.

not, as we shall see, appear in the Geneva and Milan manuscript copies). Similar lettering features in a cartouche in the Geneva manuscript given to Il Moro in 1498 (figure 2.10), albeit with one variation: small majuscules placed within larger letters, a style more common in tenth- and eleventh-century insular lettering.

The letters in de' Barbari's portrait – which could not easily have been constructed geometrically, given their small size – could be said to resemble many capital letters found on Roman lapidaries, and other early Renaissance letterforms that imitated classical examples, including those developed by Felice Feliciano (see figure 2.28), Andrea Mantegna (see figure 2.29), and Leon Battista Alberti (see figure 2.34). Even so, these painted letters' proportions – their form and weight – are very close to those of Pacioli's *degno alphabeto Anticho*. The appearance and proportions of these Roman capital letters in the de' Barbari painting strongly suggest that Pacioli was working on the question of letter proportions prior to 1495 – certainly earlier than 1509 – and that the artist(s) who painted this portrait knew of Pacioli's interest in lettering. More crucially to the study that follows, the inclusion of these proportioned letterforms signals the importance Pacioli placed on computing language's face – its façade – and his vision for the construction of "divine characters."

The Nexus of the *Divina proportione*

Pacioli was a node of knowledge exchange; his was a life filled with travel and conversation with the greatest thinkers of his time. In his early twenties, Pacioli

studied with Piero della Francesca in their Tuscan hometown of Sansepolcro. In 1464 he moved to Venice and worked for the Rompiasi family as tutor and accountant, and he attended Domenico Bragadino's lectures on mathematics at the Scuola di Rialto.[22] By 1471 he was in Rome, where he met Alberti and would later stay as his guest.[23] From the 1470s on, Pacioli moved between the leading courts of Italy, often teaching mathematics at the *studia* associated with his patrons – *studia* in Perugia, Urbino, Milan/Pavia, Florence/Pisa, Venice, Padua, Rome. At some point between 1475 and 1480, he entered the Franciscan Order. Among Pacioli's many friends were Alberti, Andrea Mantegna, Pietro Perugino, Giovanni Bellini, Antonio Cornaro, Julius II, Leo X, the young Baldassare Castiglione, the Montefeltro and Rovere, the Este, the Gonzaga, the Soderini, the Sanseverini, and Leonardo da Vinci, with whom he worked in the Sforza court in Milan between 1496 and 1499. While in Bologna in 1501 and 1502, Pacioli apparently met and collaborated with the mathematician Scipione Dal Ferro, who found the solution to one case of the cubic equation (which Niccolò Tartaglia would solve independently a few decades later, as I will discuss in Chapter 3). A half-century after Pacioli's death, Baldi reflected on Fra Luca's career: there was "no painter, sculptor, or architect of his time," he wrote, "who did not contract close friendship with him."[24] Pacioli's prolific writing and his diverse interests, his fame as a teacher, compiler, and documenter of ancient and contemporary mathematics, his contributions to the field of accounting, and his wide network of friends around Italy made him, and his works, a point of contact, a nexus, for thinkers then involved in mathematics, the arts, and humanist pursuits.

Pacioli authored six books, the largest and most renowned being the *Summa de arithmetica, geometria, proportioni et proportionalita* (Venice: Paganino Paganini, 1494). The *Summa* was an immense, comprehensive tome, presenting most mathematical knowledge to date, and it long served Italian scholars and readers – trade, merchant, and aristocratic classes alike – as an extremely valuable compendium. Yet even though it introduced the new accounting procedure of double-entry bookkeeping in the section titled "Tractatus de computis et scripturis," the *Summa* did not otherwise offer new mathematical insights or theories.[25] Pacioli was more of an educator and promoter of mathematics than a mathematician advancing some aspect of the field.

As a cataloguer of mathematical knowledge and teacher, Pacioli was renowned. His *Divina proportione*, written between 1496 and 1498,[26] was also a textbook of sorts, as we shall see, and has had a particularly celebrated history, given its illustrations by none other than Leonardo. The *Divina proportione* was published in

print only much later, in Venice by Paganini's son Alessandro in 1509, and includes illustrations by a hand other than Leonardo's (more on this publication later). Also in 1509 – following on the heels of a very well attended and well received lecture on Euclid that he presented in the Church of San Bartolomeo in Venice on 11 August 1508[27] – Pacioli produced a Latin edition of Euclid's *Elements*. Pacioli's Euclid, also published with Alessandro Paganini, did not differ substantially from Campanus's 1482 edition, but was a cleaned-up and edited version with some added commentary. Pacioli seems also to have translated Euclid's *Elements* into Italian, as is alluded to in the preface to his Latin edition of the *Elements*, but the text is now lost. Pacioli's few other surviving works include *De viribus quantitatis*, a book of mathematical puzzles, riddles, and advice to young people, which he wrote sometime between 1496 and 1508, and which was not published during his lifetime.[28] Two texts by Pacioli exist only in autograph: the circa 1478 mathematical treatise *Arithmetica et geometria*,[29] which Pacioli wrote for his students in Perugia; and *De ludo scachorum* or *Schifanoia* [The Game of Chess, or Boredom Buster], a recently discovered chess manual, written during the same period and dedicated to Isabella d'Este.[30]

While almost all of Pacioli's works will come into play at some point over the course of this chapter, my primary focus is his *Divina proportione* – and in particular, the 1509 print edition, which contains the *degno alphabeto Anticho*. Pacioli wrote the first version of the *Divina proportione* at the Sforza court in Milan at the request of Duke Ludovico, Il Moro, who had invited him there to teach mathematics at the University of Pavia. This and another, beautiful manuscript version of the *Divina proportione* survive. Pacioli gave the "Geneva" manuscript (ms n. 210 held at the Bibliothèque de l'Université de Genève) to Ludovico Sforza, and the "Milan" manuscript (ms 170 sup. held at Biblioteca Ambrosiana di Milano) to the count, *condottiere*, and close friend and patron of Leonardo, Galeazzo Sanseverino. Pacioli had a third copy made, which he gave to the Florentine politician Piero Soderini, but which is now lost. The Geneva and Milan manuscripts each number 130 leaves, and they both have been copied by the same hand, that of Giovan Battista de' Lorenzi, in humanist rotunda. Each includes sixty watercolour paintings, by Leonardo, of polyhedra (the five regular solids, and many other semi-regular forms, truncated or stellated, solid or empty). Comparison of the Geneva and Milan illustrations has revealed a few differences in the manuscripts' versions of two of these paintings, however, and the 1509 print version includes only fifty-nine polyhedra woodcuts (it is missing the *Columna rotunda vacua* – clearly a printer error).[31] The full title of this 1509 print edition reads: *De Divina proportione: Opera a tutti glingegni perspicaci e curiosi necessaria ove ciascun*

studioso di philosophia, prospectiva, pictura, sculptura, architectura, musica, e altre mathematice, suavissima, sottile e admirabile doctrina consquira e delectarassi con varie questione de secretissima scientia [On Divine Proportion: A Work for All Perspicacious and Curious Intellects, Necessary for All Who Study Philosophy, Perspective, Painting, Sculpture, Architecture, Music, and Other Mathematics Arts. A Pleasing, Subtle, and Admirable Doctrine Follows and Delights with Various Questions of Secret Knowledge].

In his dedicatory letter to Ludovico Sforza in the manuscript version of the text, which is also included in the print version, Pacioli characterized the *Divina proportione* as a *condimento*,[32] a "spice" served alongside his more basic works. Like the *Summa* and all of Pacioli's other works, the *Divina proportione* functioned as a compendium of contemporary mathematical ideas. But Pacioli's *condimento* also reveals his ideas about the aesthetic and mystical powers of numeric ratios and geometric proportions – and he detects these powers not only in mathematics, sciences, and the visual arts, but also in letters, both alphabetic and literary.

The 1509 print version of the *Divina proportione*, dedicated in its entirety to Soderini and likely encouraged and supported by him, contains three parts. Only the first of these parts, here called the *Compendium*, reproduces the content of the Geneva and Milan manuscripts. The *Compendium* consists of seventy-one chapters discussing "divine proportion" – numerous proportions that Pacioli and his Renaissance contemporaries deemed beautiful and sacred – although he focuses on the proportion we now call the "golden ratio." The two new parts of the 1509 print edition consist of a brief treatise on architecture called the *Trattato dell'architettura* (which immediately follows the last chapter of the *Compendium* without even a space, much less a header or new page) and a Latin translation of Piero Della Francesca's study of the five regular solids, the *Libellus de quinque corporibus regularibus*.[33]

Pacioli dedicated the *Trattato* to his students in Sansepolcro. In twenty brief chapters, the treatise discusses the proportions of Vitruvian architecture (especially the notion that buildings should be based on the proportions of the human body) and the art of perspective. But it does *not*, as many scholars have assumed, discuss the golden ratio, as had the *Compendium*. Part 3 – Piero's *Libellus* – like the whole of the 1509 edition, is dedicated to Soderini. It, too, does not speak of the golden ratio.[34]

From Giorgio Vasari on, many – even most – scholars have considered Pacioli's inclusion of Piero's *Libellus* to be plagiarism.[35] The unattributed borrowing is surprising, however, as on many other occasions Pacioli rejoiced in spotlighting

his collaboration or interaction with someone of note. For example, in Chapter 3 of the *Compendium* and Chapters 6 and 10 of the *Trattato dell'architettura* (henceforth, the *Trattato*), he states that Leonardo was the artist who drew (or at least drafted for a copyist, as Pacioli himself kept the originals)[36] the sixty[37] magnificent regular and semi-regular polyhedra included at the end of the manuscript versions, while he (Pacioli) had coloured them, decorated them, and put them in order.[38] In Chapter 4 of the *Compendium* he promises his text will identify all sources of content that derives from other authors' works (excepting, in this instance, only Euclid).[39] While it was not uncommon in early modern scholarship to borrow words and ideas and not credit sources, it seems out of character for Pacioli – collector of friends and knowledge, beloved teacher, and dynamic nexus of artists, patrons, and scholars – to leave out this attribution. Might the elderly Piero, in a moment of exhaustion or great generosity, have given the treatise to his younger friend from Sansepolcro and said, "Translate it and publish it as your own"? Pacioli did publish other work by Piero in his *Summa*, and he mentions in the *Compendium* his plans to publish Piero's *De prospectiva pingendi* in a forthcoming treatise on architecture.[40] It is also possible that Pacioli intended to attribute properly the version of Piero's *Libellus* he included in the 1509 printed edited of the *Divina proportione*, but the printer Alessandro Paganino – or the editor, M. Antonio Capella (figure 2.11) – failed to include that attribution.[41] Pacioli's customary direct involvement in the translating and printing of his works does, however, render this second explanation unlikely.[42]

R. Emmett Taylor has theorized that the *Libellus* was, instead, added by Alessandro or Capella after Pacioli's death, and after the copyright imposed on the text by Doge Leonardo Loredano and Pope Julius II had expired (this would have been 1523).[43] The print edition that has come down to us, Taylor theorizes, is *not* the edition actually printed in 1509 – which, he says, included only the *Compendium* and the *Trattato*. Rather, this later edition was printed by Alessandro using an undated title page (see figure 2.11), and a table of contents that does *not* mention the *Libellus*, but only the contents of the *Compendium* and the *Trattato*. Pacioli's dedicatory letter to Piero Soderini – dated 1 May 1509 – similarly says that he has added "two booklets" (*libellos duo*) to the original *Divina proportione* (the *Compendium*):

one which contains in very exact form the ancient characters of letters showing very properly the force of the curved and straight line, and the other which relates to architecture and, so to speak, builds a stairs for the architects and stonemasons of our times.[44]

íuina
p2opo2tione

O pera a tutti glingegni perſpi
caci e curioſi neceſſaria O ue cia
ſcun ſtudioſo di P hiloſophia :
P 2oſpectiua P ictura S culptu
ra: A rchitectura: M uſica: e
altre M athematice : ſua
uiſſima : ſottile : e ad
mirabile doctrina
conſequira: e de
lectaraſſi:cōua
rie queſtione
de ſecretiſſi
ma ſcien
tia.

M. Antonio Capella er uditiſſ. recenſente:
A . Paganius Paga ninus Characteri
bus elegantiſſimis accuratiſsi
me imprimebat.

2.11 Note the absence of a publication date and the identification of the printer as
A. Paganius Paganinus on this title page. Luca Pacioli, *De divina proportione*
(Venice: A. Paganini, 1509), fol. 1r. Typ 525.09.669a.
Houghton Library, Harvard University.

> ❡ Venetiis Impreſſum per probum virum Paganinum de paganinis de Briſcia. Decreto tamen publico vt nullus ibidem totiꝗ dominio an⸗ norum . xv . curriculo Imprimat aut imprimere faciat ℈ alibi impreſ- ſum ſub quouis colore i publicum ducat ſub penis in dicto priuilegio cõ tentis. Anno Remdemptionis noſtre. M·D·IX·Klen· Iunii . Leonardo Lauretano. Ve. Rem. Pu. Gubernante Pontificatus. Iulii. ii. Anno. vi.

2.12 Book 2 colophon. Luca Pacioli, *De divina proportione* (Venice: A. Paganini, 1509), fol. 35v. Typ 525.09.669a. Houghton Library, Harvard University.

> ❡ Venetiis Impreſſum per probum virum Paganinum de paganinis de Brixia. Decreto tamen publico vt nullus ibidem totiꝗ dominio annorum XV. curiculo imprimat vel iprimere faciat. Et alibi impreſſum ſub quouis colore in publicum ducat ſub penis in dicto priuilegio contentis. Anno Re demptionis noſtre. M.D. VIIII. Klen. Iunii. Leonardo Lauretano Ve⸗ Rem. Pu. Gubernante. Pontificatus Iulii. II. Anno. VI.

2.13 Book 3 colophon. Luca Pacioli, *De divina proportione* (Venice: A. Paganini, 1509), fol. 27r. Typ 525.09.669a. Houghton Library, Harvard University.

The two *libellos*, it seems, are the *Trattato* and the Roman alphabet, *not* Piero's *Libellus*. Pacioli's 1509 dedicatory letter does not mention Piero, or his *Libellus*. It is possible that Alessandro or Capella noticed Pacioli's reference to *libellos duo* (two booklets), had a copy of Piero's *Libellus* at hand, and thought Pacioli intended Piero's work for the second of the two *libellos*, rather than the pages dedicated to the Roman alphabet.

Further evidence in support of Taylor's theory can be found in the colophon of Alessandro's edition. This edition uses the same colophon (albeit with differing Roman numeral cases) at the end of Piero's *Libellus* (27r) as at the end of the *Trattato* (35v) (figures 2.12–13) – a colophon that notes *his father*, Paganino Paganini, as the printer. Alessandro also inserts a few blank leaves between the *Trattato* and the *Libellus*, and begins the *Libellus* with a few sentences in Latin – sentences that Pacioli may never have written, and which reveal that Alessandro

(or Capella) believed that Pacioli had written, or at least translated into Italian, this text.[45] The *Libellus* is, moreover, dedicated to Soderini, which may have been Alessandro/Capella's default choice, as Pacioli had dedicated the whole of the print edition to him.

Taylor believes that the surviving print edition of the *Divina proportione* was actually printed sometime after 1523 in Toscolano or Venice: the Paganini family was active in both locations, and Alessandro had published the second edition of Pacioli's *Summa* from Toscolano in 1523. Taylor's argument is suggestive and, if correct, would exonerate Pacioli from accusations of plagiarism launched at him from Vasari onward. While we have not found a single surviving exemplar of the *Divina proportione* that consists only of the *Compendium*, the *Trattato*, and the Roman alphabet, it is possible that the "1509" version we have may be *the* 1509 version – published a few years later, when the book was still under copyright and technically should not, yet, have been "re"-published. This might explain why Alessandro does not include the date on the title page. Pacioli, as far as we know, stopped publishing after 1509, and the few documents we have regarding his employment and whereabouts through 1514 say nothing about Piero's *Libellus*. I am inclined to believe that Pacioli would not have wanted or agreed to publish a text by Piero as his own.

These possible print histories for the *Divina proportione* are important, in two ways, for understanding the development of Pacioli's interest in letter proportions. First we see that the *degno alphabeto Anticho* included in the surviving edition of the 1509 *Divina proportione* was *not* in the manuscript copies given to Il Moro and Galeazzo Sanseverino (and presumably Soderini), and thus should not be thought of as a continuation of the discussion on the golden ratio. Second, if Taylor is correct in his theory about Pacioli's original intentions for the print edition of the *Divina proportione* to have two added *libellos* – one of them being the *Trattato* and the other the alphabet – then Pacioli considered the Roman alphabet more important than just an addendum to two books on proportions. It was connected to the booklet on architecture he wrote for his Sansepolcro students and to the *Compendium*, but would then have also possessed, for him, the integrity of a work in its own right.

Lettergons

Twice in the *Trattato* Pacioli announces that his text will include examples of and geometric directions for drafting Roman capital letters. In Chapter 6 he says that

this *degno alphabeto Anticho* will be placed at the "end of our book" (he uses the word *ancora*, which scholars have taken to mean "after" or "at the end"), which could indicate either the end of the *Trattato*, or the end of the *Compendium*:

> ... costumase per molti in dicto pilastro ponere lettere per diversi ordinate che dicano e narrano loro intento belle Antiche con tutta proportione e cosi in altri frontespicii e fregi e monumenti loro epytaphii quali senza dubio molto rendano venusto lo arteficio. **E pero a questo fine ho posto ancora in questo nostro volume detto dela divina proportione el modo e forma con tutte sue proportioni uno degno alphabeto Anticho** mediante el quale potrete scrivere in vostri lavori quello ve acadera e sirano senza dubio da tutti commendati. Avisandove che per questo solo mi mossi a disponerlo in dicta forma a cio li scriptori e miniatori che tanto se rendano scarsi a demostrarle li fosse chiaro che senza lor penna e pennello le doi linee mathematici curva e recta o volino o non a perfectione le conducano comme ancora tutte laltre cose fanno con cio sia che senza esse non sia possibile alcuna cosa ben formare.[46]

> It is the custom of many upon such pillars to place letters arranged in various ways which tell and declare the purpose of (the building) in the beautiful style of the ancients, in all due proportion; and the same on other summits of pillars, tablets and monuments which, beyond question, make the work very beautiful. **And so to this end I have placed at the end of our book entitled *De Divina proportione* the manner and form and all the proportions of a worthy ancient alphabet** by the means of which ye can write on your works whatever ye have in mind, and will undoubtedly be commended by all for so doing. Notifying that for this reason alone have I decided to arrange it in the said form, that scribes and miniaturists who are sparing of using it may be clear that without their pen and brush the two mathematical lines (the curved line and the straight line) will lead them to perfection, whether they will or not, as they also do other things, inasmuch as without these it is not possible to form anything well.[47]

In Chapter 11, however, when Pacioli refers to the *degno alphabeto Anticho* again, it becomes even more unclear where he intended the letters to be placed. He writes: "Comme de sopra me ricordo haver ve dicto, *in questo a suo principio me parso ponere lalphabeto antico*," which could be interpreted to mean, "As I remember having said above, I have placed the ancient alphabet *at the beginning of this book*."[48]

Either Pacioli wanted the alphabet put between the *Compendium* (Book 1) and the *Trattato* (Book 2), or right after the *Trattato*. In either case, what is important here is that both references to the alphabet's placement designate it as a separate

entity, important enough to comprise its own *libello*. In fact, as Pacioli states elsewhere in the *Trattato*, these letters were of prime importance to architecture (for engraving on buildings, monuments, or tombs), and were also useful for the work of scribes and miniaturists.[49] Moreover, as we shall see, Pacioli based his Roman alphabet on the geometry of the circle and the square – two figures he considered fundamental to *all* the arts and sciences, as well as to the human body itself, famously depicted by his friend and collaborator Leonardo as the Vitruvian Man and based in Vitruvian ideal proportions for the human body and for architecture.

The magnificent capital letters Pacioli presents in his *degno alphabeto Anticho* are quiet large: each measures 95 mm (about 3 ¾ inches) in height and each has been given its own page. Below each are directions on how to "build" them via compass and straight edge, circle and square (see figure 2.49). The location of the letters (the signature) varies across exemplars, but it is often inserted after Piero's *Libellus*, instead of between the *Compendium* (Book 1) and the *Trattato* (Book 2), as Pacioli seems to have intended them to be. This alphabet lacks the letters W and Z – letters not used in Latin – as well as J and U, letters interchangeable with I and V. It does include, however, the Greek imports K and Y, and two different versions of O. The letters' beauty and fame has been lasting: Pacioli's "M" is the emblem of New York City's Metropolitan Museum of Art, and his letter proportions and form are the foundation for Trajan and Times New Roman fonts.

Pacioli does not indicate who drafted these letters and cut them onto woodblocks for the printer. Although it is tempting to think that Leonardo may have at least drafted them, as we know he drew the polyhedra for the *Compendium*, there is no evidence he had anything to do with the letters – Pacioli most likely would have said so, if he had. Millard Meiss has proposed that the painter Andrea Mantegna, who may well have worked with Feliciano on his geometrically constructed alphabet (see figures 2.28 and 2.29) and who knew Pacioli – made them. Giovanni Mardersteig and M.D. Feld theorize, instead, that Alberti made them, as Pacioli may have been an amanuensis to Alberti in the last few years of Alberti's life, and we know he stayed at Alberti's home in 1470.[50] In the absence of documentary evidence confirming Leonardo, Mantegna, or Alberti as designer of the letters, it may be wisest to assume no artist of significant stature contributed to them. Pacioli would surely have sung his praises if one of these important figures had been involved, as he did repeatedly in the case of Leonardo's polyhedra. The letters were likely drafted and cut by an artisan working for the Paganini family, who closely followed Pacioli's directions for their construction. The directions themselves are Pacioli's (they follow the vocabulary, spelling, and syntax of the *Trattato*), although they are quite similar to the guidance offered by Damiano

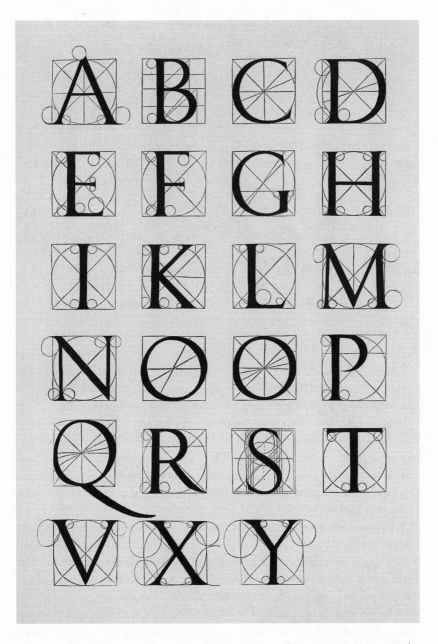

2.14 Pacioli's alphabet. Luca Pacioli, *De divina proportione* (Venice: A. Paganini, 1509), [n.p.]. Typ 525.09.669a. Houghton Library, Harvard University.

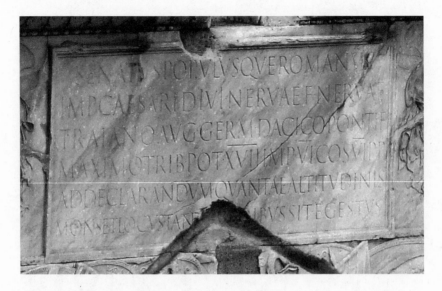

2.15 Inscription on Trajan's column, Rome (113 CE). Photo credit: Mario Casari and Camilla Russell.

Moyllus of Parma in his unprinted manual, *Alphabeto*, of circa 1480 (see figure 2.35), which Pacioli likely had seen, although he never mentioned it.

Pacioli's alphabet also closely resembles the letters offered by Feliciano – calligrapher, poet, alchemist, and the first known compiler of classical-letter formation in Italy – in his unpublished *Alphabetum Romanum* (c. 1460). Feliciano took his inspiration from the Roman capital letters engraved in lapidary inscriptions and on monuments all over Italy, such as the famous inscription on Trajan's Column in Rome (figure 2.15).

With the rediscovery of Vitruvius's books on architecture (among other important texts) by Poggio Bracciolini in 1414, early humanist scholars had begun to look closely at these capital letter shapes, much as they had begun to look at the capitals of buildings. They recommended imitation of these letters by modern-day calligraphers and stone-cutters, and, within a few decades, proposed that they be imitated as type fonts.[51] At this time in Italy, the shape of letters was changing: scribes were abandoning the angular, heavy, tight gothic hand of later medieval scripts (figures 2.18–2.19) to return to the lighter, more rounded medieval Carolingian, based on half-uncials and rotundas (figures 2.16–2.17). Also developing in this period were the new scripts (italic and chancery), which were

OMNI UIRTUTE SIT UACUUS · FRUSTRACON FLAUIT
CON FLATOR MALITIAE ENIM EORUM NON SUNT
CONSUMPTAE ECCE IGNIS EXTERIUS CONFLANS

2.16 Uncial (c. 700–50). Gregory the Great, *Moralia in Iob*. Beinecke, ms 516, fol. 1r (detail). Beinecke Rare Book and Manuscript Library, Yale University.

2.17 Carolingian minuscule (c. 873). *Capitularies of Charlemagne, Louis the Pious, etc.* Beinecke ms 413, fol. 165 (detail). Beinecke Rare Book and Manuscript Library, Yale University.

2.18 Beneventan script (1153). Unknown, *Inhabited Initial S* (detail). Tempera colours, gold leaf, gold paint, and ink on parchment. Leaf: 19.2 × 13.2 cm (7 9/16 × 5 3/16 in.). The J. Paul Getty Museum, Los Angeles. Digital image courtesy of the Getty's Open Content Program.

2.19 Blackletter gothic script (c. 1407). Latin Bible, Numbers 1:24–6 (detail). Malmesbury Abbey, Wiltshire, England. Courtesy Adrian Pingstone, Wikimedia Commons (https://commons.wikimedia.org/wiki/File:Calligraphy.malmesbury.bible.arp.jpg).

2.20 Cancelleresca (chancery or cursive) script (1420). Tertullian, *Opera*, transcribed by Niccolò Niccoli. Conventi soppressi J.VI.11: fol. 122v (detail). Biblioteca Nazionale Centrale di Firenze (BNCF). Su concessione del Ministero dei beni e delle attività culturali e del turismo/BNCF. No reproduction or duplication of this image by any means is permitted.

slanted, less angular, and more rapidly producible (figure 2.20). When, in 1464, Konrad Sweynheym and Arnold Pannartz introduced the printing press to Subiaco, Italy, letterforms also began to move from the calligraphic to the typographic (figures 2.21–2.25). In Italy, this meant a fairly rapid shift from gothic and semi-gothic typefaces to the humanist minuscule (*littera antiqua*) for many texts.[52] Alessandro Paganini's changing type for Pacioli's works serves as an excellent example: in 1494, his use of semi-gothic for Pacioli's *Summa* was a conventional choice. By 1509 the humanist minuscule (*littera antiqua*), roman or semi-roman,[53] for the *Divine proportione* reflected the general shift towards the more readable typographic letterforms (figures 2.26 and 2.27).

Niccolò Niccoli, Coluccio Salutati, and Poggio Bracciolini were among the first humanists to experiment with the new and renewed scripts, and to include Roman capital letters in their book hand. Yet not all humanists were enthusiastic about the examination of alphabets and texts in geometric terms. Guarino Veronese poked fun at Niccoli for describing manuscripts in terms of points, lines, and surfaces; Leonardo Bruni said Niccoli did not know mathematics well.[54] Niccoli's mathematics skills aside, the humanists' *littera antiqua* (their minuscule

2.21 Gothic lettering in the Gutenberg Bible (1454–5). *Biblia Latina*, vol. 1 (Mainz: Johannes Gutenberg, ca. 1454), fol. 5 (detail). Harry Elkins Widener Collection, Houghton Library, Harvard University.

2.22 Round gothic typeface in the first printed edition of Euclid's *Elements*. Euclid, *Elementorum* ([Venice]: Ratdolt, 1482), fol. 1r. Inc 4383 (20.4). Houghton Library, Harvard University.

B. F. Immo ucro pater nec reuerta-
mur: quid enim amplius nobiscum pla
tanis illis ? de iis enim loquebamur.
Sed (fi placet)ad Aetnam potius,de qua
fermo haberi coeptus eſt ,properemus.
B. P. Mihi ucro pérplacet;

2.23 Typeface cut by Francesco Griffo for Pietro Bembo, *De aetna* (Venice: Aldus Manutius, 1496), [n.p.]. Bayerische Staatsbibliothek copy, courtesy of Wikimedia Commons under a Creative Commons Attribution-Non-Commercial-ShareAlike 4.0 International License (https://commons.wikimedia.org/wiki/File:De_Aetna_1495.jpg).

POLIPHILO QVIVI NARRA,CHE GLI PAR VE AN-
CORA DI DORMIRE,ET ALTRONDE IN SOMNO
RITROVARSE IN VNA CONVALLE,LAQVALE NEL
FINE ER A SER ATADE VNA MIR ABILE CLAVSVR A
CVM VNA PORTENTOSA PYRAMIDE,DE ADMI-
RATIONE DIGNA,ET VNO EXCELSO OBELISCO DE
SOPRA.LAQVALE CVM DILIGENTIA ET PIACERE
SVBTILMENTE LA CONSIDEROE.

A SPAVENTEVOLE SILVA,ET CONSTI-
pato Nemore euaſo,&gli primi altri lochi per el dolce
fomno che ſe hauea per le feſſe & proſternate mébre diſ-
fuſo relicti,me ritrouai di nouo in uno piu delectabile
ſito aſſai piu cheel præcedente.Elquale non era de mon
ti horridi,&crepidinoſe rupe intorniato, ne falcato di
ſtrumoſi iugi. Ma compoſitamente de grate montagniole di non tro-
po altecia. Siluoſe di giouani quercioli, di roburi,fraxini & Carpi-

2.24 A mix of Roman capital letters and humanist typeface. [Francesco Colonna?], *Hypnerotomachia Poliphili* (Venice: Aldus Manutius, 1499), fol. 6v. Typ Inc 5574. Houghton Library, Harvard University.

N os patriam fugimus,tu Tityre lentus in umbra
F ormoſam reſonare doces Amaryllida ſyluas.
O Meliboee,deus nobis hæc ocia fecit.
N anq; erit ille mihi ſemper deus,illius aram
S æpe tener noſtris ab ouilibus imbuet agnus.
I lle meas errare boues ,ut cernis,et ipſum

2.25 First italic font cut by Francesco Griffo for Aldus Manutius in Vergilius Maro, *Opera* (Venice: Aldus Manutius, 1501), fol. A2r (detail). Copyright of The University of Manchester.

2.26 The semi-gothic typeface of Luca Pacioli, *Summa de arithmetica, geometria,*
proportioni and proportionalita (Venice: Paganino de Paganini, 1494), part 1, fol. 5r.
Courtesy of the Kress Collection of Business and Economics, Baker Library,
Harvard Business School.

2.27 The more rounded, humanist minuscule (*littera antiqua*) typeface of Luca Pacioli,
De divina proportione (Venice: A. Paganini, 1509), fol. 2r (detail). Typ 525.09.669a.
Houghton Library, Harvard University.

and Roman capitals) were aligned with a Petrarchan idea of *castigata et clara*, as
contrasted with *vaga … ac luxurians*.[55] Humanist letterforms likewise conformed
to Lorenzo Valla's notion of *planius, apertius,* and *distinctius*.[56] In the *Summa*,
Pacioli himself sings the praise of philosophers who are "chiari e aperti" [clear and
open],[57] and it is unsurprising that he would join the ranks of writers who were
interested in beautiful, well-proportioned, readable lettering.

It seems Pacioli did not physically measure letters on lapidary inscriptions as
did some other humanists and artists,[58] but that instead he based his proportions
and construction on those of Feliciano (figure 2.28) and Moyllus, as mentioned

2.28 Letter A. Felice Feliciano,
Alphabetum romanum
(c. 1460–3), fol. 1r. Ms Facs 93.
Houghton Library,
Harvard University.

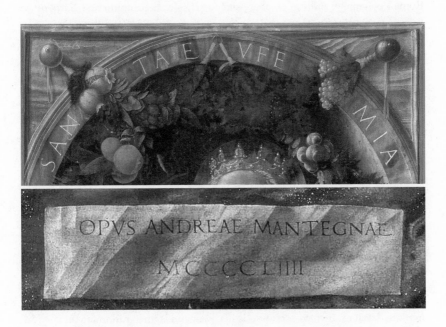

2.29 Details of lettering from Andrea Mantegna, *Saint Euphemia* (1454).
Photo: Luciano Pedicini, 1999. Museo Nazionale di Capodimonte, Naples.
Photo Credit: Alinari/Art Resource, NY.

earlier (see figure 2.35 for Moyllus), or developed his letters based on the work of artists operating in and around Venice in the second half of the fifteenth century. There was, in fact, a tight-knit group of letter measurers in Venice during this period, and there were others in Florence and Rome. Feliciano was friends, for example, with Mantegna, an early adopter of Roman capital letters for use in lapidary inscriptions and in painting (figure 2.29).

Mantegna's lettering differs from that created just a few decades earlier in Tuscany (figures 2.30–2.32) by Donatello, Luca della Robbia, and Lorenzo Ghiberti – those earlier letterforms, while beautiful, do not follow strict geometric proportions. They are considered "Romanesque";[59] visually, they occupy a middle ground between monumental rustic capitals (which were based on brushstrokes) and inscriptional Roman capitals. Some scholars of Roman and Renaissance epigraphy believe that Roman capitals – like those on Trajan's column and those reproduced by Mantegna, Feliciano, and others – may also have been based on brushstrokes,[60] but it seems likely that they were also built up and filled in through chiselling.

Niccoli, Poggio, and Coluccio Salutati had initiated interest in the aesthetics of Roman epigraphy, and calligraphers such as Biagio di Saraceno and Bartolomeo Sanvito were using Roman capitals in their work since the 1450s.[61] But it was apparently only in the 1460s, with Feliciano, that these Roman letters became the focus of mathematical consideration and geometric reproduction. Feliciano's ratio between the height of a letter and the thickness of its stem (equivalent to the stroke a calligraphic pen's nib would create if held perpendicular to a sheet of paper) is 1:10, the proportion of the letters on Trajan's column.[62] Pacioli's ratio, however, is 1:9 (figure 2.33) – an unusual proportion, but a highly enticing one, as we shall now see.

It is, in fact, Pacioli's ratio that truly sets him apart from other contemporary letter measurers/constructors. The suggestion that Alberti might have designed the letters for Pacioli is undermined by a comparison of Pacioli's letters against Alberti's own 1467 alphabet, which uses a ratio of 1:12 (figure 2.34) and is thus even less like Pacioli's than Feliciano's. Moyllus of Parma's *Alphabeto* of circa 1480 also used a ratio of 1:12, although his circle-and-square construction of the letters (figure 2.35), as well as his directions on how to draw each letter, closely resemble those of Pacioli (figure 2.36). Pacioli may well have based his geometrically constructed letters on a combination of those designed by Feliciano, Alberti, and Moyllus, as well as Donatello, but his 1:9 proportion – which we will discuss in more detail in the next section – is his own, and is uncommon for this period. In Chapter 11 of the *Trattato*, Pacioli explains that the letters that we use today derived from pictograms (hieroglyphics), like those he had observed "on the porphyry tomb opposite the Rotunda," with its "cyphers and signs of pens, knives,

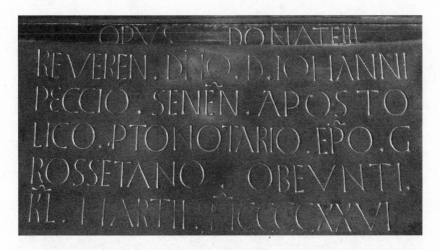

2.30 Lapidary lettering in the inscription on Donatello's *Tomb of Bishop Giovanni Pecci* (1426/7). Duomo, Siena. Courtesy of the Opera della Metropolitana, Aut. n. 608/2016. Photo credit: Lorenza Camin.

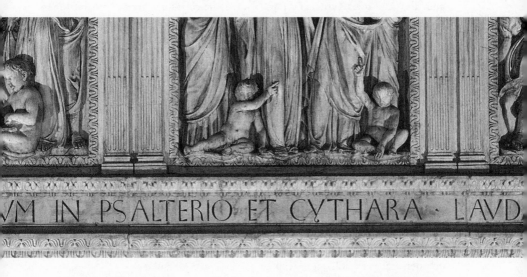

2.31 Detail of lapidary lettering in the inscription on Luca della Robbia the Elder's *Cantoria* (1431–8). Marble, l. 17 ft. Museo dell'Opera del Duomo, Florence. Photo Credit: Scala/Art Resource, NY.

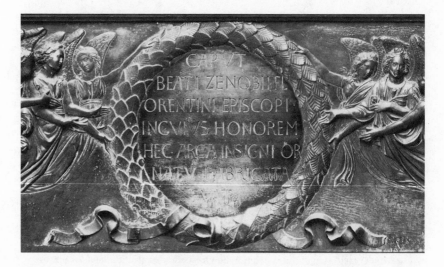

2.32 Lapidary lettering in the inscription on Lorenzo Ghiberti's *Reliquary of St. Zenobius* (1432–43). Bronze. Duomo, Florence. Photo Credit: Alinari/Art Resource, NY.

animals, shoe-soles, birds, and pots." But, as he continues, it was not until men settled on the letters we currently use that we found "the proper way to make them with compasses for the curves and the rule for the straight lines."[63]

Many treatises on the geometry of Roman capital letters followed these late fifteenth-century examples; the topic continued to interest authors and publishers throughout the Renaissance. Letterform treatises were authored by Sigismondo Fanti, Francesco Torniello, Albrecht Dürer, Giambattista Verini, Geoffroy Tory, Ferdinando Ruano, Giovan Francesco Cresci (though his work decried the use of compasses and geometric constructions), Luca Orfei, and others (figures 2.37–2.44). Dürer in particular seemed to be inspired directly by Pacioli's letters, and by the 1509 (or 1523?) *Divina proportione* as a whole: in his *Unterweysung der Messung* [Four Books on Measurement] of 1525, he includes not only a geometrically constructed alphabet, but a discussion of architecture and illustrations of Platonic and Archimedean solids. This is very similar to Pacioli's 1509 *Divina proportione*, with its *Trattato* and Piero's *Libellus*. His letterform ratio, however, is not identical to Pacioli's: it is 1:10.

Pacioli's 1:9 ratio is rare, if not unique. Most of the other weights used both before and after his were lighter (1:10 and 1:12 are the most common), while heavier weights (like Ruano's 1:8) remained infrequent. Like many authors of

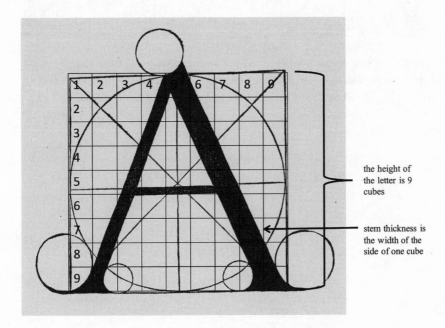

2.33 Pacioli's proportions for the Roman capital letter A. Luca Pacioli, *De divina proportione* (Venice: A. Paganini, 1509), [n.p.]. (Image edited by author.) Typ 525.09.669a. Houghton Library, Harvard University.

letterform treatises post-Feliciano, however, Pacioli's interest in "rationalizing" the letter derives more from his interest in exploring the perfection of the circle and its relationship to the square than from an idealization of ancient Rome and its epigraphy.[64] Moreover, his geometric directions for forming a *degno alphabeto Anticho* are not, or at least not explicitly, based on the golden ratio, as many scholars have assumed. Why Pacioli decided to include a set of geometrically constructed letters alongside a treatise on architecture is not hard to understand. Why, or rather, *how* he associated them with the "divine" proportion is, on the other hand, rather more puzzling; this is what we shall now explore.

Not All That Glitters Is Gold: The Divine in the *Divina proportione*

All parts of the 1509 print edition of the *Divina proportione* discuss both mathematical and aesthetic proportions – and are, Pacioli claims, useful to students of

2.34 Inscription designed by Leon Battista Alberti and Matteo de' Pasti. The ratio of the thick stem's width to the height of the letters is 1:12. Cappella Rucellai, Florence (1467). Courtesy Chiesa Santa Trinita. Photo credit: Francesca Marini.

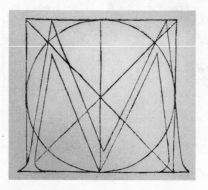

2.35 The ratio of the thick stem's width to the height of Moyllus's "M" is 1:12. Letter M. Damianus Moyllus, *Alphabeto* (Parma: [s.n.], [1480]). Facsimile: *The Moyllus Alphabet* (Paris: At the Sign of the Pegasus, 1927), fol. 12r. Typ 925.27.5820. Houghton Library, Harvard University.

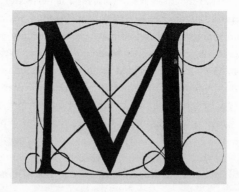

2.36 The ratio of the thick stem's width to the height of Pacioli's "M" is 1:9. Letter M. Luca Pacioli, *De divina proportione* (Venice: A. Paganini, 1509), [n.p.]. Typ 525.09.669a. Houghton Library, Harvard University.

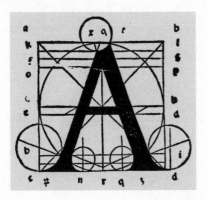

2.37 Letter A. Sigismondo Fanti, *Theorica et practica* ... (Venice: Giovanni Russo, 1514), fol. 62r. TypW 525.14.383. Houghton Library, Harvard University.

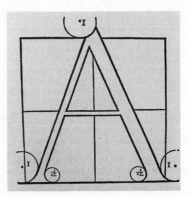

2.38 Letter A. Francesco Torniello, *Opera del modo de fare le littere maiuscole antique* (Milan: Gotardo da Ponte, 1517). Facsimile: Francesco Torniello, *The Alphabet of Francesco Torniello da Novara (1517) Followed by a Comparison with the Alphabet of Fra Luca Pacioli*, ed. Giovanni Mardersteig (Verona: Officina Bodoni, 1971), 9. Typ 925 71.8442. Houghton Library, Harvard University.

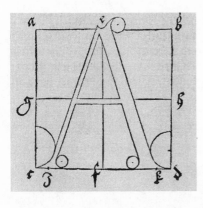

2.39 Letter A. Albrecht Dürer, *Underweysung der Messung, mit dem Zirckel und Richtscheyt, in Linien ebnen und gantzen Corporen* (Nuremberg: [s.n.], 1525), fol. 54r. Typ 520.25.340a. Houghton Library, Harvard University.

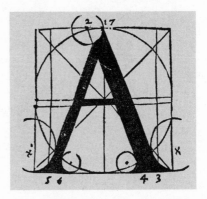

2.40 Letter A. Giambattista Verini, *Luminario. Liber elementorum litteram* (Toscolano: Paganini, [c. 1526]), Book 3, xxxviii. TypW 525.26.868. Houghton Library, Harvard University.

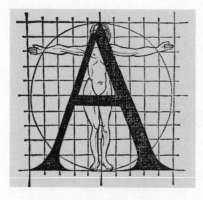

2.41 Letter A. Geoffroy Tory, *Champ fleury* (Paris: G. Tory & G. Gourmont, 1529), fol. XVIII (D6v). Typ 515.29.844. Houghton Library, Harvard University.

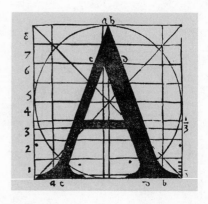

2.42 Letter A. Ferdinando Ruano, *Sette Alphabeti* ... (Rome: Valerio & Luigi Doric, 1554), fol. 3r. TypW 525.54.755. Houghton Library, Harvard University.

2.43 Letter A. Giovan Francesco Cresci, *Il perfetto scrittore* (Rome: Blado, 1570), [part 2, fol. 19r]. TypW 525.70.304. Houghton Library, Harvard University.

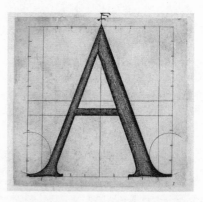

2.44 Letter A. Luca Orfei, *Alfabeto delle maiuscole antiche romane* (Rome, [s.n.], [c. 1586]), 1. Typ 525 86 657 (Facs). Houghton Library, Harvard University.

any art.[65] But the *Compendium* is the only section that directly considers the "extreme and mean ratio," known since the nineteenth century as the "golden ratio." After extolling the importance of mathematics to all the arts in Chapters 2 through 4 of the *Compendium*, Pacioli starts his discussion of the "divine proportion" in Chapter 5 – a good place to start when you are preparing to present a proportion inextricably linked to the five Platonic Solids, to the magical pentagon, and to the Platonic quintessence. Not coincidentally, he offers *five* reasons why this proportion is divine: 1) the ratio's unity and oneness; 2) its irrationality, similar to the incomprehensibility of God's essence; 3) the Trinitarian threeness in its three comparative lengths (a, b, and $a + b$); 4) the impossibility of defining the ratio in terms of human (i.e., "whole") ratios; and 5) its Platonic quintessence: its connection to the divine *fifth* element through its utility in forming such figures as the pentagon (the only polyhedron that has as many sides as diagonals) and the dodecahedron (the polyhedron with twelve sides of symmetrical pentagons, or rather pentagonal "faces," and the one resting upon the large, closed volume to the far right of the Pacioli portrait). It is also worth noting that the *Compendium* discusses at length the *five* Platonic solids, or regular polyhedra (tetrahedron, cube, octahedron, dodecahedron, and icosahedron), and that Pacioli was adamant about there being *five* arts in the quadrivium: perspective, he argued, was the fifth. He conceived of it as being like music or astronomy, which also based their calculations on arithmetic and geometry. Niccolò Tartaglia, who drew from Pacioli extensively in his own works (see the following chapter of this study), noted precisely this distinction of perspective as an art at the opening of his (Tartaglia's) translation of Euclid.[66]

As if to prepare readers for the fives that appear in the *Compendium*, Cremonese mathematician and rhetorician Daniele Caetani (or Caietani, or Gaetani, born 1465), who may have met Pacioli in Venice and likely attended his lecture on Euclid in 1508,[67] wrote an epigram for the *Divina proportione* that focused on the greatness of the five regular solids. The Latin epigram – written in distichs – is juxtaposed with a second poem in Italian, which is titled "Sonetto del auctore" and is, in fact, a translation of Caetani's Latin epigram. Clearly, Pacioli wanted to be sure readers who did not know Latin could grasp what was written. The epigram (like its sonnet translation) describes the five regular polyhedra and the many forms that can be derived from them. It links the geometrically specific to the abstract and universal: these five solids can only be five because there are four elements plus the mysterious fifth element known as ether.

Moving on to Chapter 6 of the *Compendium*, Pacioli enumerates the many admirable things that require this divine proportion (the golden ratio). The

following chapters, 7 through 22, present thirteen different *effecti* [ways or results] in which the proportion can be used – each magnificent in its own right, and each described superlatively, such as *essenziale, singolare, ineffabile, mirabile, innominabile, supremo* [essential, singular, ineffable, admirable, unnamable, supreme]. Pacioli explains in Chapter 23 that although the potential number of *effecti* is infinite, he limited himself to a small selection of thirteen: *thirteen* because it is a sacred number, representing the number of individuals present at the Last Supper (twelve disciples plus Christ). Pacioli was with Leonardo in Milan at the time the artist was working on the *Last Supper*. What is more, as Pacioli would certainly have noticed, Euclid discussed the golden proportion (extreme mean and ratio) in Book 13 of his *Elements*. Another interesting coincidence, albeit one that Pacioli may not have known, is that Pappus noted in Book 5 (*five* again!) of his *Collection* that there exist only *thirteen* semi-regular polyhedra (polyhedra with two or more types of regular polygons that meet in identical vertices). These semi-regular polyhedra would later be known as the Archimedean Solids.

The surviving books of Pappus's *Collection* were not translated into Latin until Federico Commandino did so in 1588, and it was not until 1619 that Kepler succeeded in reconstructing the entire group of thirteen solids. Pappus's manuscript was in the Vatican library by the late thirteenth or early fourteenth century (*Vat. gr.* 218), and it is possible that Pacioli had heard about the thirteen Archimedean Solids from someone who had read this text (that he does not cite Pappus in the *Divina proportione*, however, makes this connection less likely).[68] Or, perhaps Pacioli read or knew some of the Archimedean material that Giorgio Valla was to include in his encyclopedic *De expetendis et fugiendis rebus* (published posthumously by Aldus in 1501). Pacioli and Valla travelled in similar circles, and Valla had even been a tutor to the Sforza, as Pacioli would become when he arrived in Milan in 1496.

As Pacioli knew of only six semi-regular polyhedra, only six of the polyhedra in the *Divina proportione* are Archimedean (the truncated tetrahedron, truncated icosahedron, truncated octahedron, cuboctahedron, icosidodecahedron, and rhombicuboctahedron, the last of which is included in the de' Barbari portrait of Pacioli). Three of these had appeared in Piero's *Libellus* (the truncated tetrahedron, truncated icosahedron, truncated octahedron) and two were in Piero's *Trattato d'abaco* (the truncated tetrahedron and cuboctahedron).[69] It seems that Pacioli can only be credited with rediscovering the icosidodecahedron.

Chapter 24 of the *Compendium* offers a general introduction to the regular and semi-regular polyhedra that Leonardo illustrated for the text and that Pacioli discusses in detail in the subsequent chapters.

Chapters 25 and 26 explain why the number of regular polyhedra is limited to five; Pacioli recalls the Platonic notion that the potential number of regular polyhedra is linked to the five elements. Chapters 26 through 30 explain how to construct the polyhedra. Chapters 31 through 33 discuss the relationships between regular polyhedra, and Chapters 34 through 47 demonstrate methods for inscribing one regular polyhedron within another. In Chapters 48 through 55, Pacioli explains how to make other, semi-regular solids (solid, hollow, truncated, and stellated) out of the five regular ones: some of these semi-regular solids are illustrated in the sixty Leonardo-designed plates appended at the text's end (or rather, fifty-nine plates, in the print edition). Chapters 56 to 68 offer instructions for creating other forms – spheres, columns (rounded cylinders and cylinders of different numbers of sides), and pyramids.

Chapter 69 is an encomium of Il Moro, and the text closes with two final chapters (70 and 71), which sum up all the forms previously described and add a list of mathematical terms.

What then, is this particular "divine proportion"? Mathematicians since Euclid have been fascinated by the extreme mean and ratio. The term "golden section," however, was first used by German mathematicians Ferdinand Wolff in 1833 (as *Goldener Schnitt*) and then Martin Ohm, in geometry textbooks published from 1835.[70] The real hunt for golden ratios began in the mid-1800s: Adolf Zeising's theory of the human body's proportions, published in 1854, was among the first published studies to postulate that classical, medieval, and Renaissance art and architecture had all made extensive use of the golden section – as, he believed, nature itself had.[71] In the early twentieth century, mathematician Mark Barr gave the ratio the name/symbol ϕ: *phi* – the first letter of the name of the fifth-century BCE Greek sculptor Phidias, who was believed by Barr's contemporaries to have used the ratio in his work. More recently, art and architectural historians,[72] as well as mathematicians,[73] have questioned these "*phi*" attributions, seeing them as examples of the human tendency to find (or rather impose) proportions with ideal aesthetic or symbolic associations on the world that surrounds us, and the world we create for ourselves. Discussion of the ratio is absent from the published architectural treatises of Vitruvius, Alberti, Francesco di Giorgio (1439–1502), and Filarete (1400–1469). Nor do we find it in the architectural writings of Sebastiano Serlio (1475–1554), Daniele Barbaro (1514–1570), Vignola (1507–1573), Andrea Palladio (1508–1580), or Vincenzo Scamozzi (1548–1616). The ratios or intervals of choice for classical and Renaissance art, architecture, and music were commensurable ones, such as 1:2, 1:3, 3:4, 2:3, 2:1 (the octave), 3:2 (the perfect fifth), and 4:3 (the perfect fourth).

Euclid discussed the "extreme mean and ratio" in Book 6, Prop. 30, and Book 13 of his *Elements*. As he explains it, this ratio is one in which a whole line ($a + b$) is to a greater segment (a) as a greater segment (a) is to a lesser segment (b). In modern mathematics, that would be

$$\frac{a + b}{a} = \frac{a}{b} = \phi$$

$$\phi = \frac{1 + \sqrt{5}}{2} \approx 1.6180\ldots$$

Plato also alluded to the golden ratio in his *Timaeus* – a text Pacioli knew and often cited – when discussing the five regular solids:

> For whenever in any three numbers, whether cube or square, there is a mean, which is to the last term what the first term is to it; and again, when the mean is to the first term as the last term is to the mean – then the mean becoming first and last, and the first and last both becoming means, they will all of them of necessity come to be the same, and having become the same with one another will be all one.[74]

The self-reproducing ad infinitum characteristic of this proportion is immediately evident and fascinating, as it generates figures such as the golden spiral (a logarithmic spiral growing by the factor of ϕ) and golden triangle (figures 2.45 and 2.46).

While Pacioli does discuss this ratio in the *Compendium*, the *Trattato* does not explicitly use the golden ratio in its architectural measurements, nor does Pacioli encourage its use in either art or architecture. Piero's *Libellus* likewise has no discussion of the golden ratio in terms of its relationship to architecture. Though many have believed over the centuries that all parts of Pacioli's print *Divina proportione* of 1509 were about the golden ratio, mathematician Roger Herz-Fischler has traced that assumption to a claim first made in 1799 by mathematician Jean Etienne Montucla and astronomer Jérôme de Lalande in their *Histoire des Mathématiques*;[75] later scholars – until recently – have simply repeated that assertion without returning to the original text to see that it is not the case. Scholars, however, continue to explore the possibility of the presence of the golden ratio in parts of the *Divina proportione* outside of the *Compendium*, such as in the diagram of a human head (which appears twice: once in the *Trattato* in Chapter 1, 25r and a second time as a plate at the end of the *Libellus* following leaf 27), and in the letterforms themselves.[76]

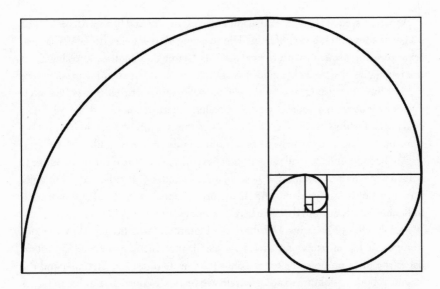

2.45 A Fibonacci spiral, which is an approximation of the golden spiral. Image in the public domain, courtesy of Wikimedia Commons.

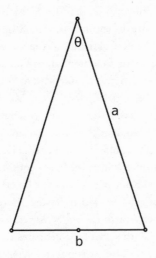

2.46 The golden triangle. The ratio a:b is equivalent to φ. Image courtesy of Wikimedia Commons, under a Creative Commons Attribution-Share Alike 3.0 Unported License.

As can be seen in figure 2.47, Pacioli overlays the face and head with rectangles, diagonal lines, and horizontal lines. The two tangent rectangles defining the head seem to form a square, with their diagonals forming an equilateral triangle. Yet the rectangles also resemble golden rectangles in their proportion, although the vertical line descending next to the ear, as well as the fact that two golden rectangles do not form a square, seem to preclude that. Alessandra Angelini, Paola Magnaghi-Delfino, and Tullia Norando offer another way of considering proportions in the diagram of the head that is quite interesting and could well be what Pacioli had in mind.[77] As all note, Pacioli never discussed the head in terms of the golden ratio in the *Trattato*, and as such, it seems unlikely that he was thinking of it in terms of being "golden." The "divine proportions" of the head and face seem to be those built on, and divisible by, the number three.

Pacioli refers often in his *Trattato* to the Platonic, Hermetic, and Vitruvian notion that man is measure of all things, and adds that the human head's size establishes the ideal proportions for a work of art or architecture. The *capo* and the "capitals" both of columns and of letters are certainly connected in his mind, as are the face and a building's façade, the circle and the square, the curvilinear line and the straight line. He uses the 1:9 ratio for a number of the face and head proportions, the same one he used for constructing the *degno alphabeto Anticho*. What is more, in the temple façade image that in many exemplars of the 1509 *Divina proportione* follows the last letter (Y) of his alphabet (figure 2.48), we see Roman capital letters spelling out "HIEROSOLIMIS" [King Solomon] on the tympanum, and a frieze above the entrance reading "PORTA TEMPLI DOMINI DICTA SPECIOSA" [The beautiful gate of the sacred temple]. These phrases recall Acts 3:1, which describes Solomon's divine temple. The bases of the two large columns – which Pacioli may have intended to be of the Ionic or Corinthian 1:9 proportion[78] – bear the initials "MA. LU." – Maestro Luca, that is, Pacioli. Pacioli closes his *Trattato* with a façade – a face – of a building. He chooses not just any building, but a divine building. And not just any divine building, but King Solomon's Temple, and, once again, the number five: Dante, as Pacioli would have known, made Solomon the fifth star in his Sphere of the Sun. Pacioli inscribed his geometrically proportioned Roman letters on this façade, and supported the whole structure with mathematics – or, rather, rested the entire edifice on himself (Maestro Luca) as the mouthpiece for mathematics. The de' Barbari portrait we explored at the beginning of this chapter anticipates Pacioli's vision of himself as the "face" of mathematics, but also its support. Pacioli certainly held the human face/head and the *degno alphabeto Anticho* to be "divine" in the way other proportions including 9s, 3s, 5s, and 10s are divine, albeit not necessarily golden.

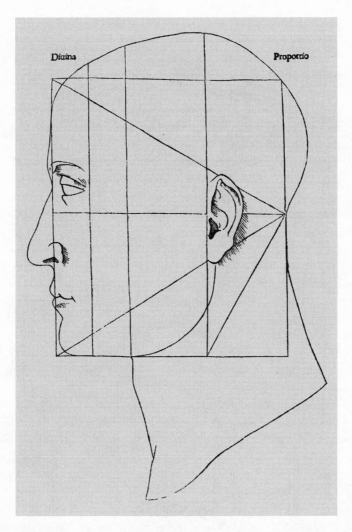

2.47 Pacioli's diagram of a head appears twice in the *Divina proportione*: in the *Trattato*, Chapter 1, 25r, and again at the end of Piero's *Libellus*, following leaf 27 (immediately preceding the unnumbered pages of the *degno alphabeto Anticho*), which is the version being shown here. The two large, horizontally oriented rectangles seem to be golden in their proportions, but the fact that two adjacent golden rectangles do not form a square, nor do the diagonals of two adjacent golden rectangles form an equilateral triangle, precludes this. Luca Pacioli, *De divina proportione* (Venice: A. Paganini, 1509), [n.p., immediately following Book 3]. Typ 525.09.669a. Houghton Library, Harvard University.

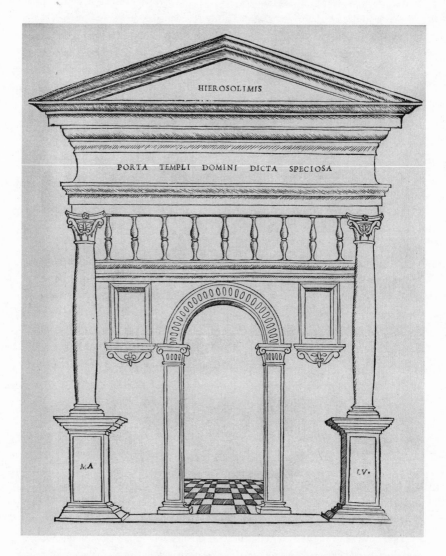

Figure 2.48 Solomon's Gate, inserted as a separate leaf in the 1509 *Compendium*, which follows the unnumbered letter pages. (In the exemplar consulted, this illustration follows the alphabet and precedes the polyhedra.) Luca Pacioli, *De Divina Proportione* (Venice: A. Paganini, 1509), fol. 27r. Typ 525.09.669a. Houghton Library, Harvard University.

While the alphabet of Roman capital letters Pacioli presented in the 1509 print edition of the *Divina proportione* does not explicitly make use of the golden ratio, these letters must possess something of the "divine" to warrant Pacioli's choice to include them alongside the *Compendium* and *Trattato*. Yet Pacioli never identifies what is divine about the letters, and says nothing about his proportion of 1:9. Why "9," and not 8, 10, or 12, or even his beloved 5 or 13? Vitruvius, whose ratios Pacioli otherwise follows so closely in his *Trattato*, did not use 1:9 as a ratio in measuring any of man's proportions, nor did Leonardo in drawing his famous Vitruvian Man. Given the connections he draws between letters, faces, and façades, Pacioli might be expected to have chosen one of Vitruvius's ratios for a head/face (1:8, from top of the head to below the chin: the height of a man; or 1:10, from the hairline to the bottom of the chin [the face]: the height of a man)[79] for his letters. I would venture that he considered these ratios, but rejected them for some reason. Pacioli may have chosen his 1:9 ratio to reference nine as the square of three, the Trinity; or he may have had in mind Dante's *Vita nuova*, using Beatrice's number to indicate the proportion's beauty and divinity. He may simply have wanted to link it to the Ionic (a column that is nine times its lower diameter) order. But rather than explain his number nine, Pacioli focuses – in both the *Compendium* and *Trattato* – on the role of the circle and the square in creating beautiful works of art and architecture. For the letters of his *degno alphabeto Anticho*, Pacioli is primarily interested in demonstrating their direct relationship to both the circle and square. In the first chapter of the *Trattato* (25r) he writes:

> The two principal figures – without which it is impossible to do anything well – are the most perfect circle and all the other isoperimetric [having the same perimeter] figures as Dionysius says in *De spheris*,[80] and the square. And these are the figures that are created by the two principal lines: curved and straight.[81]

In Platonic and Neoplatonic thought, the circle was often associated with divinity, the square with the natural world, and the fusion of the two as a unified ideal. The philosophical Pacioli revels in these mathematical mysteries. The practical, teacherly Pacioli wishes to help his students make whatever great and beautiful things they can. When he explains his techniques for forming the Roman capital letters, the teacher in Pacioli takes over and offers directions that are clear and concise (figures 2.49 and 2.50).

The proportions for Pacioli's *degno alphabetico Anticho* are beautiful, and Pacioli warns his students (25v–26r) not to be surprised that their hands cannot imitate

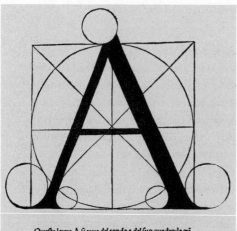

Quefta letera A fi caua del tondo e del fuo quadro:la gã
ba da man drita uol effer groffa dele noue partiluna de
lalteza. La gamba feniftra uol effer la mita de la gãba grof
fa. La gamba de mezo uol effer lá terza parte de la gamba
groffa. La largheza de dita letera cadauna gamba per me
zo de la crofiera, quella di mezo alquanto piu bafta com
me uedi qui per li diametri fegnati.

Questa letera A si cava del tondo e del suo quadro: la gamba da man drita vol esser grossa dele nove parti luna de lalteza. La gamba senistra vol esser la mita de la gamba grossa. La gamba de mezo vol esser la terza parte de la gamba grossa. La largheza de dita letera cadauna gamba per mezo de la crosier, quella di mezo alquanto piu bassa come vedi qui per li diametri segnati.

This letter derives from the circle and square. The right limb must be one-ninth of the height's thickness. The left limb is to be half as thick as the thick one. The middle [cross-] limb is to be one-third of the thickness of the thick limb. Of the said letter, the middle limb – the breadth of the letter [between] each limb – lies a little lower than the junction [of the diagonals] as you see by the diameters indicated.

2.49 Pacioli's directions for constructing the letter A. Luca Pacioli, *De divina proportione* (Venice: A. Paganini, 1509), [n.p.]. Typ 525.09.669a. Houghton Library, Harvard University.

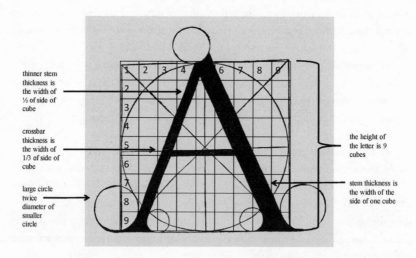

thinner stem thickness is the width of ½ of side of cube

crossbar thickness is the width of 1/3 of side of cube

large circle twice diameter of smaller circle

the height of the letter is 9 cubes

stem thickness is the width of the side of one cube

2.50 Summary of Pacioli's proportions for the letter A. Luca Pacioli, *De divina proportione* (Venice: A. Paganini, 1509), [n.p.]. (Image edited by author.) Typ 525.09.669a. Houghton Library, Harvard University.

everything that nature can do, as mathematical disciplines deal with abstract forms, the "actualities" of which are not visible. We call the signs we make with our pens by imperfect names (point, line, surface, etc.) because we lack more precise words to describe their concepts.[82] On the one hand, Pacioli inspires students to recognize how much they *can* do with circles and squares, curves and straight lines, compasses and straight edges; on the other hand, he asks students to bow before nature, which is able to access mathematical abstractions and truths in ways that we cannot.

Although Pacioli's Roman capital letters are not themselves golden, they are constructed mathematically, and, as such, he believed that they could "en-golden" our minds. As if anticipating the word "golden" later used in connection with the ratio, Pacioli writes that "gold is proved through fire, and the mind through mathematics."[83] The letters Pacioli presents are quite literally "divine" characters on the page, on stones, on architectural capitals, anywhere and everywhere you direct them to be.

Divine Characters

In the *Trattato* Pacioli says that the construction of letters, as the making of everything (by humans and by nature), "proceeds from mathematics."[84] In the dedicatory epistle to his *Summa*, he acknowledges that mathematics is not easy to "hear" (understand), but explains that it is fundamental to all the arts, the verbal arts included:

> And although mathematical terms do not fall clearly on our ears, there is nothing that is not contained in their power. Mathematics is the principle and foundation of all the other arts. Just as the grammar's goals are correct measure in writing and speaking – with its grave, acute, and circumflex accents – and rhetoric gains its elegance from proper harmony, poetry's dactyl, iamb, spondee, trochee, anapest, tribrach, proceleus maticus, and the other feet have certain, definite, measurable harmonies and measures.[85]

He repeats these words nearly verbatim in the Introduction to Book 5 of his Latin edition of Euclid *Elements*:

> By imitating music the poets write their verses and use almost the same media [as the musicians]. They use the dactyl, iambic, spondee, trochee, anapest, tribrach,

proceleusmatic, and the rest of the feet by way of proportion. Sometimes rhetoricians after the example of the above assign the parts of their orations to fitting and proper rhythms. Grammar seems to follow this very origin and foundation of all the liberal arts when it has the beginner learn the rule for correct speaking and writing, a rule ending with the use of the grave, acute, and circumflex accents.[86]

For Pacioli, abstract and transcendent as mathematics is, it finds its way into every aspect of every art, and the verbal arts owe much to its ability to set proportions and harmonies.

Following the title page of the 1509 *Divina proportione*, Pacioli includes a brief dialogue between the divine "characters" of geometry and the reader (figure 2.51). Leonardo also penned a tercet nearly identical to the first tercet of this dialogue, but it is not clear if he wrote it and Pacioli used it, or if he copied it from Pacioli into his notebook.[87] In either case, the dialogue – the final distich being a variation on a verse in Virgil's *Georgics* (2.490) – is a concise expression of the delight the philosophical mind takes in learning mathematics. Here, specifically, it is the polyhedra that speak to their reader (viewer/listener).

Tartaglia, as we will see further in the next chapter, borrowed often from Pacioli's poetic verses and sayings: he even copied the geometric bodies' final distich almost word for word for the title page of his 1537 *Nova scientia*.[88]

Pacioli was not alone in recognizing the importance of mathematics to writing. The French typographer Geoffroy Tory – printer to King Francis I, teacher of famous type designer Claude Garamond, professor of grammar and philosophy, and librarian at the University of Paris – also thought deeply about the relationship between mathematics and language. Tory studied in Italy at the turn of the sixteenth century and, unfortunately, he had no kind words for Pacioli. He believed – probably incorrectly – that Pacioli had stolen his letter-shape ideas from him. Twenty years after Pacioli's 1509 *Divina proportione*, Tory published *Champ Fleury*, an entire book devoted to the proportions and symbolism of letters. A look at the French scholar's comments on geometry and letterforms can help us better understand what Pacioli might have seen as "divine" in his *degno alphabeto Anticho*.

Although he uses some computation to create his letterforms, Tory mainly discusses the relationship between letters and the worlds of myth and mysticism. We see, for example, that he linked the letter "I" to the nine Muses + Apollo, and the letter "O" to the liberal arts + Apollo (figure 2.52).

Tory criticized Pacioli for his 1:9 ratio: he considered 1:10 more appropriate, as it represented the nine Muses + Apollo (though this argument ignores letters

Corpora ad lectorem.	**The geometric bodies to the reader**
El dolce fructo vago e si dilecto. *Cõstrinse gia i Philosophi cercare.* *Causa de noi che pasci lintellecto.*	The sweet fruit, beautiful and cherished, Has long compelled Philosophers to seek What causes their intellect to feed from us.
Disticon ad idem	**Distich to the same**
Quærer de nobis fructus dulcissius egit *Philosophos cãm mẽs vbi læta mãet.*	The sweetest fruit compels philosophers to seek the cause from us, where a happy mind endures.
Corpora loquuntur	**The geometric bodies speak**
Qui cupitis R ẽp varias cognoscere cãs *Discite nos: Cũctis hac patet vna via* **FINIS**	You, who wish to understand the varied causes of things, learn us: this one road lies open to all. END.

2.51 A dialogue between geometric solids and the reader that follows the title page in the 1509 print edition of *De divina proportione*. The initial tercet, with some modification, appears in Leonardo's Codex M, f. 80, followed by small drawings of the five regular solids, sketched shortly before 1500. Luca Pacioli, *De divina proportione* (Venice: A. Paganini, 1509), following title page. Typ 525.09.669a. Houghton Library, Harvard University. Translation by author.

like "O" that are ten cubes tall but contain only eight of Tory's elements). The Muses inspire all manner of written works (epic poetry, lyric poetry, history, comedy, tragedy, and hymn) as well as music (elegiac poetry), dance, and astronomy; they do not, however, seem to inspire arithmetic, geometry, grammar, rhetoric, logic, or even the art of perspective. Adding Apollo could cover rhetoric and logic, but the model ignores the other arts. While Pacioli certainly thought often and concertedly about all the arts, especially as they related to mathematics, it seems unlikely that the Franciscan friar Pacioli would have considered his *degno alphabeto Anticho* as Tory did his alphabet – that is, lacking a connection to geometry, arithmetic, and grammar.

Tory's treatise may, however, hint at a mindset he and Pacioli would have shared, although one Pacioli never explicitly mentioned in reference to his Roman alphabet. This was a view commonly advanced, at least as an ideal, among Renaissance scholars and artists: "as above, so below." In this understanding, every microcosm reflects the cosmic macrocosm, and humans must strive to recognize and

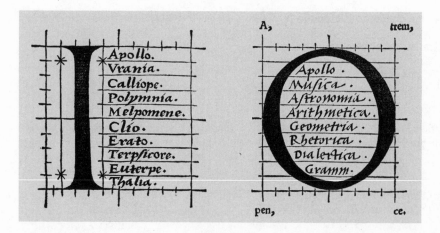

2.52 Letters I and O. Geoffroy Tory, *Champ fleury* (Paris: G. Tory & G. Gourmont, 1529), Part 2, fol. 14v (D3v). Typ 515.29.844. Houghton Library, Harvard University.

reproduce the proportions that God-as-Geometer saw fit to employ in the world. Connected with such "as above, so below" thinking was the belief that man, as God's creation, was divinely proportioned and thus could be used as a ruler or a measure for all things.

Yet Pacioli approached this "as above, so below" and "man as the measure of all things" sensibility differently from Tory and other more esoteric thinkers of the period. He recalls in the Introduction to the *Divina proportione* the verse from Dante's *Paradiso* 33.87 that describes how everything in the universe is bound together (*in un volume*). But for Pacioli this "binding" is grounded in mathematics: "si squaterna quello de necessita al numero pero e mensura sia soctoposto" [the binding is, however, necessarily linked to number, and subject to measurement] (2r). Mathematics – a divine art – is the measure of all things. Mathematics binds the things above to those below. It seems that the Trinity, and maybe even Dante's beloved Beatrice as the number 9 (the square of 3), and the "Love that moves the heavens and the other stars" motivated Pacioli's letter proportions – not the Muses, not the Vitruvian head/face to body proportions (of 1:8 or 1:10), not the earlier proportions of Feliciano, Moyllus, or Alberti.

For Pacioli, mathematics was a manifestation of the divine. In Chapter 11 of the *Trattato*, he writes that no language, "not even Greek," he writes, "can make a square have five angles" (again the number *five*).[89] Mathematics offers primary

and absolute meaning: words cannot change what mathematics has established as true, and, as noted earlier, words lack the precision necessary to describe true (Platonic) geometric shapes. Despite his inclination towards Christian, Pythagorean, and Platonic symbolism, Pacioli was a realist; in the absence of "divine proportions" he did not force natural or human creations to conform to them. He admitted that human art pales in comparison to nature, to the divine, and to abstract forms. But he did grant that, with effort, the human mind and hand could approach natural or divine beauty and perfection. Yes, he saw the "divine" power of circles and squares to aid the arts and sciences; and yes, he saw the "golden ratio" as the fascinating, transcendent (and transcendental) ratio it is. But he was not a mystagogue like Tory, who attempted to impose his philosophical ideas onto the arts and who saw those ideas everywhere in nature (much as would the "golden ratio hunters" of the nineteenth and twentieth centuries).

Pacioli was not the only Renaissance thinker to consider the heavens, the natural world, and human artifice through the optic of mathematics. In the previous chapter, I argued that Alberti saw similar potential in mathematics, and we shall see that Tartaglia shared their perspective. Their approach to knowing the world is closely linked to the humanist project of recovering ancient knowledge. Even if Pacioli did not go out to measure the proportions of Roman lapidaries, he did observe the geometry of classical lettering as he observed and studied the immense body of mathematical thought, ancient and modern. Pacioli was as strongly committed as other humanists to the recovery and transmission of knowledge.

Unlike many of his humanist contemporaries, however, who wrote in Latin as a sign of erudition and familiarity with their ancient sources, Pacioli wrote nearly all of his works in the vernacular. He published unwaveringly and confidently in the same vernacular that his contemporaries criticized as unadorned and inelegant. Baldi, for example, described Pacioli's writing as such in *Le vite de' matematici*:

> His writing is of [such] a barbarous, irregular, rough, and unsuccessful style that it nauseates those who read it. Certainly, if beneath such verbal filth there were not such beautiful and useful [mathematical] discussions, his work would not be worthy of publication. As such, he who studies his opus can really say that he gathers gems from garbage, as Virgil said with regard to Ennius. He mixes Latin phrases with vernacular ones, and mangles both. His writing, even his native Borghese [from Borgo Sansepolcro], which is in and of itself ugly and hateful, is mixed with Venetian and all the worst Italian vernaculars. This, I believe, is caused by his never

having devoted much time and effort to the study of literary Latin and vernacular writing, always having been immersed in mathematical study. It is no surprise that those who do not put effort into those arts do not acquire them. Part of the blame, however, also should be laid on his century: a time in which, even although Latin was among one of the highly refined goods, the vernacular was still quite buried in mud. His having been a friar may also have been a reason for this sort of [linguistic] barbarity, as we see how cloistered people who are separated from secular life show little grace in secular literature.[90]

Such critiques aside, in Pacioli's works, he often emphasizes the value of making mathematical knowledge as widely available as possible. In the dedicatory epistle to the *Summa*, for example, he explains, "... I wrote this in the mother tongue so that scholars and non-scholars will not only have access to useful information, but will obtain great pleasure in practising these things."[91]

Choosing Latin for mathematical treatises was problematic for another reason for Pacioli: Latin lacked many of the everyday technical, practical words Pacioli used, and wanted to use, in his writing. He preferred an informal Italian mixed with dialect (Tuscan, Venetian), although he typically added a smattering of classical references and popular sayings that merchant-class readers could understand, often followed with translations into Italian, just to be sure the message was received.[92] The *Trattato* and the *degno alphabeto Anticho* of the *Divina proportione* – more so than the *Compendium*, and certainly more so than the *Summa* – were meant to be concise, didactic presentations to students and artisans. The quarto format of the 1509 *Divina proportione* further reinforces our understanding that Pacioli aimed to produce a portable and useful work, accessible to the widest possible audience.

Caetani, who wrote the epigram for the 1509 *Divina proportione*, also contributed a laudatory poem to Pacioli's edition of Euclid's *Elements*. The poem for Pacioli's Euclid (unlike the epigram that had celebrated the five regular solids) commends Pacioli for his renewal of Euclid's works.[93] Although Pacioli produced his edition of the *Elements* in Latin – it was one of his only works in Latin – he claimed that his edition would amend mistakes published in earlier Latin editions of the *Elements*, and would add commentary and glossing on Euclid's propositions and proofs, thus improving understanding of the original Latin text. This, however, is not actually what he did; rather, he basically followed Campanus's 1482 edition of Euclid and made few modifications.[94] Pacioli's enthusiasm for dissemination of mathematical knowledge and education motivated all his published

works. He was fortunate to be writing just as printing presses were appearing in Italian cities, and we are fortunate that he embraced the new print technology. His *libello* on Roman capital letters offers stone workers, calligraphers, and punch cutters alike a way to standardize and fix the alphabet's characters. Although brief and lacking an explicit explanation of their "divinity," Pacioli's alphabet is an exquisite example of his vision of mathematics' importance to nature and to all human art, even the smallest syntagmatic elements.[95]

As Erika Boeckeler notes, letters have the "triple-quality" of sound, image, and, when combined, meaning.[96] Pacioli was clearly most interested in letters' morphology, but as a teacher and a champion for the communication of ideas, he was also aware of their syntagmatic and paradigmatic qualities. In an unpublished work dating to the period 1496 to 1508, when he was at work on the original *Divina proportione* and preparing for the print version, Pacioli seems to hint at this "triple-quality" of letters. The *De viribus quantitatis* [On the Power of Numbers or Quantities] contains mathematical word problems in the tradition of *matematica recreativa*, as well as games and "magic tricks" (card tricks, invisible writing, juggling) and bits of advice.[97] Book 3, entitled "Documenti morali utilissimi" [Highly Useful Moral Documents], opens with two poems: the first, in twenty-three distichs, advises young people to learn and master the "secrets" of mathematics, but not to use these secrets for competitive or harmful purposes (figure 2.53).

The repetition of first letters for each distich suggests an intentional pattern, though I have yet to discern a guiding principle. Note that the copyist writes these letters in Roman capitals, much like the letters Pacioli designed for the 1509 *Divina proportione*.

The second poem is entitled "Lamento de uno inamorato verso una donzella" [The Lament of One in Love with a Woman] (figure 2.54). In full-on Petrarchan *imitatio* (arguably parody), Pacioli writes twenty-seven distichs, each beginning with a letter of the alphabet, more or less in an alphabetical-order acrostic. The last two characters before the "Finis Alfabeti" are, it seems, abbreviations (*con*, "with" and *per*, "for"; or the Latin endings *rum*, *ram*, *ius*, or an end stroke in general). Yet they could also be numbers: 94, perhaps the year he actually wrote these verses. It is possible, in fact, that Pacioli composed this poem, and much of the *De viribus*, before he requested printing permission in Venice – on 19 December 1508, near the publication dates for the *Divina proportione* and *Euclidis*.[98] This simple acrostic might be nothing more than play – a common device at that – but in a book about number games and magic tricks, one cannot help but

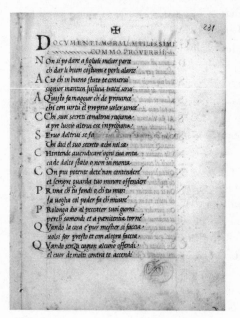

2.53 The opening poem of the section entitled "Documenti morali utilissimi" in the earliest surviving manuscript of *De viribus*; it is not in Pacioli's hand, but is a copy from c. 1550. Luca Pacioli, *De viribus quantitatis* (1498). Ms Biblioteca Universitaria di Bologna, cod. 250, fols. 231r/v. Su concessione della Biblioteca Universitaria di Bologna.

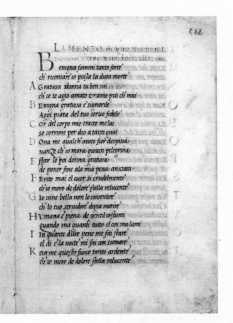

2.54 "Lamento de uno inamorato verso una donzella." Luca Pacioli, *De viribus quantitatis* (1498). Ms Biblioteca Universitaria di Bologna, cod. 250, fols. 232r/v, 233r. Su concessione della Biblioteca Universitaria di Bologna.

think that Pacioli saw the geometric shape of letters and writing much in the way Alberti did.

In the decades before and after publication of the *Divina proportione*, Italian copyists and printers increasingly chose to use Roman capital letters and typefaces, as well as the newly developed upright humanist and italic letters, in literary works; this choice was especially made for works by classical authors, or by contemporary authors composing works on classical topics and in classical styles. We see a new desire at work to have font reflect content, or to link the content with humanist (in some cases Neoplatonic) philosophy.[99] The gothic fonts, quick to produce given their angularity but hard to read, remained dominant in Northern Europe, especially Germany. In Italy, these gothic fonts were preferred for religious, didactic, legal, and commerce-focused works – but the lighter and more rotunda letterforms were favoured for literary works. These forms recalled classical literary works and an early, clear hand. This is not the first time book hands announced a work's content – some scholars believe uncials, based on Latin cursive hand, were developed in Constantine's time, used instead of Roman rustic and square capitals to signal pagan texts.[100]

During the Renaissance, the same scholars who debated whether to write in Latin or in the vernacular argued over which letterforms to use in a given text. Most letterform construction manuals were written, not coincidentally, in the vernacular – and these manuals changed the shape and readability of literature in a time of increased literacy. Along with a growing court culture and middle class, and the increased accessibility of texts facilitated by printing, the letterform manuals made it easier for more people to read more texts. These manuals also contributed to rationalizing and codifying the particles of language – including diphthongs, accents, serifs, ligatures, abbreviations, and punctuation. By the late 1500s, mathematics, too, would be further codified through an increase in notation and further stabilization of notational conventions.

Pacioli's alphabet is an extraordinary example of the confluence between computation and writing during a time when notations for mathematical operations were mainly written in words; geometry was primarily Euclidean; classical art and architecture, as well as letterforms, were being rediscovered; and "divine" proportions were intentionally reproduced in the man-made word as best as possible. All scripts and typefaces have a fascinating history. What makes Pacioli's *degno alphabeto Anticho* and the various Roman capital letter alphabets drafted in this period particularly interesting is the tight link between these letterforms and actual mathematics; how closely calculated debates over letterforms paralleled

literary debates over whether to use ancient or modern language, gothic or humanist script, for a given text; and how, even as the printing press standardized and mechanized letter-shapes, those same shapes actively contributed to the very process of their transformation through how they were used. Computation's contributions to all alphabets – the building blocks of phonemes, words, sentences – cannot be overstated. Pacioli's writing on the construction of Roman capital letters is an extraordinary example of how computation underlies the face and façade of letters, giving them their character.

Three

Word Problems:
Niccolò Tartaglia's "Quando chel cubo"
(1546)

Cancel me not – for what then shall remain?
Abscissas, some mantissas, modules, modes,
A root or two, a torus and a node:
The inverse of my verse, a null domain …[1]

– Stanisław Lem

It was "with quick steps and light feet" ["non con passi tardi"] in "the watery city surrounded by shore" ["nella città del mar'intorno centa," that is, Venice], as Brescian mathematician Niccolò Tartaglia writes at the end of a twenty-five-line poem published in 1546, that he found the method for solving cubic equations.[2] This important discovery happened, he says, in 1535 (or rather, "1534" in the poem, as Venice was on a different calendar). It led to a significant advancement in the algebra of higher-degree equations, and also to one of the earliest and best-known intellectual property cases in Western mathematics. Mentioned only briefly in the many studies that have debated the priority and propriety of Tartaglia's equation was his unusual move to embed his mathematical solution into a poem. Tartaglia's "Quando chel cubo," as we shall see, weaves three cases of cubic equations into a series of vernacular, hendecasyllable, *terza rima* verses. The study that follows focuses on what led him to compose a poem of this kind, and what his decision to do so might tell us about his relationship to both mathematics and the written word. Tartaglia's poetic solution, as we shall see, is a calculated act of revealing while concealing, and concealing while revealing, both mathematical and biographical knowledge.

Niccolò Fontana began his life in Brescia around 1499. His father – he thought but was never sure – was a mailman known as Michelotto Fontana. When Niccolò was six years old, Fontana died, leaving his family with few resources. When Niccolò was twelve, Brescia (then belonging to the Republic of Venice) was sacked by the French. At some point during the French army's violent invasion of the city, young Niccolò received five blows to the head and face – including one that cut his jaw and his palate, leaving his speech impaired.[3] Thereafter his voice sounded in a kind of *tartagliare*, a stuttering or muttering. He would later adopt the nickname "Tartaglia" as his surname, thus claiming as a triumph over death the episode that had left his speech impaired, and adopting a name that was not contingent on the identity of his biological father.

Tartaglia's education was less than stellar. He tells his readers in his *Quesiti et inventioni diverse* that he spent only a few weeks in school: his study of the alphabet terminated at the letter "k," because his family could not afford the school fees that would allow him to continue.[4] This quick litotes – or, rather, paraliptic statement – is the account of an author who simultaneously seeks to elicit sympathy for his lack of erudition, and to boast that he made great strides in learning on his own. The boast is underscored by Tartaglia's claim that he stopped at the letter "k" – a letter not in the Italian or the Latin alphabet. It could very well be true that he stopped his classwork at this letter, which young students learned so they could eventually read other foreign words (as would often be necessary in the Venetian Republic's mercantile culture). Or the choice of "k" might be a conceit of sorts, Tartaglia's hint to readers that although his education ended early on, he was actually more educated than people might think. Tartaglia, as we shall see, was unquestionably pained by his exclusion from elite circles, and often eager to demonstrate what he had accomplished on his own.

By 1529 Tartaglia was an abacus teacher in Verona, instructing merchants in basic mathematics. In 1534 he moved to Venice, where he taught mathematics at the school annexed to the Church of San Zanipolo (Giovanni and Paolo) – a position he would hold until his death in 1557. He may have married and had a family; some evidence suggests that he married a woman fourteen years his senior while in Verona and that together they had a daughter.[5] Tartaglia says nothing, however, of a wife or daughter in any of his works' biographical passages – although, admittedly, he also offered few words about his mother and siblings. The lack of mention of a wife or other family, along with Tartaglia's evident failure to form an extensive network of friends and connections, has led many scholars to believe he was a solitary, and even lonely, person. Whether he had much contact with the intellectuals of Venice between 1534 and 1557 (Pietro Aretino, Pietro

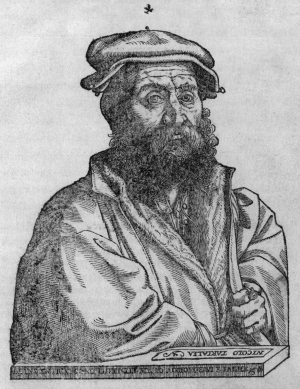

QVESITI,ET INVENTIONI DI-
VERSE DE NICOLO TARTALEA
BRISCIANO,

Con gratia, & priuilegio dal Illuſtriſſimo Senato Veneto, che niuno ardiſca
ne preſuma, di ſtampare la preſente opera, ne ſtampate altroue uendere ne
far uendere in Venetia, ne in alcuno altro luoco, o terra del Dominio Vene-
to, per anni diece ſotto pena de ducati trecento, & perdere le opere, el ter-
zo della qual pena immediate che ſia denontiata, ſi applica al Arſenale,
& un terzo ſia del magiſtrato, ouer rettore del luoco doue ſe farà la
aſſecutione, & laltro terzo ſarà del denuntiante, ouer accuſato-
re, & ſarà tenuto ſecreto, come nel priuilegio appare.

3.1 Title page. Niccolò Tartaglia, *Quesiti et inventioni diverse*
(Venice: Venturino Ruffinelli, 1546). IC5 T1788 546q.
Houghton Library, Harvard University.

Bembo, Bernardino Telesio, and many others were in Venice during this period) has not been investigated, but could offer further insight into his position on the *questione della lingua*, on memory, and on issues of personal and political power.

Perhaps in part because of his difficult and introverted personal life, Tartaglia published furiously. He wrote on mathematics, military science, tactics and fortification, and mechanics. His first published work was a well-received treatise on new ballistic techniques, the *Nova scientia* (1537). His next publication, *Quesiti et inventioni diverse* (1546), consists of mathematical problems posed and solved in dialogue form and, in a few cases, through letters (this is the text that includes his solution to the cubic equation). Tartaglia dedicated the *Quesiti* to King Henry VIII of England, likely on the recommendation of his student, the English nobleman Richard Wentworth. The text's interlocutors include the Duke of Urbino, Francesco Maria della Rovere; the mathematician Giambattista Memmo; Diego Hurtado de Mendoza, Emperor Charles V's ambassador to the Republic of Venice in the first half of the 1540s and possibly a Tartaglia patron; students, including Wentworth; and Girolamo Cardano. His introversion notwithstanding, Tartaglia revealed himself to be forceful interlocutor on the page.

Tartaglia's other major works include the *Travagliata inventione* (1551), which investigates methods for raising sunken ships, and the mammoth and unfinished *General trattato di numeri et misure* (1556), a compendium of current mathematical knowledge that ostensibly updates Pacioli's *Summa de arithmetica et geometrica, proportioni et proportionalita* (1494). In 1543, as well, Tartaglia published two translations: the first translation into Italian of Euclid's *Elements*, which he based on the Latin translations by Campanus, Adelard, Pacioli, and Zamberti; and a selection of works by Archimedes (*De centris gravium, libri duo*; *Tetragonibus ovvero De quadratura circuli*; and *De insidentibus aquae, liber unus* [On Floating Bodies]). In Part 4 of his *General trattato* Tartaglia also translated into Italian Archimedes' *On the Sphere and the Cylinder*.[6]

Tomaso Garzoni cites Tartaglia three times in his *Piazza universale di tutte le professioni del mondo* (1585): first, along with Pacioli, Fibonacci, and Francesco Maurolico in the category of "arithmeticians, computationalists, counters, or masters of abacus";[7] second, alongside Leon Battista Alberti, Federico Commandino, Guidobaldo, and other "masters of building, fortifiers of fortresses, and masters of machines, and mechanics in general, or rather, engineers";[8] and finally in a footnote discussing writers on "things relevant to the military."[9] At least in the mind of the learned Garzoni, Tartaglia's fame derives more from his contributions to engineering and applied mathematics than from his advancement of pure mathematics. Still, these citations show how prolific and present Tartaglia was in

the mathematical disciplines of the sixteenth century. It is not just the "cubic scandal," which we will review briefly below, for which Tartaglia was, and still is, known. In the pages that follow I hope to show the uniqueness of his poem in the history of mathematics.

The Cubic Scandal

For nearly fifteen centuries before Tartaglia, mathematicians had been seeking a general algebraic solution to cubic equations, that is, a polynomial equation in which the highest exponent is always three. Although Omar Khayyám had found a geometric solution in the twelfth century, an algebraic solution had continued to elude scholars. In Western mathematics, the first successful solution to cubic equations – albeit only equations lacking the quadratic term (i.e., ones of the form $ax^3 + bx + c = 0$, which are lacking in the 2 term) – was discovered by the Bolognese mathematician Scipione Dal Ferro sometime between 1500 and 1515.[10] Dal Ferro, however, revealed the solution only from his deathbed in 1526, to his son-in-law and successor as mathematics professor at the University of Bologna, Annibale della Nave, and to his student, Antonio Maria Fior.

In 1530, without revealing that he had a solution in hand, Fior challenged a mathematician from Brescia, Giovanni de Tonini da Coi, to a contest in which each would attempt to solve the cubic equations posed to him by the other. Da Coi failed to solve the equations, and subsequently passed on the challenge to his fellow Brescian, Tartaglia – who was known to have solved a certain different type of cubic equation. With Dal Ferro's solutions in hand, ready to win the contest and advance his career, Fior confidently challenged Tartaglia to a competition that would present its results in public on 22 February 1535. The contest involved thirty equations for each participant: thirty presented by Fior to Tartaglia (all cubic equations without the quadratic term), and thirty diverse algebraic and geometric problems from Tartaglia to Fior.[11] The competitors had eight days to complete their work. The day before the deadline, as Tartaglia tells us, he found a method for solving the cubic equations that Fior had posed and solved all thirty within two hours.[12] Fior, on the other hand, did not manage to solve the problems that Tartaglia had given him.

News of Tartaglia's triumph moved quickly through the mathematical community; great controversy surrounding his solution, however, would emerge only four years later. Renowned physician and mathematician Cardano, in the midst of publishing his *Practica arithmeticae* (1539), understandably wanted to include

the method for solving cubics in his next work, the *Ars magna* ("great art") of algebra. When published in 1545, the *Ars* would become the most complete and influential work on algebra to date and would remain so for many years to come. But Tartaglia refused to give his method to Cardano, fearing (rightly) that Cardano would then publish it before Tartaglia could do so himself. Finally, after many solicitations and promises from Cardano that he would keep the solution secret, Tartaglia began to relent. Perhaps because Cardano had offered to introduce Tartaglia to powerful Milanese patrons – such as his own patron Alfonso d'Avolos, the Marchese Del Vasto – or perhaps because of his pride in his accomplishment, he finally consented. In March 1539 Tartaglia went to Milan to meet Cardano and the Marchese; the latter was, unfortunately for Tartaglia, out of town at the time. Though he had missed a promised opportunity to meet a powerful patron, Tartaglia nevertheless revealed his prized secret – in poetic form – in a meeting at Cardano's house on 25 March 1539 (figures 3.2 and 3.3). Both Cardano and his seventeen-year-old student and assistant Lodovico Ferrari were present for the long-awaited unveiling.

The solution Tartaglia gave Cardano involved only cubic equations with no quadratic term. Tartaglia's method divides the equations into three types, in an attempt to keep the coefficients p and q positive, as mathematicians in this period were not comfortable working with negative numbers. To solve, for example, the first type of equations $x^3 + px = q$, one defines two quantities u and v, which satisfy $u - v = q$ and $uv = (p/3)^3$. Knowing the difference $u - v$ and the product uv, one can then determine u and v separately by solving a quadratic equation. Once u and v are determined, the solution to the cubic equation is $x = u^{1/3} - v^{1/3}$. Cardano and Ferrari tried, unsuccessfully, to develop from Tartaglia's method a general solution that would work for all forms of cubic equations. Even for cubic equations with no quadratic term, however, they encountered difficulties in cases where the associated quadratic equations had solutions involving square roots of negative numbers – numbers that Cardano called *radices sophisticae* and that today we call complex and imaginary numbers. Cardano considered such numbers "as subtle as they are useless";[13] it was only in 1572 that Raffaele Bombelli would treat seriously solutions to higher-degree equations (up to the quartic) using square roots of negative numbers. Though Bombelli discussed such equations in his *Algebra*, he found them conceptually disturbing, and he, too, failed to develop a general solution that would work for all forms of cubic equations.

Although Cardano had vowed that he would never share Tartaglia's solution, he did eventually publish it in Chapters 11–13 of the *Ars magna* (1545). He gave Tartaglia full credit for the discovery, and justified why he, Cardano, was publishing the solution – Tartaglia was taking too long to do so, and advancing

Quando chel cubo con le cose apresso
Se agualia à qualche numero discreto
Trouan dui altri differenti in esso
Dapoi terrai questo per consueto
Ch'el lor produtto sempre sia eguale
Al terzo cubo delle cose neto
El residuo poi suo generale
Delli lor lati cubi ben sottratti
Varra la tua cosa principale.
In el secondo de cotesti atti
Quando chel cubo restasse lui solo
Tu osseruarai quest'altri contratti·

Del numer farai due tal part'à uolo
Che l'una in l'altra si produca schietto
El terzo cubo delle cose in stolo
Delle qual poi, per commun precetto
Torrai li lati cubi insieme gionti
Et cotal summa sara il tuo concetto
El terzo poi de questi nostri conti
Se solue col secondo se ben guardi
Che per natura son quasi congionti
Questi trouai, & non con passi tardi
Nel mille cinquecent'e quatro è trenta
Con fondamenti ben sald'è gagliardi
Nella citta dal mar'intorno centa.

3.2 "Quando chel cubo." Niccolò Tartaglia, *Quesiti et inventioni diverse* (Venice: Venturino Ruffinelli, 1546), 123r–v (123v is mislabelled 124). IC5 T1788 546q. Houghton Library, Harvard University.

Quando chel cubo con le cose appresso
Se agguaglia a qualche numero discreto
Trouan dui altri differenti in esso
Dapoi terrai questo per consueto
Che'l lor produtto sempre sia eguale
Al terzo cubo delle cose neto,
El residuo poi suo generale
Delli lor lati cubi ben sottratti
Varra la tua cosa principale.
In el secondo de cotesti atti
Quando chel cubo restasse lui solo
Tu osseruarai quest'altri contratti,
Del numer farai due tal part'à uolo
Che l'una in l'altra si produca schietto
El terzo cubo delle cose in stolo
Delle qual poi, per commun precetto
Torrai li lati cubi insieme gionti
Et cotal summa sara il tuo concetto.
El terzo poi de questi nostri conti
Se solue col secondo se ben guardi
Che per natura son quasi congionti
10. Questi trouai, & non con passi tardi
Nel mille cinquecent'e, quatro e trenta
Con fondamenti ben sald'è gagliardi
Nella citta dal mar'intorno centa.

1. When the cube and things together
 are equal to some number,
2. find two other numbers differing in this one
3. that their product should always be equal
 exactly to the cube of a third of things. .
4. The whole remainder
 of their cube roots subtracted
 will be equal to your principal thing.
5. In the second of these acts,
 when the cube remains alone,
6. you will observe these other agreements:
 you will at once divide the number into two parts
7. so that the one times the other produces clearly
 the cube of the third thing exactly.
8. Then of these two parts, as a habitual rule,
 you will take the cube roots added together,
 and this sum will be your thought.
9. The third of these calculations of ours
 is solved with the second if you take good care,
 as in their nature they are almost matched.
10. With quick steps and light feet these solutions I found,
 in one thousand five hundred, thirty and four,
 my foundations quite sure and certainly sound
 in the watery city surrounded by shore.

1. $(x^3 + px = q)$
2. $(u - v = q)$
3. $(uv = (p/3)^3)$
4. $(x = \sqrt[3]{u} - \sqrt[3]{v})$
5. $(x^3 = px + q)$
6. $(u + v = q)$
7. $(uv = (p/3)^3)$
8. $(x = \sqrt[3]{u} + \sqrt[3]{v})$
9. $(x^3 + q = px)$

3.3 Tartaglia's poem "Quando chel cubo." Sections 1–9, translation by Veronica Gavagna, "*Radices Sophisticae, Racines Imaginaires*: The Origins of Complex Numbers in the Late Renaissance," in *The Art of Science: From Perspective Drawing to Quantum Randomness*, ed. Rosella Lupacchini and Annarita Angelini (New York: Springer, 2014), 165–90. Section 10 translation mine.

knowledge was of the utmost importance.[14] Cardano further assuaged his conscience by noting that Dal Ferro had solved the cubic equation sometime before his death in 1526 (Cardano went to Bologna to confirm this), and thus had achieved this feat before Tartaglia. Many contemporary (and near-contemporary) mathematicians – including Bernadino Baldi, Federico Commandino, Raffaele Bombelli, and Pedro Nuñez – heartily supported Cardano's decision. They argued that Tartaglia wronged the mathematical community by keeping his solution to himself for so long, and that Cardano, by keeping Tartaglia's secret, would have perpetuated this wrong. Tartaglia, needless to say, was enraged that Cardano had scooped him on publishing his cherished solution. A year later, when he published his *Quesiti*, he not only revealed the poem he had given Cardano but also recounted their dialogue during his visit to Cardano's home, as well as the letters they had exchanged both before and after he gave Cardano the poem-solution. By publishing these conversations and letters, Tartaglia hoped to show not only Cardano's betrayal but also Cardano's difficulty in understanding his solution: Cardano, he said, was "ignorante" [ignorant], "tondo" [thick], and "poverello" [lacking].[15] The first query Cardano posed to Tartaglia about the poem – the solution to $x^3 + 3x = 10$ (see Tartaglia's 9 April 1539 response to Cardano)[16] – may indeed reveal Cardano's misunderstanding of section 5 (see figure 3.3, second column), but his confusion might as easily derive from Tartaglia's unintentionally sloppy writing, or even from Tartaglia's intentional lack of clarity, as from Cardano's intellectual failure. Tartaglia replied that Cardano must have mistakenly thought the verse meant $p^3/3$ [the third of (the *cosa* cubed)] instead of $(p/3)^3$ [(the third of the *cosa*) cubed]. Cardano contacted Tartaglia again, pointing out a different problem in his solution to the cubic equation $x^3 = 9x + 10$ (see Cardano's letter received 4 August 1539 and Tartaglia's response):[17] here, solving the associated quadratic equations involves square roots of negative numbers. It is not clear from Tartaglia's response whether he considered the need for imaginary numbers a problem.

With the publication of Tartaglia's *Quesiti* began a protracted battle between Tartaglia and Ferrari, Cardano's faithful student who fought on his teacher's behalf. Ferrari challenged Tartaglia to a public debate – or, rather, a showdown. During the full year leading up to their public contest, the two exchanged a series of public letters (six each) now known as the *Cartelli di sfida*.[18] The letters of this remarkably vicious but fascinating correspondence were printed by both Tartaglia and Ferrari and sent to hundreds of mathematicians and scholars, such as Sperone Speroni and Enea Silvio Piccolomini. At the height of the controversy, Tartaglia was invited to apply for a position as lecturer of mathematics at the University in Brescia – but the job offer was conditional on his triumphing publicly over

Ferrari. Instead, when Tartaglia and Ferrari finally presented their work at the church of Santa Maria del Giardino in Milan, before a large audience of mathematicians and lay people, Ferrari won. Tartaglia himself (and some historians since) have insisted that Tartaglia was actually the victor,[19] but a surviving handwritten sonnet tucked into a collection of the Tartaglia-Ferrari *cartelli* suggests that Tartaglia failed to win over public opinion. The sonnet, composed by a Milanese priest at the time of the contest, condemns Tartaglia as "pazzo a tuffi" [totally mad] in his attacks on Cardano, and sings the praises of Ferrari for valiantly and justly defending Cardano's name.[20] Tartaglia also failed to win the job at Brescia.

After the contest, Tartaglia returned to Venice. In the final decade of his life he was poor, scorned, and bitter, but busy writing his *General trattato*. Death, unfortunately, came before he finished the last few books of this massive tome – the books that would have included his treatise on the cubic equation.

A Poetic Solution

Tartaglia's solution was an important step forward in early modern algebra, and the circumstances surrounding its publication raised questions about the relationship between the scholar's intellectual property and his proper responsibility to make advances public. The solution has, as I have noted, one other special distinction: it is embedded in a poem, and in such a way as to make it an exceptional occurrence in the history of mathematics. Although it is likely that Tartaglia did not intend to publish his solution in poetic form – that it served, as he claimed, primarily as a mnemonic device (see below) – he did publish the poem to show the world exactly what he had composed and had shared with Cardano.

Many ancient mathematical texts in both the West and East were written in verse, and mathematical riddles and recreational problems were (and are) often put into verse – some intentionally developed as mnemonic aids, others versified in the course of transmission through oral culture. Yet Tartaglia's poem is the only instance I have found in early modern Europe that was written to hold a solution to a long-standing problem found by the mathematician himself.

Tartaglia may have been inspired by a brief poem offering three famous solutions to the quadratic equation (figure 3.4) that Luca Pacioli – a highly influential source for Tartaglia – included in a margin of his 1494 *Summa*.[21] But Pacioli was versifying well-known solutions, while Tartaglia's cubic equation solutions are his own. It may be surprising, in fact, that cases of poetry in mathematics were so few

3.4 Three famous solutions to the quadratic equation, included in the margin
of Luca Pacioli, *Summa de arithmetica, geometria, proportioni and proportionalita*
(Venice: Paganino de Paganini, 1494), 8.5, fol. 145r. Courtesy of the Kress Collection
of Business and Economics, Baker Library, Harvard Business School.

in this period, given that mathematicians were still primarily using natural lan-
guage instead of symbols to communicate equations, analyses, and proofs (see
figure 3.5). But this rarity makes Tartaglia's solution especially significant, not
only to the history of mathematics but to the history of literature.

I have consulted hundreds of early printed mathematical texts (1450s–1650s)
from Europe contained in the Giardino di Archimede's *Matematica Antica* CD
ROMs, looking for another poetic solution like "Quando chel cubo." Since 2001,
under the direction of Enrico Giusti, this Florentine museum of mathematics
has been scanning exemplars of pure and applied mathematical texts published
in Europe from the beginning of print through the nineteenth century; the

dire altrimente, che R.q.18.m.4, & cosi R.q.18, di 6,
si dirà 6. m.R.q.18, & se dicesse 4. di R.q.8. si dirà R.
q.8. m.4. Et questo non è come il sommare, che si
mette la maggior quantità prima, mà bisogna metterè
per ultima la parte, che si caua.

Sottrare di Radici.

Il sottrare di Radici si può fare in quattro modi come
nel sommare, e hanno tutte quelle medesime proprie-
tà, però non mi estenderò in parole, mà uerrò à gli
essempij, e prima:

Cauasi R.q. 48 di R.q. 75 Se si hauerà à ca-
 R. q. 75 R.q .48 uare R.q.3, di R.
 ——— ——— q. 27. moltipli-
 123 R.q.3600 chisi l'una uia l'al
 126 lato 60 trasfa R.q.81, & di
 ——— 2 questo si troui il
Resta R.q. 3 120 lato, ch'è 9, quale
 si raddoppij per
Cauasi R.q. 24 di R.q. 96 regola: fà 18, e
 R.q. 96 R.q. 24 questo si caui del
 ——— ——— la somma del-
 R.q. 2304 120 li quadrati delle
 lato 48 96 due Radici, ch'è
 ——————— 30. cosi resta 12,
 96 Resta R.q.24 e di questo piglia
 tone il lato farà R.
q.12. e R.q.12, resta à cauare R.q.3. di R.q.27. Et è da
auertire, che quando l' 81. non hauesse hauuto lato, ta-
li Radici

Subtract √48 from √75
(the first problem on the page)

On the left, add
48 + 75 = 123

On the right, multiply
75 x 48 = 3600

On the right, find the square root of 3600
√3600 = 60 (*lato, as in a "side" of a square*)

On the right, doubling the principal square
root (the *lato*) 60
60 + 60 = 120

On the left, subtract the sum of 75 and
48 (123) from the doubled *lato* (120)
123 – 120 = 3

**The result of subtracting √48 from
√75 is √3**

3.5 Example of abbreviations and non-standardized symbolic convention.
Raffaele Bombelli, *Algebra* (Bologna: Giovanni Rossi, 1579 [1572]),
1:18. ETH-Bibliothek Zürich, Alte und Seltene Drucke. First printed 1572.

Giardino collection now extends to more than sixty CD ROMs containing over
1500 texts. My research confirms that if a poetical-mathematical equivalent to
"Quando chel cubo" ever existed, it has not, as of 2016, found its way into the
Matematica Antica collection. Many early modern scientific texts were written in
verse, but few early modern theoretical mathematicians adopted a verse format.
"Theoretical" or "pure" mathematics in the period consisted of arithmetic, geom-
etry, trigonometry, and algebra. It was distinct from the much larger category of
applied mathematics – called at that time "mixed" mathematics – which com-
prised the material and/or applied sciences of mechanics, architecture, optics,
perspective, geography, astronomy, and physics. Theoretical mathematics was

also distinct from practical disciplines such as accounting and engineering. Pietro Mengoli's *Via regia ad mathematicas* (1655) – written a century after Tartaglia's poem – is one of the few instances of an early modern mathematical treatise written entirely in verse (figure 3.6).[22]

Earlier works in poetic form – Paolo del Rosso's *La fisica* (1578) and Giordano Bruno's *De triplici, minimo et mensura* (1591)[23] – include some theoretical mathematics in their verses, but are not entirely dedicated to mathematics; they treat natural philosophy and metaphysics as well. Mathematical notions – especially of proportion – however, do appear frequently – often structurally and symbolically – in poetry from this period; conversely, there were mathematicians who were also poets (e.g., Francesco Maurolico, the Sicilian mathematician who wrote numerous sonnets). Furthermore, it was not unusual for a great poet, such as Torquato Tasso, to be so learned in mathematics as to be able to teach geometry, which Tasso did at the University of Ferrara from 1573 to 1579.

Poetry did make its way into mathematical treatises, too, but typically only in prefatory poems. These poems might be written by author or publisher, or a friend of the author or publisher, and were usually addressed to author, reader, or the work's dedicatee, functioning as epigrams or testimonies. They were as common in mathematical treatises as they were in other scientific, philosophical, and literary works of the time. Prefatory poems – usually sonnets or *canzoni* – would typically be inserted in the front matter near the title page, or dedicatory epistle, though poems of similar function were also occasionally placed at end of a work.[24] Prefatory poems gradually disappeared from mathematical treatises after the middle of the seventeenth century. Renaissance mathematical treatises, however, occasionally featured playful word problems set to verse, or verses cited from earlier works of natural philosophy or from famed literary works: in both cases, poetry citations were employed to add authority and support for the argument at hand. Tartaglia, for example, borrowed a verse-form word problem by Vincenti di Gaffari for Book 9.xxii of his *Quesiti*,[25] and Perugino Leandro Bovarini cited fragments from Dante, Petrarch, and Bembo in his 1603 *Del moto*, in a strong example of the *florilegia* tradition (figure 3.7).[26]

Tartaglia's poetic solution stands apart from these more familiar uses of poetry in early modern mathematical treatises: it is neither a dedication nor an authentication, neither prefatory nor marginal. The poem is the solution itself. Tartaglia's ostensible explanation as to why he put his solution into a poem is the following:

[P]er potermi ricordare in ogni mia improvisa occorrentia tal modo operativo, io l'ho redutto in un capitolo in rima, perche se io non havesse usato questa cautela

36 PLANIMETRIA.

De dimenſione triangulorum, & paral-
lelogrammorum.

Sīue trigona quadratellum quæratur ad vnum;
Siue parallelogramma figura, quota eſt.
Qui baſis eſt numerus, numerum ducatur in altum.
Semis habet factum, triga; quadriga, ſemel.

De ratione triangulorum inter ſe, vel paralle-
logrammorum inter ſe.

Sīc, vt longa baſes, vt & alta triangula dantur
Eſſe; parallelogrammaue: iuſta probo.
Hic tamen inter ſe volo bina triangula; & illic
Bina parallelogramma, relata volo.
Alta ſient ambo pariter: variantur & ambo,
Pro baſibus varijs, in ratione pari.
Sint pariter baſibus longa: vt variantur in altum;
Sic variant ambo, pro ratione pari.
Alta ſient, baſibus quoque longa æqualiter ambo:
Et fatum eſt, numeros eſſe in vtroque pares.
Quatuor vtrimque ex numeris, proportio (binis,
Hinc ad diſiuncta; hinc ad loca iuncta, ſitis)
Ponatur; minimis numerentur, & ambo quadratis:
Et fatum eſt, numeros eſſe in vtroque pares.

De triangulis ſimilibus.

Ecce duo hic, illic, propono triangula; quorum
Sex, bini æquales, anguli vtrimque iacent.

Quo

PLANIMETRIA. 37

Quo deinceps hinc, inde iacent tres anguli; eodem
Hinc, inde oppoſitas, ordine, pono baſes.
Ordine nam parili, quæ ſunt hinc, inde repoſtæ,
Binæ conueniunt, in ratione pari.
Quæ ratio, amborum priùs hanc, mox comparat illam
Areolas inter ſe, duplicata, duas.
Conſimiles igitur formas propono: baſeſque
Conſimiles, parili ſub ratione, probo.
Non ſecus, & ſimiles vtrimque probare figuras,
Conſimili baſium de ratione, licet.

De triangulo rectangulo.

Ecce trigonon, vbi vertex rectangulus: vnde
Linea in oppoſitam decidat alta baſim.
Sic data diſſecta in formas eſt forma trigonas,
Conſimiles toti, conſimileſque ſibi.
Secta ſimul baſis eſt in, quas proportio confert
Extremas, alta continuante, duas.
Partem iterum, & totam confert proportio; crure
Vicino extremas continuante duas.
Inde fit, in numeris crurumque, baſiſque quadratis,
Singula quos poſſunt, cruribus æqua baſis.

De circulo.

Circulus eſt planum; quâ, cætera mobilis, vnum
Fixa caput, fertur linea recta, viâ.
Interea caput in recta verſatile, curuam
Scribit: quæ ſimplex eſt, ſimiliſque ſibi.
Curua, peripheriæ; punctum non mobile, centri;
Hæc inter, radij nomine, recta venit.

De

3.6 Pietro Mengoli, *Via regia ad mathematicas* (Bologna: Vittorio Benacci, 1655), 36–7.
© The British Library Board (1042.k.4.(4.)).

spesso me saria uscito di mente, & quantunque tal mio dire in rima sta molto terso non mi ho curato, perche mi basta che mi serva à ridurme in memoria tal regola ogni volta, che io il dica, il qual capitolo ve lo voglio scrivere de mia mano, accio che siati sicuro, che vi dia tal inventione giusta & buona.[27]

[T]o be able to recall this operation at a moment's need I reduced the solution into a rhyme, because if I had not taken this precaution the equation would have often escaped me. And however terse and unrefined my verses are, I do not care, because their only purpose is to aid my memory in recalling the rule each time I say it; and so it is this solution that I want to write down for you with my own hand, so you are certain that I am giving it to you exactly.

> # MOTO. 27
> *chi, & alla morte conduca . Et dice dolce ingan-*
> *no; non perche la dolcezza sia propria dell'in-*
> *ganno; ma per questa parola Dolce, vuol dir gra-*
> *to, & piaceuole. Come il Petrarca disse*
> Dolci ire, dolci sdegni, & dolci paci.
> *& Dante*
> Dolce color d'oriental Zaffiro.
> *come anche il Cardinal Bembo*
> Dolce mal, dolce guerra, dolce inganno,
> *pigliando la metafora dalle cose più vicine al*
> *senso, che tanto loda Aristotele. Dice adunque*
> Questo, che'l tedio, onde la vita è piena
> Temprando và con dolce inganno, ed arte
> *cio è questo horologio, che mediante il suo mo-*
> *uimento misura il tempo, & con artifitioso, &*
> *piaceuole inganno rende men dispiaceuole, me-*
> *no acerbo, & men graue il tedio della vita hu-*
> *mana; la quale in vero per esser piena d'affanni*
> *non può dubbitarsi, che ciascuno per vn certo*
> *naturale istinto non debbia procurare d'allege-*
> *rirgli tal volta con qualche piacere. onde disse*
> *il Petrarca, se mal non mi ricordo*
> Con diletto l'affanno disacerbo.
> *& altroue, parlãdo della vista angelica di Laura,*
> Ch'altro rimedio non hauea il mio core
> Contra

3.7 Literary *florilegia*; note the citations from Petrarch, Dante, and Bembo. Leandro Bovarini, *Del moto* (Perugia: Vincenzo Colombara, 1603), 27. IC6 B6692 B603p. Houghton Library, Harvard University.

Tartaglia claims he composed his *capitolo* as a poem (here he calls his whole poem – in all its cases and solutions – a *capitolo*, though elsewhere he terms each case of the solution a *capitolo*) to aid his own memory and to maintain the solution in its most pristine form. Pacioli, too, claims that putting something into verse can help you recall it in his book of mathematical problems and games, *De viribus quantitatis*: "a più tua memoria asettarla in versi" [it will stay in your mind better if in verse].[28] Yet for Tartaglia, this seems far too facile a reason. It seems quite possible that he also used his poem to prolong Cardano's struggle to

understand the method. Tartaglia had delivered the solution, yes, but Cardano would still need to decipher the verses, which could potentially reduce the likelihood that Cardano could publish it before Tartaglia did himself. When Tartaglia discussed his own reading of the word-problem poem by Gaffari cited above, he suggested that Gaffari had chosen its format with the specific intention of rendering the reader (in this case Tartaglia) "totally confused."[29] Tartaglia's poem, which was far from straightforward, may well have functioned as a kind of puzzle for Cardano to solve. Was Tartaglia frustrated, as he claimed in the months following the delivery of his poem-solution to Cardano, because the latter was a poorer mathematician than he had assumed – or was he frustrated because Cardano was a better reader of poetry than Tartaglia had anticipated, because he had actually reached an understanding of the solution too quickly?

While Tartaglia's poem-solution gave Cardano the answer to cubic equations, it did so only in part. Tartaglia did not, as Cardano and Ferrari were quick to point out, include a demonstration.[30] Historians of mathematics such as Paolo Freguglia and Kellie Gutman have, however, argued that Tartaglia *did* give the equation's demonstration; Satyanad Kichenassamy, moreover, notes Tartaglia's comments in the *Quesiti* on the use of a geometrical theory of proportions to solve cubics, following the "keys" Pacioli mentions in his 1494 *Summa*.[31] Reading the "Quando chel cubo" while imaging the solution in geometric terms (as the quadratic equation was solved), the demonstration is evident. And, Kichenassamy argues, this is precisely how Tartaglia read and imagined his work.

Now let us turn to the poem itself. There are only a few translations of Tartaglia's poem into English (with algebraic notation) – Kellie Gutman's *terza rima* and iambic pentameter version from 2005, Friedrich Katscher's from 2011, and Kichenassamy's from 2015 are especially worth noting.[32] Figure 3.3 above offers an excellent recent translation by historian of mathematics Veronica Gavagna. In mid-sixteenth-century Italy, mathematicians were not yet using symbols in their algebra, and an unknown was often called a *cosa* ("thing"); the "thing squared" was called a *censo* ("census"); and the known quantity was called the *numero* ("number").

> Quando chel cubo con le cose appresso
> Se agguaglia à qualche numero discreto
> Trouan dui altri differenti in esso.
> Dapoi terrai questo per consueto
> Che'l lor produtto sempre sia eguale
> Al terzo cubo delle cose neto,

El residuo poi suo generale
　　Delli lor lati cubi ben sottratti
　　Varra la tua cosa principale.
In el secondo de cotesti atti
　　Quando chel cubo restasse lui solo
　　Tu osseruarai quest'altri contratti,
Del numer farai due tal part'à uolo
　　Che l'una in l'altra si produca schietto
　　El terzo cubo delle cose in stolo
Delle qual poi, per commun precetto
　　Torrai li lati cubi insieme gionti
　　Et cotal summa sara il tuo concetto.
El terzo poi de questi nostri conti
　　Se solue col secondo se ben guardi
　　Che per natura son quasi congionti.
Questi trouai, & non con passi tardi
　　Nel mille cinquecent'e, quatro e trenta
　　Con fondamenti ben sald'è gagliardi
Nella citta dal mar' intorno centa.[33]

The poem is presented in Book 9.xxxiv, 123r–v (mislabelled as 124r in the 1546 edition) of Tartaglia's *Quesiti* and consists of twenty-five verses in hendecasyllabic *terza rima*. Not coincidentally, this poem about the cubic is full of threes: lines grouped into tercets, plus a triple rhyme scheme. As Pacioli had presented his quadratic "canons" in unrhymed quatrains (see figure 3.4), Tartaglia made sure *his* metric reflected threes. The *terza rima* rhyme scheme, invented by Dante, forms a braiding pattern that is famously difficult for a later writer to manipulate by inserting or subtracting a verse. The choice of this Dantean form may have given Tartaglia a further sense of security that Cardano – or other future readers-mathematicians – would not be able to alter it. Though Tartaglia chose *terza rima* at a time when Dante's vernacular was under intense criticism, the form was still used by renowned contemporary poets including Ludovico Ariosto (*Le satire*) and Francesco Berni, both in satiric contexts, and the latter in a verse form often called *capitoli*. Tartaglia may also have selected the *terza rima* for his *capitolo/i* to voice his support for the *Commedia*'s vernacular, and the vernacular's value in general. Or perhaps he wished to frame his discovery in a memorable form, like Dante's, choosing *terza rima* not only for himself, but also for posterity. Or perhaps choosing this poetic form was an attempt to show the erudition he had obtained on his own.

Tartaglia's only other known poems are the sonnet following the title page of *La travagliata inventione*, "Da nostri antiqui savi" (figure 3.8), and the sonnet "Alli lettori" that opens his *Quesiti* (figure 3.9). "Alli lettori" is dedicated to those wishing to learn about new inventions and "speculations" in the art of war and in the "arte maggiore," that is, in mathematics. Tartaglia may have intended his "inventioni nell'arte maggiore" as one-upping Cardano's *Ars magna*, the "Great Art": *his* art was "greater" or even "the greatest." That this poem is not in *terza rima* further reinforces the argument that Tartaglia intentionally chose the *terza rima* for his "cubic" poem.

Like Pacioli, Tartaglia wrote nearly all his works in Italian (his 1543 *Opera Archimedis Syracusani* was an exception) instead of Latin, still the language of choice for scholarly works in his time. He claimed he did not know Latin well (although he did, as mentioned earlier, also translate Euclid's *Elements* into Italian from various Latin editions). He also claimed that his Italian was not highly refined, a view echoed by many of his contemporaries (and later historians), who have variously described his Italian as "disadorna" [unadorned],[34] "rozza" [coarse],[35] "rozza e dialettale" [coarse and full of dialect],[36] and "strano e primitivo" [strange and primitive],[37] and his literary style as "intralciato" [hampering],[38] "ributtante" [disgusting],[39] "burbera" [unfriendly],[40] and "barbaro" [barbarian].[41] Ferrari described Tartaglia's writing (and, of course, his ideas about Cardano) as "tartagliata" [babbling],[42] not to mention full of errors and "finzione" [fiction].[43] Bernardino Baldi, in his *Cronica de' matematici*, wrote that there was "così poco alla bontà della lingua che move a riso talhora chi legge le cose sue" [so little good to [Tartaglia's] language that one is moved to laugh when reading his works].[44] Baldi also criticized Pacioli's Italian in similar terms, but modern readers, most notably Mario Piotti, have recognized Tartaglia's mathematical language as more precise than that of Pacioli and other mathematical contemporaries.[45]

In his own writing, Tartaglia stressed that accessibility was his primary goal. His dedicatory letter to Henry VIII in the *Quesiti* admits that his literary style is "rozzo" [coarse] and "basso" [low]; he claims to be more concerned that his inventions be understood and employed than that their descriptions be eloquently expressed. Piotti aligns Tartaglia with contemporaries including Piccolomini, Citolini, and Speroni who championed writing scientific treatises in the vernacular – not just those works intended for a merchant audience or for other technical application, but theoretical writings, too.[46] Tartaglia, Piotti argues, wanted his work to be understood by the masses, and did not wish to participate in "holding back" mathematical progress, as he believed works written in Latin did.[47] This might seem an ironic position to be held by a mathematician who was slow to publish and reluctant to share his findings. But timing, as ever, was important in Tartaglia's

<div style="text-align:center">

Da nostri antiqui saui, le inuentioni
S'afferma esser di gran difficultade,
Ma publicata la sua qualitade
Vi segli aggiunge da tutti i cantoni,
Et quando, che per molte, & uarie attioni
Con il uolgo sian ben dimesticade,
Per cose certo di facilitade
Tenute son da tutte le nationi.
Questo non uogllo gia star a prouare,
Perche la sperientia nel dimostra
Nelle cose ab antico ritrouate.
Pero non si de alcun marauigliare.
Sel medesimo occor nell·eta nostra
Sopra quelle di nouo inuistigate,
Et se anchor biasmate,
Saran d'alcun (come che spesso nasce,)
Che nell'mal dire se nutrisse pasce

</div>

Inventions, according to our great sages,
 are quite difficult [to grasp at first];
But once their workings are made public,
 Anyone can build upon them,
And, after many have engaged these inventions,
 They come to be known by all nations
 as things of ease.
I am not going to waste time proving this,
As our experience of ancient inventions
 has demonstrated this to be so;
But one should not marvel
 If the same happens in our time
Regarding things of new invention.
 And if there are still critics,
 They are those who (as often happens)
Live to bad-mouth others.

3.8 "Da nostri antiqui savi." Niccolò Tartaglia, *Regola generale … La travagliata inventione* (Venice: Nicolo de Bascarini, [1551]), iv. IC5 T1788 B555n. Houghton Library, Harvard University. Translation by Arielle Saiber, Veronica Gavagna, and Pier Daniele Napolitani.

To My Readers

<div style="text-align:center">

ALLI LETTORI.

Chi Brama di ueder noue inuentioni,
Non tolte da Platon, ne da Plotino,
Ne d'alcun altro Greco, ouer Latino,
Ma sol da Larte, misura, e Ragioni.
Lega di questo le interrogationi,
Fatte da Pietro, Pol, Zuann', e Martino
(Si come, l'occorea sera, e Matino)
Et simelmente, le responsioni.
Qui dentr'intendara, se non m'inganno
De molti effetti assai speculatiui,
La causa propinqua del suo danno,
Anchor de molti atti operatiui,
Se uedera essequir con puoc'affanno
Nell'arte della guerra Profittiui.
Et molto defensiui.
Con altre cose di magno ualore,
Et inuentioni nell'arte maggiore.

</div>

He who desires new inventions –
 Not those pulled from Plato and Plotinus,
 Nor from other Greeks or Latins,
 But only from Art, Measure, and Reason –
Read these questions,
 Posed by Peter, Paul, John, and Martin
 (by nearly everyone, day and night)
As well as the answers.
Here in this book one will learn, if I am not mistaken,
 The most immediate cause of a given problem
And its theoretical consequences.
One will also come to see resolved,
 with little effort, many operations
That will be of benefit in the art of war
 And in defense,
Along with other things of great value,
 And inventions in the greatest art.

3.9 "Alli lettori." Niccolò Tartaglia, *Quesiti et inventioni diverse* (Venice: Venturino Ruffinelli, 1546), following title page. IC5 T1788 B555n. Houghton Library, Harvard University. Translation by Arielle Saiber, Veronica Gavagna, and Pier Daniele Napolitani.

mathematical community: winning a contest or a coveted university position might easily turn on the opportune reveal of a closely held mathematical innovation.

Tartaglia, it appears, gave serious consideration to language: he chose the vernacular for the sake of advancing knowledge, and boasted that the literary style his critics derided as coarse simply favoured clarity over elegance. And he wrote in his *General trattato* about the importance of grammar, linked with and fundamental to the other liberal arts:

> ... le sette arti liberali sono tanto insieme colligate, & miste, ch'eglie impossibile a poterne insegnar una senza interponervi alcuno di termini, over particolar soggetti di quelle, che dapoi quella seguitano. Et che sia il vero, si vede chiaramente nella grammatica, la quale è la prima delle sette arti liberali ...[48]

> ... the seven liberal arts are so linked and mixed that it is impossible to teach them without interspersing some of the terminology or particular concepts of the others that follow. And be it true, as one sees clearly in Grammar, which is the first of the seven liberal arts ...

Grammar, for Tartaglia, was significant to all the other liberal arts because it was central to communicating ideas; like other intellectuals of the time, he considered it the "prima" art – first in the order of learning, albeit not in the hierarchy of importance. Geometry and arithmetic were highest in Tartaglia's scale of value: in his translation of Euclid's *Elements*, he extols in Lesson 2 mathematics' superiority to the other arts and calls it "the true food of our intellectual life."[49] In Lesson 2 he discusses what subjects such important thinkers as Boethius, Giorgio Valla, and Pacioli considered to be "mathematical disciplines," and what subjects they thought should be part of the *quadrivium*. Tartaglia recognized that there were many mixed mathematical arts, and he was not particularly concerned about which of these might be deemed worthy of inclusion in the *quadrivium*. What did matter to him was that geometry and arithmetic – like grammar for rhetoric and logic – be set apart as fundamental disciplines to be learned prior to other mathematical arts, as well as philosophy: these two arts do not require outside knowledge to understand them, but all other arts and sciences, he argued, need pure mathematics. Tartaglia endowed arithmetic and geometry with primacy in both senses of the world.

Tartaglia's argument for the primacy of these two mathematical branches is beautifully expressed in the title page to his 1537 *Nova scientia* (reproduced more legibly in the 1550 Nicolini da Sabbio edition, figures 3.10 and 3.11) – a work on new techniques in artillery, which the author dedicated to Francesco Maria

della Rovere. The woodcut image shows a proud Tartaglia (here spelled Nicolo Tartalea) standing among the quadrivial arts (Geometry, Arithmetic, Music, and Astronomy, as well as Perspective) and in front of a crowd of divinatory and other mathematically related arts: Hydromantia, Necromantia, Geomantia, Cosmografia, Astrologia, Sortilegio [divination], Horoseitio [clock making?], Presti[di] g[itat]io [magic/conjuring], and Architectura.[50] The image's composition stresses the superiority of pure mathematics (Tartaglia's art) to these pseudo-arts or applied arts in the background. Moreover, placing a large crowd of divinatory arts behind the author seems to indicate the visionary nature of his own art. Most prominent – standing before all the other arts and pseudo-arts – are Geometry and Arithmetic. These figures even slightly upstage the author, standing at his left and right hand and slightly in front of him, although he is equal to them in height. At the top of the woodcut (figure 3.10), woven between the Della Rovere and Gonzaga family coats of arms, Tartaglia placed this motto: "aurum probatur igni et ingenium mathematicis" [the goodness of gold is proved by fire, the goodness of the intelligence by mathematics], echoing once again Pacioli, who stated in *De divina proporitone*: "gold is proved through fire, and the mind through mathematics."[51]

The rest of the woodcut offers further hints at Tartaglia's position on mathematics' power. Consider, for example, the small, enclosed circular space at the top of the image, where Lady Philosophy reigns, accompanied only by Plato and Aristotle. Plato, holding a banner that reads "Nemo huc geometri[a]e expers ingrediatur" [Let no one enter who does not know Geometry] (figure 3.12) – the famous saying supposedly placed at the entrance to Plato's Academy – stands above Aristotle, who opens the door to the large group of sciences, divinatory arts, and Tartaglia. Plato's closer proximity to Lady Philosophy might be simply a matter of chronology: Plato came first. Or it may imply that Tartaglia was more inclined towards Platonic philosophy, as Anna De Pace and Annarita Angelini have argued.[52] Tartaglia viewed mathematics and mathematical reasoning not only as the foundations of the other arts, these scholars suggest, but indeed as the primary models, the "ideals," that were separate from (and superior to) the world of matter. In order to understand these models, however, one must begin with understanding the material world.

In the large centre space of the title page, a cannon has recently fired a ball – a large, arched trajectory is traced – and a second cannon fires another ball to the right – this time with a flatter trajectory. Under the arch formed by the path of the first cannon shot stand two men, perhaps newly admitted to the journey towards knowledge, who look over towards Tartaglia and the arts, and upwards

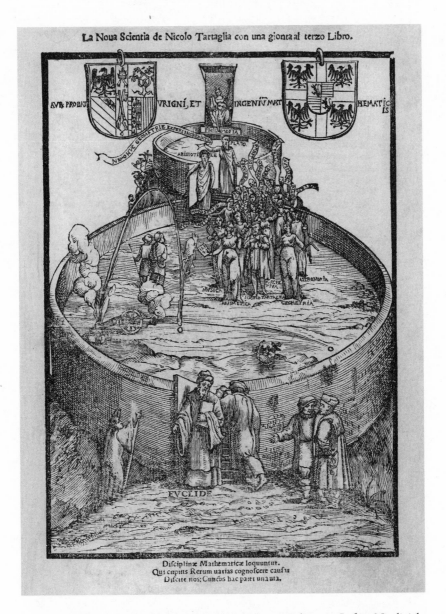

3.10 Tartaglia's *Nova scientia* was originally published in 1537 (Venice: Stefano Nicolini da Sabbio); however, this title page is from the 1550 Nicolo de Bascarini edition, which more clearly reproduced the woodcut. Niccolò Tartaglia, *Nova scientia* (Venice: Nicolo de Bascarini, 1550). IC5 T1788 B555n. Houghton Library, Harvard University.

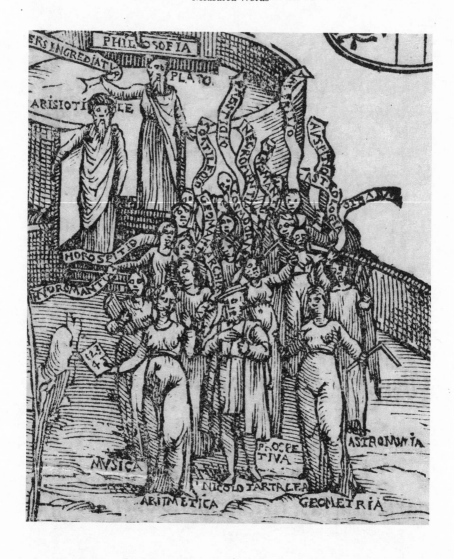

3.11 Title page (detail). Niccolò Tartaglia, *Nova scientia* (Venice: Nicolo de Bascarini, 1550). IC5 T1788 B555n. Houghton Library, Harvard University.

3.12 Title page (detail). Niccolò Tartaglia, *Nova scientia* (Venice: Nicolo de Bascarini, 1550). IC5 T1788 B555n. Houghton Library, Harvard University.

towards the inner sanctum of Philosophy. Surrounding Philosophy's inner circle, and the larger sphere in which Tartaglia directly confronts the weapon systems that are the work's ostensible focus, is an outer wall, its door opening onto what appears to be the everyday world. Euclid guards this outer door, welcoming in a new arrival, as two other men stand outside talking; from Tartaglia's writing, we can assume that one of these men is explaining to the other that he must first know Euclid if he would like to understand the "new science" (figure 3.13). Would-be thieves of knowledge attempt to scale surreptitiously both outer and inner walls (figure 3.14) – attempts that are bound to fail.

At the bottom of the woodcut (figure 3.15) Tartaglia quotes verses of a poem Pacioli had included after the title page of his 1509 *Divina proportione* (figure 3.16) – part of which is drawn from no less than Virgil's *Georgics*.[53] Again, Tartaglia shows his affinity for Pacioli's versification.

Tartaglia's verses read "Disciplinae mathematicae loquuntur. / Qui cupitis Rerum varias cognoscere causas / Dicsite nos: Cunctis hac patet una via" [The mathematical disciplines speak. You who desire to know the various causes of things, study us: by such means one path lies open to all]. There are no short cuts

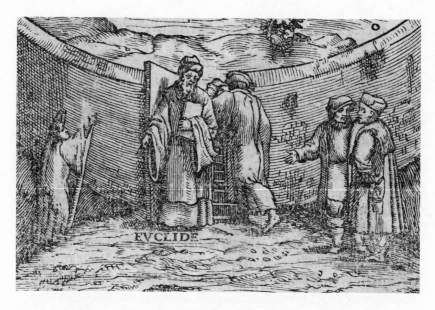

3.13 Note the person on the left attempting to enter the realm of science by sneaking past Euclid (geometry). Title page (detail). Niccolò Tartaglia, *Nova scientia* (Venice: Nicolo de Bascarini, 1550). IC5 T1788 B555n. Houghton Library, Harvard University.

3.14 Another climber (or two) attempting to enter the sanctum of the sciences and Philosophy without knowledge of geometry. Title page (detail). Niccolò Tartaglia, *Nova scientia* (Venice: Nicolo de Bascarini, 1550). IC5 T1788 B555n. Houghton Library, Harvard University.

Difciplinæ Mathematicæ loquuntur.
Qui cupitis Rerum uarias cognofcere caufas
Difcite nos; Cunctis hac patet una uia.

3.15 An epigraph at the bottom of the title page. Niccolò Tartaglia, *Nova scientia* (Venice: Nicolo de Bascarini, 1550). IC5 T1788 B555n. Houghton Library, Harvard University.

Corpora ad lectorem.

El dolce fructo vago e fi diletto.
Cóstrinfegia i Philofophi cercare.
Caufa de noi che pafci lintelletto.

Difticon ad idem

Quæref de nobis fructus dulciffius egit
Philofophos câm mēs vbi læta māet.

Corpora loquuntur

Qui cupitis Reɜ varias cognofcere cās
Difcite nos; Cūctis hac patet vna via
FINIS

The geometric bodies to the reader

The sweet fruit, beautiful and cherished,
Has long compelled Philosophers to seek
What causes their intellect to feed off of us.

Distich in response to them

The sweetest fruit compels philosophers to seek the
cause from us, where a happy mind endures.

The geometric bodies speak

You, who wish to understand the varied causes of things,
learn us: this one road lies open to all.
END.

Figure 3.16 Luca Pacioli, *De divina proportione* (Venice: A. Paganini, 1509), [n.p.]. Typ 525.09.669a. Houghton Library, Harvard University. Translation mine.

to learning the causes of things – only through geometry can you reach supreme knowledge and wisdom.

Euclid's prominent position in the title page seems to be clear evidence that Tartaglia chose geometry over arithmetic in the ongoing debate over which branch better explained the natural and supernatural worlds. Yet in the same image he placed Lady Geometry and Lady Arithmetic on equal footing beside him, and Arithmetic – not Geometry – is to his right, in the traditional position

of superiority. He may have intended to balance their importance in the composition as a whole, conveying a reluctance to prioritize one over the other even as he insisted on their shared priority over the other arts. Furthermore, while this title page at the incipit of his first published work included only the mathematical and divinatory arts, one of his last published works – his Euclid translation – cites the importance of mathematics to non-mathematical disciplines including jurisprudence and theology.[54] His *General trattato*, written two decades after the *Nova scientia*, also raised grammar and the other arts of the trivium to equal importance with the *quadrivium*. Had Tartaglia revised this title page for a new edition before he died, I believe he would have added in three more banner wavers beside him. Indeed, his choice of a poem-solution for the cubic equation might even suggest that to reach understanding, the knowledge seeker must enter not only through the doors of Arithmetic and Geometry, but through those of Grammar, Logic, and Rhetoric, too.

Tartaglia embedded the long-sought solution to a mathematical equation within a poem because, he says, the poem helped his memory and kept the equation in its correct form even as he passed it on to Cardano. Yet the poem-solution seems also to indicate a desire for secrecy and a wish for recognition by posterity. It reveals Tartaglia's thinking about the interrelation between the theoretical and applied arts. It demonstrates his interest in, or rather, anxiety regarding, language. And it illustrates his firm belief in the importance of the vernacular to literature and the mathematical arts.

Solving the cubic equation was so precious an accomplishment for Tartaglia that it triggered a conflict between his professional desire to reveal and his impulse to conceal. Poetry nicely served these conflicting impulses. Writing down the solution in the first place – both as a memory aid and to give to Cardano – was born out of Tartaglia's impulse to reveal. Poetry's ability to harbour multiple interpretations served his wish to conceal. Since so few works of pure mathematics were written in poetry or used poetry, Tartaglia's use of poetry to "speak" mathematics is a peculiar manoeuvre that demands the attention of historians and literary scholars alike: Tartaglia's use of poetry to encode or encrypt mathematics might be understood as an almost perfect inverse of Alberti's use of mathematics as a key for encoding, and decoding, language. When Ferrari claimed that Tartaglia's accusations of Cardano were like Lucian's "fantastic" tales, he condemned Tartaglia for delusional thinking: for rewriting history in such a way as to hide the truth.[55]

Tartaglia's solution to the cubic equation, which he believed Cardano had stolen and other mathematicians had failed to appreciate, became like a mythic creature

3.17 The text shown here, which is a detail appearing beneath the bust of Tartaglia on the *Quesiti* title page, also appears on the title pages of volumes 1 and 2 (but not 3) of his *General trattato* (Venice: Curzio Troiani dei Navò, 1556). Niccolò Tartaglia, *Quesiti et inventioni diverse* (Venice: Venturino Ruffinelli, 1546). IC5 T1788 B555n. Houghton Library, Harvard University.

> *La fede unqua non debbe esser corrotta*
> *O data à un solo, ò data insieme à mille*
> *E così in una selua, in una grotta*
> *Lontan dalle Cittadi, e da le uille:*
> *Come dinanzi à tribunal in frotta*
> *Di testimoni, di scritti, e di postille*
> *Senza giurare, ò segno altro piu espresso*
> *Basti una uolta, che s'habbia promesso.*
>
> *Et con questa uoglio che per hora facciamo fine al nostro ragionamento, uero è che ui ho molte altre particolarità de adimandarui, le quali per non fastidiarui le riserba ro à un'altro giorno.*

FINE DELLI RAGIONAMENTI
de Nicolo Tartaglia.

A pledge, whether sworn only to one or
to a thousand, ought never to be broken.
And in a wood or cave, far from towns
and habitations, just as in the courts amid
a throng of witnesses, amid documents
and codicils, a promise should be enough
on its own, without an oath or more
specific taken.

(Translation by Guido Waldman,
Ludovico Ariosto's Orlando Furioso,
Oxford University Press, 2008:
246-7).

3.18 Canto 21.2 from Ludovico Ariosto's *Orlando furioso* (1516, 1532). Niccolò Tartaglia, *Ragionamento sopra la travagliata inventione: Terzo ragionamento* (Venice: Nicolo de Basciarini, 1551), fol. 21v. IC5 T1788 B555n. Houghton Library, Harvard University.

for him: larger than life, a "new science," "the greatest art." His motto – quoted at the base of his title page portraits on the of *General Trattato* and *Quesiti* (figure 3.17), albeit challenging to read, given the print quality – is recalled in Book 9.xxvi of his *Quesiti* when he tells the story of his great discovery and his later betrayal by Cardano: "Le inventioni sono difficili ma lo aggiongergli / aggiongervi è facile" [Inventions are hard to come by, but easy to add to].[56] He is highlighting the efforts he made in coming up with a solution to the cubic equation, and the relative ease mathematicians like Cardano and Ferrari had when building upon what he laboured to discover.

In another moment he stings Cardano yet again, closing the third book of his 1551 *Ragionamenti de Nicolo Tartaglia sopra la sua travagliata inventione* with a stanza from Ariosto's *Orlando furioso* (figure 3.18) that "A promise should be enough on its own, without an oath or more specific taken." Clearly, Tartaglia had never fully recovered from this blow.

Tartaglia is not someone who danced through his days with "quick steps and light feet." Yet he showed himself to be a computer of the highest order who valued the power of writing to divulge and enlighten, who noted how carefully selected and metred language could be used to puzzle and confound, and who never forgave someone who had once given him his word and who had taken it back.

Hidden Curves:
Giambattista Della Porta's
Elementorum curvilineorum libri tres
(1601/10)

Pure mathematics is the magician's true realm.

– Novalis[1]

Physician, playwright, philosopher, magus: Giambattista Della Porta (1535–1615) wrote wildly successful books and actively pursued new knowledge, new inventions, and scientific progress. He travelled through Italy, France, and Spain and dedicated works to patrons as diverse as Philip II, Rudolph II, Cardinal Luigi d'Este, and Federico Cesi.[2] He claimed to have been the inventor of the telescope (although he never built one)[3] and the *camera obscura* (although he never built one of those either), and was among the earliest researchers in criminal physiognomy studies. He compiled and concocted countless recipes to heal, beautify, and alter one's constitution; he cast astrological charts; he championed techniques to strengthen memory and to send hidden messages. He was an authority in botany, agriculture, magnetism, distillation, and optics; and he was also a prolific playwright, albeit most of his works travelled only among the upper classes of Neapolitan society to which he, of minor nobility himself, belonged.[4]

Underlying his inexhaustible passion for discovery and the popularization of knowledge, however, was a proclivity to think of knowledge he acquired in terms of secrets. He named the scientific academy he founded in 1558 (one of the first scientific academies in Europe) the Accademia dei Segreti, and he presented much of his work as secret-knowledge-now-revealed. As Louise George Clubb has rightly pointed out, even more than in acquiring secrets, Della Porta rejoiced in talking about them with others.[5] "Nature," he wrote in the preface to his treatise on cryptography, "has given me the inclination to probe whatever is secret and

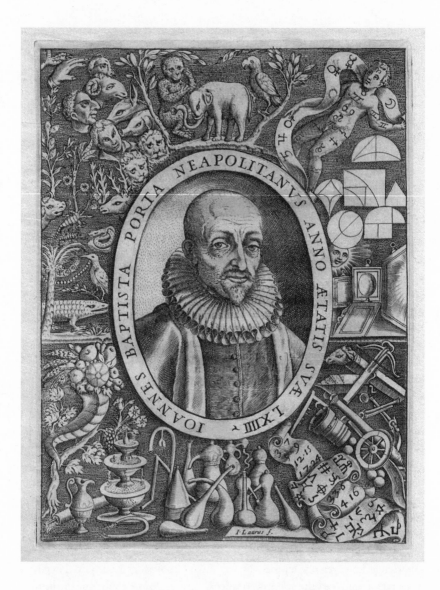

4.1 Frontispiece. Note the signalling of Della Porta's diverse areas of expertise and the geometric curves floating below the astrological body (top right). Giambattista Della Porta, *De distillatione libri IX* (Rome: Reverenda Camera Apostolica, 1608). Ry 251: d. ETH-Bibliothek Zürich, Alte und Seltene Drucke.

concealed."[6] Nature, or perhaps Fortuna, also gave him the time and talent to extensively catalogue many of her "secrets": his *Magiae naturalis sive de miraculis rerum naturalium* (first published in four books in 1558 and expanded to twenty in 1589) sold like wildfire throughout Europe.[7]

Della Porta turned words and signs into active accomplices in his secrets, assistants in his magic acts, and characters in his plays. In his one and only treatise on pure mathematics, the *Elementa* (published first in 1601 and revised 1610), he extended his symbolic stage to include mathematical objects and concepts.[8] The semiotic acrobatics of his mathematics in that work epitomizes the balance he continually sought – like Alberti and Tartaglia before him – between secret and revealed, and, as his own motto, *Metior, ne metiar*, reveals and we will soon see, between measuring and being measured in his actions.

Although the *Elementa* is his only work on mathematics, it is not surprising, I will argue, that Della Porta chose to devote a book to mathematics, and specifically to the construction of curves. The *Elementa* is an ebullient, theatrical display of geometric figures that reveals his unorthodox relationship to the mathematics of his time as much as it does his desire to entertain and impress. It is a curious treatise teetering between Renaissance classicism and Baroque curvilinear flourishes; between Renaissance notions of ideal harmonies and the nascent Enlightenment ethos of experimental method; between the severe precision of geometry and histrionic displays of enthusiasm and imagination. It claims to illustrate the wonders of mathematical truths, but ultimately does nothing more than explore axioms of basic, planar geometry. A work that ends up being neither fish nor fowl, neither cataloguing great troves of knowledge as Pacioli did, nor adding anything new to current mathematics as Alberti and Tartaglia did, the *Elementa* garnered no interest from the mathematicians of his time. Yet it is a fascinating document for viewing what an important, late Renaissance writer found compelling about mathematical computation – its beauty, its power to communicate, and its secrets – and how this particular thinker transformed simple Euclidean geometry into a sort of theatre with curves as characters and actors. In a sense, the *Elementa* is the inverse of the anonymous early seventeenth-century English play found in the Venerable English College in Rome, *Blame Not Our Author*. There, as Carla Mazzio has shown, the characters (Euclidean figures such as circles, triangles, squares, etc.) try to understand their place in the "real world" of mathematics.[9] In the *Elementa*, mathematical curves seem to burst from the pages, endeavouring to be considered "real characters" in the abstract world of mathematics.

Della Porta was a seeker of patterns, codes, systems, and keys. When he could not find answers in the works of classical authorities, he developed his own – or

he urged his readers to find their own answers, invent the systems they needed to solve the problems they confronted in the world around them.[10] His cryptographic manual mentioned above, *De furtivis* (1563),[11] is a striking example of this search for pattern and meaning; one that engages codes and coding more from a love of spectacle and illusion, however, than from a sense of pragmatism and urgency such as we saw in Alberti's *De Cifris*. Yet even with its dramatic flourishes, Della Porta's *De furtivis* has, like Alberti's treatise, a claim to an important cryptographic first: the digraphic cipher, a code that uses a single symbol of cipher text to represent two different letters of plaintext and forces the coder and decoder to think in terms of the "probable word." Such an approach to variable meaning is not, perhaps, surprising coming from an author who was fascinated by the verisimilar and what he called "affinities" between things: invisible and visible similarities found between the natural, celestial, and human worlds. Moreover, as a playwright, Della Porta loved double-entendres, mistaken identities, and plot twists that required playgoers to seek the "probable" among multiple potential outcomes. Della Porta's cryptographic systems of polyalphabeticity (following on the heels of Alberti), substitution, transposition, synonyms, deliberate misspellings, and irrelevant words reverberate throughout his literary and scientific works – even, in fact, through his *Elementa*, subverting the expectations of a reader who would anticipate from this mathematical treatise the clarity and precision of Euclid's own *Elements*.

In writing the mathematics of the *Elementa*, Della Porta played the role of the wizard: manipulating and interpreting signs, affinities, and "signatures" (the astral influences moulding nature and man). He would play this role elsewhere – in his theatre, in his writings on astrology, physiognomy, cryptography, in his study of medicine and nature. He had even planned to publish a book on the symbolism of numbers – there is surviving evidence of a manuscript, now lost, that he had entitled *Divinae aritmeticae commentationes*.[12] As Della Porta wrote in his comedy *La carbonaria* (1601), "Signs are signs [only] to those who know them" (V.vii).[13] And most stunning and marvellous of all signs were the signs that he himself had created or deciphered. Unlike Galileo or Kepler – or, as I have argued, Alberti, Pacioli, and Tartaglia – who tried to understand nature through its own mathematical language, Della Porta approached the secrets of the cosmos as accessible only partly to mathematics, but otherwise susceptible to the application of "rhetorical and symbolic instruments"[14] that he had identified as crucial for understanding and interacting with the world around him.

In the age of the Inquisition, however, inventing and interpreting signs and secrets, as Della Porta took pride in doing, could prove dangerous. In 1574 he was

arrested by the Inquisition for his *Magiae*. In 1577 the Inquisition accused him again of trafficking in magic; a year later, it ordered that his Accademia dei Segreti be disbanded. Further inquisitorial actions were brought against him in 1586. From 1592 to 1598 Pope Paolo IV banned Della Porta from publishing – or even investigating – anything to do with the occult arts or philosophy; he was, rather condescendingly, encouraged to focus on writing more comedies.[15]

And write more comedies he did, stealthily filled with codings and doublings, with interpretation of signs, affinities, and secrets. Della Porta is believed to have written twenty-eight or twenty-nine plays, of which fourteen comedies, two tragedies, and one tragicomedy have survived.[16] These plays are replete with classical and *commedia erudita* characters, themes, and rule-bound formats, but his comedies also belong to the emerging *commedia dell'arte* and hint at early Baroque melodrama. Della Porta used a polyphony of diverse languages, dialects, and registers; his wordplay was fast and furious. Like Aretino, Machiavelli, and Bruno, but even more so in some instances, Della Porta energetically re-formed language's threads, and then braided them together into new meanings. His theatrical writing stretched and contorted language into words like *quellissima* ["thatnessist"], in *La tabernaria*, IV.9, or *arcipedantescamente* ["archpedantly"], in *I fratelli simili*, I.3. He played with doublings (*bugiarda bugia*: lying lie, *La Cintia*, IV.9), with augmentation and accumulation: "Menti d'una mentissima, arcimentita arcimentitissima, mentissimissima – missimissima mentita" [You lie with a super-lie, arch-lie arch-super-lie, super-duper-duper lie – a duper-duper lie] (*La Cintia*, III.8). As we shall see, the *Elementa* does the same with its neologisms, its repeated figures, its incremental building of more and more complex curves, and its attempt to square the circle. Della Porta blurs the lines between pure mathematics, art, and artifice.

Della Porta's plays are rich with transpositional devices: anastrophe and hyperbaton, epanalepsis and paronomasia, polyptoton and antithesis. Scholars have described Della Porta's theatrical language in terms of "eccentric verbalism,"[17] "exuberant hyperbole,"[18] and "hypertrophy,"[19] and have noted a vocabulary that "si gonfia" [swells] to make room for new terms and new word combinations.[20] When Della Porta described the character Filesia's language in the Prologue to his comedy *La trappolaria* he might easily have been writing about himself: "arguta, faceta, festosa, e motteggevole" [clever, witty, merry, and jesting].[21] His theatre is one of spectacle and the spectacular, full of curiosities both empirical and theoretical, predictable and surprising. And his characters, as Nadia Pesetti has observed, are continually coding and having to decode signs and foreign tongues.[22] Reading the *Elementa* with this in mind helps us to see not only how akin it is to theatre, but why it befuddled the mathematicians of Della Porta's time and beyond.

As Della Porta's theatre abounds with investigations and manipulations of signs, so do his scientific, magical, and mathematical writings abound in theatricality. Carmelo Greco and Sergius Kodera have discussed Della Porta's use of rhetorical devices in his scientific and magical writing, noting how he masterfully used histrionic artifice to generate wonder.[23] Della Porta's mathematical writing also employed theatricality and careful rhetoric, attempting to mediate between empiricism and wonder as it engaged mathematical axioms with histrionic enthusiasm. The computational content of the *Elementa* of 1610 served the elderly Della Porta as a new stage on which to perform, a new laboratory in which to experiment, a new "communicative modality"[24] – as Oreste Trabucco has characterized Della Porta's move away from medieval encyclopedism – and a way to share secrets with the world through writing. Yet his prescient choice to pen a study of curves – the geometric form par excellence of the emerging Neapolitan Baroque aesthetic – and his remarkable linguistic inventiveness notwithstanding, Della Porta's treatise made not even a single wave and quickly sank into oblivion. This vanishing act is *the* central act to the play – a tragicomedy, I would venture – that is the *Elementa*.

The Vanishing Act

First printed in Naples as *Curvilineorum elementorum libri duo* and bound together with a work on pneumatics,[25] Della Porta's treatise on the geometry of curves failed utterly to interest the mathematical community when it was first published in 1601. In 1610, he reworked and reorganized the books of the *Elementa*, added a third book on how to square the circle (or rather, *not* square the circle), and retitled the treatise *Elementorum curvilineorum libri tres in quibus altera geometriae parte restituta, agitur de circuli quadratura* (Rome: Bartolomeo Zannetti). An autograph copy of the 1601 edition is held in the Archive of the Accademia dei Lincei (ms XV[i]).[26] The margins of this manuscript have been heavily annotated by Della Porta, and by an unidentified second hand, likely belonging to an editor proficient in mathematics, perhaps even to the great mathematician and Accademia dei Lincei co-founder Francesco Stelluti. The text was printed by Bartolomeo Zannetti, under the auspices of the Accademia dei Lincei, and funded by its principal founder and underwriter, Federico Cesi. Unfortunately, this 1610 version was, like the first edition, ignored: its publication received no response from contemporary mathematicians, or indeed from anyone else.

IO. BAPTISTAE PORTAE
NEAPOLITANI
ELEMENTORVM CVRVILINEORVM

LIBRI TRES.

In quibus altera Geometriæ parte reftituta, agitur de
CIRCVLI QVADRATVRA.

Ad Illuftriffimum Principem ac D.

D. FEDERICVM CAESIVM
MONTIS CAELII MARCHION. II. &c.
BARONEM ROMANVM.

ROMAE,
Apud Bartholomæum Zannettum. M. DC. X.

SVPERIORVM PERMISSV.

4.2 Title page. Giambattista Della Porta, *Elementorum curvilineorum libri tres*
(Rome: Bartolomeo Zannetti, 1610). IC5 P8304 601eb.
Houghton Library, Harvard University.

The 1610 *Elementa* opens with a typical exchange of compliments between author and patron. Della Porta dedicated the 1610 edition to Cesi – adoring supporter of the eccentric and now aged magus (the title page features Cesi's coat of arms). On the following page, a laudatory epigram in Greek by Giovanni Demisiani of Cephalonia (poet, priest, and mathematician to Cardinal Gonzaga) praises Della Porta.[27] Della Porta would have met Demisiani at the Accademia dei Lincei in Rome, or at a Lincei event in Naples, but it was probably Cesi who invited Demisiani to write an encomium for the book.[28] In the encomium, Demisiani notes Della Porta's many inventions, albeit in cryptic analogies. He associates Della Porta with Venusian fertility (he can make the earth flower) and says his "Daedelian, many-coloured, artful words" make the seas laugh and the heavens sparkle. Warring circles and squares seal pacts of friendship under Della Porta's influence, and Della Porta is said to be "one of a kind," as unique as the city of Naples itself.

Demisiani's encomium is followed by a six-line epigram from another Linceo: the aforementioned mathematician Stelluti. Stelluti knew Della Porta and, as suggested above, may have annotated the manuscript for this second, Roman edition. Stelluti's epigram for this edition honours Della Porta's "Protean forms" – referring in general to his multifaceted talents, but also, more specifically, to his dynamic collection of curved lines and polygons, and to his unsuccessful efforts to square the circle.[29] Cesi had asked Stelluti to translate the *Elementa* into Italian and to write a commentary on the work; Stelluti never completed either of these projects. The epigram – and, perhaps, a few editorial comments on Della Porta's manuscript – might be an apology to the author (and to Cesi) for declining to engage further with his mathematical work.[30]

That the 1610 *Elementa* is prefaced with two poems is not unusual: as discussed in the chapter on Tartaglia, many early modern mathematical and scientific treatises contain prefatory poems written by the author in praise of his patron or subject, or by another scholar in praise of author and subject. Della Porta would become a Linceo on 8 July 1610 – a sufficient motivation for these Lincei to welcome him with such votes of confidence.[31]

Like most geometric treatises, and certainly like Euclid's *Elements*, the *Elementa* offers definitions, axioms, propositions, proofs, and diagrams. The text, divided into three books, is ninety-six pages in length (rather brief given its quarto size: 8.54 x 6.22 inches) with 164 woodcut diagrams. Book 1 reviews elementary geometry and methods for constructing curved figures (lines and planes) made with circles; it has twenty-six definitions, twenty-six propositions, and seventy-five woodcut diagrams.

IO. BAPT. PORTAE
NEAPOLITANI
ELEMENTORVM CVRVILINEORVM
Liber Primus.

DEFINITIONES.

PRIMA.

INEA curua eft, quæ inter
fua nó æquè fluit puncta, fed
facto finu flectitur.

II.

Angulus flexilineus eft flexarum linea-
rum retufio fuo nutu fibi coincidentium.

III.

Angulus flexilineus rectus, qui rectilineo refpondet.

Exempli caufa fit A.B.infidens linea iacens FBC. vtrobiq. fibi
æquales conftituens angulos ABF, ABC. fitq. AB. ipfi B. C.
æqualis & ipfi AB.hemicyclium circumfcribatur ADB.vel cir-
culi portio, & ipfi BC. alter B. E C. vel æqualis circuli portio.
Cyclogoni ergo DBA. CBE. funt æquales, & quanto angulus
AD.B.F. maior eft recto ipfo contingentiæ angulo DBF. tanto
ABE. fuperat ipfum ABC. altero contingentiæ angulo ABE.

A totus

4.3 The opening pages of each book of the 1610 *Elementa*. Giambattista Della Porta,
Elementorum curvilineorum libri tres (Rome: Bartolomeo Zannetti, 1610), 1, 39, 65.
Courtesy of the Internet Archive under a Public Domain Mark 1 Creative
Commons License.

IO. BAPT. PORTAE
NEAPOLITANI
ELEMENTORVM CVRVILINEORVM
Liber Secundus.

AXIOMATA.

I.

SI eidem addideris, quod prius dempferis, quanti-
tas æqualis erit.

II.

Si nota quantitas à nota fubtrahatur, quæ remanet no-
ta erit.

Triangulum femicuruilineum ex æqualibus,
ijfdemq. circumferentijs compofitum
quadrare. Prop. 1.

ESto triangulum quodpiam fe-
micuruilineum A D B C E,
Aequalibus nimirum ijfdemq. cir-
cumferentijs ADB, AEC, & recta
BC bafi conftituta volo illud qua-
drare. Ducatur linea AB, & AC,
aio aream trianguli femicuruilinei
ADBCE effe æqualem triangulo rectilineo A B C. Quoniam
circumferentia ADB eft æqualis portioni A E C, ablata
ADB, repofitâq. in A E C æquale remanet triangulum
rectilineum A B C femicuruilineo per primum axioma
noftrum.

Vel

65

IO. BAPT. PORTAE
NEAPOLITANI
ELEMENTORVM CVRVILINEORVM
Liber Tertius.

In quo de Circuli quadratura agitur.

Lunulam ex dupla, & subdupla proportione
quadrare. Prop. *1*.

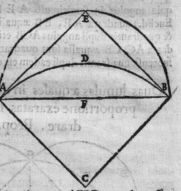

Escripto duplis circuli quadrā-te his charaĉteribus distinguatur ADBC, cuius subtensam A B, scinde bifariam, & punĉtus scissionis adamussim medius F charaĉterē sortiatur, in quo circini pede infixo ex FA interuallo circum duĉto semiambitum subdupli AEB ducito, aio triangulum reĉti-lineum ABC interceptæ lunulæ areæ AEBD æqualem esse. In medio periferiæ subdupli E punĉtus instituendus, & ab vtraque circuli extremitate A B lineæ excurrant vsque ad E, ibique mutuo concurrant, quia dupli portio A D B F quarta sui circuli pars valet quantum duæ subdupli portiones A E, E B, etiam sui circuli pars quarta (per 20. primi nostri) ideo

I sub-

Book 2 demonstrates – in some instances, inaccurately – how simple figures with curved boundaries can be measured, or squared. This section contains two axioms, twenty-two propositions, and fifty-six diagrams. Book 3 uses Hippocrates of Chios's method to square the circle by means of planar *lunes* (a figure shaped like a moon whose area is bounded by two circular arcs or unequal radii); this book contains twenty propositions and thirty-three diagrams.

The theatrical, writerly rhetoric begins straight away, in the opening pages of Book 1, where Della Porta defines twenty-six different types of circle-based curvilinear figures (figure 4.4). Della Porta's terminology mixes conventional geometric terms and invented words – nouns and adjectives based, it seems, on impressions that the shapes evoked for him personally.[32] Historians of mathematics – the few who have studied this work – have observed that the *Elementa* is full of terms – part empirical and part colloquial – that cannot be found in other early modern mathematical treatises, Latin dictionaries, or Marshall Clagett's glossary of Latin mathematical terms from the Middle Ages and early Renaissance.[33] It is possible, of course, that further philological work could still uncover earlier (or, for that matter, later) uses of Della Porta's unusual terms, such as *cyclogonus* (Definition 10). But given all that we know about Della Porta's penchant for inventive language, might we not conclude that the same author who invented neologisms like "thatnessist" and "archpedantly," to suit theatrical occasion, would happily coin terms like *arcualem* and *cuspidale* when the language he had inherited from earlier mathematicians failed to follow the geometric curves of his imagination?

Among Della Porta's unique and highly descriptive geometrical terms are the *flexilinearum triangulum* (flexilinear triangle), *semicurvilinearum triangulum* (semicurved triangle), *tricuspidarum triangulum* (three-pointed triangle in which all angles are acute), *corona* (a crown-shaped figure), and *agonia* (a no-angled figure, such as a circle). Della Porta's *metriscus* should, perhaps, be *meniscus* (a moon-shaped figure); an *arbilon* might be his version of *arbelos* (a figure in the shape of a cobbler's knife). Other imaginative curvilinear terms include *monoeides* (a half-lune), *keratoeides* (a horn or sickle-shaped figure), and *pelekoides* (a hatchet-shaped figure). As he does in his comedies, Della Porta here invents numerous adjectives from substantives – such as *arcualem, circulosis, cuspidale, quadrabile* – and builds terms by adding prefixes like *sub* and *semi*: *sublunula, subtriangulum, subquadrupli, semicyssoide, semiorbis, semiexagona, semitriangula*.[34]

It is not, in fact, surprising that Della Porta's mathematical lexicon would be filled with neologisms, given his passion for verbal invention, his eloquence in Latin and knowledge of Greek, and his tendency to pull expressions from many

different languages for use in his literary and scientific works. But the *Elementa* was also his first and only work in pure mathematics. Though Della Porta was a competent mathematician – he translated Theon's commentary on the first book of Ptolemy's *Almagest*, wrote books on optics (*De refractione*), military fortifications, and mechanics (*Magiae naturalis*), and likely knew Proclus's, Clavius's, and Commandino's commentaries on Euclid, as well as some Archimedes, Serenus, Pappus, Dürer (on geometry), Regiomontanus (*De triangulis*), Clavius's *Geometria pratica*, and the work of François Viète[35] – the *Elementa* does not engage with current mathematical debates. The generous comment of the editor of Della Porta's posthumously published comedy, the *Tabernaria*, notwithstanding (and perhaps, withstanding), that Della Porta was a "filosofo sì grande e celebrato universalmente nelle scienze Matematiche e Naturali" [exceedingly great and universally celebrated philosopher of the mathematical and natural sciences],[36] it can be argued that Della Porta was insufficiently familiar with current mathematical terminology – that he coined words because he did not know existing alternatives. Yet we also know that mathematical terminology in the sixteenth and early seventeenth centuries was in its adolescence; there was still a great deal of room for invention and even play.[37] It was not unusual for a term that was gaining currency in the vernacular or in a dialect to have no Latin translation, and vice versa. As Della Porta notes in the preface to his 1601 edition: "I, who prefer to treat new things as opposed to transcribing things known by others, converted many of Euclid's propositions into propositions on curves and I realize that he had not done anything in this area."[38] Had the *Elementa* received more attention, Della Porta could, in fact, have contributed to the mathematical lexicon of his, and later, times.

Della Porta scholars have generally not studied the *Elementa*, and have missed seeing the quirkiness of its language and mission. Historians of mathematics, on the other hand, who have investigated the *Elementa* have noted Della Porta's linguistic inventiveness, but have focused on correcting the text's numerous errors, or offering clarifications for his unclear and illogical demonstrations. Some demonstrations in the 1610 edition are, in fact, sloppy, but essentially correct; others reveal incorrect reasoning. There are typographic mistakes, mislabelled diagrams, simple oversights. Although Della Porta's recent editors believe that the 1610 printed edition was based on the autograph, annotated copy of the 1601 *Elementa* now held in the Accademia dei Lincei, they note that the 1610 edition's first two books are not identical with the autograph manuscript. Some diagram-labelling errors from 1601 still remain in the printed 1610 edition: either Della Porta and the unknown editor did not notice them when copying or revising the 1601 edition, or the printer Zannetti chose to speed the printing along (and keep costs

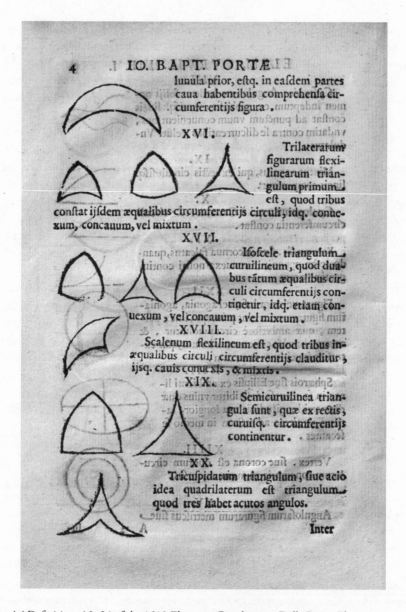

4.4 Definitions 16–24 of the 1610 *Elementa*. Giambattista Della Porta, *Elementorum curvilineorum libri tres* (Rome: Bartolomeo Zannetti, 1610), 4–5. Courtesy of the Internet Archive under a Public Domain Mark 1 Creative Commons License.

ELEM. CVRVIL. LIB. I. 5

XXIX

Inter triangulares figuras πελεκοειδῆς. Figura est, quæ securis vel bipennis formā habet.

Eius Theocritus meminit. Nicandri Scholiastes sutorium scalprum. Τὰ κυκλοτερῆ σιδήρεια, οἷς οἱ σκυτοτόμοι τέμνουσι ἢ ξύουσι τὰ δέρματα. Idest circularia ferramenta quibus pelles incidunt, & deradunt.

XXII.

Arbilones ex tribus circumferentijs compræhensi; Horum meminit Pappus spatium illud inter circumferentias interiectum ἀρβηλον vocans.

XXIII.

Quadrilaterarum quidum figurarum curuilinearum quadratum quidem flexilineū est, quod rectis angulis, & æqualibus circumferentijs perscribetur.

XXIIII.

Rhombus flexilinea æquilatera quidem, sed non rectangula, aduersos tamen angulos æquales habet, eorumq. aliquos concauos, conuexos, & mixtos.

Rhom-

ELEM. CVRVIL. LIB. I. 3

VIII.
Cyssoides Angulus ex hederæ folijs no-
men indeptum ex gibbosis, cauisq. lineis
constat ad punctum vnum conuenientibus,
vndatim contra se discurrentibus veluti Vn-
dulatus.

IX.
Mixtus angulus, qui ex rectis circulosisq.
lineis componitur.

X.
Cyclogonus, qui à Caua, & recta circuli
circumferentia constat.

XI.
Κερατοειδής. siue in cornua falcatus, quan-
do rectæ opponitur conuexa nostri contin-
gentiæ vocant.

XII.
Figura vel angulosa, vel agonia, agonia-
rum figurarum circulus princeps, lineæ par-
tem, quæ ambitiose circumuoluitur, &
aream obambit concauum dicimus, quæ ex-
torsum inuehitur conuexum.

XIII.
Sphærois siue Ellipsis ex ambienti li-
nea in se recursa describitur vnius duæ
diametri, longitudinis vna longior, la-
titudinis altera ad rectum in medio se
secantes.

XIIII.
Vertex. siue corona est duorum circu-
lorum concentricorum circumcursus.

XV.
Angulosarum figurarum metriscus siue

A 2 Iu-

4.5 "Cyclogonus" in Definition 10; "κερατοειδής" (keratoeides) in Definition 11; "agonia" in Definition 12. Giambattista Della Porta, *Elementorum curvilineorum libri tres* (Rome: Bartolomeo Zannetti, 1610), 3. Courtesy of the Internet Archive under a Public Domain Mark 1 Creative Commons License.

down) by reusing woodcuts from the 1601 edition, even woodcuts whose diagrams contained errors. Yet many diagrams have been corrected, and in other cases the unknown editorial hand adjusted the demonstrations, rather than their diagrams, so the original woodblocks could be used without confusion. Out of 164 woodblocks in 1610 edition, 114 are recycled from the 1601 printing.

Della Porta's choice to write a mathematical treatise on curvilinear figures – how to find their areas, and how to square them – may well have been aesthetically motivated, anticipating the torrent of curves soon to flow through Baroque art and architecture; and it may have been more symbolically motivated, addressing the curve as it relates to the circle: that most sublime of shapes. But at the time of writing, he was the first to devote an entire book to the topic of curvilinear figures; this primacy would have justified him in thinking of the *Elementa* as a foundational text, a guide, or a key. Besides the obvious reference to Euclid, consider his choice of the term "elements": the smallest parts, building blocks, or essential pieces needed to understand a larger whole. In this sense, Della Porta's effort to comprehend and label his curvilinear *Elementa* is not unlike Alberti's study of letter frequency: cryptography, like understanding objects of the natural world, requires combining, permuting, and building upon elements. And as Pacioli did with letterforms, Della Porta thought of curvilinear figures as comprising elementary parts, and hoped that by cataloguing and building upon those parts he might achieve the spectacular result of squaring the circle (not realizing that squaring the circle with a compass and straight edge was, in fact, impossible).[39] For Della Porta, computing towards a spectacular mathematical result was not much different from writing a play with twists and turns that would, ultimately, yield a theatrically spectacular resolution. Similarly, his imagination seems to have led him to imagine how a lens – a curved object – might eventually be used to see "into the Empyrean,"[40] though he would leave to later scientists the practical implementation of this spectacular telescopic idea.

As Della Porta demonstrates his theoretical understanding of the elements of curves, he also seems to have thought of the "affinities" between curvilinear figures and the material, physical world.[41] Even when he describes the importance of contemplation (*vis contemplativa*) to investigations, he implies that "observation," rather than theory, is the key to knowledge.[42] His works are filled with empirical observations of nature and man: questions of physiognomy, astrology, optics, agriculture, codes, even the issue of human equivocation as he repeatedly displays it on the stage. In the *Elementa*, Della Porta is less interested in moving mathematical study forward through new theoretical foundations than he is in displaying to the world a spectacular catalogue of the curves he *sees* in the world – and then teaching the reader to master them, to capture them, to tame them through

measuring. Many of the curved figures he chose to measure *look* complex, but in most cases are easy to construct by adding and subtracting segments (figure 4.6).

By demonstrating how to construct complex-looking curvilinear figures, he could certainly have impressed readers (who were not mathematicians). By claiming to solve one of mathematics' oldest conundrums – how to create a circle with the same area as a square (or vice versa) using only compass and straight edge, Della Porta likely hoped he would impress readers even more, and entice mathematicians to read his text, too (figure 4.7). But if the 1601 edition of the *Elementa* failed to elicit interest from general readers or mathematicians, the 1610 edition with its attempt to square the circle made the treatise even less of interest to the mathematicians of his time.

Though there are reasons why Della Porta's *Elementa* could have been useful to the mathematics of his time, such as its imaginative terminology and the utility of having the construction of many curves for the first time all in one place, both versions of the *Elementa* were ignored. It was as if the text had never existed, as if it had performed (or someone had performed upon it) a vanishing act. Years after the *Elementa*'s publication, only a very few of the six hundred printed copies had been sold.[43] Della Porta may not have been entirely surprised, however, by the scientific community's indifference: as he had explained in the dedicatory epistle to Cesi, many of his ideas, mathematical and otherwise, had been scorned over the years.

Did the mathematical community ignore the *Elementa* because of its mathematical errors (careless mistakes, conceptual errors, and errors of reason) and its *stravaganze* – extravagant, but non-mathematical demonstrations?[44] Was the 1610 edition's squaring-the-circle addition a further strike against it? Della Porta's method for squaring the circle with lunes (or rather, squaring the lune of the hexagon, Prop. 6 III) was immediately recognized as untenable by mathematicians including Artus de Lionne, Paolo Aurineto, and Giovanni Camillo Gloriosi. Lionne wrote a treatise refuting the lunes method – though this work was not published until 1654 – and theologian/mathematician Aurineto also published a refutation of Della Porta's method, in 1632.[45] Was the basic geometry too obvious and lacking in any contribution to mathematical progress? Likely yes to all of the above. Mathematicians who might otherwise have criticized the book (Lincei and non-Lincei alike), however, remained silent, perhaps out of fear that criticism could offend Cesi, a great patron of the sciences and a strong Della Porta supporter. Furthermore, because Della Porta preferred to stay out of academic disputes, he did not promote his book or encourage reactions; his own scholarly reticence would have done little to overcome reluctance

to engage with his problematic, yet prominently championed, work.[46] Over the centuries since its publication, the *Elementa* was only prized for one thing: its list of Della Porta's other published and forthcoming works (both scientific treatises and plays) that publisher Zannetti included in the back matter of the 1610 edition (figure 4.8).[47]

More than for any other reason, however, it seems mathematicians of Della Porta's time ignored or looked askance at the *Elementa* because their mathematics was moving in new directions: towards the new algebras of Bombelli and Viète and, soon, the calculus of Leibniz and Newton. By the early 1600s, Italy started to lose its hold as the centre of mathematical scholarship. Even with its claim to empirical observation and its useful compilation of curves, Della Porta's treatise – especially the circle-squaring part – presents more as a playful text than as a serious contribution to mathematical advancement. In the period from 1472 to 1620 tracked by Pietro Riccardi, 1582 saw the highest number of mathematical treatises (38) published in Italy during a single year. Between 1531 and 1560, 427 mathematical works were published in Italy; between 1561 and 1590 there were 648; but between 1591 and 1620 the total number would decline to 593; and then again between 1621 and 1650 to 550.[48]

Historians have likewise passed over (or not known) the *Elementa*, or noticed it only to dismiss it as error-filled or even ridiculous. The early modern mathematician and historian Bernardino Baldi, in his massive collection of mathematicians' biographies, *Le vite de' matematici* (see the Introduction to the present book), does not even mention Della Porta, much less include him among the two hundred mathematicians from Thales to Christopher Clavius whose lives he recounts and works he examines.[49] In the 1830s, Guillaume Libri judged Della Porta "not a genius of mathematics," and his *Elementa* a work "filled with errors and insignificant things."[50] Augustus De Morgan called the circle squaring in the *Elementa* a "ridiculous attempt, which defies description, except that it is all about lunules."[51] Joseph Hofmann in 1953 concluded that Della Porta was "neither a distinguished nor creative mathematician."[52] Roberto Marcolongo in 1936 described Della Porta as having a "bizzaro ingegno napoletano" [bizarre Neapolitan intelligence], and cited the *Elementa* only to notice that its quadrature of lunes diagrams are similar to Leonardo da Vinci's. He does note, however, that the *Elementa* is the first work printed on Hippocrates' method of squaring figures through lunes.[53]

Indeed, few have praised the *Elementa*, since Della Porta's fellow Lincei Demisiani and Stelluti first set forth their comments in dedicatory poems for the edition of 1610, and since publisher Zannetti celebrated Della Porta's

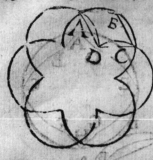
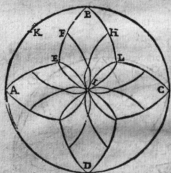

4.6 Various curvilinear shapes in Book 2 of the 1610 *Elementa*. Giambattista Della Porta, *Elementorum curvilineorum libri tres* (Rome: Bartolomeo Zannetti, 1610), 60–1. Courtesy of the Internet Archive under a Public Domain Mark 1 Creative Commons License.

ELEM. CVRVIL. LIB. II. 61

dammodo recuruis, &
refractis lineis.

Propositum ergo sit
quadrare volutam BED
GIFCHLMA scio hanc
volutam octauam esse
partem volutæ circuli
NOPQRS, & omnes
circuli volutæ non ca-
piunt nisi octogoni a-
ream, ergo vnaquæque
octauam partem com-

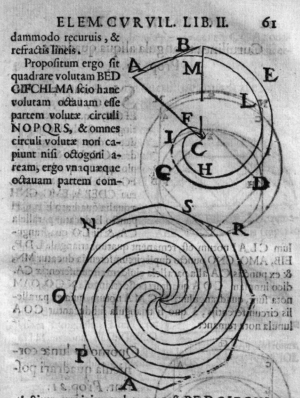

plectitur : vna igitur volutæ pars est BEDGIFCHLMA
est octaua circuli pars, & octaua circuli pars est triangulum
ABG, ergo tota proposita voluta quadrata triangulo meti-
tur. Possumus, & hoc modo cyssoidem triangulum etiam
quadrare, quod vidimus in 5. propositione huius.

Curui-

74 **IO. BAPT. PORTÆ**

gulum RDL esse æquale sublunulæ CFLH, & triangulum ACR æquale lunulæ ABCT, à quo si triangulum ACS subtrahatur, æquale lunulæ ABCE (per primam huius) remanet subtriangulum ASR imæ lunulæ AECT par, quod erat demonstrandum.

Vel hoc modo si triangulum ACL æquale est lunulis ABCT, CGLF, compleatur triangulum GRL; & compleatur perfecta lunula, quę sit CGLH, ergo addita pars trianguli RDL æqualis erit additæ lunulæ CFLH, sed pars trianguli addita RDL æqualis est triangulo ACR, vt vidimus, & par est lunula ABCT lunulæ CFLH.

Vel hoc modo. Tres lunulæ ABCE, CGLF, AECT sunt æquales trigono ACL, & duæ lunulæ CGLF, CFLH trigono CDL, ergo omnes quatuor iam dictæ lunulæ sunt æquales duobus trigonis ACR, & CDL, sed tres lunulę ABCE,

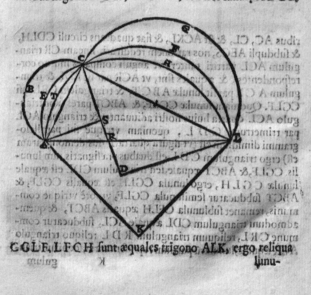

CGLF, LFCH sunt æquales trigono ALK, ergo reliqua lunu-

4.7 Steps towards squaring the circle in Book 3 of the 1610 *Elementa*. Giambattista Della Porta, *Elementorum curvilineorum libri tres* (Rome: Bartolomeo Zannetti, 1610), 74–5. Courtesy of the Internet Archive under a Public Domain Mark 1 Creative Commons License.

ELEM. CVRVIL. LIB. III. 75
lunula AECT eſt æqualis trigono ASR, quod quęrebamus.

Vel tres lunulę ABCE, AECT, CGFL æquales ſunt trigono ACL, & trigonum CDL æquale lunulę CGLH, tolle triangulum CDL equale iam dictę lunulę CGLH, reliquum triangulum ACR lunulis ABCE, AECT æquale eſt, tolle lunulam perfectam ABCE ſub lunula AECT ſub triangulo ASR æqualis erit, quod erat demonſtrandum.

Trianguli in circulo deſcripti angulo per medium diſciſſo, & lunulis à circulo medio diuiſis, proportio partis maioris trianguli ad minorem, eſt ſicut ſuperior pars maioris lunulæ ad inferiorem, & ſuperior eadem pars ad minorem lunulam,& ſuperior pars trianguli ad inferiorem ſequitur eam ſuarum lunularum. Prop. 7.

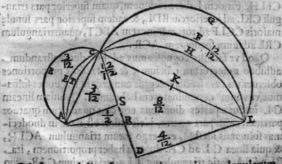

Priuſquam ad diuerſarum partium rationem lunularum
K 2 deſcen-

Bartholomæus Zannettus amico Lectori.

IOannis Baptistæ Portæ Lyncæi, Neapolitani V.Cl. ingenium Babylonicis palmis consimile semper existimaui, ex illis enim mella conficere, cibos parare, vina colligere, contexere vestes, & sexcenta alia ad vitam vel sustinendam, vel ornandam sibi comparare dicuntur Assyrij. En tibi, amice Lector fæcundum ingenium Portæ infinita, vel ornamenta, vel adiumenta parturijt, ac elaborauit. Ad excolendum animum philosophicas disputationes, ac mathematicas lucubrationes; ad recreandum reficiendumq. Villam, Pomarium, & lepidissimas Comedias. Ad exornandum Admiranda, & alia multiplicis eruditionis volumina. Vno verbo nihil est in natura maiestate repositum, Nihil in huius vniuersi luce versatur, quod tibi Porta non suppeditet. Plerisque iam olim frui contigit, multa propediem expecta, quæ nobis omni disciplinarum genere excultus, ac dignus longiore felicioreq. æuo Comes Anastasius de Filijs Lyncæus, & Portæ ipsi, quo cum plurima de litteris contulit collega perneccessarius, amantissime impertiuit. Optandum interea est, vt Porta diutius sibi, tibi, Reipublicæ viuat. Vt autem vno oculorum aspectu omnes magni viri lucubrationes agnoscas illorum Catalogum exponere visum est.

In lucem iam editæ.

Physiognomoniæ Humanæ tum Latina, tum Italica lingua libri sex, in quibus docetur, quomodo animi propensiones naturalibus signis dignosci naturalibusq. remedijs compesci possint.

Physiognomoniæ Cœlestis, libri sex, vnde quis facile, ex humani vultus extima inspectione poterit ex coniectura futura præsagire, spretis, ac reiectis Astrologorum inanibus iudicijs, Lat.

Phytognomonicæ, libri octo, in quibus, noua facillimaq. affertur methodus, qua plantarum animalium metallorum rerum, deniq. omnium ex prima extima faciei inspectione quiuis abditas vires assequatur, infinitis prope modum selectioribus secretis confirmantibus, Lat.

Magia naturalis Lat. & Ital. primum quatuor libris, demum viginti absoluta, in quibus scientiarum naturalium diuitiæ & delitiæ demonstrantur. In primo agitur, de mirabilium rerum causis. Secundo, de varijs animalibus gignendis. Tertio, de nouis plantis producendis. Quarto, de augenda supellectili. Quinto, de metallorum

N

4.8 Dated 1611 and appended to the 1610 *Elementa*, these pages contain the list of works Della Porta had written to date. Giambattista Della Porta, *Elementorum curvilineorum libri tres* (Rome: Bartolomeo Zannetti, 1610), [n.p., following the text]. Courtesy of the Internet Archive under a Public Domain Mark 1 Creative Commons License.

tallorum transmutatione . Sexto, de gemmarum adulterijs . Sep-
timo, de miraculis Magnetis . Octauo, de portentosis medelis . No-
no, de mulierum cosmetice . Decimo, de extrahendis rerum essen-
tijs . Vndecima, de Myropœia . Duodecimo, de incendiarijs igni-
bus . Decimotertio , de raris ferri temperaturis . Quartodecimo ,
de miro conutsiorum apparatu . Decimoquinto, de capiendis ma-
nuseris . Decimosexto , de inuisibilibus litterarum notis . Deci-
moseptimo, de catoptricis imaginibus.Decimooctauo, de staticis ex-
perimentis . Decimonono, de Pneumaticis . Vigesimo, Chaos .
De Furtiuis litterarum notis vulgus de ziseris, libri quatuor , pri-
mum euulgati mox alio superaucti, scatent innumeris occulte scri-
bendi modis ijsq. pulcherimis atque vtilissimis, eaq. insuper omnia
exponunt atque examinant , quæ à veteribus & nuperis ea de re
tradita sunt .
Villa Lat. Pomarium, & Oliuetum olim seorsim, demum vno volu-
mine, libris duodecim comprehensa . Primo, Domus . Secundo,
Sylua cædua . Tertio, Sylua Glandaria . Quarto, Cultus & insi-
tio . Quinto, Pomarium . Sexto, Oliuetum . Septimo , Vinea .
Octauo, Arbustum . Nono, Hortus Coronarius. Decimo, Hortus
Olitorius . Vndecimo, Seges . Duodecimo, Pratum . In quibus
maiori ex parte cum verus plantarum cultus, certaq. insitionis
ars , & prioribus sæculis non visos producendi fructus via mon-
strantur, tum ad frugum, vini, ac fructuum multiplicationem
experimenta prope modum insinita exhibentur .
De Refractione optices , libri nouem , Lat. Primus, de refractione
& eius accidentibus. Secundus, de Pilæ crystallinæ Refractione .
Tertius, de Oculorum partium Anatome,& earum munijs.Quar-
tus , de visione . Quintus , de visionis accidentibus . Sextus, Cur
binis oculis rem vnam cernamus . Septimus, de his quæ intra ocu-
lum fiunt , & foris existimantur . Octauus, de Speculis. No-
nus, de coloribus ex refractione , scilicet de Iride , Lacteo cir-
culo, &c.
De Curuilineis, libri duo primum, cui additus tertius, Lat. In qui-
bus altera Geometria parte restituta agitur de Circuli Quadra-
tura .
Interpretatio primi Almagesti cum Comm. Theonis, Lat.
De Munitione, libri tres, Lat. quibus Arcium, Castellorum, Ciui-
tatum munimina plene , ac Methodice traduntur .
Pneumaticorum , libri tres , Lat. Italicè Spiritali : cioè d'inalzar
acque per forza d'aria .
De Transmutationibus aeris, libri quatuor, Lat. In quo opere diligen-
ter

ter pertractatur de ijs, quæ vel ex atre, vel in aere oriuntur μ-τωρολόγον mnltiplices opiniones, quæ illustrantur, quæ refelluntur demum variarum causa mutationum aperiuntur.

De Distillatione, libri nouem, Lat. Quibus certa methodo multipliciq. artificio penitioribus naturæ arcanis detectis, cuiuslibet mixti in propria elementa resolutio perfecte docetur. Primus, primordia pandit distillationis, eiusq. causas, & instrumenta. Secundus, Odoratas elicit aquas. Tertius, Olea distillat. Quartus, è Plantis exoticis olea trahit. Quintus, Resinas distillat. Sextas, Oleum elignis educit. Septimus, Validas extrahit aquas. Octauus, Rerum virtutes & spiritus extrahit. Nonus, Olea exprimit.

Ars Reminiscendi, Lat. & Ital.

Nondum editæ.

Catoptrica, in qua admirabilis speculorum ars plenissime exponitur, & ipsius plurima delitescentia recluduntur arcana.

Theologumena, siue de numeris, mirisq. eorum mysterijs.

Taumatologia, opus selectioribus admirandis experimentis, atque arcanis refertum.

Scientiarum omnium Synopsis.

Comedie stampate.

La Fantesca.	*I due Fratelli riuali.*
L'Olimpia.	*La Sorella.*
La Cintia.	*Il Moro.*
La Turca.	*La Trappolaria.*
La Furiosa.	*La Carbonaria.*
L'Astrologo.	*La Chiappinaria.*

La Penelope Tragicomedia.
Il Georgio Tragedia.

Da stamparsi.

Arte da comporre Comedie.
Plauto tradotto in lingua Italiana.

Tragedie.

Santa Dorotea. *Santa Eugenia.*

Come-

Comedie.

I Fratelli Simili. La Strega.
La Notte. L'Alchimista.
Il Fallito. La Bufalaria.

Cinque Comedie d'vna fauola sola con le medesime Persone, e la prima è argomento di se, & di tutte; la seconda è protesi di se & di tutte; la quinta è la Catastrofe per se, e tutte insieme.

Due Comedie d'vna medesima fauola che l'vna si recita in Villa, e l'altra nella Città; e l'vna è intermedio dell'altra, mutandosi ogn'atto faccia.

Ab amicis eiusdem Doctissimi Porta monitus, & illud subijcio habere ipsum præ manibus, de Lynceo Telescopio opusculum. Quod præclarum hoc Perspicillum, iam pridem ante triginta annos, ab ipso inuentum in prænumeratis operibus, non vno in loco pateat, indeq. ab eo plurimi vberiorem eius doctrinam efflagitauerint. Vale Roma Kal. Septembris MDCXI.

mathematical abilities in his note to readers.[54] In the nineteenth century, Francesco Colangelo complimented Della Porta for the rigour of his geometry (and, from the historical distance of 1813, was prepared to excuse him for his foray into circle squaring).[55] Cesare Fornari, in 1871, cited the work's "precision in definition, rigour in demonstration," which show "the great diligence and hard study Porta devoted to the ancient geometers."[56] Though he was little involved in mathematics, Antonio Rossetti, an early editor of the *Tabernaria*, praised Della Porta's mathematical work,[57] while Gino Loria offered mixed praise in 1916 for Della Porta's project:

> of little importance and not true originality, but [a work that] proves that the author had a thorough knowledge of the work of Euclid and that he made use of it with remarkable ease ... [Porta] knew the classics of the science and was so imbued by the methods of the ancients as to make an evident effort to imitate their procedure and their style ... Porta appears – I will not say as a new Archimedes, but at least a *monoculus in terra caecorum* [one-eyed man in the kingdom of the blind].[58]

Clubb mentions the *Elementa* in her biography of Della Porta, but does not comment on its merits or demerits.[59]

Giuseppe Gabrieli, when he compiled the Accademia dei Lincei documents, claimed to feel ill equipped to judge Della Porta as a mathematician and scientist; he described him as the "last scientist of the Renaissance, the forerunner of modernity, or rather, of modern science."[60] Yet Maurizio Torrini has argued that Della Porta actually remained resistant, or at least indifferent, to new scientific theories and methodologies – this despite his love of novelty, and his long life through an era of scientific transition. For Torrini, the *Elementa* is a backward-looking case in point.[61] This diversity of views on where to locate Della Porta's intellectual stance shows just how teetery his *Elementa* – and other of his works – were between "magical" thinking and scientific method.

But rather than trying to identify Della Porta's work as *either* backward- or forward-looking, it may be helpful to re-examine the *Elementa* as demonstrating the same Janus tendencies that Raffaele Sirri has noted in Della Porta's theatre. In his comedies, the playwright looked backwards to antiquity (to Plautus in particular) for inspiration and models of writing. Yet in the same works he tried to move away from the fixed, academic, literary page and towards a more direct and kinetic conversation with actors, audience, and the stage.[62] By the same token, even though Della Porta wrote his scientific works in Latin (unlike Pacioli and Tartaglia, who more consistently published in the vernacular), he had most texts

quickly translated into the vernacular – something he had intended for the *Elementa*, too. This sensitivity to the importance of the vernacular likewise shows Della Porta as pulling away from humanist dictates and moving towards the more modern trend to reach more of one's fellow countrymen.

The *Elementa*'s teetering is part of its fascination. It simultaneously looks backward to the authority of ancient Greek mathematics and attempts to look forward and do something new: pushing and pulling curvilinear lines and figures in as many ways as he could, creating new words for describing these forms, and – so he thought – solving that intractable problem of squaring the circle. As do so many of Della Porta's works, the *Elementa* points to secrets (how to construct seemingly difficult figures) and then delights in revealing their true nature. Unfortunately, mathematicians were not interested in linguistic inventiveness, and other readers who might have delighted in Della Porta's curvilinear marvels did not have access to the text, or were put off by the mathematics. Della Porta wanted to share the wonders he found in curvy shapes – object/concepts that mathematics, and mathematical language, offered; but his particular computation-writing mix did not find its audience. The *Elementa* vanished. Were the computer-writers of previous decades beginning to disappear? Galileo – a most excellent computer-writer – was certainly going strong at this time, as were Kepler and others. Yet something about either the way Della Porta wove mathematical computation together with writerly imagination, or the topic of his study itself, made his treatise fall between the cracks that were forming as the Enlightenment approached.

That said, "vanishing" was not always a negative for Della Porta. Instances of intentionally crafted semantic vanishing appear repeatedly in his comedies. A classic example of this theatre of "fra-intendimento" [misunderstanding; understanding "in between," or rather not at all] can be found in his 1596 play *La trappolaria*, a comedy of errors set in Naples. In this play, Della Porta's cast of characters includes a miserly, domineering father (Callifrone); a son (Arsenio), who is in love with a beautiful young woman (Filesia) but expected to marry another (his stepsister Elvira, who has been living in Barcelona along with Arsenio's twin brother, another stepsister, and Arsenio's stepmother Elinora); a procurer; a braggart Captain; a glutton named Fagone; and the clever servant Trappola, who devises the complex plan (and subplans) needed to achieve Arsenio's union with Filesia. Filesia is ultimately revealed to be none other than Elvira herself, and Trappola is ultimately successful not only in uniting the loving couple but in orchestrating a trick to win his own freedom.

In Act IV, Scene ii, Arsenio seeks Filesia at the house of the glutton Fagone, and finds his way into a shocking, confusing conversation. Fagone is both inebriated

and furious; Fagone's wife has misconstrued Filesia as his mistress, and, in a rage, she has smashed the food and wine (Fagone's true loves) he had brought home. Arsenio and Fagone engage in an extended back-and-forth in which neither understands the other, enacting a literal "fra-intendimento" – a misunderstanding in which the interlocutors fall "in between" meaning. A humorous and gory zig-zagging of language and missed points ensues:

Arsenio: Che è della mia innamorata?

Fagone: Male novelle.

Arsenio: Oime infelice!

Fagone: Anzi me infelice, à cui sono accadute tutte le disgratie.

Arsenio: Che male novelle?

Fagone: Le peggiori che potresti intendere: habbiamo faticato invano.

Arsenio: Si sono forse accorti dell'inganno, e non l'hai condotta a casa?

Fagone: Anzi l'avea condotta à casa, e poi …

Arsenio: Che poi? Parla presto, non mi tener così sospeso, non mi far morir a poco a poco, che m'uccidi di doppia morte.

Fagone: Rumori, fracassi, naufragi, uccisioni.

Arsenio: Che rumori, che fracassi, che uccisioni?

Fagone: Me l'han tolta.

Arsenio: Oime, che dici?

Fagone: Il vero. Al primo incontro levò una botta in testa e si ruppe in mille parti, e sparse tutto il sangue.

Arsenio: Oime, o vita mia, o morte cruda, perche non togli me dal mondo.

Fagone: Poi, salita sù coi piedi, la calpestò tutta, che nulla ci rimase di sano o di buono.

Arsenio: Son morto, m'hai ucciso, m'hai dato un coltello nel cuore!

Fagone: Io? Nò, nò: non ti hò tocco. Il coltello al cuore, io? Dio me ne guardi, non mi ci sono impacciato.

Arsenio: Segui presto, finisci d'uccidermi.

Fagone: Io non ti vò uccidere. Io ti dico: se vuoi essere ucciso, va' ad altri, và al boia.

Arsensio: Come l'han morta?

Fagone: A bastonate.

Arsensio: Dunque ella è morta?

Fagone: Mortissima.

Arsensio: A bastonate?

Fagone: A bastonatissime.

Arsensio: E sparso tutto il sangue?

Fagone: Tutto il sanguissimo.

Arsensio: O Filesia mia.

Fagone: O cena mia.

Arsensio: O che mi muoio di doglia.

Fagone: O che mi muoio di fame.

Arsensio: E come potrò vivere senza te?

Fagone: E come potrò viver senza cena, come andrò digiuno a letto? Ma habbi
 pazienza, che Idio così ha voluto, che già se egli non havessi voluto,
 questo non sarebbe accaduto.

Aresenio: E come non vuole Idio, che fassi il simile à te?

Fagone: Perchè?

Arsensio: Perchè non l'aiutavi?

Fagone: Attendeva à me.

Arsensio: A che attendevi?

Fagone: A ricoglier la parte mia.

Arsensio: Di che?

Fagone: Delle bastonate.

Arsensio: Che t'importavano due bastonate più ò meno.

Fagone: Canchero, che mi dolevano forte.

Arsensio: Chi dava le bastonate?

Fagone: Mia moglie.

Arsensio: Perche tua moglie?

Fagone: Per rabbia, odio, furore, e gelosia.

Arsensio: O povera, ed innocente, che colpa ci haveva ella?

Fagone: Nè meno ci haveva colpa io.

Arsensio: Dove fu questa ruina?

Fagone: In mezzo la strada.

Arsensio: Dove è il sangue? Dove sono le cervella? Dove la povera morta?

Fagone: Non vedi quà i pezzi? Non senti l'odor del vino, che farebbe risuscitar'
 un morto.

Arsensio: Che vino? Che pezzi?

Fagone: Che donna? Che povera? Che innocente?

Arsensio: Di che parli tu?

Fagone: E tu di che parli?

Arsensio: De Filesia mia.

Fagone: Ed io della mia cena, e del fiasco rotto in mille parti: questo appartiene
 à me, di questo parlavo io.

Arsensio: Canchero mangi te, la tua cena, ed il tuo fiasco.

Fagone: Canchero mangi te, la tua Filesia, e quante femine sono al mondo.

Arsensio: M'havevi trafitto l'anima. In somma che n'è di Filesia? E' viva, or morta? (IV.ii)[63]

Arsenio: Where's my beloved?

Fagone: Bad news.

Arsenio: O unhappiness!

Fagone: Actually, the unhappy one is me, to whom the horrors happened.

Arsenio: What bad news?

Fagone: The worst possible: we have laboured in vain.

Arsenio: They found out about the deception, perhaps, and you didn't accompany her home?

Fagone: Actually, I accompanied her home and then …

Arsenio: What? Tell me right away, don't keep me in suspense, don't kill me little by little, giving me a double death.

Fagone: Sounds, chaos, drownings, killings.

Arsenio: What do you mean by sounds, chaos, and killings?

Fagone: They took her.

Arsenio: Oh no! What are you saying?

Fagone: The truth. At the first meeting a bottle was raised to the head and broke into a thousand parts, spilling blood everywhere.

Arsenio: Oh no! O my life! O cruel death, why don't you take me from the world?

Arsenio: How did they kill her?

Fagone: By beating.

Arsenio: So she is dead?

Fagone: Totally dead.

Arsenio: Because of the beating?

Fagone: A super-duper beating.

Arsenio: With blood everywhere?

Fagone: All of it; a bloodfest.

Arsenio: O my Filesia!

Fagone: O my dinner!

Arsenio: O, I'm dying of pain!

Fagone: O, I'm dying of hunger.

Arsenio: How can I live without you?

Fagone: How can I live without dinner? How can I go to bed famished? What to do? God wanted it this way; if he hadn't, all this wouldn't have happened.

Arsenio: And didn't God want it to happen to you, too?

Fagone:	What, why?
Arsenio:	Why didn't you help her?
Fagone:	Because I would have gotten it, too.
Arsenio:	What would have happened to you?
Fagone:	I would have gotten my share.
Arsenio:	Of what?
Fagone:	Of the beatings.
Arsenio:	What do a few extra beatings here and there matter to you?
Fagone:	Heck, they hurt a ton.
Arsenio:	Who was doing the beating?
Fagone:	My wife.
Arsenio:	Why your wife?
Fagone:	Out of anger, hatred, fury, possessiveness.
Arsenio:	O my poor and innocent one! What was her crime?
Fagone:	I wasn't guilty of anything either.
Arsenio:	Where did this horrendous thing happen?
Fagone:	In the middle of the street.
Arsenio:	Where's the blood? Where are her brains? Where is the poor dead thing?
Fagone:	Don't you see the pieces over there? Don't you smell the wine that would revive a dead man?
Arsenio:	What wine? What pieces?
Fagone:	What woman? What poor thing? What innocent?
Arsenio:	What are you talking about?
Fagone:	What are you talking about?
Arsenio:	About my Filesia.
Fagone:	And I about my dinner, and about the shattered flask – this is mine and this is what I was talking about.
Arsenio:	May a cancer eat you and your dinner, and your flask!
Fagone:	May a cancer eat you, your Filesia and however many women there are in the world.
Arsenio:	You have pierced my soul. So now, where is Filesia? Is she alive or dead?

This sustained dialogue, based entirely on "missed"-understanding and missed signs, is symmetrical: both speakers weave interpretations based on incorrect assumptions regarding their interlocutor's meaning. Like a symmetry group in abstract algebra – an anachronistic comparison for Della Porta's time, but a mathematical object he would likely have found fascinating – this dialogue shows a collection of transformations in which the figures (the character/s)

remain invariant (each stuck in their misunderstanding). Each transforms through a series of ostensibly shared conversational subjects (news, death of the beloved, mourning by the lover), and only at the end of their long, winding conversation do the speakers realize their errors. Arsenio and Fagone were reading from different mental scripts. So, it seems, were Della Porta and the mathematicians of his time reading from different scripts regarding the nature and purpose of mathematics.

A Wave of the Hand

In explaining how to form or measure geometric curves or square the circle, Della Porta managed, with a wave of his hand, to make simple operations appear difficult, the monstrous seem innocuous – and all that he described quite marvellous. Mathematical language, procedure, and form were, for Della Porta, new "elements" for him to manipulate. The magician's wand was always close by the playwright's pen, and mathematics was not far from either:

> One's understanding cannot comprehend high and sublime things unless it stands firm on true principles. Given that the mathematical sciences rise from some trivial and common axioms to most sublime demonstrations, I thought it better to write about true and profitable things, rather than about false things that are great. True things, be they ever so small, will give occasions to discover greater things by them.[64]

Della Porta seems to have understood mathematics as he did language and natural magic: mathematics had the potential to say great things (or to express fascinating tricks and equivocations); its ostensibly simple, "obvious" entities (signs, symbols, phonemes) could be permutated like cryptographic codes to say something more, to serve a greater end. Della Porta conceived of a mathematics that could facilitate a game of combining signs much like the games he played with language in his writing for the theatre. When the parasite Lardone of *La tabernaria* tells an audience, "... vengo per disfamare l'affamata affamatagine del famoso mio affamamento" [... I come here to disfamish the famished famishedness of my renowned famish] (II.iv), for example, Della Porta manipulates a term much as he does with the myriad prefixes and descriptive terminology he uses to name shapes in the *Elementa*, such as *flexi, curvi, semicurvi*.

The *Elementa*'s section devoted to squaring the circle can be viewed, in Francesco Fiorentino's words, as "un nuovo ed impotente sforzo di tentare l'impossibile"

[a new and ineffectual effort to attempt the impossible];[65] and yet, attempting the impossible was what Della Porta loved. As maker of marvels and master of spectacles, he must have seen the discipline of mathematics as offering yet another opportunity to seek affinities, to manipulate signs, to discover secrets. And as with the many other domains to which he turned his attention, he felt able to enter triumphantly, showing that the magus could conquer even this most rational of realms. It was this cavalier hand waving that Tomaso Garzoni critiqued in the *Piazza universale di tutte le professioni del mondo* when he described contemporary "professors of secrets" as seekers after the marvellous, the obscure, the abstruse, and the ultimately useless.[66] But for Della Porta the profession of secrets was his calling and his point of pride. "If ever a man laboured earnestly to discover the secrets of nature it was I," he wrote in the first version of *Magiae*.[67] We could certainly raise our eyebrows at such a claim, but we cannot deny either the force of Della Porta's efforts or the beauty of the results. His mathematics, like his magic and his theatre, pulses with the excitement of discovery in a world of wonder.

Mathematics was central not only to the work Della Porta produced and the way he saw the world, but to the way he saw *himself* in that world: as an instrument of measure and measurement, inscribing, circumscribing, sweeping out new parameters for thought, and revealing secret patterns. In an unpublished notebook Della Porta wrote:

> È stato sempre mia impresa un compasso, non per superbia che volesse dimostrarmi la mia professione di matematico, ma per esser misurato nei mie desiderij, col motto: *Metior, ne metiar.*

> The compass has always been my emblem – not out of pride for my profession as a mathematician, but rather to be metred in my desires – with the motto: *Metior, ne metiar.*[68]

Della Porta's Latin motto offers multiple meanings. It can be read as "I measure, on the condition that I do not measure"; or as "I measure, although I do not measure"; or "I measure, lest I do not measure"; or "I measure, however much I do not measure." *Metior, ne metiar* might even be read as a negative hortatory: "I measure, let me not measure!" Della Porta may have felt like a measurer in spite of himself – or like a person who wishes to "be measured," balanced in his desires and actions, but who is, by nature, wildly devoted to measuring the world around him. Or perhaps the motto looks back at the Sermon on the Mount: "Do not judge or you too will be judged. For in the same way as you judge others, you will

be judged, and with the measure you use, it will be measured to you" (Matthew 7:1–2; and similar in Mark 4:24 and Luke 6:38). Clear in any interpretation, however, is that here Della Porta identifies with the calculator, measurer, and the "learner" or "learned" person that the Greek term *mathêmatikos* implied.

Della Porta also claimed other emblems – a lynx, an oak tree, a grapevine, a candle, and a fish[69] – and Cesi at one point "solidified" Della Porta's emblematic associations with a medal that played on his last name, *Porta* (door), to indicate "the Door through which nature exited from her most secret and deepest hiding places to show herself to philosophers."[70] The motto on the medal's reverse read *Natura reclusa* – "nature disclosed" – and Cesi no doubt sought to honour Della Porta's role in facilitating that disclosure. But of the many emblems Della Porta himself used over his lifetime (magical, astrological, religious, celestial, theatrical, chemical, mechanical, botanical, animal, and mineral), the compass seems most appropriate. The compass measures, but it also creates all sorts of rational, as well as irrational, forms, such as the "gon-less," "perfect" circle. The compass creates a vocabulary of curvilinear and mixed figures, and it reckons shape, area, and size. Like the curved lens Della Porta knew could bring faraway things closer, and which he hoped one day could be used to see Heaven itself, the compass was capable of performing marvels, but ever maintained its link to the natural world, to the real and the rational. As Gabrieli wrote, Della Porta's genius could be compared to "a stream of water which, painstakingly opening the way through centuries of layers and sediments, carries debris of every kind, and then flows out into the open among the wild waves, rich with vital, fertile elements."[71] Some of the errors and oddities of the *Elementa* could be considered debris, but much of what the *Elementa* offers attempts to articulate the beauty of curves, the beauty of mathematics, and the beauty of computation and writing to perform together on a page and in one's mind.

Mathematics inspired Della Porta. It was a language of signs, offering room for invention and manipulation. He could play with mathematics' signs as he did with the language of characters on a stage, or read its signs like the signatures from the heavens that he saw elsewhere in the natural world – on people's faces, on the shapes of flowers, everywhere in the creation around him. Della Porta's affinity with the compass, with being a measured measurer of the world's secrets, reveals his intention and even his sense of obligation to integrate number, shape, symbol, and word into the systems of understanding that he had built and into his own creative interpretations of the human, natural, and celestial worlds. Although he did not cross the threshold into the new edifice of scientific theory and methodology that contemporaries like Galileo and Kepler had begun to

build, he hovered on its doorstep, and he enthusiastically supported the work of younger colleagues at the Accademia dei Lincei and elsewhere in the cities where he lived and visited. Della Porta's mathematical treatise is fascinating not for what it tries (and ultimately fails) to demonstrate, but *for* its hand waving and histrionic flair: what the decision to focus on curvilinear figures and to create new mathematical lexicons can tell us about how and why a thinker like Della Porta would enter into the world of mathematics with magician's wand and writer's pen. We can celebrate the *Elementa* for the inventiveness of its language, for the theatricality of its curvaceous characters, and for the spectacle of squaring the circle. While the mathematics of Della Porta's mathematical work may have vanished into the "in between" of meaning and even utility, the elements (computational signs and symbols that they are) of his *Elementa* still dance on the stage of his writing and thought.

Notes

Introduction

1 William James, review of *Lectures and Essays* (1879), by W.K. Clifford, in *Collected Essays and Reviews* (London: Longmans, Green, and Co., 1920), 138.

2 These are some of the terms Tomaso Garzoni uses to describe mathematicians in his 1585 study *La piazza universale di tutte le professioni del mondo*, ed. Paolo Cherchi and Beatrice Collina, 2 vols. (Turin: Einaudi, 1996), Part 1, Chapters 11, 15, 24: they are "mathematicians," "arithmeticians or calculators or counters," "geometers, measurers, and weighers." All translations from Garzoni are mine.

3 Ibid., Part 1, Chapter 11, 30v and Chapter 20, Discorso 11: "De' matematici in genere."

4 "Complurimas item manus ex iisdem habet humeris fluentes, ex quibus quidem alie calamos, alie lyram, alie laboratam concinnamque gemmam, alie pictum exculptumve insigne, alie mathematicorum varia instrumenta, alie libros tractant. Huic superadscriptum nomen: Humanitas Mater." Leon Battista Alberti, "Picture," in *Intercenales*, ed. and trans. Franco Bacchelli and Luca D'Ascia (Bologna: Pendragon, 2003), § 95, 176. Translation by David Marsh, *Dinner Pieces*, ed. and trans. David Marsh (Binghamton: Medieval & Renaissance Texts & Studies, 1987), 56.

5 See Plato's *Phaedrus*, 274c–275c.

6 See Jean Dietz Moss, "Rhetoric, the Measure of All Things," *MLN* 119.1 (2004): 56–65.

7 Texts that have contributed most to my thinking about mathematics *as* a language, and mathematics *as* narrative, include Brian Butterworth, *The Mathematical Brain* (London: Macmillan, 1999); William Byers, *How Mathematicians Think: Using Ambiguity, Contradiction, and Paradox to Create Mathematics* (Princeton: Princeton University Press, 2007); Daniel F. Daniel, "Math and Metaphor," in *Bridges: Mathematical Connections in Art, Music, and Science: Conference Proceedings*, ed. Reza Sarhangi (Arkansas City: Gilliland, 1998), 225–36; Stanislas Dehaene, *The Number Sense:*

How the Mind Creates Mathematics (New York: Oxford University Press, 1997);
Margarete Delazer et al., "Language and Arithmetic – a Study Using the Intracarotid
Amobarbital Procedure," *NeuroReport* 16.12 (2005): 1403–5; Keith J. Devlin, *The
Math Gene: How Mathematical Thinking Evolved and Why Numbers Are Like Gossip*
(New York: Basic Books, 2000); Peter Gärdenfors, *Conceptual Spaces: The Geometry
of Thought* (Cambridge, MA: MIT Press, 2000); Joanna Gavins and Gerard Steen,
eds., *Cognitive Poetics in Practice* (London: Routledge, 2003); Jacques Hadamard,
An Essay on the Psychology of Invention in the Mathematical Field (New York: Dover,
1954); Nicole Harlaar et al., "Mathematics Is Differentially Related to Reading
Comprehension and Word Decoding: Evidence from a Genetically Sensitive Design,"
Journal of Education Psychology 104.3 (2012): 622–35; Ray Jackendoff, *Foundations
of Language: Brain, Meaning, Grammar, Evolution* (Oxford: Oxford University Press,
2002); Mark Johnson, *The Body in the Mind: The Bodily Basis of Meaning, Imagination,
and Reason* (Chicago: University of Chicago Press, 1987); Edward Kasner and
James Newman, *Mathematics and the Imagination* (New York: Simon and Schuster,
1940); George Lakoff and Rafael Núñez, *Where Mathematics Comes From: How
the Embodied Mind Brings Mathematics into Being* (New York: Basic Books, 2000);
Dieter Lohmar, "Non-Language Thinking in Mathematics," *Axiomathes* 22.1 (2012):
109–20; Paolo Mancosu et al., eds., *Visualization, Explanation and Reasoning Styles
in Mathematics* (Dordrecht: Springer, 2005); Irving Massey, *The Neural Imagination:
Aesthetic and Neuroscientific Approaches to the Arts* (Austin: University of Texas
Press, 2009); Reviel Netz, "Linguistic Formulae as Cognitive Tools," *Pragmatics
& Cognition* 7.1 (1999): 147–76; Barry Mazur, *Imagining Numbers: (Particularly
the Square Root of Minus Fifteen)* (New York: Farrar, Straus, and Giroux, 2003);
John Onians, "Alberti and the Neuropsychology of Style," in *Leon Battista Alberti
e il Quattrocento: Studi in onore di Cecil Grayson e Ernst Gombrich: Atti del convegno
internazionale, Mantova, 29–31 ottobre 1998*, ed. Luca Chiavoni, Gianfranco Ferlisi,
and Maria Vittoria Grassi (Florence: Olschki, 2001), 239–50; Philippe Pinel and
Stanislas Dehaene, "Beyond Hemispheric Dominance: Brain Regions Underlying the
Joint Lateralization of Language and Arithmetic to the Left Hemisphere," *Journal of
Cognitive Neuroscience* 22.1 (2010): 48–66; Steven Pinker, *The Language Instinct: How
the Mind Creates Language* (New York: HarperPerennial, 1995); Howard W. Pullman,
"The Relation of the Structure of Language to Performance in Mathematics," *Journal
of Psycholinguistic Research* 10.3 (1981): 327–38; V.S. Ramachandran and William
Hirstein, "The Science of Art: A Neurological Theory of Aesthetic Experience," *Journal
of Consciousness Studies* 6 (1999): 15–51; Brian Rotman, *Mathematics as Sign: Writing,
Imagining, Counting* (Stanford: Stanford University Press, 2000); Carlo Semenza et al.,
"Is Math Lateralized on the Same Side As Language? Right Hemisphere Aphasia and
Mathematical Abilities," *Neuroscience Letters* 406 (2006): 285–8; Marjorie Senechal,
"Mathematics and Narrative at Mykonos," *Mathematical Intelligencer* 28.2 (2006):
24–33; Stewart Shapiro, *Philosophy of Mathematics: Structure and Ontology* (New York:

Oxford University Press, 1997); Yiyuan Tang et al., "Arithmetic Processing in the Brain Shaped by Cultures," *PNAS* 103.28 (2006): 10775–80; Mark Turner, *The Literary Mind* (New York: Oxford University Press, 1996); and Sabrina Zarnhofer et al., "The Influence of Verbalization on the Pattern of Cortical Activation during Mental Arithmetic," *Behavioral and Brain Functions* 8.13 (2012): 1–15.

8 See my Introduction to "Mathematics and the Imagination," written with Henry S. Turner, for a special issue of *Configurations* 17 (2009): 1–18.

9 Arielle Saiber, *Giordano Bruno and the Geometry of Language* (Burlington: Ashgate, 2005).

10 Timothy Reiss, *Knowledge, Discovery and Imagination in Early Modern Europe: The Rise of Aesthetic Rationalism* (Cambridge: Cambridge University Press, 1997); David Glimp and Michelle R. Warren, eds., *Arts of Calculation: Numerical Thought in Early Modern Europe* (New York: Palgrave, 2004); Jessica Wolfe, *Humanism, Machinery, and Renaissance Literature* (Cambridge: Cambridge University Press, 2004); Henry S. Turner, *The English Renaissance Stage: Geometry, Poetics, and the Practical Spatial Arts 1580–1630* (Oxford: Oxford University Press, 2006); Tom Conley, *The Self-Made Map: Cartographic Writing in Early Modern France* (Minneapolis: University of Minnesota Press, 1996); and Katherine Hunt and Rebecca Tomlin, eds., *Numbers in Early Modern Writing*, special issue of *Journal of the Northern Renaissance* 6 (2014).

11 Among the many studies on mathematics/science and humanism, the following have been highly useful for my project: Ann Blair and Anthony Grafton, "Reassessing Humanism and Science," *Journal of the History of Ideas* 53.4 (1992): 535–40; Marie Boas, *The Scientific Renaissance, 1450–1630* (New York: Harper & Row, 1962); Ernst Cassirer, *The Individual and the Cosmos in Renaissance Philosophy*, 1927, trans. Mario Domandi (Philadelphia: University of Pennsylvania Press, 1972); Eric Cochrane, "Science and Humanism in the Italian Renaissance," *American Historical Review* 81.5 (1976): 1039–57; A.C. Crombie, *Augustine to Galileo: The History of Science, A.D. 400–1650* (London: Falcon Press, 1952); Pierre Duhem, *Le système du monde: Histoire des doctrines cosmologiques de Platon à Copernic*, 10 vols. (Paris: A. Hermann, 1913–59); Eugenio Garin, *Scienza e vita civile nel Rinascimento italiano* (Bari: Laterza, 1965); Glimp and Warren, eds. *Arts of Calculation*; Anthony Grafton, *Defenders of the Text: The Traditions of Scholarship in an Age of Science, 1450–1800* (Cambridge, MA: Harvard University Press, 1991); Alexandre Koyré, *From the Closed World to the Infinite Universe* (Baltimore: Johns Hopkins University Press, 1957); Thomas Kuhn, *The Copernican Revolution: Planetary Astronomy in the Development of Western Thought* (Cambridge, MA: Harvard University Press, 1957); W.R. Laird, "Archimedes among the Humanists," *Isis* 82.4 (1991): 628–38; Pamela O. Long, "Humanism and Science," in *Renaissance Humanism: Foundations, Forms, and Legacy*, ed. Albert Rabil, Jr, vol. 3 (Philadelphia: University of Pennsylvania Press, 1988), 486–512; Jean Dietz Moss, "Rhetoric, the Measure of All Things," *MLN* 119.1 (2004): 56–65; Margaret Osler, *Reconfiguring the World: Nature, God, and Human Understanding from the Middle Ages*

to Early Modern Europe (Baltimore: Johns Hopkins University Press, 2010); Reiss, *Knowledge, Discovery and Imagination in Early Modern Europe*; Neil Rhodes and Jonathan Sawday, eds., *The Renaissance Computer: Knowledge Technology in the First Age of Print* (London: Routledge, 2000); Paul Lawrence Rose, "Humanist Culture and Renaissance Mathematics: The Italian Libraries of the Quattrocento," *Studies in the Renaissance* 20 (1973): 46–105; Paolo Rossi, *La nascita della scienza moderna in Europa* (Bari: Laterza, 1997); George Sarton, *Six Wings: Men of Science in the Renaissance* (Bloomington: Indiana University Press, 1957); Lynn Thorndike, *A History of Magic and Experimental Science*, 8 vols. (New York: Columbia University Press, 1934–58); and Cesare Vasoli, *Magia e scienza nella civiltà umanistica* (Bologna: Il Mulino, 1976).

12 On mathematics in the Renaissance, see Kristi Andersen and Henk J.M. Bos, "Pure Mathematics," in *The Cambridge History of Science Vol 3: Early Modern Science*, ed. Katharine Park and Lorraine Daston (Cambridge: Cambridge University Press, 2006), 679–723; Mario Biagioli, *Galileo, Courtier: The Practice of Science in the Culture of Absolutism* (Chicago: University of Chicago Press, 1993) and "The Social Status of Italian Mathematicians 1450–1600," *History of Science* 27.1 (1989): 41–95; Florian Cajori, *A History of Mathematical Notations*, 1928–9 (New York: Dover, 1993); Marshall Clagett, ed., *Critical Problems in the History of Science: Proceedings* (Madison: University of Wisconsin Press, 1959); Marshall Clagett, ed., *Archimedes in the Middle Ages*, 10 vols. (Madison: University of Wisconsin Press, 1964–84); Paolo Freguglia, *La geometria fra tradizione e innovazione: Temi e metodi geometrici nell'età della rivoluzione scientifica, 1550–1650* (Turin: Bollati Boringhieri, 1999); Menso Folkerts, *The Development of Mathematics in Medieval Europe: The Arabs, Euclid, Regiomontanus* (Burlington: Ashgate, 2006); Thomas Heath, Introduction, *Euclid: The Thirteen Books of the Elements*, ed. and trans. Thomas Heath, 3 vols. (New York: Dover, 1956); George Hersey, *Pythagorean Palaces: Magic and Architecture in the Italian Renaissance* (Ithaca: Cornell University Press, 1976); Jens Høyrup, *Measure, Number, and Weight: Studies in Mathematics and Culture* (Albany: SUNY Press, 1994) and *The Founding of Italian Vernacular Algebra* (Roskilde: Roskilde University, 1999); Morris Kline, *Mathematical Thought from Ancient to Modern Times*, 3 vols. (Oxford: Oxford University Press, 1972); François Le Lionnais, ed., *Great Currents of Mathematical Thought*, 1962, trans. R.A. Hall and Howard G. Bergman, 2 vols. (New York: Dover, 1971); Guillaume Libri, *Histoire des sciences mathématiques en Italie: Depuis la renaissance des lettres jusqu'à la fin du dix-septième siècle*, 4 vols. (Paris: J. Renouard, 1838–41); Karl Menninger, *Number Words and Number Symbols: A Cultural History of Numbers*, trans. Paul Broneer (Cambridge, MA: MIT Press, 1969); Pier Daniele Napolitani and Pierre Souffrin, eds., *Medieval and Classical Traditions and the Renaissance of Physico-Mathematical Science in the 16th Century* (Turnhout: Brepols, 2001); Karen H. Parshall, "The Art of Algebra from Al-Khwarizmi to Viète: A Study in the Natural Selection of Ideas," *History of Science* 26.2 (1988): 129–64; Pietro Riccardi, *Biblioteca matematica italiana dalla origine della stampa ai primi anni del secolo XIX*,

3 vols. (Modena: Soliani, 1870–86); Warren Van Egmond, "The Contributions of
the Italian Renaissance to European Mathematics," *Symposia Mathematica* 27 (1983):
51–67; G.J. Whitrow, "Why Did Mathematics Begin to Take Off in the Sixteenth
Century?" in *Mathematics from Manuscript to Print, 1300–1600*, ed. Cynthia Hay
(Oxford: Clarendon Press, 1988), 264–9; and works cited in the bibliography for
each case study, especially the work on Alberti and cryptography by David Kahn,
and on Alberti's mathematics by Kim Williams; on Pacioli and letterforms by Stanley
Morison; on Tartaglia by Veronica Gavagna; and on Della Porta by Veronica Gavagna
and Pier Daniele Napolitani.

13 Elizabeth Eisenstein, *The Printing Press as an Agent of Change: Communications and
Cultural Transformations in Early Modern Europe*, 2 vols. (Cambridge: Cambridge
University Press, 1979); Anthony Grafton, "The Importance of Being Printed," *Journal
of Interdisciplinary History* 11.2 (1980): 265–86; Cynthia Hay, ed., *Mathematics from
Manuscript to Print, 1300–1600* (Oxford: Clarendon Press, 1988); Robin Rider, "Early
Modern Mathematics in Print," in *Non-Verbal Communication in Science Prior to 1900*,
ed. Renato G. Mazzolini (Florence: Olschki, 1993), 91–113; Robert S. Westman,
"On Communication and Cultural Change," *Isis* 71.3 (1980): 477.

14 On Renaissance education, see especially James Bowen, ed., *Civilization of Europe, Sixth
to Sixteenth Century* (London: Methuen & Co., 1975), vol. 2 of *A History of Western
Education*; Eugenio Garin, *L'educazione in Europa, 1400–1600: Problemi e programmi*
(Bari: Laterza, 1976); Grafton, *Defenders of the Text*; Paul Grendler, *Schooling in
Renaissance Italy: Literacy and Learning, 1300–1600* (Baltimore: Johns Hopkins
University Press, 1989); Paul Grendler, *The Universities of the Italian Renaissance*
(Baltimore: Johns Hopkins University Press, 2002); Paul Oskar Kristeller, *Renaissance
Thought: The Classic, Scholastic, and Humanist Strains* (New York: Harper & Row,
1961); Albert Rabil, Jr, ed., *Renaissance Humanism: Foundations, Forms, and Legacy*
(Philadelphia: University of Pennsylvania Press, 1988); and John Herman Randall,
Jr, *The School of Padua and the Emergence of Modern Science* (Padua: Antenore, 1961).

15 Works catalytic to my thinking about the conversation between arts and sciences in
general include Vittore Branca et al., eds. *Letteratura e scienza nella storia della cultura
italiana: Atti del IX Congresso A.I.S.L.L.I.: Palermo-Messina-Catania, 21–25 aprile
1976* (Palermo: Manfredi, 1978); Eva Brann, *The World of the Imagination: Sum
and Substance* (Savage, MD: Rowman & Littlefield, 1991); Scott Buchanan, *Poetry
and Mathematics* (New York: The John Day Company, 1929); Mary B. Campbell,
Wonder and Science: Imagining Worlds in Early Modern Europe (Ithaca: Cornell
University Press, 1999); Conley, *The Self-Made Map*; Sarah Glaz, "Poetry Inspired
by Mathematics: A Brief Journey through History," *Journal of Mathematics and the
Arts* 5.4 (2011): 171–83; Stephen Greenblatt, *The Swerve: How the World Became
Modern* (New York: W.W. Norton, 2011); Fernand Hallyn, *The Poetic Structure of
the World: Copernicus and Kepler*, 1987, trans. Donald M. Leslie (New York: Zone,
1993); N. Katherine Hayles, *Chaos and Order: Complex Dynamics in Literature and

Science (Chicago: University of Chicago Press, 1991); N. Katherine Hayles, *Writing Machines* (Cambridge, MA: MIT Press, 2002); S.K. Heninger, Jr, *Touches of Sweet Harmony: Pythagorean Cosmology and Renaissance Poetics* (San Marino: Huntington Library, 1974); Dorothy Koenigsberger, *Renaissance Man and Creative Thinking: A History of Concepts of Harmony, 1400–1700* (Hassocks: Harvester, 1979); Laird, "Archimedes among the Humanists"; Jean-Pierre Luminet, ed., *Les poètes et l'univers* (Paris: Le Cherche Midi, 1996); Giuseppe Mazzotta, *Cosmopoiesis: The Renaissance Experiment* (Toronto: University of Toronto Press, 2001); Franco Moretti, *Graphs, Maps, Trees: Abstract Models for a Literary Theory* (London: Verso, 2005); Reviel Netz, "The Aesthetics of Mathematics: A Study," in *Visualization, Explanation and Reasoning Styles in Mathematics*, ed. Paolo Mancosu, Klaus Frovin Jorgensen, and Stig Andur Pedersen (Dordrecht: Springer, 2005), 251–94; Robert Osserman, *Poetry of the Universe: A Mathematical Exploration of the Cosmos* (New York: Anchor Books, 1995); Mark Peterson, *Galileo's Muse: Renaissance Mathematics and the Arts* (Cambridge, MA: Harvard University Press, 2011); Georges Poulet, *The Metamorphoses of the Circle*, trans. Carley Dawson and Elliott Coleman (Baltimore: Johns Hopkins University Press, 1966); Ezio Raimondi, *Scienza e letteratura* (Turin: Einaudi, 1978); Rotman, *Mathematics as Sign*; Walter Schatzberg, Ronald A. Waite, and Jonathan K. Johnson, eds., *The Relations of Literature and Science: An Annotated Bibliography of Scholarship, 1880–1980* (New York: Modern Language Association of America, 1987); Michel Serres, Josué V. Harari, and David F. Bell, *Hermes: Literature, Science, Philosophy* (Baltimore: Johns Hopkins University Press, 1981); Barbara Herrnstein Smith and Arkady Plotnitsky, eds., *Mathematics, Science, and Postclassical Theory* (Durham, NC: Duke University Press, 1997); and journals including *Configurations: A Journal of Literature, Science, and Technology; Journal of Mathematics and the Arts; Journal of Humanistic Mathematics;* and *Leonardo: Journal of the International Society for the Arts, Sciences, and Technology.*

16 Baldi prefaces his "One Hundred Apologues" (1582) with a greeting to Alberti, complimenting the latter's own apologues and asking Alberti's spirit to approve Baldi's. If Baldi's hundred apologues don't please, he suggests that Alberti's spirit may "burn them or sink them in the waters of the Lethe." (Baldi's preface is itself in imitation of Alberti, who wrote a similar plea to Aesop.) The spirit of Alberti returns a favourable reply to Baldi: "Greetings. When I was alive, I witnessed the lively ingenuity of your fellow citizens. I return your writings, which deserve neither fire nor Lethe's waters. Pursue virtue, and live happily. Farewell." Translation by David Marsh, *Renaissance Fables: Aesopic Prose by Leon Battista Alberti, Bartolomeo Scala, Leonardo da Vinci, Bernardino Baldi* (Tempe: Arizona Center for Medieval and Renaissance Studies, 2004), 321.

17 In his *Cronica de' matematici*, written between 1586 and 1590 and published posthumously by A.A. Monticelli (Urbino, 1707), Baldi writes brief biographies of Alberti, Pacioli, and Tartaglia (he includes a longer *vita* of Alberti in the *Vite*). He says nothing of Della Porta in either work.

On Alberti he wrote, "Leon Battista Alberti nobile Fiorentino huomo d'ingegno acutissimo, & à tutti gli studii egualmente disposto, attese felicemente alla Pittura, Architettura, & alle Matematiche, e scrisse con molta eleganza in latino più libri. Lasciò dieci libri d'Architettura, ne quali pare, che non solo emulasse, ma superasse Vitruvio. Scrisse di pittura, de lumi, e dell'ombre. Scrisse anco le piacevolezze Matematiche, & un libro della nave. Fù argutisimo nelle cose morali, onde leggiamo del suo cento Apologi, il Momo, overo del Prencipe, & alcune altre opere. Dicono, ch'egli per via dello specchio fece il suo ritratto eccellentissimamente al naturale" [Leon Battista Alberti, Florentine noble, man of acute genius and equally excellent at all studies, engaged happily in painting, architecture, and mathematics; he wrote a great many books in Latin with great eloquence. He authored ten books on architecture in which he not only emulated Vitruvius, but surpassed him. He wrote on painting, light, and shadows. He also wrote on mathematical games, and a book on ships. He was sophisticated on topics of morality, as we can read in his one hundred *Apologues*, in *Momus, or the Prince*, and in other works. They say that he produced an excellent portrait of himself by using a mirror]. *Cronica de' matematici*, 98–9. All translations of Baldi's works, besides the *Apologues*, are mine.

On Pacioli: "Luca Pacioli dal Borgo S. Sepolcro Frate Minoritano di S. Francesco, attese fin da fanciullo alle Matematiche, nelle quali per l'acutezza del suo ingegno egli divenne eccellente. Fù publico Lettore delle dette professioni in Perugia, ove scrisse alcuni libri d'Algebra, e dedicolli alla gioventù Perugina. Fù doppo chiamato col detto carico in Roma, & indi à Napoli. Scrisse molte opere Geometriche, & Aritmetiche. Tradusse in volgare gl'Elementi d'Euclide. Scrisse il libro della Divina proportione, e compilò quel suo gran volume, intitolato – Somma dell'Aritmetiche, e Geometriche proportioni, la quale egli dedicò al Duca Guidobaldo figliuolo di Federico Feltrio d'Urbino. Scrisse anco un libro de corpi regolari, & alcune altre cose. Fù egli barbaro nella lingua, poiche senza alcuna scelta mescolava le parole volgari, e le latine, e l'une, e l'altre corrompeva, il che diede occasione ad Annibal Caro di chiamar l'opere di Fra Luca ceneracci, poiche era in loro sepolto l'oro delle cose come fra le ceneri degl'Orefici sogliono esser nascoste le minuzzaglie dell'oro" [Luca Pacioli from Borgo S. Sepolcro, Friar Minor of Saint Francis, laboured since childhood on mathematics, [a subject] in which, given the brilliance of his intellect, he became excellent. He was a public lector of this profession in Perugia, where he wrote a few algebra books, and dedicated them to the youth of Perugia. He was, then, called to teach mathematics in Rome, and then in Naples. He wrote many works on geometry and arithmetic. He translated Euclid's *Elements* into the vernacular. He wrote the book *Della Divina proportione* and compiled his great volume, entitled *Summa dell'aritmetiche e geometriche proportioni*, which he dedicated to Duke Guidobaldo son of Federico da Montefeltro of Urbino. He also wrote on regular bodies and some other things. He was barbarian in his language, randomly mixing together Italian and Latin words, both of which he corrupted, and gave Annibale Caro the occasion to call the works of Fra Luca "dirty ashes," within which

one could find gold, as among the ashes of goldsmiths one can often find little bits of gold hidden]. *Cronica de' matematici*, 107.

On Tartaglia: "Nicolò Tartaglia Bresciano d'humile nascimento attese alle cose Matematiche, e particolarmente alla Geometria, & all'Aritmetica con tanto genio, che si lasciò molti adietro. Trasferì costui in lingua volgare gl'Elementi di Euclide ch'egli leggeva publicamente in Venetia. Scrisse molte opere appartenenti al moto de corpi gravi, à tiri dell'Artigliarie, à fortificationi de luoghi, à misurar con la vista, and altre cose tali, e finalmente scrisse due gran volumi, ne quali raccolse tutto quello, che s'appartiene ad una compita specolatione, e pratica delle cose dell'Aritmetica, e della Geometria. Fù egli grand'Avversario di Girolamo Cardano, e scrisseli contro alcune opere. Attese nondimeno così poco alla bontà della lingua, che move à riso talhora chi legge le cose sue" [Nicolò Tartaglia of Brescia of humble birth dedicated himself to mathematical things, particularly geometry and arithmetic, with such great genius that he left many in the dust. He translated Euclid's *Elements* into the vernacular, and read it aloud to the public in Venice. He wrote many works on the motion of heavy bodies, on ballistics, on fortifications, on surveying, and other similar things, and two massive volumes in which he gathered all things that belonged to the theory and practice of arithmetic and geometry. He was a major adversary of Girolamo Cardano and wrote a few works against him. One could, nonetheless, expect to see little good to his language, to the point that it incites laughter in whoever reads his works]. *Cronica de' matematici*, 133.

18 In Garzoni's *Piazza universale* Alberti is among the astronomers and astrologers (Dis. 39); the painters, miniaturists, and mosaic artists (Dis. 90); the architects, fortress fortifiers, machine masters, and engineers (Dis. 107); and the ship builders, mariners, boat builders, customs officials, raft builders, pirates, and privateers. Pacioli is only placed with arithmeticians, calculators, and counters (Dis. 15); while Tartaglia is located with arithmeticians, calculators, and counters (Dis. 15), and also with the military, captains and soldiers, and mine makers (Dis. 82). Like Alberti, Tartaglia is also grouped with the architects, fortress fortifiers, machine makers, and engineers (Dis. 107). Della Porta is with the professors of secrets (Dis. 22); with incantatory magicians, venomous or evil enchanters or necromants, seers, and the superstitious (Dis. 41); the ruffians (pimps or panderers) (Dis. 75); and mirror makers and utilizers (Dis. 145). Alberti can also be found in Garzoni's *Theatro de' vari e diversi cervelli mondani* (Venice: Paolo Zanfretti, 1583), Dis. 34, among the "huge universal brains, industrious and brilliant" (Cervelloni universali, industriosi ed ingegnosi).

19 Out of two hundred lives, only those of Hero and Vitruvius – the only two lives he wrote in Latin – were published before Baldi's death. Baldi included the life of Vitruvius in his *De verborum Vitruvianorum significatione* (Augsburg: Johannes Praetor, 1612) and that of Hero in his *Heronis ctesibii belopoeeca* (Augsburg: Davidis Franci, 1616). Not even the biography of his beloved teacher and friend, the great mathematician Federico Commandino, was published in Baldi's lifetime, although Commandino's death in 1575 was Baldi's declared inspiration for writing

his biographies of mathematicians (see "La vita di Commandino," first published in *Giornale de' Letterati d'Italia* 19 [1714]: 140–85). Roughly half of the other lives have been published to date, less than eighty of them with critical commentary. The first life to appear after Baldi's death was, appropriately, Commandino's, in 1714; nothing further appeared for the rest of the eighteenth century. Fifty-four of Baldi's lives were published in the nineteenth century: lives of twenty-eight Italian mathematicians by Enrico Narducci (see Narducci, "Vite inedite di matematici italiani scritte da Bernardino Baldi" in *Bullettino di bibliografia e di storia delle scienze matematiche e fisiche* 19 (1886): 335–406, 437–89, 521–640); thirteen Arab mathematicians by Moritz Steinschneider (see Steinschneider, "Vite di matematici arabi tratte da un'opera inedita di Bernardino Baldi" in *Bull.* 5 [1872]: 429–534); and the lives of Gerard of Cremona, Aristides Quintilianus, Johannes Eligerius, Alhazen, Witelo, Andalò de Negri, Hero of Alexandria, John of Saxony, John of Lignéres, Luca Pacioli, Paolo dal Pozzo Toscanelli, Pythagoras, and Paul of Middleburgh by a variety of different scholars (see Elio Nenci's bibliography in *Le vite de' matematici. Edizione annotata e commentata della parte medievale e rinascimentale*, ed. Nenci [Milan: FrancoAngeli, 1998], 29–30). In 1998 Nenci completed an excellent critical edition of the seventy-two medieval and early modern mathematicians, from Persian-Jewish late eighth-century astronomer Mashallah through Guidobaldo del Monte. The classical authors up to Mashallah have yet to be systematically edited.

The *Vite* survive in two autograph manuscripts and two early copies (exact date and copyist unknown) at the Centro Internazionale di Studi Rosminiani, located in Stresa (Piedmont). The two autographs are Tomo I: Coll. Boncompagni 153 (cat. 1862), 62 (cat. 1892), già Codice Albani 618, carte 1–466; and Tomo II: Coll. Boncompagni 154 (cat. 1862), 63 (cat. 1892), già Codice Albani 618, carte 1–499. The two early copies of the *Vite* are Tomo I: Coll. Boncompagni 155 (cat. 1862), 64 (cat. 1892), già Codice Albani 619, carte 1–704; and Tomo II: Coll. Boncompagni 156 (cat. 1862), 65 (cat. 1892), già Codice Albani 619, carte 1–601. The Centro also has a slightly later copy of one volume: Tomo II: Coll. Boncompagni 157 (cat. 1862), 66 (cat. 1892), già Codice Albani 619, carte 1–503. These four texts, plus another early copy of the *Vite* also held at the Centro in Stresa, have a convoluted history. Scholars presume that some lives contained in the copies, which do not exist in the autographs, may have been copied from autographs no longer extant (See Nenci, *Le vite de' matematici*, 13–30 and Alfredo Serrai, *Bernardino Baldi: La vita, le opere, la biblioteca* [Milan: Bonnard, 2002]). There is no edited publication of all two hundred lives, but a team at the Max-Planck-Institut für Wissenschaftsgeschichte has recently completed scanning all the material at Stresa and made it available on the European Cultural Heritage Online website; the two autograph manuscripts, two early copies, and one later copy can all be accessed through ECHO (Cultural Heritage Online). Also accessible via this site is the *Cronica de' matematici*, which is now held at the University of Oklahoma's History of Science Library, and Giovanni Crescimbeni's autograph of *La vita di Monsignore Bernardino Baldi* dated 1704.

The first volume (Tomo I) of Baldi's autograph manuscript contains 70 classical mathematicians, arranged in an approximate, but not precise, chronological order, starting with Pythagoras and ending with Vitruvius. The second autograph (Tomo II) contains a total of 105 mathematicians (bringing the total to 175) from antiquity through the early modern period. Here again, the lives are not presented in precise chronological order; the manuscript begins with Dionysius Exiguus and ends with Christopher Clavius (though in fact the life of Proclus follows that of Clavius). Of the two volumes constituting the early copy of the *Vite*, the first (Tomo I) includes 88 classical mathematicians. Eighteen of these mathematicians are not present in the autographs, indicating that they were either written by someone other than Baldi and added to the *Vite*, or that Baldi had written them in a now-lost manuscript. Given the importance of some of these "added" mathematicians – including Euclid and Archimedes – most scholars consider the latter theory more likely. With these 18 new classical mathematicians, the total number of lives now reaches 193. The second volume of the copy (Tomo II) held at Stresa contains 113 lives, with 7 mathematicians not included in either of the two Baldi autographs or in Tomo I of the copy. With these 7 mathematicians – including Boethius, Ptolemy, Nicomachus, and Federico Commandino – the total count of lives is 200.

A manuscript copy of the *Cronica* (also held at the Centro Internazionale di Studi Rosminiani: Coll. Boncompagni 158 [cat. 1862, 68 (cat. 1892], carte 1–91) can, like the *Vite* manuscripts, be found online through ECHO (Cultural Heritage Online).

20 Baldi added Thales, who comes chronologically before Pythagoras, later in the text.
21 Van Egmond, "The Contributions of the Italian Renaissance to European Mathematics," 67.
22 Cap. 20: "dev'essere oratore, dialettico, fisico ed anche filosofo morale: ha bisogno delle cognizioni matematiche, e della notizia delle leggi divine e umane …' [he must be an orator, dialectician, physicist, and moral philosopher, too. He needs mathematical knowledge, and information about divine and human laws …], *Breve trattato dell'istoria* in *Versi e prose scelte di Bernardino Baldi*, ed. Filippo Ugolini and Filippo-Luigi Polidori (Florence: Le Monnier, 1859), 624.
23 Ibid., 621.
24 See Baldi's *vite* of Campanus and Witelo, for example.
25 Ann Moyer, "Renaissance Representations of Islamic Science: Bernardino Baldi and His Lives of Mathematicians," *Science in Context* 12.3 (1999): 469–84.
26 Baldi obtained most of his source material for the *Vite* in Padua, Milan, Urbino, and Rome, as well as in Guastalla. Sources include Commandino's preface to his edition of Euclid's *Elements* (1572), Guidobaldo del Monte's introduction to *De Aequeponderantibus*, the Suda (tenth-century Byzantine encyclopedia), Plutarch, Petrus Ramus, Trithemius, Conrad Gesner, Erasmus Reinhold, Georg von Peuerbach, Girolamo Cardano, and Scaliger. While Baldi is considered the first modern historian of mathematics, he was also able to draw on the work of scholars who in fact predated

him (albeit with less monumental projects), including ancients Eudemus of Rhodes, Eutocius of Ascalon, and Simplicius; and early moderns Niccolò Luccari, Giglio Gregorio Giraldi, Ramus, Luca Gaurico, and Regiomontanus.

27 On Commandino, Baldi writes: "Negli studij fu egli assiduo, percioché non era solito di studiare fra la mattina e la sera manco di otto hore. Nel mangiare fu sobrio, nel vestire pulito e condecent al suo grado e tale apunto quale si conveniva ad uomo di lettere giudizioso e conversato in corte. Nel ragionare non molto eloquente, essendo egli nato più tosto per lo scrivere ... Di statura era giusta e quadrata, di faccia venerabile e leonine, e di bonissimo colore d'andare grave e conforme all'età et alla professione ... s'egli non fosse stato inclinato alquanto a' piaceri femminili, Momo medesimo non hevrebbe trovato in che riprenderlo," in Nenci, ed., Le vite de' matematici, 518.

28 From the sonnet "Chi traduce," which precedes Baldi's Discorso di chi traduce sopra le machine se moventi, transcribed by Giovanni Ferraro, Bernardino Baldi e il recupero del pensiero tecnico-scientifico dell'antichità (Alessandria: Edizioni dell'Orso, 2008), 135; see also Baldi, Versi e prose scelte, 242.

29 See Chapter 13 of Baldi's Descrizione del Palazzo Ducale d'Urbino in Versi e prose scelte, 540.

1. Cryptographica

1 Hermann Weyl, "The Mathematical Way of Thinking," in The World of Mathematics, ed. James Roy Newman, vol. 3 (New York: Simon and Schuster, 1956), 1836.

2 "Cum essem apud Dathum in hortis pontificis maximis ad Vaticanum et nostro pro more inter nos sermones haberentur de rebus quae ad studia litterarum pertinerent, incidit ut vehementer probaremus Germanum inventorem qui per haec tempora pressionibus quibusdam characterum efficeret ut diebus centum plus CCta volumina librorum opera hominum non plus trium exscripta redderentur dato ab exemplari ... Unica enim pressione integram exscriptam reddit paginam maioris chartae. Hinc cum itidem aliquorum ingenia circa res varias laudaremus, vehementer admirari Dathus visus est eos qui fictis characterum inusitatissimorurm significationibus litteras tantum ex composito consciis notas, quas cyfras nuncupant, suis scrutandi artibus compertum quid narrent, faciant atque explicent." De Cifris, 1, 27–8. All page references to De Cifris in Latin are to the following edition: Dello scrivere in cifra, ed. Augusto Buonafalce and Alessandro Zaccagnini (Turin: Galimberti, 1994). Unless otherwise noted, translations into English of De Cifris are from the following edition: Kim Williams, trans., The Mathematical Works of Leon Battista Alberti, ed. Kim Williams, Lionel March, and Stephen R. Wassell (Basel: Birkhäuser, 2010).

3 "Hoc opusculum velim apud amicos nostros observari ne in vulgus imperitorum prodeat et profanetur digna res principe et maximis rebus agendis dedito." De Cifris, 26, 46.

4 See Buonafalce's introduction in Dello scrivere in cifra, ed. Buonafalce and Zaccagnini, xv–xvi.

5 *Opuscoli morali*, ed. Cosimo Bartoli (Venice: Franceschi, 1568), 200–19. Included in this collection of translated works are *Momo*; *Discorsi da Senatori*; *Dell'amministrar la ragione*; *Della comodità e incomodità delle lettere*; *Della vita di San Potito*; *La Cifera*, *Piacevolezze matematiche*; *Della republica, vita civile, e rusticana, e della fortuna*; *Della statua*; *Della pittura*; *Della mosca*; *Del cane*; *Apologi*; *Hecathonfila*; *Deifira*.

6 *A Treatise on Ciphers*, ed. Augusto Buonafalce, trans. Alessandro Zaccagnini (Turin: Galimberti, 1997). This is the first English translation.

7 See Williams et al., eds., *The Mathematical Works of Leon Battista Alberti*, and Lucia Bertolini, *Leon Battista Alberti: Censimento dei manoscritti*, 2 vols. (Florence: Polistampa, 2004) for the most recent census of *De Cifris* manuscripts. Charles Mendelsohn notes manuscript copies of *De Cifris* in Rome's Chigi Library (first part of Cod. M II 49, f. 9–34v), the Vatican Library (Series Politicorum, vol. LXXX, f. 173–81; Cod. Vat. Lat. 6532, f. 176–201), and the State Archives of Venice (Trattati in Cifra, busta VI, No. 1); see Mendelsohn, "Bibliographical Note on the *De Cifris* of L.B. Alberti," *Isis* 32 (1940): 48–51. Aloys Meister assigns all but the last to the end of the sixteenth century; he dates the Archives of Venice copy to the seventeenth century. See Meister, *Die Geheimschrift im Dienste der Päpstlichen Kurie Von Ihren Anfängen Bis Zum Ende des XVI. Jahrhunderts. Mit fünf kryptographischen Schriftafein* (Paderborn: F. Schöningh, 1906). Girolamo Mancini locates the following manuscripts: Magliabechianus 6, cl. XVII, fo. 187 and Magliabechianus II.IV.39, fo. 187–93 (not complete) at Florence's Biblioteca Nazionale Centrale; Riccardiana 0767, fo. 45 and Riccardiana 0927; Marciana, 32, cl. XI (Cod. Marc. Lat. XIV 32); and an uncatalogued manuscript of the Marquis Ferraioli of Rome. See Mancini, *Vita di Leon Battista Alberti* (Florence: Sansoni, 1882). See also B.VI.39 at the Marucelliana; Cod. Vat. Lat. 5118 and Cod. Vat. Lat. 5357 at the Vatican; Lat. 8754 at the Bibliothèque Nationale in Paris; and Misc. Correr 47 2130 at the Museo Civico Correr.

8 Johannes Trithemius holds the honour of authoring the first printed book on cryptography: *Polygraphia libri sex* (written in 1506, and published posthumously in Basel, 1518). For Giovan Battista Bellaso, see *La cifra* (Venice, 1553), *Novi et singolari modi di cifrare* (Brescia, 1555), and *Il vero modo di scrivere in cifra* (Brescia, 1564). For Blaise de Vigenère, see his *Traicté des Chiffres* (Paris, 1586). Giovanni Soro's works have been lost.

The earliest known cipher system in Italy (a simple homophonic substitution cipher) is that of Simeone de Crema (Mantua, 1401). David Kahn asserts that the earliest published Western cryptographic treatise is Italian, and by Cicco Simonetta: *Regule ad extrahendum litteras zifratas sine exemplo* (1474); see Kahn, *The Codebreakers* (New York: Scribner's, 1967), 110. Marcello Simonetta, a scholar and descendant of Cicco, used this treatise to decode a letter implicating Federico da Montefeltro in the Pazzi Conspiracy of 1478; see Simonetta, "Federico da Montefeltro architetto della Congiura dei Pazzi e del Palazzo di Urbino," in *Francesco di Giorgio alla corte di Federico da Montefeltro: Atti del convegno internazionale di studi: Urbino, Monastero di Santa Chiara,*

11–13 ottobre 2001, ed. Francesco Paolo Fiore (Florence: Olschki, 2004), 81–102 and "Federico da Montefeltro contro Firenze. Retroscena inediti della congiura dei Pazzi," *Archivio storico italiano* 161 (2003): 261–84.

Other notable early Italian cryptographic treatises are by Michele Zopello, *Litterarum simulationis liber* (Rome, 1455–8); Girolamo Cardano, *De subtilitate rerum* (Nuremberg, 1550) and *De rerum varietate* (Basel, 1556); and Giambattista Della Porta, *De furtivis literarum notis* (Naples, 1563).

For information about Italian Renaissance cryptographers, see Kahn, *The Codebreakers*, 106–56; Rawdon Brown, "History of Italian Cipher," in *Calendar of State Papers and Manuscripts Existing in the Archives and Collections of Venice*, vol. 2 (London: Longmans, Green, Reader, and Dyer, 1867), xix–xxii; Luigi Sacco, ed. and trans., *Un primato italiano: La crittografia nei secoli XV e XVI* (Rome: Istituto Storico e di Cultura dell'Arma del Genio, 1958); and Gerhard F. Strasser, "The Rise of Cryptology in the European Renaissance," in *The History of Information Security: A Comprehensive Handbook*, ed. Karl de Leeuw and Jan Bergsta (Boston: Elsevier, 2007), 277–325.

9 On mathematics as a dark art, see G.J. Whitrow, "Why Did Mathematics Begin to Take Off in the Sixteenth Century?" in *Mathematics from Manuscript to Print 1300–1600*, ed. Cynthia Hay (Oxford: Clarendon Press, 1988), 264–9. On mathematics' status as a speculative, secondary art, see Raffaele Rinaldi and Ludovico Geymonat's introduction to their edition of Alberti's *Ludi matematici* (Milan: Guanda, 1980), 8.

10 See Mario Carpo's discussion of the printing press's importance to the architectural imagination, *Architecture in the Age of Printing: Orality, Writing, Typography, and Printed Images in the History of Architectural Theory*, trans. Sarah Benson (Cambridge, MA: MIT Press, 2001).

11 Ovid, *Ars amatoria*, Book 3. 627–30; Suetonius, *De Vita Caesarum: Divus Julius*, 56.6 and *Divus Augustus* 88.1; and Aulus Gellius, *Noctes Atticae*, 17.9 speak of the monoalphabetic cipher used by Caesar, now known as the Caesar Cipher, which was a simple substitution system.

12 The few scholars who have discussed the origins of Alberti's two-wheel cipher system have noted the possibility that Alberti knew Ramón Llull's *Ars inventiva veritatis*.

13 See M.D. Feld, "Constructed Letters and Illuminated Texts: Regiomontanus, Leon Battista Alberti, and the Origins of Roman Type," *Harvard Library Bulletin* 28 (1980): 357–79.

14 Mancini, *Vita di Leon Battista Alberti*; Paul-Henri Michel, *Un idéal humain au XVe siècle: La pensée de L.B. Alberti* (Paris: Les Belles Lettres, 1930); Cecil Grayson, "Leon Battista Alberti and the Beginnings of Italian Grammar," 1943, in *Il volgare come lingua di cultura dal Trecento al Cinquecento: Atti del convegno internazionale, Mantova, 18–20 ottobre 2001*, ed. Arturo Calzona et al. (Florence: Olschki, 2003), 193–213; Joan Gadol, *Leon Battista Alberti: Universal Man of the Early Renaissance* (Chicago: University of Chicago Press, 1969); Anthony Grafton, *Leon Battista Alberti: Master Builder of the Italian Renaissance* (Cambridge, MA: Harvard University Press, 2000).

15 See Williams et al., eds., *The Mathematical Works of Leon Battista Alberti*; and Bernard Ycart, "Alberti's Letter Counts," *Literary and Linguistic Computing* 29.2 (2014): 255–65.

16 A number of the manuscript copies I consulted, such as Magliabechianus II.IV.39, were missing the wheels and number table, either indicating that the copyist did not take the time to make them, or that they were removed for use. Riccardiana 0767 did not have a wheel, but did have the number table. One manuscript has the wheels, but introduces several errors, such as including H, K, and Y in the outer wheel (which Alberti does not), adding a rotunda *rum* syllable, and leaving out the numbers 1–4.

17 The Latin passage reads: "Sic enim adnotasse videor apud poetas vocales a consonantibus numero superari non amplius quam ex **octava**; apud rhetores vero non excedere consonantes ferme ex proportione quam **sesquitertiam** nuncupant. Nam si fuerint quidem connumeratae in unumque collectae omnes istius generis paginae vocales numero pura tricentarum, reliquarum omnium consonantium numerus una coadiunctus erit fere quadringentarum." *De Cifris*, 4, 30; emphasis mine.

18 See Ycart, "Alberti's Letter Counts," 265.

19 Ibid.

20 *De Cifris*, 13, 42.

21 See *De Cifris*, 6, 32.

22 Kahn, *The Codebreakers*, 128.

23 See Franco Eugeni and Raffaele Mascella's explanation of how to use numbers within the plaintext to encrypt and decrypt: Eugeni and Mascella, "Leon Battista Alberti, crittografia e crittoanalisi," in *Atti di convegno nazionale scienziati mantovani* (Mantua, 2001), web.

24 Paul Lawrence Rose, *The Italian Renaissance of Mathematics: Studies on Humanists and Mathematicians from Petrarch to Galileo* (Geneva: Droz, 1975), 6.

25 In reference to the first book of *Della pittura*, Alberti writes that it is "tutto matematico, dalle radici entro dalla natura fa sorgere questa leggiadra e nobilissima arte" (*Della pittura*, Prologue). On Alberti's relating mathematics to nature, see Dorothy Koenigsberger, *Renaissance Man and Creative Thinking: A History of Concepts of Harmony, 1400–1700* (Hassocks: Harvester, 1979), 7; Maria Karvouni, "Il ruolo della matematica nel *De re aedificatoria* dell'Alberti," in *Leon Battista Alberti*, ed. Joseph Rykwert and Anne Engel (Milan: Electra, 1994), 282–91; and Anthony Grafton, who writes, "Gli strumenti dell'Alberti partivano dal presupposto che si potessero ridurre oggetti fisici a una serie di dati quantitativi, e poi ricostruire gli oggetti in questione partendo dalle tavole numeriche," in "Un passe-partout ai segreti di una vita: Alberti e la scrittura cifrata," in *La vita e il mondo di Leon Battista Alberti: Atti del convegno internazionale, Genova 19–21 febbraio 2004*, vol. 1 (Florence: Olschki, 2008), 9–10.

26 "... ad phisicam se atque mathematicas artes contulit; eas enim satis se posse colere non diffidebat, siquidem in his ingenium magis quam memoriam exercendam intelligeret." Latin in "Leonis Baptistae de Albertis Vita," ed. Riccardo Fubini and Anna Menci Gallorini, *Rinascimento* 2.12 (1972): 70; English translation by Renée Watkins,

"L.B. Alberti in the Mirror: An Interpretation of the *Vita* with a New Translation," *Italian Quarterly* 30.177 (1989), 8. Perhaps Alberti's memory troubles were what brought him to Llull's *Artis*, where he would have seen examples of mnemonic, combinatoric wheels – the wheels that he would often use as tools in his own work.

27 For information on Alberti's library, see Ida Mastrorosa, "Alberti e il sapere scientifico antico: Fra meandri di una biblioteca interdisciplinare," in *Leon Battista Alberti: La biblioteca di un umanista*, ed. Roberto Cardini, Lucia Bertolini, and Mariangela Regoliosi (Florence: Mandragora, 2005), 133–50. For discussions on Alberti and mathematics broadly, see Paul Lawrence Rose, "Humanist Culture and Renaissance Mathematics: The Italian Libraries of the Quattrocento," *Studies in the Renaissance* 20 (1973): 46–105; Williams et al., eds., *The Mathematical Works of Leon Battista Alberti*; Filippo Camerota, "Leon Battista Alberti e le scienze matematiche," in *L'Uomo del Rinascimento: Leon Battista Alberti e le arti a Firenze: Tra ragione e bellezza*, ed. Cristina Acidini and Gabriele Morolli (Florence: Mandragora/Maschietto, 2006), 361–5; and the earlier study by Gino Arrighi, "Leon Battista Alberti e le scienze esatte," in *Convegno internazionale indetto nel V centenario di Leon Battista Alberti* (Rome: Accademia Nazionale dei Lincei, 1974), 155–212; Carlo Maccagni, "Leon Battista Alberti e Archimede," *Studi in onore di Luigi Bulferetti* 3 (1987): 1069–82; and Salvatore Di Pasquale, "Tracce di statica archimedea in Leon Battista Alberti," *Palladio* 9 (1992): 41–68.

28 See Rose, *The Italian Renaissance of Mathematics*.

29 Paola Massalin and Branko Mitrović, "L'Alberti ed Euclide," *Albertiana* 11–12 (2008): 165–247.

30 See especially Mastrorosa, "Alberti e il sapere scientifico antico"; and Massalin and Mitrović, "Alberti ed Euclide."

31 See Di Pasquale, "Tracce di statica archimedea in Leon Battista Alberti," and Maccagni, "Leon Battista Alberti e Archimede."

32 Cardini et al., eds., *Leon Battista Alberti: La biblioteca di un umanista*, 389–510. Scholars have currently only identified five manuscripts that were owned by Alberti, although we know his personal library was much larger. See ibid., 388.

33 For references to Pseudo-Pythagoras's *aurea praecepta* and *Symbola*, see Cardini et al., eds., *Leon Battista Alberti: La biblioteca di un umanista*, 412–14.

34 See, for example, Lionel March, *Architectonics of Humanism: Essays on Number in Architecture* (Chichester: Academy Editions, 1998). On Alberti and Neoplatonism, see Koenigsberger, *Renaissance Man and Creative Thinking*.

35 See Arrighi, "Leon Battista Alberti e le scienze esatte," 168–71; Camerota, "Leon Battista Alberti e le scienze matematiche"; and Williams et al., eds., *The Mathematical Works of Leon Battista Alberti*, 5.

36 See Cardini et al., eds., *Leon Battista Alberti: La biblioteca di un umanista*, 396; Maccagni, "Leon Battista Alberti e Archimede"; and Massalin and Mitrović, "Alberti ed Euclide."

37 Cardini et al., eds., *Leon Battista Alberti: La biblioteca di un umanista*, 406.

38 See Karsten Harries, "On the Power and Poverty of Perspective: Cusanus and Alberti," in *Cusanus: The Legacy of Learned Ignorance*, ed. Peter Casarella (Washington, DC: Catholic University of America Press, 2006), 105–27.

39 See Peter Pesic, "Secrets, Symbols, and Systems: Parallels between Cryptanalysis and Algebra, 1580–1700," *Isis* 88.4 (1997), 681.

40 See Rose, *The Italian Renaissance of Mathematics*, 143.

41 Arrighi notes this manuscript in the Riccardiana's Cod. 927. See Arrighi, "Leon Battista Alberti e le scienze esatte," 168–9.

42 On Alberti's inspiration from the printing press, see Friedrich Kittler, "Perspective and the Book," *Grey Room* 5 (2001): 41.

43 Giorgio Vasari, *Le vite* (Florence: Giunti, 1568), vol. 3, 368. Vasari writes, "[I]n the year 1457, when the very useful method of printing books was discovered by Johannes Gutenberg the German, Leon Batista, working on similar lines, discovered a way of tracing natural perspectives and of effecting the diminution of figures by means of an instrument, and likewise the method of enlarging small things and reproducing them on a greater scale; all ingenious inventions, useful to art and very beautiful." Translation by Gaston Du C. De Vere in *Lives* (London: Philip Lee Warner, 1912–14), 45.

44 "... huomo d'ingegno acutissimo, e a tutti gli studii egualmente disposto." Bernardino Baldi, *Cronica de' matematici overo epitome dell'istoria delle vite loro* (Urbino: Angelo Ant. Monticelli, 1707), 98. Elio Nenci notes that Baldi intended to write a longer *vita* of Alberti. See Nenci, ed., *Le vite de' matematici*, by Bernardino Baldi (Milan: FrancoAngeli, 1998), 23.

45 See Kahn, *The Codebreakers*, 108.

46 Martin McLaughlin, "Leon Battista Alberti and the Redirection of Renaissance Humanism," *Proceedings of the British Academy* 167, 2009 Lectures (2010): 25–59.

47 Carmela Colombo, "Leon Battista Alberti e la prima grammatica italiana," *Studi Linguistici Italiani* 3 (1962): 176–87.

48 See Guglielmo Gorni, "Leon Battista Alberti e le lettere dell'alfabeto," *Interpres* 9 (1989): 257–66, who cites other adherents to this possibility.

49 Caterina Tristano, "Il modello e la regola: Teoria e pratiche di scrittura di Leon Battista Alberti," in Cardini et al., eds., *Leon Battista Alberti: La biblioteca di un umanista*, 40.

50 On the *Grammatichetta*'s letter chart being ordered in terms of phonological principles, see Gianfranco Folena, "Note sul pensiero linguistico di Leon Battista Alberti," *Studi di Grammatica Italiana* 20 (2001): 14; Teresa Poggi Salani, "La grammatica dell'Alberti," *Studi di Grammatica Italiana* 20 (2001): 1–12; and Lucia Bertolini, "Fuori e dentro la *Grammatichetta* albertiana," in *Da riva a riva: Studi di lingua e letteratura italiana per Ornella Castellani Pollidori*, ed. Paola Manni and Nicoletta Maraschio (Florence: Franco Cesati, 2011), 55–70. See also Grafton, "Un passe-partout ai segreti di una vita," 7. Folena, Salani, and Colombo also refer to the organization as partly phonetic, but emphasize the progression of shapes in the letterforms. See also Paolo Bongrani, "Nuovi contributi per la *Grammatica* di L.B. Alberti," *Studi di Filologia Italiana: Bollettino*

Annuale dell'Accademia della Crusca 40 (1982): 65–106; and Colombo, "Leon Battista Alberti e la prima grammatica italiana."

51 See Bertolini, "Fuori e dentro la *Grammatichetta* albertiana," 66.

52 See Colombo, "Leon Battista Alberti e la prima grammatica italiana," 182; and Bongrani, "Nuovi contributi per la *Grammatica* di L.B. Alberti," 76–7.

53 "Proxime ad hanc raritatem accedit vocalis **A**; **U** quoque litteram quae vocalis sit rariusculam inveniri, tamen paulo hanc reddit numerosiorem **V** littera consonans quam alibi, cum de litteris atque caeteris principiis grammaticae tractaremus, quod medium quidpiam inter **B** atque **V** sonet, sic **V** quasi **v** hasta inflexa scribendam suadebam, atque hanc quidem ipsam fuere apud veteres qui F inversam scribendum censerent sic. Caeterum inter vocales ipsas adverti **E** litteram atque in primis **I** frequentissimam apud Latinos inveniri. Itaque circa vocalium numerum isthaec adverti." *De Cifris*, 4, 30–1.

54 Latin from "Leonis Baptistae de Albertis Vita," lines 13–17 in the edition by Fubini and Gallorini, 68. The English translation is by Watkins, "L.B. Alberti in the Mirror," 7.

55 Gorni, "Leon Battista Alberti e le lettere dell'alfabeto," 275–6; translation mine. See also Salani, who says with regard to Alberti's letters, "è l'artista amante della geometria (una geometria applicata e funzionale) a disporle sulla pagina, badando alla forma del segno, mentre la lista isolata delle vocali segue l'ordine alfabetico (come fanno i grammatici latini)," in "La grammatica dell'Alberti," 2.

56 "Ubi vocalis non sit, nulla dabitur syllaba." *De Cifris*, 4, 30; translation Williams et al., eds., *The Mathematical Works of Leon Battista Alberti*, 173.

57 See Robert Tavenor's foreword in Williams et al., eds., *The Mathematical Works of Leon Battista Alberti*, ix.

58 Alberti, *De re aedificatoria*, VI.v, p. 83r in the edition printed by M. Jacobus Cammerlander Moguntinus (Strasbourg, 1541).

59 Alberti, *Profugiorum ab aerumna libri III*, Book 3. 20 (title in Latin, but text in Italian): "E sopratutto quanto io provai, nulla più in questo mi satisfa, nulla tutto tanto mi compreende e adopera, quanto le investigazioni e dimostrazioni matematice (*sic*.), massime quando io studi ridurle a qualche utile pratica in vita …" in *L.B. Alberti: Opere Volgari*, ed. Cecil Grayson (Bari: Laterza, 1966), vol. 2.

60 *De re aedificatoria*, IX.v, 137v; translation by Koenigsberger, *Renaissance Man and Creative Thinking*, 7.

61 Blaise de Vigenère, *Traicté des chiffres ou Secrètes manières d'escrire* (Paris, 1586), as cited by Kahn, *The Codebreakers*, 146.

62 Alberti, *Apologo 73*: "Dixerat Philomela strepenti merulae: 'Aut tace aut concinnum aliquid cane.' Respondit illa: 'Deliras tu quidem, quae nihil nisi ex intima arte depromptum effers; namque sic vivitur hac aetate, ut non qui didicerint, sed qui didicisse videantur periti in primis habeantur.'" Translation by David Marsh in *Renaissance Fables: Aesopic Prose by Leon Battista Alberti, Bartolomeo Scala, Leonardo da Vinci, Bernardino Baldi*, ed. and trans. David Marsh (Tempe: Arizona Center for Medieval and Renaissance Studies, 2004), 69.

63 Many scholars have written on Alberti's pessimism about the closed-mindedness of the educated people of his time. See especially Timothy Kircher, "Dead Souls: Leon Battista Alberti's Anatomy of Humanism," *MLN* 127.1 (2012): 108–23 and *Living Well in Renaissance Italy: The Virtues of Humanism and the Ironies of Leon Battista Alberti* (Tempe: Arizona Center for Medieval and Renaissance Studies, 2012).

64 See Martin McLaughlin's introduction to *Leon Battista Alberti: La vita, l'umanesimo, le opere letterarie* (Florence: Olschki, 2016), xiii.

65 Alberti's autobiography, written in the third person in Latin c. 1438–41 and left unfinished, was only recently attributed to him. See Riccardo Fubini and Anna Menci Gallorini, "L'autobiografia di Leon Battista Alberti: Studio e edizione," *Rinascimento* 2.12 (1972): 21–78.

66 See especially "Ritratto dell'artista da cucciolo rinascimentale: Struttura e fonti del *Canis* di Leon Battista Alberti," in McLaughlin, *Leon Battista Alberti*, 71–96.

67 Mark Jarzombek, "The Enigma of Alberti's Dissimulatio," in *Leon Battista Alberti: Actes du Congrès International de Paris, 10–15 avril 1995*, ed. Francesco Furlan et al., vol. 2 (Turin: Nino Aragno, 2000), 741–8.

68 See David Marsh, "The Self-Expressed: Leon Battista Alberti's Autobiography," *Albertiana* 10 (2007), and McLaughlin, "Pessimismo stoico e cultura classica nel *Theogenius* dell'Alberti," in *Leon Battista Alberti*, 125–44.

69 "… hominum perfidiam datur ut possint." *De Cifris*, 1, 27; translation mine.

70 "O rem optimam nosse erudito artificio fucatae fallacisque simulationis suos operire atque obnubere sensus!" Alberti, *Momus*, 2, §14; English translation by Sarah Knight, *Momus*, ed. Virginia Brown and Sarah Knight (Cambridge, MA: Harvard University Press, 2003), 105. All subsequent translations of *Momus* are from this edition unless otherwise noted.

71 "Dices: 'Nequeo esse non Momus; nequeo non esse qui semper fuerim, liber et constans.' Esto sane: ipsum te intus in animo habeto quem voles, dum vultu, fronte verbisque eum te simules atque dissimules quem usus poscat. Et tuam, qui tam belle id possis, et illius, qui id non recuset, rideto ineptias.'" *Momus*, 1, §43; translation by Knight, 45.

72 See Grafton, *Leon Battista Alberti*, and McLaughlin, "La vita dell'Alberti: Dall'autobiografia al ritratto di Burckhardt," in *Leon Battista Alberti*, 3–18.

73 "A fabris, ab architectis, a naviculariis, ab ipsis sutoribus et sartoribus sciscitabatur, si quidnam forte rarum sua in arte et reconditum quasi peculiare servarent; eadem illico suis civibus volentibus communicabat." *Vita*, ed. Fubini and Gallorini, line 15 ["From craftsmen, architects, shipbuilders, and even from cobblers and tailors, he tried to learn, wishing to acquire any rare and secret knowledge contained in their particular arts. And such knowledge he at once gladly shared with those of this fellow citizens who were interested," trans. Watkins, p. 10].

74 "[N]uovo cameleonta." Cristoforo Landino, "Proemio al Commento dantesco" in *Scritti critici e teorici*, ed. Roberto Cardini, vol. 1 (Rome: Bulzoni, 1974), 120. See also

Stefano Cracolici, "Flirting with the Chameleon: Alberti on Love," *MLN* 121.1 (2006): 102–29.

75 See Cardini, "Alberti o della scrittura come mosaico," in Cardini et al., eds., *Leon Battista Alberti: La biblioteca di un umanista*, 92.

76 On Alberti's use of the mosaic as an analogy to writing, see ibid., and Martin McLaughlin, "Literature and Science in Alberti's *De re aedificatoria*," in *Science and Literature in Italian Culture from Dante to Calvino*, ed. Pierpaolo Antonello and Simon Gilson (Oxford: European Humanities Research Centre, 2004), 94–114.

77 On Alberti's choice of the name "Leo/Leon" and his identification with the lion, see Renée Watkins, "L.B. Alberti's Emblem, the Winged Eye, and His Name, Leo," *Mitteilungen des Kunsthistorischen Institutes in Florenz* 9 (1960): 256–8; and Martin McLaughlin, "From Lepidus to Leon Battista Alberti: Naming, Renaming, and Anonymizing the Self in Quattrocento Italy," *Romance Studies* 31.3–4 (2013): 152–66.

78 See ibid., 161.

79 "Musca quidem cum se ad rerum investigationem et cognitionem ortam animadverter-et, cum a natura ita se adornatam oculis pregrandibus senserit, ut que trans celum, que imo sub profundo queve omnem ultra regionis limbum atque ultimum orizontem latitent facile discernat." "Musca" in *Opuscoli inediti: "Musca," "Vita Santi Potiti,"* ed. Cecil Grayson (Florence: Olschki, 1954), 53. Translation mine.

80 "... et laetitiae et gloriae insigne est: oculo potentius nihil, velocius nihil, dignius nihil; quid multa? Ejusmodi est ut inter membra primus, praecipuus, et rex, et quasi deus sit. Quid quod deum veteres interpretantur esse quidpiam oculi simile, universa spectan-tem, singulaque dinumerantem? Hinc igitur admonemur, rerum omnium gloriam a nobis esse reddendam Deo; in eo laetantdum totoque animo virtute florido et virenti amplectendum praesentemque, videntemque nostra omnia et gesta et cogitata existi-mandum. Tum et alia ex parte admonemur pervigiles, circumspectosque esse oportere, quantum nostra ferat animi vis, indagando res omnes quae ad virtutis gloriam pertine-ant, in eoque laetandum si quid labore et industria bonarum divinarumque rerum simus assecuti." Latin edition edited by Girolamo Mancini of Alberti, *Leon Baptistae Alberti: Opera inedita et pauca separatim impressa* (Florence: Sansoni, 1890), 229–30. Translation by David Marsh, in *Leon Battista Alberti: Dinner Pieces*, ed. and trans. Marsh (Binghamton: Medieval & Renaissance Texts & Studies, 1987), 211–12.

81 For a variety of interpretations of Alberti's winged eye emblem, see Watkins, "L.B. Alberti's Emblem," and Alberto Cassani, "Explicanda sunt mysteria: L'enigma albertiano dell'occhio alato," in *Leon Battista Alberti: Actes du Congrès International de Paris, 10–15 avril 1995*, ed. Francesco Furlan et al., vol. 2 (Turin: Nino Aragno, 2000), 245–304. On the dating and history of Alberti's emblem (the drawings and the medals), as well as extensive analysis of its symbolism, see Cassani, "Explicanda sunt mysteria."

82 See Marsh's note to "Anuli," in *Dinner Pieces*, 261n14; and Marsh, "Poggio and Alberti: Three Notes," *Rinascimento* 23 (1983): 189–215.

83 See *De re aedificatoria*. IX.10.861 and Vitruvius, *De arch.* I.1.3.

84 On the puzzle of "Quid tum?" see Cassani, "Explicanda sunt mysteria"; Ingrid
 Rowland's essay on Renaissance medals, "Character Witnesses," *New York Review
 of Books*, 1 December 1994; David Marsh's response, "So What?" 12 January 1995;
 and Rowland's reply to Marsh, 12 January 1995. See also Marsh's note to "Anuli," in
 Dinner Pieces, 261n14; and McLaughlin, "Leon Battista Alberti and the Redirection
 of Renaissance Humanism," 55–6.

85 Cecil Grayson, "The Humanism of Alberti," 1957, in *Studi su Leon Battista Alberti*,
 ed. Paola Claut (Florence: Olschki, 1998), 134.

86 Mark Jarzombek, *Leon Baptista Alberti: His Literary and Aesthetic Theories* (Cambridge,
 MA: MIT Press, 1989), 3.

87 See March, *Architectonics of Humanism*.

88 "... sed parum praevisum parumque perceptum intellegatur, ut scriptoris officium
 deputem nihil sibi ad scribendum desumere quod ipsum non sit his qui legerint incog-
 nitum atque incogitatum?" Alberti, *Momus*, Prooemium §3; translation by Knight, 5.

89 "Secundum fuit, ur scriptione uterentur non solum nova et invisa." *De Cifris*, III, 29;
 translation mine.

90 "Foliis arborum mandata quae ventus cum dissipasset nullo in ordine in unum a te
 collecta et disposita sint." *De Cifris*, 12, 40; translation mine.

91 Hope Glidden, "*Polygraphia* and the Renaissance Sign: The Case of Trithemius,"
 Neophilologus 71.2 (1987): 183.

92 "... semper istas reconditas artes abditasque naturas sectatus es." *De Cifris*, 2, 28; trans-
 lation mine. Alberti celebrates his ability for divination in his *Vita*, and occult
 arts elsewhere in his works; see Marsh, "The Self-Expressed," 134.

2. The Calculated Alphabet

 1 Bernardino Baldi, Apologue 54 in "One Hundred Apologues," in *Renaissance Fables:
 Aesopic Prose by Leon Battista Alberti, Bartolomeo Scala, Leonardo da Vinci, Bernardino
 Baldi*, trans. and ed. David Marsh (Tempe: Arizona Center for Medieval and
 Renaissance Studies, 2004), 341.

 2 Pacioli calls his letters the "degno alphabeto Anticho" in the *Trattato d'architettura* of the
 1509 *De Divina proportione* (Venice: Paganini, 1509), Chapter 6, 28r; and "Lalphabeto
 dignissimo Antico" in Chapter 19, 32v. All citations are from the 1509 edition unless
 otherwise specified.

 3 Renzo Baldasso discusses the identification of both the scholar and the artist who
 painted him with Pacioli, and offers an excellent analysis of the painting's significant
 objects: Baldasso, "Portrait of Luca Pacioli and Disciple: A New Mathematical Look,"
 Art Bulletin 92.1–2 (2010): 83–102. See also Enrico Gamba, "Pittura e storia della sci-
 enza," in *La ragione e il metodo: Immagini della scienza nell'arte italiana dal XVI al XIX
 secolo* (Milan: Electra, 1999), 43–53; and for the theory that the young man next to

Pacioli is Dürer, see Nick Mackinnon, "The Portrait of Fra Luca Pacioli," *Mathematical Gazette* 77.479 (1993): 130–219.

4 See Baldasso's discussion of the numerous *pentimenti* in the portrait, especially his footnotes 9, 10, 12, 13, and 15, "Portrait of Luca Pacioli."

5 Two original manuscript copies of the *Divina proportione* have survived: the "Geneva manuscript" was given to Ludovico Sforza and is at the Bibliothèque de l'Université de Genève (n. 210); the "Milan manuscript" was given to Galeazzo Sanseverino and is at the Biblioteca Ambrosiana di Milano (ms 170 sup.). Another copy, intended for Piero Soderini, is now lost.

6 Baldasso, "Portrait of Luca Pacioli," 101n66.

7 See Sergio Guarino, "La formazione veneziana di Jacopo de' Barbari," in *Giorgione e la cultura veneta tra '400 e '500: Mito, allegoria, analisi icono logica* (Rome: De Luca, 1981), 196, as cited by Baldasso, "Portrait of Luca Pacioli," 101n66.

8 See the essay by Duilio Contin on Giasone del Maino's miniatures for the *Divina proportione*, "Il *De divina proportione* di Luca Pacioli: rassegna bibliografica sui manoscritti e sull'opera a stampa," in *Antologia della Divina proportione di Luca Pacioli, Piero della Francesca e Leonardo da Vinci*, ed. Duilio Contin, Piergiorgio Odifreddi, and Antonio Pieretti (Sansepolcro: Aboca Museum Edizioni, 2010), 37–48.

9 Pacioli, *Summa de arithmetica, geometria, proportioni et proportionalita* (Venice: Paganino, 1494), Part 2, 68v. All citations of the *Summa* will refer to this edition.

10 See Ernest Stevelinck, "The Many Faces of Luca Pacioli: Iconographic Research over Thirty Years," *Accounting Historians Journal* 13.2 (1986), retrieved 19 June 2015. Stevelinck also offers other hypotheses as to the painter's identity, such as "Barbaglia," a nickname in the Pacioli family.

11 See Baldasso, "Portrait of Luca Pacioli," 83–6.

12 "… et alcuni corpi regolari finti di cristallo appesi in alto." Bernardino Baldi, *Le vite de' matematici: Edizione annotata e commentata della parte medievale e rinascimentale*, ed. Elio Nenci (Milan: FrancoAngeli, 1998), 344.

13 On the fly in Quattrocento and early Cinquecento Flemish and Italian painting, see André Chastel, *Musca depicta* (Milan: Franco Maria Ricci, 1984).

14 Nick Mackinnon points out that in the 1482 Campanus translation printed by Erhard Ratdolt in Venice (the first printed edition of Euclid), the theorem is numbered 8, not 12. See Mackinnon, "The Portrait of Fra Luca Pacioli," 134.

15 Baldasso, "Portrait of Luca Pacioli," 89–93. Including mathematical diagrams was a new trend in mathematical printing at the time; contemporary mathematicians argued over the value and dangers of including such diagrams in a treatise.

16 Ibid., 93.

17 See Mackinnon for more information on these figures and their possible sources.

18 "Luca Paciolus, theologus insignis, altissima mathematicarum disciplinarum scientia rarissimus iudico castigatissimo detersit et emendavit. Figuras centum et undetriginta

que in aliis codicibus inverse et deformate erant ad rectam symmetriam concinnavit et multas necessarias addidit," on the title page of Pacioli's edition of Euclid's *Elements* (Venice: Alessandro Paganini, 1509), 144v. Translation by Baldasso, "Portrait of Luca Pacioli," 91.

19 Baldasso, "Portrait of Luca Pacioli," 83.

20 The term "Roman letters," *lettere romane*, was coined by Ludovico Arrighi in 1520. Before that, they were called *littera antiqua*.

21 See note 2 above.

22 See the *Summa*, 67v, where he talks about his early education.

23 See the *Divina proportione*, 29v.

24 "Ne vi fu pittore, scultore, o architetto de' suoi tempi che seco non contrahesse strettissima amicitia." Bernardino Baldi on Pacioli in *Le vite de' matematici*, 8 April 1589, 343–4; translation mine.

25 David Eugene Smith in a letter to Stanley Morison in Pacioli, *Pacioli's Classic Roman Alphabet*, 1933, ed. Morison (New York: Dover, 1994), 4.

26 Pacioli may have written the *Divina proportione* between 1496 and 1497: the Geneva manuscript dates completion to 1498, but Milan and Venice used different calendars.

27 We have evidence of this lecture in the introduction to Book 5 of Pacioli's Latin edition of Euclid's *Elements*, 30r–v.

28 The earliest version we have of *De viribus* is a copy from circa 1550, held at the University of Bologna, ms 250. It consists of 305 pages and 98 drawings.

29 Pacioli, *Arithmetica et geometria* (Vatican Library, Vat. Lat. 3129).

30 Pacioli, *De ludo scachorum* (Fondazione Palazzo Coronini Cronberg, ms 7955).

31 In the Milan manuscript the *Piramis laterata exagona vacua* is numbered XLI, and in the Geneva manuscript there is an incomplete figure with the note "Hac figura est superflua ex errore." See Isabelle Jeger, "Description matérielle du manuscript 210," in *Antologia della Divina proportione di Luca Pacioli, Piero della Francesca e Leonardo da Vinci*, ed. Contin, Odifreddi, and Pieretti, 31–5; and Contin, "Il *De divina proportione* di Luca Pacioli," 37–44. It is also worth noting that Leonardo sketched a few polyhedra in his notebooks (Cod. Atlantico, fol. 263r and 310r).

32 Dedicatory letter of the first book to Ludovico Sforza, *Divina proportione*, 1v.

33 See *Divina proportione*, 23r.

34 See Margaret Daly Davis, "Luca Pacioli, Piero della Francesca, Leonardo da Vinci: Tra 'Proportionalita' e 'Prospettiva' nella *Divina proportione*," in *Piero della Francesca tra arte e scienza: Atti del convegno internazionale di studi, Arezzo, 8–11 ottobre 1992, Sansepolcro, 12 ottobre 1992*, ed. Marisa Dalai Emiliani and Valter Curzi (Venice: Marsilio, 1996), 355–62; and J.V. Field, "Rediscovering the Archimedean Polyhedra: Piero della Francesca, Luca Pacioli, Leonardo da Vinci, Albrecht Dürer, Daniele Barbaro, and Johannes Kepler," *Archive for History of Exact Sciences* 50.3–4 (1997): 252. Robert Emmett Taylor, in *No Royal Road: Luca Pacioli and His Times* (Chapel Hill: University of North Carolina Press, 1942), 340, also notes that Piero generally wrote in Italian,

and points to a comment from Pacioli in the *Summa* regarding Piero's book on perspective and its translation into Latin by Matteo de Borgo.

35 Giorgio Vasari, "Vita di Pietro della Francesca," 1550 edition, §365.

36 See Noémie Etienne, "Rassegna bibliografica sui contenuti del Codice di Ginevra," in *Antologia della Divina proportione di Luca Pacioli, Piero della Francesca e Leonardo da Vinci*, ed. Contin, Odifreddi, and Pieretti, 63. Pacioli apparently made many models of the polyhedra himself out of wood, or paper, or glass. Taylor cites a document that says the Florentine Signoria paid him 52.9 lire on 20 August 1504 for "various geometric regular bodies"; see Taylor, *No Royal Road*, 298.

37 Although there are sixty polyhedra in the two surviving manuscripts and the sixtieth is different in each, there are only fifty-nine of the polyhedra xylographs printed in the 1509 edition. Also, the table of contents in all editions calls for sixty-one polyhedra, but none of these editions contains more than fifty-nine.

38 Pacioli writes, for example, "Comme apien in le dispositioni de tutti li corpi regulari e depedenti di sopra in questo vedete quali sonno stati facti dal degnissimo pictore prospectivo architecto musico e de tutte virtu doctato Lionardo da Vinci fiorentino." *Divina proportione*, *Trattato*, Chapter 6, 28v.

39 See the *Divina proportione*, *Compendium*, Chapter 4, 3v: "Ma quando l'auctorita per noi aducta fosse d'altra sua opera o d'altro auctore quella tale e quel tale auctore nominaremo."

40 See the *Divina proportione*, 23r, as noted by Davis, "Luca Pacioli, Piero della Francesca, Leonardo da Vinci," 355–62.

41 See Taylor, *No Royal Road*, 255, 284–7. For more information on Alessandro and his printing of Pacioli's *Divina proportione*, see Angela Nuovo, *Alessandro Paganino (1509–1538)* (Padua: Editrice Antenore, 1990), especially 15–21, 142.

42 See Maria Paola Negri, "Luca Pacioli e Daniele Gaetani: Scienze matematiche e retorica nel Rinascimento," *Annali della Biblioteca Statale e Libreria Civica di Cremona* 45 (1994): 118.

43 Taylor, *No Royal Road*, 278–87.

44 "… libellos duo velut appendices addidi alter veterum caracterum formam exactissimam quandam cont.[?] in quo lineae curvae et recte vis ostenditur. Alter quasi gradus nescio quos architectis struit et marmorariis nostratibus." Translation by Taylor, *No Royal Road*, 280–1.

45 The opening of Piero's *Libellus* in the 1509 *Divina proportione* reads "Libellus in tres partiales tractatus divisus … corporum regularium dependentium actine perfectutationis. Petro Soderino principi perpetuo populi florentinia. Luca Paciolo Burgense in oritano particulariter dicatus feliciter incipit" (1r).

46 Pacioli, *Trattato*, Chapter 6, 28v; emphasis mine.

47 Translation by Morison, ed., *Pacioli's Classic Roman Alphabet*, 9, with modifications. Emphasis mine.

48 Pacioli, *Trattato*, Chapter 11, 30v; translation by Morison, ed., *Pacioli's Classic Roman Alphabet*, 11; emphasis mine.

49 In the *Trattato*, Chapter 11, 30v, he says, "meniatori e altri scriptori," and in Chapter 19, 32v–33r, "li scriptori e miniatori."

50 For various theories on who made the letter prototypes for Pacioli, see M.D. Feld, "Constructed Letters and Illuminated Texts: Regiomontanus, Leon Battista Alberti, and the Origins of Roman Type," *Harvard Library Bulletin* 28.4 (1980): 357–79.

51 For a recounting of Poggio's recovery of ancient texts, especially Lucretius's *On the Nature of Things*, and how powerfully these texts moved the intelligentsia's imaginations in the early Renaissance, see Stephen Greenblatt, *The Swerve: How the World Became Modern* (New York: W.W. Norton, 2011).

52 See E.P. Goldschmidt, *The Printed Book of the Renaissance: Three Lectures on Type, Illustration and Ornament* [1950] (Cambridge: Cambridge University Press, 2010), 4.

53 See Nuovo, *Alessandro Paganino*, 142.

54 Veronese, *Epistolario*, 1.37. See Paul Lawrence Rose, "Humanist Culture and Renaissance Mathematics: The Italian Libraries of the Quattrocento," *Studies in the Renaissance* 20 (1973): 67.

55 See Petrarch, *Epistolae familiares*, 23.19.8.

56 Lorenzo Valla speaks of language and writing that is "planius, apertius, and distinctius" in his invective against Bartolomeo Facio and Il Panormita, *Invectivarum sive recriminationum* in *Opera nunc primo non mediocribus* (Basel: Henricus Petrus, 1465), Book 1, 477. See Millard Meiss, "Toward a More Comprehensive Renaissance Palaeography," *Art Bulletin* 42.2 (1960): 99.

57 Pacioli, *Summa*, Part 2: *Tractatus geometrie*, Distinctio 1.1, 1r.

58 See Armando Petrucci, *La scrittura: Ideologia e rappresentazione* (Turin: Einaudi, 1986), xi.

59 See Paul Shaw, ed., *The Eternal Letter: Two Millennia of the Classical Roman Capital* (Cambridge, MA: MIT Press, 2015), 3.

60 See especially Edward M. Catich, *The Origin of the Serif: Brush Writing and Roman Letters* (Davenport, IA: Catfish Press, 1968), 270.

61 See Shaw, ed., *The Eternal Letter*, 3.

62 Robin Rider, "Shaping Information: Mathematics, Computing, and Typography," in *Inscribing Science: Scientific Texts and the Materiality of Communication*, ed. Timothy Lenoir (Stanford: Stanford University Press, 1998), 39–54.

63 "... in la sepultura porfiria nanze ala rotunda guardata dali doi Lioni dove penne, coltelli, animali, sola de scarpe, ucelli, boccali per lor letere a quel tempo e cifre se usavano. Onde poi piu oltra speculando li homini se sonno fermati in queste che al presente usiamo. Peroche li hano trovato el debito modo con lo circino in curva e libella recta debitamente saperle fare." *Trattato*, Chapter 11, 30v.

64 See Antonio Pieretti on the Neoplatonic elements in Pacioli's works: "Luca Pacioli: La matematica come paradigma universale del sapere," in *Antologia della Divina proportione di Luca Pacioli, Piero della Francesca e Leonardo da Vinci*, ed. Contin, Odifreddi, and Pieretti, 11–18.

65 Pacioli writes, "Questo vocabulo Mathematico excelso Duca sia greco derivato da [Greek, absent in the exemplars I consulted] che in nostra lengua son a quanto a dire disciplinabile, e al proposito nostro per scientie e discipline mathematici se intendano. Arithmetica, Geometria, Astrologia, Musica, Prospectiva, Architectura, e Cosmographia, e qualuncaltra da queste dependente. Non dimeno communamente per li saui. le quatro prime se prendano, cioe Arithmetica, Geometria, Astronomia, e Musica, e laltre sienno dette subalternate cioe da queste quatro dependenti." *Compendium*, Chapter 3, 3r.

66 See Niccolò Tartaglia, "Fra' Luca dal Borgo San Sepulchro vuole che le dette discipline Mathematice siano overamente cinque (aggiongendo alle predetter Quattro la Perspettiva," in *Euclide Megarense Philosopho* (Venice: Venturino Ruffinelli, 1543), 5v–6r. Note that in this period Euclid was thought to have been from Megara. Euclid's true place of origin – Alexandria – was established only with the publication of Federico Commandino's 1572 edition in Latin.

67 For more on Daniele Caetani/Gaetani, see Negri, "Luca Pacioli e Daniele Caetani."

68 See Field, "Rediscovering the Archimedean Polyhedra," 243.

69 Ibid., 244.

70 Ferdinand Wolff, *Lehrbuch der Geometrie* (Berlin: Reimer, 1830–45); and Martin Ohm, *Die reine Elementar-Mathematik* (Berlin: Jonas, 1835). See Marcus Frings, "The Golden Section in Architectural Theory," *Nexus Network Journal* 4.1 (2002): 19.

71 Adolf Zeising, *Neue lehre von den proportionen des menschlichen körpers, aus einem bisher unerkannt gebliebenen, die ganze natur und kunst durchdringenden morphologischen grundgesetze entwickelt und mit einer vollständigen historischen uebersicht der bisherigen systeme begleitet* (Leipzig: R. Weigel, 1854) and *De goldene Schnitt* (Halle: Engelmann, 1884).

72 Frings, "The Golden Section in Architectural Theory," and Matthew A. Cohen, "How Much Brunelleschi? A Late Medieval Proportional System in the Basilica of San Lorenzo in Florence," *Journal of the Society of Architectural Historians* 67.1 (2008): 18–57.

73 George Markowsky, "Misconceptions about the Golden Ratio," *College Mathematics Journal* 23.1 (1992): 2–19; and Clement Falbo, "The Golden Ratio: A Contrary Viewpoint," *College Mathematics Journal* 36.2 (2005): 123–34.

74 Plato, *Timaeus*, 31c–32a, *Dialogues of Plato*, ed. and trans. B. Jowett (London: Macmillan and Co., 1892), vol. 3, 451.

75 See Roger Herz-Fischler, *The Shape of the Great Pyramid* (Waterloo, ON: Wilfrid Laurier University Press, 2000).

76 See Alessandra Angelini, "Luca e Leonardo nelle lettere capitali del *De Divina Proportione*," in *Luca Pacioli a Milano*, ed. Matteo Martelli (Brera: Accademia di Belle Arti di Brera e Biblioteca del Centro Studi "Mario Pancrazi," 2014), 125–42; and Paola Magnaghi-Delfino and Tullia Norando, "Le Geometrie ricostruite delle lettere capitali di Luca Pacioli" in *Luca Pacioli a Milano*, ed. Matteo Martelli, 143–165 and "Luca Pacioli's *Alphabeto Dignissimo Antiquo*: A Geometrical Reconstruction," *Proceedings*

of the 14th Conference of Applied Mathematics (Bratislava: Slovak University of Technology, 2015), 1–20. Neither Angelini nor Magnaghi-Delfino and Norando are arguing that the golden ratio is found in the construction of the letters, but both investigate the question.

77 Angelini, "Luca e Leonardo nelle lettere capitali del *De Divina Proportione*," 139; and Magnaghi-Delfino and Norando, "Le Geometrie ricostruite delle lettere capitali di Luca Pacioli" and "Luca Pacioli's *Alphabeto Dignissimo Antiquo*."

78 The capitals of this drawing closely resemble the capitals on the columns at the entrance archway to the Church of San Giovanni Evangelista in Brescia, Lombardy. The entrance was constructed in the early sixteenth century and is attributed to Filippo de' Grassi.

79 See Vitruvius, *De architectura* 3.1.2–3.

80 It is not clear to which work Pacioli refers here: it could be Pseudo-Dionysius's *On the Celestial Hierarchy*, Archimedes' *On the Sphere and Cylinder*, or Sacrobosco's *De sphaera*.

81 "… le doi principalissime figure senza le quali non e possibile alcuna cosa operare cioe la circular perfectissima e di tute l'altre ysoperometrarum capacissima comme dici Dionisio in quel de Spheris. L'altra la quadrata equilatera. E queste sono quelle che sonno causate dale doi linee principali cioe curva e recta." *Trattato*, Chapter 1, 25r.

82 "… le scientie e discipline mathematici essere abstracte e mai actualiter non e possibile ponerle in esse visibili. Onde el ponto, linea, superficie, e ognaltra figure mai la mano la po formare." We call what we make with our pens, point, line, etc., but only because "non habiamo vocabuli piu proprii a exprimer lor concepti." *Trattato*, Chapter 1, 25v–26r.

83 "Aurum probatur igni et ingenium mathematicis, cioe la bonta de loro demostra el fuoco e la peregrineza del ingegno le mathematici discipline." *Compendium*, Chapter 2, 2v.

84 "E non si lagnino li scriptori e li miniatori se tal necessita habia messa in publico lo facto solo per mostrare che le doi line essentiali recta e curva sempre sano tucte cose in ogibilibus (agibilibus) se possano machinare e per questo negli ochi loro senza la penna e pennello li ho posto el quadro e tondo acio vechino molto bene che dale discipline mathematici tutto procede." *Trattato*, Chapter 19, 33r.

85 "E benche nellorechie nostre lor termini puri mathematici non sonino: nondimeno altro non sonno che le forze loro. Onde el principio e fondamento de tutte laltre. Grammatica meta e norma del retto scrivere e parlare: con suoi limitati acenti, grave, acuto, e circonflexo termina quali a lei sonno certa e debita mesura. La rethorica ancora sempre de tutte sue orationi e ornato dire le parti (quali non si possano negare essere dela ragione dela discreta quantita) con debito numero distingue. La poesia similmente li suoi piedi, dattilo, iambo, spondeo, trocheo, anapesto, tribaco, procelleumatico e altri per mesure e bilancia de tutti suoi armonici versi per regole e canoni asegna." *Summa*, 2v; translation by Taylor, *No Royal Road*, 193, with modifications.

86 "Quem morem imitando poetae Carmina sua (eisdem fere mediis) Datilo, iambo, spondeo, trocheo, anapesto, tribraco, proceleumatico, ceterisque proportionis loco utendo pedibus component. Nec non est rethores (ad istorum instar) orationum suarum partes debitis ac congruis numeris assignant. Hoc idem origo est fundamentum omnium liberalium artium grammatica observare videtur dum normam recteloquendi recteque scribendi discere incipientibus tradit gravi acuto circumflexoque acentibus terminatam." Pacioli's *Euclidis*, 30v; translation by Taylor, *No Royal Road*, 325, with modifications.

87 See Martin Kemp, *Leonardo da Vinci: The Marvelous Works of Nature and Man* (Oxford: Oxford University Press, 2006), 134–5. Leonardo titled his version "Terzetto fatto per li corpi regolari e loro derivativi," which is followed by two other tercets. The three read as follows: "El dolce fructo vago e sì diletto / constrinse già filosofi cercare / causa di noi per pascere lo 'ntelletto. // Se 'l Petrarca amò si forte il lauro / fu perché gli è bon fra la salsiccia e tor[do]; / i' non posso di lor giance far tesauro. // O se d'un mezzo circol far si pote / triangol sì ch' un recto non avessi / e che gli altri due un retto non facessi." See Augusto Marinoni, ed., *Scritti Letterari*, by Leonardo da Vinci (Milan: Rizzoli, 1987), 234. Marinoni posits that Leonardo copied the first tercet from Pacioli. Note that the first two verses of the final tercet are from Dante, *Par.* 13.101–2.

88 Tartaglia only changed the "Corpora loquuntur" to "Disciplinae mathematicae loquuunitur."

89 "… non mutando el greco le figure geometriche, cioe che non facesse el quadro con 5 cantoni." *Trattato*, Chapter 11, 30v.

90 Baldi, *Le vite de' matematici*, 8 April 1589, 338–9. The Italian reads: "Il suo dire è di maniera barbaro, irregolato, rozo et infelice che rende nausea a quelli che leggono le cose sue, e certo che se sotto cotanta sordidezza di parole non vi fossero considerationi così belle et utili, non sarebbe quell'opera degna della luce, laonde veramente si può dire che chi studia l'opera sua raccolga le gemme da l'immonditie come già disse Virgilio al proposito d'Ennio. Mescola egli le frasi latine con le volgari e stroppia e l'une e l'altre; l'idioma poi benchè per lo più sia materno Borghese, che per se stesso è brutto et odioso è mescolato di Venetiano e di tutte le lingue italiane peggiori. La cagione di ciò credo che sia da recarsi al non haver egli giamai dato opera a le belle lettere latine e volgari, ma sempre essere stato immerso ne le specolationi matematiche, onde non è maraviglia che non s'acquistino quell'arti a le quali altri non attende. Parte de la colpa devesi anco a quel secolo, nel quale se bene la lingua Latina era appresso i buoni molto affinata, la volgare se ne stava poco meno che nascosta nel fango. L'esser egli anco stato frate può esser stato cagione di questa sua barberie, poi ché noi vediamo per lo più claustrali, come quelli che sono separate dal secolo, haver poca gratia ne le lettere secolari."

On Pacioli's Italian, see Enzo Mattesini, "Luca Pacioli e l'uso del volgare," *Studi Linguistici Italiani* 22 (1996): 160 and following; Annibale Caro's *Apologia degli Academici di Banchi di Roma, contra M. Lodovico Castelvetro da Modena* (Parma:

Viotto, 1558) and *Opere*, ed. Stefano Jacomuzzi, vol. 2 (Turin: Unione Tipografico-Editrice Torinese, 1974), 43.

91 "… in materna e vernacula lengua mi so messo a disponerla in modo che litterati e vulgari oltra lutile ne haranno grandissimo piacere in esse exercitandose." *Summa*, 2r; translation mine.

92 On Pacioli's language, see Enzo Mattesini, "La lingua nel *De divina proportione*," in *Antologia della Divina proportione di Luca Pacioli, Piero della Francesca e Leonardo da Vinci*, ed. Contin, Odifreddi, and Pieretti, 68; Franco Riva, "Rassegna bibliografica comparativa: Il Codice della Biblioteca Universitaria di Ginevra, il Codice della Biblioteca Ambrosiana di Milano e la versione a stampa del 1509," in *Antologia della Divina proportione di Luca Pacioli, Piero della Francesca e Leonardo da Vinci*, ed. Contin, Odifreddi, and Pieretti, 129–30; and Patricia McCarthy et al., "Pacioli and Humanism: Pitching the Text in *Summa Arithmetica*," *Accounting History* 13.2 (1995): 183–206.

93 See leaf 2v of Pacioli's *Euclidis megarensis* (Venice: A. Paganini, 1509), between Pacioli's dedicatory letter to Francesco Soderini and Caetani's introductory epistle. As Taylor translates the poem: "Sadly Euclid returned from Hades' shades wan, misshapen, his face hidden by dust. Hospitality he asked of many a person, in pitiful tones as he made his way through the public squares, thresholds of all kinds, and schools. He was received by no one except those who mistakenly thought they were acquainted with him but his glory but poorly shone for his being recognized. And for long he journeyed to the farthest shores of the world to see if any right hand might succor him in his wretchedness. Finally he discovered such a one as the happy fates brought in answer to his prayers for patrons. This is the brother (Pacioli) by whose means he is now radiant and beautiful and is restored just as he was in antiquity." Taylor, *No Royal Road*, 317–18.

94 See Menso Folkerts, "Luca Pacioli and Euclid," in *The Development of Mathematics in Medieval Europe: The Arabs, Euclid, Regiomontanus* (Aldershot: Ashgate, 2006), 219–31.

95 On the notion of rationalizing the mathematical elements of language, see Timothy Reiss, *Knowledge, Discovery and Imagination in Early Modern Europe: The Rise of Aesthetic Rationalism* (Cambridge: Cambridge University Press, 1997).

96 Erika Boeckeler, "Building Meaning: The First Architectural Alphabet," in *Push Me, Pull You: Physical and Spatial Interaction in Late Medieval and Renaissance Art*, ed. Sarah Blick and Laura D. Gelfand, vol. 1 (Leiden: Brill, 2011), 162.

97 The earliest known copy of *De viribus* is from 1550.

98 On Pacioli's request to publish *De viribus*, see Enrico Giusti and Carlo Maccagni, eds., *Luca Pacioli e la matematica del Rinascimento* (Florence: Giunti, 1994).

99 See Elizabeth Eisenstein, *The Printing Press as an Agent of Change* (Cambridge: Cambridge University Press, 1979), vol. 1, 88–107; Alvin Kernan, *Printing Technology, Letters and Samuel Johnson* (Princeton: Princeton University Press, 1987), 48–55; Walter Ong, *Orality and Literacy: The Technologizing of the Word* (London: Methuen, 1982), 123–9; Brian Richardson, *Printing, Writers, and Readers in Renaissance Italy*

(Cambridge: Cambridge University Press, 1999); and Goldschmidt, *The Printed Book of the Renaissance*.

100 See Stan Knight's discussion of this subject in *Historical Scripts: From Classical Times to the Renaissance*, 2nd ed. (New Castle, DE: Oak Knoll Press, 2003), 33. Knight does not agree with this theory, identifying numerous pre-Constantine examples of uncials.

3. Word Problems

1 Stanisław Lem, "Love and Tensor Algebra," in *The Cyberiad: Fables for the Cybernetic Age* (1967), trans. Michael Kandel (New York: Seabury Press, 1974), 52.

2 Niccolò Tartaglia, "Quando chel cubo" (verses 22–5) in *Quesiti et inventioni diverse* (Venice: Venturino Ruffinelli, 1546), Book 9, q. xxxiv, 123r–v (mislabelled in the book as page 124r). All citations unless otherwise noted are from this edition. Tartaglia actually discovered the solution in 1535; in the poem he dates the event to "one thousand five hundred thirty and four," following the Venetian calendar, which began its year on 1 March.

3 Tartaglia, *Quesiti*, Book 6, q. viii (69v–70r in the 1554 edition, as Books 2–7 are missing from the 1546 edition digitized by the Max Planck Institute for the History of Science).

4 Ibid.

5 See Giovanni Battista Gabrieli, *Nicolò Tartaglia: Invenzioni, disfide e sfortune* (Siena: Università degli Studi di Siena, 1986), 329 and following.

6 Tartaglia, ed. and trans., *Euclide Megarense Philosopho* (Venice: Venturino Ruffinelli, 1543) and *Opera Archimedis Syracusani* (Venice: Venturino Ruffinelli, 1543).

7 "Degli aritmetici, computisti, contisti, o maestri d'abaco," Dis. 15 in Tomaso Garzoni, *La piazza universale di tutte le professioni del mondo*, 1585, vol. 1, ed. Paolo Cherchi and Beatrice Collina (Turin: Einaudi, 1996), 270.

8 "Maestri d'edificii, e fortificatori di fortezze, e maestri di machine, et mecanici in commune, overo ingenieri," Dis. 107 in ibid., vol. 2, 1210.

9 "[C]ose pertinenti alla militia," note to Dis. 82 in ibid., vol. 2, 782.

10 See Tartaglia, *Quesiti et inventioni diverse: Riproduzione in facsimile dell'edizione del 1554*, ed. Arnaldo Masotti (Brescia: La Nuova Cartografica, 1959), vi; and note 48 in Karen H. Parshall's "The Art of Algebra from Al-Khwarizmi to Viète: A Study in the Natural Selection of Ideas," *History of Science* 26.2 (1988): 129–64.

11 See Satyanad Kichenassamy's study of Tartaglia's procedure for solving various types of cubic equations (with and without the linear term) through a theory of continued proportions ("keys"), as discussed by Pacioli in his *Summa de arithmetica, geometrica, proportioni e proportionalita* (Venice: Paganino, 1494), Part 1, 6.6.x: Kichenassamy, "Continued Proportions and Tartaglia's Solution of Cubic Equations," *Historia Mathematica* (2015), 15 April 2015.

12 *Quesiti*, Book 9, q. xxxi, 115r.

13 Girolamo Cardano, *Ars magna*, 1545, in *Opera omnia*, ed. Charles Spon (Lyon: Huguetan & Ravaud, 1663), Chapter 37, q. iii, r. ii, 287.

14 "Scipio Ferreus Bononiensis iam annis ab hinc triginta fermè capitulum hoc invenit, tradidit verò Anthonio Mariae Florio Veneto, qui cùm in certamen cum Nicolao Tartalea Brixellense aliquando venisset, occasionem dedit, ut Nicolaus invenerit & ipse, qui cum nobis rogantibus tradidisset, suppressa demonstratione, freti hoc auxilio, demonstrationem quaesivimus, eámque in modos, quod difficillimum fuit, redactam sic subiiciemus." Cardano, *Ars magna*, Chapter 11, 249. See also Chapter 1, 222.

15 See *Quesiti*, Book 9, q. xxxv–xl. See also Ferrari's first *cartello* to Tartaglia, 10 February 1547, in Tartaglia and Ferrari, *Cartelli di sfida matematica: Riproduzione in facsimile delle edizioni originali 1547–1548*, ed. Arnaldo Masotti (Brescia: Ateneo di Brescia, 1974).

16 *Quesiti*, Book 9, q. xxxv.

17 Ibid., q. xxxvii.

18 In 1876, Enrico Giordani published the first edition of the collected letters. More recently, Arnaldo Masotti has edited a facsimile reprint of the originals: Tartaglia and Ferrari, *Cartelli di sfida matematica*.

19 See, for example, Pietro Cossali, *Origine, trasporto in Italia, primi progressi in essa dell'algebra: Storia critica di nuove disquisizioni analitiche e metafisiche arricchita*, 2 vols (Parma: Reale Tipografia, 1797–9); and Antonio Favaro, *Per la biografia di Niccolò Tartaglia* (Rome: Ermann Loescher & C., 1913).

20 The inserted poem by Giovanni Antonio Cazzuolo reads, "Credendosi Tartaglia d'offenere / Del proprio nome la primiera parte, / Non s'accordendo che'l cog-nome e l'arte / Per pazzo a tuffi ce'l dano a vedere. / Ha preso di biasmar contra il devere / Quell'ingegno sottil, che in tante carte, / Per tutta Europa ha le sue lode sparte. / Vero argomento del suo gran sapere. / Ma il bon Ferrero a cui niente cale, / Piu che del suo Cardano l'intera fama, / S'è mosso per frenargli la pazzia. / Ne è per mancar di quanto po' et vale, / Fin che l'honor di lui che tanto l'ama / Dal vaneggiar di quel riscosso sia." See Tartaglia and Ferrari, *Cartelli di sfida matematica*, ed. Masotti, table 26.

21 Luca Pacioli, *Summa de arithmetica et geometrica, proportioni et proportinalita*, 8.5, p. 145r. See also Elisabetta Ulivi, "Luca Pacioli: Una biografia scientifica," in *Luca Pacioli e la matematica del Rinascimento*, ed. Enrico Giusti and Carlo Maccagni (Florence: Giunti, 1994), 47; and Kichenassamy, "Continued Proportions and Tartaglia's Solution of Cubic Equations."

22 Pietro Mengoli, *Via regia ad mathematicas* (Bologna: Vittorio Benacci, 1655).

23 Paolo del Rosso, *La fisica* (Paris: Le Voirrier, 1578); Giordano Bruno, *De triplici, minimo et mensura* (Frankfurt: Johann Wechel & Peter Fischer, 1591).

24 Of the 240 texts published between 1450 and 1650 included in the Giardino di Archimede's CD ROMs 1–16, 50 have prefatory poems, or poems at the very end of the treatise that serve to praise the text's topic, author, patron, or reader. Of those 240

treatises, 29 would today be considered pure mathematics (that is, focused on arithmetic, algebra, and/or geometry, as opposed to mechanics, optics, astronomy, other areas of natural philosophy, apologies or lauds of a mathematical theory, numerology, calendar reform, or treatises that are concerned with military or mercantile application). Of the pure mathematical treatises, 20 have prefatory poems. The edition of Cardano's *Opera omnia* edited by Charles Spon (1663) does not contain prefatory material, and I have not yet been able to examine an exemplar of this edition to determine whether this edition of Cardano's 12 mathematical treatises contained poems at the incipits.

25 A word problem set to verse by Vicenti di Gaffari that Tartaglia includes in his *Quesiti*, Book 9, q. xxii, 105r: "Saggi diece di oro che tenia / De argento in se la sua cuba Radice / Costo ducati diece, hor stati al quia / Che alla rason medesima se dice. / Diece altri saggi che tenia inserto / De argento in se la sua quadra Radice / Costa ducati nuove intendi il merto / Proportionatamente qual dimanda / Che valse il saggio di ciascun incerto / A noi spirto gentil questa si manda / Et perche hormai si spanda / La fama di colui che l'ha composta / Di Gaffari Vicenti è la proposta."

26 Pietro Paolo Caravaggio, *In Geometria male restaurata* (Milan: Ludovico Monti, 1650), 4; Leandro Bovarini, *Del moto* (Perugia: Vincenzo Colombara, 1603), 26–7.

27 *Quesiti*, Book 9, q. xxxiv, 123r (mislabelled as page 124r); translation mine.

28 See Problem 35 in Luca Pacioli, *De viribus quantitatis* [On the Power of Numbers and Quantities], 77v, written sometime between 1496 and 1508. There is no autograph, nor published exemplar. The earliest known copy is from 1550 and held at the library of University of Bologna, ms 250.

29 "… credendosi lui con tal suo quesito di farmi totalmente restar confuso." *Quesiti*, Book 9, q. xxii, 105r.

30 See Ferrari's second *cartello*, 1 April 1547, in Tartaglia and Ferrari, *Cartelli di sfida matematica*, ed. Masotti.

31 See the hypothesis as analysed by Paolo Freguglia, "Niccolò Tartaglia e il rinnovamento delle matematiche nel Cinquecento," in *Cultura, scienze e tecniche nella Venezia del Cinquecento: Atti del convegno internazionale di studio Giovan Battista Benedetti e il suo tempo*, ed. Antonio Manno (Venice: Istituto Veneto di Scienze, Lettere ed Arti, 1987), 212. For this demonstration, see Kellie O. Gutman, "Quando Che'l Cubo," *Mathematical Intelligencer* 27.1 (2005): 34–6. For an analysis of Pacioli's theory of proportions for magnitudes, see Kichenassamy, "Continued Proportions and Tartaglia's Solution of Cubic Equations."

32 Gutman, "Quando Che'l Cubo," 32–6; Friedrich Katscher, "How Tartaglia Solved the Cubic Equation: Tartaglia's Poem," *Loci* (August 2011), Mathematical Association of America, 2013; and Kichenassamy, "Continued Proportions and Tartaglia's Solution of Cubic Equations."

33 *Quesiti*, Book 9, q. xxxiv, 123r–v (mislabelled as page 124r).

34 Masotti, "Introduction" to *Quesiti et inventioni diverse: Riproduzione in facsimile dell'edizione del 1554* (Brescia: La Nuova Cartografica, 1959), xviii.

35 Favaro, *Per la biografia di Niccolò Tartaglia*, 14.

36 Maria Luisa Altieri Biagi, *Galileo e la terminologia tecnico-scientifica* (Florence: Olschki, 1965), 15.

37 See Silvio Maracchia, "La rivolta ad Euclide sotto il profilo storico e didattico," *Cultura e scuola* 6 (1967): 206 as cited by Mario Piotti, *La lingua di Niccolò Tartaglia: Un puoco grossetto di loquella: "La Nova scientia" e i "Quesiti et inventioni diverse"* (Milan: LED, 1998), 35.

38 Girolamo Tiraboschi, *Storia della letteratura italiana*, vol. 7 (Modena: Società Tipografica, 1777), 147, as cited by Piotti, *La lingua di Niccolò Tartaglia*, 33.

39 Carlo Cocchetti, *Brescia e la sua provincia: Grande illustrazione del Lombardo-Veneto*, ed. C. Cantù, vol. 3 (Milan: Corona e Caimi, 1858), 137, as cited by Piotti, *La lingua di Niccolò Tartaglia*, 34.

40 Piotti, *La lingua di Niccolò Tartaglia*, 173n1.

41 Pietro Riccardi, *Biblioteca matematica italiana dalla origine della stampa ai primi anni del secolo XIX*, vol. 2 (Modena: Soliani, 1870–86), 498.

42 See Ferrari, third *cartello*, 24 May–1 June 1547, 1; and fifth *cartello*, October 1546, 7, in Tartaglia and Ferrari, *Cartelli di sfida matematica*, ed. Masotti.

43 Ferrari, first *cartello*, 10 February 1547, 2, in ibid.

44 Bernardino Baldi, *Cronica de' matematici overo epitome dell'istoria delle vite loro* (Urbino: Angelo Ant. Monticelli, 1707), 79r/v; translation mine.

45 Piotti, *La lingua di Niccolò Tartaglia*.

46 Ibid., 22.

47 Ibid., 33.

48 Tartaglia, *General trattato di numeri et misure* (Venice: Curtio Troiano dei Navò, 1556), Part 2, Book 9, 155r; translation mine.

49 Tartaglia, *Euclide Megarense acutissimo philosopho, solo introduttore delle scientie mathematice*, 1543 (Venice: Giovanni Bariletto, 1569), 3. See also Edward Strong, *Procedures and Metaphysics: A Study in the Philosophy of Mathematical-Physical Science in the Sixteenth and Seventeenth Centuries* (Berkeley: University of California Press, 1936), 57.

50 Strong, *Procedures and Metaphysics*, 59.

51 "Aurum probatur igni et ingenium mathematicis, cioe la bonta de loro demostra el fuoco e la peregrineza del ingegno le mathematici discipline." Luca Pacioli, *De divina proportione* (1497/8), 2v in the manuscript version given to Ludovico Sforza, currently held at the Bibliothèque de l'Université de Genève (n. 210).

52 See Anna De Pace, *Le matematiche e il mondo: Ricerche su un dibattito in Italia nella seconda metà del Cinquecento* (Milan: FrancoAngeli, 1993), especially 242–60; and Annarita Angelini, *Simboli e questioni: L'eterodossia culturale di Achille Bocchi e dell'Hermathena* (Bologna: Pendragon, 2003), 72 and following. See also Strong,

Procedures and Metaphysics, 57–61, and Luigi Besana, "La Nova Scientia di Nicolò Tartaglia: Una lettura," in *Per una storia critica della scienza*, ed. Marco Beretta, Felice Mondella, and Maria Teresa Monti (Milan: Cisalpino, 1996), 49–71.

53 The second-to-last verse, "Rerum varias cognoscere causas," in Pacioli's poem following the title page of the printed version of *De divina proportione* (Venice: A. Paganini, 1509), is nearly identical to Virgil, *Georgics* (II, v. 490): "Felix, qui potuit rerum cognoscere causas" [Happy is he who is able to know the causes of things].

54 See Tartaglia, *Euclide Megarense acutissimo philosopho*, Lesson II, sections 27–8.

55 Ferrari, first *cartello*, 10 February 1547, 2, in Tartaglia and Ferrari, *Cartelli di sfida matematica*, ed. Masotti.

56 *Quesiti*, Book 9, q. xxvi, 108r.

4. Hidden Curves

1 Novalis, *Schriften* (Berlin: G. Reimer, 1837), vol. 2, 147.

2 Della Porta discusses many of his travels and acquaintances in his preface to *Magiae naturalis libri XX* (Naples: Apud Horatium Saluianum, 1589). He dedicated *Physiognomia* (Vico Equense: Giuseppe Cacchio, 1586) to Cardinal Luigi d'Este; *De furtivis literarum notis vulgo de ziferis* (Naples: Giovanni Maria Scoto, 1563) to Philip II; *Taumatologia* (manuscript, never published) to Rudolph II; and *Elementorum curvilineorum libri tres: In quibus altera geometriae parte restituta, agitur de circuli quadratura* (Rome: Bartolomeo Zannetti, 1610) to Federico Cesi.

3 On the priority of claims for inventing the telescope, see Eileen Reeves, *Galileo's Glassworks: The Telescope and the Mirror* (Cambridge, MA: Harvard University Press, 2008), especially 70–80.

4 For information on Della Porta's biography, see especially Della Porta, *Della magia naturale del signor Gio. Battista Della Porta Napolitano libri XX*, trans. Pompeo Sarnelli (Naples: Antonio Bulifon, 1677); Francesco Colangelo, *Racconto istorico della vita di Gio. Battista Della Porta filosofo napolitano: Con un'analisi delle sue opere stampate* (Naples: Fratelli Chianese, 1813); Francesco Fiorentino, *Studi e ritratti della rinascenza*, ed. Luisa Fiorentino (Bari: Laterza, 1911); Della Porta, *De telescopio*, ed. Vasco Ronchi and Maria Amalia Naldoni (Florence: Olschki, 1962); Miller Howard Rienstra, "Giovanni Battista Della Porta and Renaissance Science" (PhD dissertation, University of Michigan, 1963); Louise George Clubb, *Giambattista Della Porta, Dramatist* (Princeton: Princeton University Press, 1965); Raffaele Sirri, *L'attività teatrale di G.B. Della Porta* (Naples: Libreria De Simone, 1968); Gabriella Belloni, *"Criptologia" di Giovan Battista Della Porta: Conoscenza magica e ricerca scientifica in G.B. Della Porta* (Rome: Centro Internazionale di Studi Umanistici, 1982); Laura Balbiani, *La "Magia Naturalis" di Giovan Battista Della Porta: Lingua, cultura e scienza in Europa all'inizio dell'età moderna* (Bern: Lang, 2001); and Sergius Kodera, "Giambattista Della Porta,"

in *The Stanford Encyclopedia of Philosophy*, ed. Edward N. Zalta, 19 May 2015. See also the many volumes of the *Edizione Nazionale delle opere di Giovan Battista Della Porta*, ed. Raffaele Sirri (Naples: Edizioni Scientifiche Italiane, 1996–).

 Giuseppe Gabrieli's publications on Della Porta and the Lincei offer extensive insights into Della Porta's later life and works. See also Gabrieli's bibliography of studies that mention Della Porta: "Giambattista Della Porta, Notizia Bibliografica dei suoi mss. e libri, edizioni, ecc. con documenti inediti," *Rendiconti della R. Accademia Nazionale dei Lincei* s.6a.8 (1932): 206–77.

5 Clubb, *Giambattista Della Porta, Dramatist*, 38.

6 "Requirenti mihi veterum in omni rerum genere quaedam manuscripta monumenta, ut arcani quid & abditi inde depromerem (ita me semper ad haec propensum natura tulit) cum non semel contigisset in obscuras quasdam notas, & characteres impingere, quibus scriptores dum legentibus inuident rerum cognitionem, ex industria solent sua scripta occultare, ea dimittere saepenumero cogebar, ad quae magis cupiditas animum accendebat." In the "Preface to the Reader," *De furtivis literarum notis vulgo de ziferis* (Naples: Giovanni Maria Scotto, 1563), 3. English text is from the 1591 edition of *De furtivis*, printed in London by John Wolfe.

7 The first version of Della Porta's *Magiae* saw fifty-eight editions over the course of a century, and the second version was almost as popular, with thirty-five editions. See Laura Balbiani, "La ricezione della *Magia naturalis* di Giovan Battista Della Porta: Cultura e scienza dall'Italia all'Europa," *Bruniana & Campanelliana* 5.2 (1999): 277–303.

8 See notes 25 and 26 below for publication information on the *Elementa*.

9 Carla Mazzio, "The Three-Dimensional Self: Geometry, Melancholy, Drama," in *Arts of Calculation: Numerical Thought in Early Modern Europe*, ed. David Glimp and Michelle R. Warren (New York: Palgrave, 2004), 39–65.

10 See Raffaele Lucariello, "Introduction," *Le zifere o della scrittura segreta*, by Giambattista Della Porta, ed. Lucariello (Naples: Filema, 1996), 14.

11 *De furtivis literarum notis vulgo de ziferis* (Naples: Giovanni Maria Scotto, 1563). A 1602 edition was published in Naples by "J.B. Subtilem," which may be the "subtle" Della Porta himself. Della Porta's books *Criptologia* and *De ziferis* have no relationship to the combinatorial processes proposed in *De furtivis*; they are instead concerned with the physical processes of secret writing (e.g., invisible ink, or hiding words on the inside of an eggshell).

12 See Giuseppe Gabrieli, *Contributi alla storia della Accademia dei Lincei*, vol. 1 (Rome: Accademia Nazionale dei Lincei, 1989), 694.

13 "I segni sono segni a coloro che li conoscono." Della Porta likely wrote *La carbonaria* in 1601, the same year he published the first *Elementa*; see Alberto Granese, "L'edizione delle commedie," in *L'edizione nazionale del teatro e l'opera di G.B. Della Porta: Atti del convegno, Salerno, 23 maggio 2002*, ed. Milena Montanile (Pisa: Istituti Editoriali e Poligrafici Internazionali, 2004), 97.

14 Cesare Vasoli, "L'analogia universale: La retorica come semiotica nell'opera del Della Porta," in *Giovan Battista della Porta nell'Europa del suo tempo: Atti del convegno Giovan Battista della Porta, Vico Equense-Castello Giusso, 29 settembre–3 ottobre 1986*, ed. Maurizio Torrini (Naples: Guida, 1990), 32.

15 See Luigi Amabile, *Il Santo Officio della inquisizione in Napoli, narrazione con molti documenti inediti* (Città del Castello: S. Lapi, 1892), 327, as cited by Clubb, *Giambattista Della Porta, Dramatist*, 16.

16 See Raffaele Sirri, "Teatralità del teatro di G.B. Della Porta," in *L'edizione nazionale del teatro e l'opera di G.B. Della Porta*, ed. Montanile, 70.

17 Elena Candela, "Un caso di esasperato plurilinguismo in commedia," *Annali Istituto Universitario Orientale, Napoli, Sezione Romanza* 32.2 (1990): 503–22. See also Raffaele Sirri, "L'artificio linguistico di G.B. della Porta: Le tragedie," *Annali Istituto Universitario Orientale, Napoli, Sezione Romanza* 20 (1978): 307–57; "L'artificio linguistico di G.B. Della Porta," *Annali Istituto Universitario Orientale, Napoli, Sezione Romanza* 21 (1979): 59–112; and "Invenzione linguistica e invenzione teatrale di G.B. Della Porta," *Annali Istituto Universitario Orientale, Napoli, Sezione Romanza* 29.2 (1987): 255–77; Vasoli, "L'analogia universale"; and Paolo Silvestri, "Aspetti del comico linguistico nel teatro di Giambattista Della Porta," *Annali Istituto Universitario Orientale, Napoli, Sezione Romanza* 35.2 (1993): 629–48.

18 Luisa Muraro, *Giambattista Della Porta mago e scienziato* (Milan: Feltrinelli, 1978), 27. See also Nada Pesetti, "Tipologie e linguaggio nelle commedie di Giovambattista Della Porta," *Studi di filologia e letteratura* 4 (1978): 127–46; and Francesco Tateo, "Sul linguaggio scientifico di Giambattista della Porta," in *Giambattista della Porta in edizione nazionale: Atti del convegno di studi*, ed. Raffaele Sirri (Naples: Istituto Italiano per gli Studi Filosofici, 2007), 47–60.

19 Silvestri, "Aspetti del comico linguistico," 640.

20 Giorgio Pullini, "Stile di transizione nel teatro di Giambattista della Porta," *Lettere Italiane* 8.3 (1956): 302.

21 Della Porta, Introductory statement to *La trappolaria* (Bergamo: Comin Ventura, 1596). Translations from the play in this chapter are mine. Granese dates this comedy to 1596; see his "L'edizione delle commedie," 97.

22 Pesetti, "Tipologie e linguaggio," 132.

23 Carmelo Greco, "Scienza e teatro in G.B. Della Porta," in *Letteratura e scienza nella storia della cultura italiana: Atti del IX Congresso A.I.S.L.L.I.: Palermo-Messina-Catania, 21–25 aprile 1976* (Palermo: Manfredi, 1978), 429; and Sergius Kodera, "Giambattista Della Porta's Histrionic Science," *California Italian Studies* 3.1 (2012): 1–27. William Eamon has discussed the high level of theatricality that characterized presentations of scientific experiments and results in early modern Europe in "Markets, Piazzas, and Villages," in *The Cambridge History of Science Vol. 3: Early Modern Science*, ed. Katherine Park and Lorraine Daston (Cambridge: Cambridge University Press, 2006), 206–23.

24 Oreste Trabucco, "Nell'officina di Giovan Battista Della Porta," *Bruniana &*
Campanelliana 7.1 (2001): 269–79.

25 *Pneumaticorum libri tres quibus accesserunt Curvilineorum elementorum libri duo* (Naples:
Io. Iacobum Carlinum, 1601). This publication information refers only to the *Pneumatica*;
the *Elementa*, although bound in the same volume, has a different publisher (Naples:
Antonio Pace, 1601).

26 In their introduction to the *Elementorum curvilineorum libri tres: Edizione nazionale*
delle opere di Giovan Battista Della Porta (Naples: Edizioni Scientifiche Italiane, 2005),
Veronica Gavagna and Carlotta Leone offer an excellent description of the autograph
Elementa held in the Archive of the Accademia dei Lincei (ms XV[i]). The manuscript
has 165 numbered leaves; the first 30 of these contain the *Elementa*. The autograph
is not dated, and though it names a fourth book, no fourth book is included in the
manuscript. Every page, except for 23v, has at least one diagram.

27 I would like to thank Pier Daniele Napolitani and Paolo d'Alessandro for provid-
ing me with a translation of Demisiani's poem from Greek into Italian. Francesco
Gabrieli, son of the Lincei historian Giuseppe Gabrieli, also translated the poem;
his version can be found in Giuseppe Gabrieli, "Un greco accademico dei primi
Lincei: Demisianos," *Studi Bizantini* 1 (1924): 125–34, and it is reprinted in Gabrieli,
Contributi, vol. 2, 1117–27. I include here the original Greek followed by Napolitani
and d'Alessandro's translation:

Ἦμος ἑοῖς ἐπέεσσι πολύχροα Δαίδαλα Πόρτης
φαίνει, τοῖς θαλέθει γαῖα πυκαζομένη·
οὔατι θαμβαίνουσα βιαρκέι μῦθον ἀκούει
καὶ σφετέρης γαίει φέγγεσιν ἀγλαΐης.
Ἀτρυγέτου βάζοντος ἀπείριτα θαύματα πόντου,
σιγαλέη πόντος νηνεμίη γελάει[a].
Ἤερος αἰγλήεντος ὅταν χύσιν αὖτις ἐνίσπει,
ἴσον ἀπαστράπτει δώμασιν οὐρανίων
Αἰθέρος ἀστροχίτωνος ἀτειρέα νῶτα πιφάσκει
καὶ Πόλος ἠρεμέων οὐδ᾿ ἑτέρωσε θέει
Κύκλα δὲ καὶ Τετράγωνα, Τρίγωνάτε, Πρίσματα, Κῶνες
καὶ γράμμας μετρεῖ κέντρατε πυραμίδων
ὅσσατε πὰρ Νείλου προχοῆς μητίσατο τέχνη
λήια δαιτρεύων Ἡερίης ναέτης
Αὐτή νυν Σοφίη πολυμήχανα δήνεα τίει,
ὕδωρ πρηὺ ῥέον Νεῖλος ἐρυκακέει·
ἔδρακε γὰρ Τετράγωνα πάρος πολεμήια Κύκλοις
ὅρκια συνθεσίης καὶ φιλίης ταμέειν,
ἔδρακε καὶ θάμβησεν ὅπερ χρόνος ὀψὲ φαείνειν
ἤμελλε, ζαθέων ἠὺ τέκος πραπίδων.

Ἄλλον ἐγώ, Κρονίδη, δώσω πολυΐδμονα Πόρτην
ἥν ἡμῖν ἄλλην Παρθενόπην ὀπάσεις.

Quando con le sue parole variopinti artifici dedalici Porta
rivela, avvoltane fiorisce la terra:
attonita ne ascolta il messaggio con orecchio vivificatore
e gioisce dei raggi del suo splendore.
Se dice le infinite meraviglie del mare ondoso,
in silenziosa bonaccia il mare ride.
Quando poi racconta la distesa dell'aria splendente,
brilla come le dimore dei cieli.
Dell'etere ammantato di stelle illumina le insondabili convessità
e la Volta celeste fermatasi non corre dall'altra parte.
E Cerchi e Quadrati e Triangoli, Prismi, Coni
e figure misura e i centri delle piramidi
e quante [forme] presso le foci del Nilo abbia meditato con abilità,
i campi ripartendo, l'abitante di Aeria.
Sapienza stessa invero gli ingegnosi progetti onora,
il Nilo arresta l'acqua che placida scorreva:
vide infatti i Quadrati un tempo in guerra con i Cerchi
stringere patti giurati di alleanza e amicizia,
vide e stupì di ciò che il tempo alfine a portare alla luce
si appressava, nobile figlio di venerandi pensieri.
Un altro Porta dalla molta scienza io ti concederò, o Cronide,
quando tu ci donerai un'altra Partenope.

28 Although the event actually postdates publication of the 1610 *Elementa*, we know
that Della Porta and Demisiani both attended the famous dinner in honour of
Galileo's celestial discoveries that Cesi hosted in Rome on 14 April 1611. At this
dinner, the device that Della Porta is often credited with inventing – and that Galileo
had used to make his planetary observations – finally received its name. Some said
it was Demisiani who dubbed the invention a "telescopio" (τηλεσκόπιο, meaning "to
see at a distance"). Others, including Della Porta and the physician Johannes Faber,
attribute the term to Cesi. On naming the telescope, see Edward Rosen, *The Naming
of the Telescope* (New York: Henry Schuman, 1947); Henry C. King, *The History of
the Telescope* (London: Griffin, 1955); Stillman Drake, *The Unsung Journalist and the
Origin of the Telescope* (Los Angeles: Zeitlin & Ver Brugge, 1976); and Reeves, *Galileo's
Glassworks*.

29 Francesco Stelluti's poem reads, "Vidimus innumeras mutatem Protea formas, /
Credite, nam veri Nuncia Fama canit. / Tortilis en Orbis species se vertit in omnes, /
Et QUADRUM teretes efficit arte rotas. / Dicite Pierides quo tandem munere
factum? / Aut nostro, aut PORTAE visq. laborq. pares."

30 See Pier Daniele Napolitani, "La matematica nell'opera di Giovan Battista Della Porta," in *Giovan Battista della Porta nell'Europa del suo tempo*, ed. Torrini, 137–9; and Gavagna and Leone, "Introduction," xvi.

31 The dedicatory letter Della Porta wrote to Cesi is dated 1 July 1610, although the *Elementa* would not be published until September of that year. See Gabrieli, *Contributi*, vol. 1, 639–40.

32 See Napolitani, "La matematica," 121, 128–9.

33 Marshall Clagett, ed., *Archimedes in the Middle Ages*, vol. 4 (Madison: University of Wisconsin Press, 1964).

34 See Gavagna and Leone, "Introduction," xxi.

35 See Napolitani, "La matematica," 119. Napolitani also points to an Arabic text entitled *Liber Assumptorum* that Della Porta may have consulted when working on *arbeli* for the *Elementa* ("La matematica," 132–3). The text was likely owned by Giovanni Battista Raimondi; he or one of the many Arabic translators in Rome and Naples could have helped Della Porta access pertinent information from the treatise.

36 Antonio Rossetti thus describes the recently deceased Della Porta in a dedicatory letter to Carlo Saracini, the *Tabernaria*'s editor (Ronciglione: Domenico Domenici, 1616). See Candela, "Un caso di esasperato plurilinguismo in commedia," 504.

37 On the presence of "play" in early modern scientific works, see Paula Findlen, "Jokes of Nature and Jokes of Knowledge: The Playfulness of Scientific Discourse in Early Modern Europe," *Renaissance Quarterly* 43.2 (1990): 292–331.

38 "Ipse quidem, qui potius noua tractare, quam ab aliis transcribere natus, Euclidis propositiones multas in curuilineas converti, et cum nihil fecisse cognouerim." Preface to the 1601 edition of the *Elementa*.

39 In his 1610 dedicatory letter to Federico Cesi, Della Porta admits his uncertainty. He may not yet have found "the" way to square the circle: "An uero modum quadrandi circuli inuenerim, sicque praemium, et fructuum meorum coeperim laborum, non facile statuerim."

40 See Della Porta, *Magiae naturalis libri XX*, Book 17, Chapters 10–11. See also his *De telescopio*, published posthumously, edited by Ronchi and Naldoni (1962). In a letter to Galileo of 26 September 1614, Della Porta writes that "se con 'l solito [telescope] si vede fin nell'ottava sfera, con questo si vedrà fin nell'empireo, e piacendo al Signore spiaremo i fatti di là su, e faremo un Nuncio Empireo" (mss Gal. P.I.T. VII, car. 174, at the Biblioteca Nazionale di Firenze). I wish to thank Eileen Reeves for providing me with this reference.

41 See especially Napolitani on Della Porta's inclination towards the sensible and tangible, as opposed to the "logico-deduttiva" ("La matematica," 128–9).

42 See Rienstra's discussion of Della Porta's concept of "contemplation." Rienstra argues that Florentine Platonism influenced Della Porta in his fusion of the classical binaries contemplation and action. Rienstra, "Giovanni Battista Della Porta and Renaissance Science."

43 See Gavagna and Leone, "Introduction," 13–14n11; and Gabrieli, *Contributi*, vol. 1, 67.
44 For a detailed review of both errors and *stravaganze*, see Gavagna and Leone, "Introduction," and Napolitani, "La matematica."
45 See Napolitani, "La matematica," 159.
46 See the notes for an "academic elegy" for Della Porta written by an Accademia dei Lincei member or members, cited by Gabrieli in "Giovan Battista Della Porta Linceo: Da documenti per gran parte inediti," in *Contributi*, vol. 1, 425.
47 Gabrieli, *Contributi*, vol. 1, 703.
48 See Pietro Riccardi, *Biblioteca matematica italiana dalla origine della stampa ai primi anni del secolo XIX*, vol. 2 (Modena: Soliani, 1880), xiii–xx. G.J. Whitrow discusses the decline of Italian mathematics in "Why Did Mathematics Begin to Take Off in the Sixteenth Century?" in *Mathematics from Manuscript to Print, 1300–1600*, ed. Cynthia Hay (Oxford: Clarendon Press, 1988), 264–9.
49 See the Introduction to this present study for a discussion and dating of Baldi's *Vite de' matematici* (1586–90). Della Porta is also absent from Baldi's briefer *Cronica de' matematici*, written contemporaneously with the *Vite* though not published until 1707.
50 Guillaume Libri, *Histoire des sciences mathématiques en Italie: Depuis la renaissance des lettres jusqu'à la fin du dix-septième siècle*, vol. 4 (Paris: J. Renouard, 1841), 138.
51 Augustus De Morgan, *A Budget of Paradoxes*, 1872, in *The Encyclopedia of Eccentrics* (La Salle: Open Court, 1974), 68.
52 Joseph E. Hofmann, "Über Portas Quadratur krummlinig begrenzter ebener Figuren," *Archives internationales d'histoire des sciences* 23–4 (1953): 199.
53 Roberto Marcolongo, "Su due opere poco conosciute di Luca Valerio e G.B. Porta," *Rivista di fisica, matematica e scienze naturali* 10 (1936): 179–80. See also Marcolongo's *Memorie sulla geometria e la meccanica di Leonardo da Vinci* (Naples: S.I.E.M, 1937).
54 "En tibi, amice Lector faecundum ingenium Portae infinita, vel ornamenta, vel adiumenta parturijt, ac elaborauit" (Bartolomeo Zannetti's note to readers in the 1610 *Elementa*, 97).
55 Colangelo, *Racconto istorico*, 22–4.
56 Cesare Fornari, *Di Giovanni Battista Della Porta e delle sue scoperte: Discorso* (Naples: Fratelli de Angelis, 1871), 13.
57 "... filosofo sì grande e celebrato universalmente nelle scienze Matematiche e Naturali": Antonio Rossetti, editor of the *Tabernaria* (1616), describing the recently deceased Della Porta in his dedicatory letter to Carlo Saracini. See Candela, "Un caso di esasperato plurilinguismo in commedia," 504.
58 Gino Loria, "The Physicist J.B. Porta as a Geometer," *Bulletin of the American Mathematical Society* 22.7 (1916): 340–3.
59 Clubb, *Giambattista Della Porta, Dramatist*, 37.
60 Gabrieli, *Contributi*, vol. 1, 662–3.
61 Maurizio Torrini, "Della Porta scienziato," in *L'edizione nazionale del teatro e l'opera di G.B. Della Porta*, ed. Montanile, 3–4.

62 See Sirri, "Teatralità del teatro." Giorgio Bàrberi Squarotti argues the opposite –
 viewing Della Porta's theatre as structurally and thematically opposed to novelty –
 in his "Della Porta o il teatro del mondo," in *Giovan Battista Della Porta nell'Europa
 del suo tempo*, ed. Torrini, 439–67.

63 Della Porta, *La trappolaria* (Bergamo: Comin Ventura, 1596), IV.ii, 41v–42v.
 Translation mine.

64 From the 1658 English translation, *Natural Magick* (London: Thomas Young and
 Samuel Speed), with some modifications. The Latin reads, "Ex notissimis aliquando &
 vilissimis ad utilia & excelsa pervenitur, & quae vix mens percipere potest. Intellectus
 noster nisi verissimis principiis innitatur, non potest alta & sublimia speculari.
 Mathematica scientia, ex tritis & vulgatis quibusdam ad multa ardua & sublimia
 supervehitur, unde vera potius & utilia, quam falsa, & magna scribere visum est."
 Leaf 2r of the 1589 edition printed in Naples by Orazio Salviani.

65 Francesco Fiorentino, *Studi e ritratti della rinascenza*, ed. Luisa Fiorentino (Bari:
 Laterza, 1911), 283.

66 Tomaso Garzoni, *La piazza universale di tutte le professioni del mondo*, 1585, ed. Paolo
 Cherchi and Beatrice Collina, 2 vols (Turin: Einaudi, 1996), especially Dis. 22, vol. 1,
 324–7. See also Dis. 41: "De' maghi incantatori, o venefici, o malefici, o negromanti …"
 (vol. 1, 677–99).

67 "Sumptibus ne parcat, sed perquirendo prodigus, dumque attentius, examinatiusque
 perquirit, patiens revocare ne gravetur, nec laboribus parcat: ociosis enim, & ignaris
 Naturæ secreta non panduntur." *Magiae naturalis, sive, De miraculis rerum naturalium
 libri IIII* (Antwerp: Christopher Plantin, 1560), Book 1, Chapter 2, p. 3.

68 Della Porta, Archivi dei Lincei di Roma, ms IX, fol. 21 and 22, in Gabrieli, *Contributi*,
 vol. 1, 752.

69 Paula Findlen, *Possessing Nature: Museums, Collecting, and Scientific Culture in Early
 Modern Italy* (Berkeley: University of California Press, 1994), 318. Findlen writes,
 "the oak tree symbolized Virgilian humility: *Descendo ut ascendam* (I descend so that
 I may ascend) … Della Porta was a grapevine, bowed by the weight of its fruit, with
 the motto *Perit ubertate sua* (It perishes from its fertility) because he 'had given himself
 away in order to help many of his friends.' Likewise a candle – *Morior mihi, ut vivam
 aliis* (I die for myself so that I may live for others) – signified the fate of a man who
 'consumed himself to give pleasure to his friends.' … the fish who gazed upward at the
 heavens, was meant to reinforce his contemplative side" (318–19). The fish motto
 was *ex animo*. See Gabrieli, *Contributi*, vol. 1, 754.

70 As cited and translated by Findlen, *Possessing Nature*, 319.

71 Gabrieli, *Contributi*, vol. 1, 662.

Bibliography

1. Leon Battista Alberti
2. Luca Pacioli
3. Niccolò Tartaglia
4. Giambattista Della Porta
5. Other Works Consulted

1a. Leon Battista Alberti: *De componendis Cifris* (chronological order)

Alberti, Leon Battista. *De componendis Cifris*. Manuscript Copy. Florence, Biblioteca Nazionale Centrale, Cod. II, IV, 39. Fondo Principale (Magliabechianus II.IV.39).

_____. *De componendis Cifris*. Manuscript Copy. Florence, Biblioteca Riccardiana, 0767 and 0927.

_____. *De componendis Cifris*. Manuscript Copy. Florence, Biblioteca Marucelliana, B. VI. 39.

_____. *De componendis Cifris*. Manuscript Copy. Vatican City, Biblioteca Apostolica Vaticana, ms Chigi M II 49, vol. 35; Vat. Lat. 6532, 5118, and 5357; Varia Politicorum LXXX and 5357.

_____. *De componendis Cifris*. 1466. *Opuscoli morali*. Ed. Cosimo Bartoli. Venice: Franceschi, 1568. 200–19.

_____. "*De cifra* (the proem)." *Leon Baptistae Alberti: Opera inedita et pauca separatim impressa*. Ed. Girolamo Mancini. Florence: Sansoni, 1890. 309–11.

_____. *Trattato della cifra. Un primato italiano: La crittografia nei secoli XV e XVI*. Ed. and trans. Luigi Sacco. Rome: Istituto Storico e di Cultura dell'Arma del Genio, 1958. 37–50.

_____. *Dello scrivere in cifra*. Ed. Augusto Buonafalce and Alessandro Zaccagnini. Trans. Alessandro Zaccagnini. Turin: Galimberti, 1994.

_____. *A Treatise on Ciphers.* Ed. Augusto Buonafalce. Trans. Alessandro Zaccagnini. Turin: Galimberti, 1997.

_____. *Sur la cryptographie.* Trans. Martine Furno. *Leon Battista Alberti: Actes du Congrès International de Paris, 10–15 avril 1995.* Ed. Francesco Furlan et al. Vol. 2. Turin: Nino Aragno, 2000. 709–25.

_____. *De componendis cifris/On Writing in Ciphers.* Ed. Lionel March. Trans. Kim Williams. *The Mathematical Works of Leon Battista Alberti.* Ed. and trans. Kim Williams, Lionel March, and Stephen R. Wassell. Basel: Birkhäuser, 2010. 171–200.

1b. Leon Battista Alberti: Other Works and Critical Studies Consulted

Alberti, Leon Battista. "Anuli." *Leon Baptistae Alberti: Opera Inedita et pauca separatim impressa.* Ed. Girolamo Mancini. Florence: Sansoni, 1890. 224–35.

_____. *Apologi Centum/Apologhi.* Ed. and trans. Marcello Ciccuto. Milan: Rizzoli, 1989.

_____. *De Pictura/Della pittura.* Ed. and trans. Cecil Grayson. 1975. Bari: Laterza, 1980.

_____. *De re aedificatoria.* Strasbourg: M. Jacobus Cammerlander Moguntinus, 1541.

_____. *De re aedificatoria/Ten Books on Architecture.* Trans. into Italian by Cosimo Bartoli. Ed. Joseph Rykwert. Trans. into English by James Leoni. New York: Transatlantic Arts, 1966.

_____. *Descriptio urbis Romae/Delineation of the City of Rome.* Ed. Mario Carpo and Francesco Furlan. Trans. Peter Hicks. Tempe: Arizona Center for Medieval and Renaissance Studies, 2007.

_____. *Dinner Pieces.* Ed. and trans. David Marsh. Binghamton: Medieval & Renaissance Texts & Studies, 1987.

_____. *Grammatichetta e altri scritti sul volgare.* Ed. Giuseppe Patota. Rome: Salerno, 1996.

_____. *Intercenales.* Ed. and trans. Franco Bacchelli and Luca D'Ascia. Bologna: Pendragon, 2003.

_____. "L.B. Alberti in the Mirror: An Interpretation of the *Vita* with a New Translation." Ed. and trans. Renée Watkins. *Italian Quarterly* 30.177 (1989): 5–30.

_____. "Leonis Baptistae de Albertis Vita." Ed. Riccardo Fubini and Anna Menci Gallorini. *Rinascimento* 2.12 (1972): 21–78.

_____. *Ludi matematici.* Ed. Raffaele Rinaldi and Ludovico Geymonat. Milan: Guanda, 1980.

_____. *Momus.* Ed. Virginia Brown and Sarah Knight. Trans. Sarah Knight. Cambridge, MA: Harvard University Press, 2003.

_____. "Musca." *Opuscoli inediti: "Musca," "Vita Santi Potiti."* Ed. Cecil Grayson. Florence: Olschki, 1954.

_____. *On Painting.* Ed. Martin Kemp. Trans. Cecil Grayson. London: Penguin Books, 1991.

Bibliography

_____."One Hundred Apologues." *Renaissance Fables: Aesopic Prose by Leon Battista Alberti, Bartolomeo Scala, Leonardo da Vinci, Bernardino Baldi.* Ed. and trans. David Marsh. Tempe: Arizona Center for Medieval and Renaissance Studies, 2004. 34–83.

_____. *Opere volgari.* Ed. Cecil Grayson. 3 vols. Bari: Laterza, 1960–73.

_____. *La prima grammatica della lingua volgare. La "Grammatichetta" vaticana* Cod. Vat. Reg. Lat. 1370. Bologna: Commissione Per i Testi di Lingua, 1964.

_____. *Profugiorum ab aerumna libri III. Opere volgari.* Ed. Cecil Grayson. Vol. 2. Bari: Laterza, 1966.

_____. *Rime e versioni poetiche.* Ed. Guglielmo Gorni. Milan-Naples: Ricciardi, 1975.

_____. *Trivia senatoria.* Ed. Stefano Cartei. Florence: Polistampa, 2008.

_____. *The Use and Abuse of Books.* Ed. and trans. Renée Neu Watkins. Prospect Heights, IL: Waveland Press, 1999.

Arrighi, Gino. "Leon Battista Alberti e le scienze esatte." *Convegno internazionale indetto nel V centenario di Leon Battista Alberti.* Rome: Accademia Nazionale dei Lincei, 1974. 155–212.

Bertolini, Lucia. "Fuori e dentro la *Grammatichetta* albertiana." *Da riva a riva: Studi di lingua e letteratura italiana per Ornella Castellani Pollidori.* Ed. Paola Manni and Nicoletta Maraschio. Florence: Franco Cesati, 2011. 55–70.

_____. *Leon Battista Alberti: Censimento dei manoscritti.* 2 vols. Florence: Polistampa, 2004.

Bongrani, Paolo. "Nuovi contributi per la *Grammatica* di L.B. Alberti." *Studi di Filologia Italiana: Bollettino Annuale dell'Accademia della Crusca* 40 (1982): 65–106.

Borsi, Franco. *Leon Battista Alberti: The Complete Works.* Trans. Rudolf G. Carpanini. New York: Rizzoli, 1973.

Brown, Rawdon. "History of Italian Cipher." *Calendar of State Papers and Manuscripts Existing in the Archives and Collections of Venice.* Vol 2. London: Longmans, Green, Reader, and Dyer, 1867. xix–xxii.

Burroughs, Charles. "Grammar and Expression in Early Renaissance Architecture: Brunelleschi and Alberti." *RES: Anthropology and Aesthetics* 34 (1998): 39–63.

Camerota, Filippo. "Leon Battista Alberti e le scienze matematiche." *L'uomo del Rinascimento: Leon Battista Alberti e le arti a Firenze: Tra ragione e bellezza.* Ed. Cristina Acidini and Gabriele Morolli. Florence: Mandragora/Maschietto, 2006. 361–5.

Cardini, Roberto. *Mosaici: Il "Nemico" dell'Alberti.* Rome: Bulzoni, 1990.

_____. "Alberti o della scrittura come mosaico." *Leon Battista Alberti: La biblioteca di un umanista.* Ed. Roberto Cardini, Lucia Bertolini, and Mariangela Regoliosi. Florence: Mandragora, 2005. 91–4.

Cardini, Roberto, Lucia Bertolini, and Mariangela Regoliosi, eds. *Leon Battista Alberti: La biblioteca di un umanista.* Florence: Mandragora, 2005.

Cardini, Roberto, and Mariangela Regoliosi, eds. *Alberti e la cultura del Quattrocento: Atti del Convegno internazionale del Comitato Nazionale VI centenario della nascita di Leon Battista Alberti, Firenze: 16–18 dicembre, 2004.* 2 vols. Florence: Polistampa, 2007.

Bibliography

Carpo, Mario. *Architecture in the Age of Printing: Orality, Writing, Typography, and Printed Images in the History of Architectural Theory.* Trans. Sarah Benson. Cambridge, MA: MIT Press, 2001.

Cassani, Alberto. "Explicanda sunt mysteria: L'enigma albertiano dell'occhio alato." *Leon Battista Alberti: Actes du Congrès International de Paris, 10–15 avril 1995.* Ed. Francesco Furlan et al. Vol. 2. Turin: Nino Aragno, 2000. 245–304.

Chiavoni, Luca, Gianfranco Ferlisi, and Maria Vittoria Grassi, eds. *Leon Battista Alberti e il Quattrocento: Studi in onore di Cecil Grayson e Ernst Gombrich.* Florence: Olschki, 2001.

Colombo, Carmela. "Leon Battista Alberti e la prima grammatica italiana." *Studi Linguistici Italiani* 3 (1962): 176–87.

Cracolici, Stefano. "Flirting with the Chameleon: Alberti on Love." *MLN* 121.1 (2006): 102–29.

Di Pasquale, Salvatore. "Tracce di statica archimedea in Leon Battista Alberti." *Palladio* 9 (1992): 41–68.

Di Stefano, Elisabetta. *L'altro sapere: Bello, arte, immagine in Leon Battista Alberti.* Palermo: Centro Internazionale Studi di Estetica, 2000.

Eriksen, Roy. *The Building in the Text: Alberti to Shakespeare and Milton.* University Park: Pennsylvania State University Press, 2001.

Eugeni, Franco, and Raffaele Mascella. "Leon Battista Alberti, crittografia e crittoanalisi." *Atti di convegno nazionale scienziati mantovani.* Mantua, 2001. Web.

Feld, M.D. "Constructed Letters and Illuminated Texts: Regiomontanus, Leon Battista Alberti, and the Origins of Roman Type." *Harvard Library Bulletin* 28 (1980): 357–79.

Folena, Gianfranco. "Note sul pensiero linguistico di Leon Battista Alberti." *Studi di Grammatica Italiana* 20 (2001): 13–14.

Frauenfelder, Elisa. *Il pensiero pedagogico di Leon Battista Alberti.* Naples: Edizioni Scientifiche Italiane, 2000.

Gadol, Joan. *Leon Battista Alberti: Universal Man of the Early Renaissance.* Chicago: University of Chicago Press, 1969.

Gaines, Helen. *Cryptanalysis: A Study of Ciphers and Their Solution.* 1939. New York: Dover, 1956.

Garin, Eugenio. "Leon Battista Alberti e il mondo dei morti." *Giornale critico della filosofia italiana* 52.2 (1973): 179–89.

Glidden, Hope H. "*Polygraphia* and the Renaissance Sign: The Case of Trithemius." *Neophilologus* 71.2 (1987): 183–95.

Gorni, Guglielmo. "Leon Battista Alberti e le lettere dell'alfabeto." *Interpres* 9 (1989): 257–66.

Grafton, Anthony. *Leon Battista Alberti: Master Builder of the Italian Renaissance.* Cambridge, MA: Harvard University Press, 2000.

————. "Leon Battista Alberti: The Writer As Reader." *Commerce with the Classics: Ancient Books and Renaissance Readers.* Ann Arbor: University of Michigan Press, 1997. 53–92.

_____."Un passe-partout ai segreti di una vita: Alberti e la scrittura cifrata." *La vita e il mondo di Leon Battista Alberti: Atti del convegno internazionale, Genova 19–21 febbraio 2004*. Vol 1. Florence: Olschki, 2008. 3–21.

Grayson, Cecil."Appunti sulla lingua dell'Alberti." *Il volgare come lingua di cultura dal Trecento al Cinquecento: Atti del convegno internazionale, Mantova, 18–20 ottobre 2001*. Ed. Arturo Calzona et al. Florence: Olschki, 2003. 81–90.

_____. *De commodis litterarum atque incommodis: Il volgare come lingua di cultura dal Trecento al Cinquecento: Atti del convegno internazionale, Mantova, 18–20 ottobre 2001*. Ed. Arturo Calzona et al. Florence: Olschki, 2003. 389–405.

_____."The Humanism of Alberti." 1957. *Studi su Leon Battista Alberti*. Ed. Paola Claut. Florence: Olschki, 1998. 129–48.

_____."Leon Battista Alberti and the Beginnings of Italian Grammar." 1943. *Il volgare come lingua di cultura dal Trecento al Cinquecento: Atti del convegno internazionale, Mantova, 18–20 ottobre 2001*. Ed. Arturo Calzona et al. Florence: Olschki, 2003. 193–213.

Harries, Karsten."On the Power and Poverty of Perspective: Cusanus and Alberti." *Cusanus: The Legacy of Learned Ignorance*. Ed. Peter Casarella. Washington, DC: Catholic University of America Press, 2006. 105–27.

Jarzombek, Mark."The Enigma of Alberti's Dissimulatio." *Leon Battista Alberti: Actes du Congrès International de Paris, 10–15 avril 1995*. Ed. Francesco Furlan et al. Vol. 2. Turin: Nino Aragno, 2000. 741–8.

_____. *Leon Baptista Alberti: His Literary and Aesthetic Theories*. Cambridge, MA: MIT Press, 1989.

Kahn, David. *The Codebreakers*. New York: Scribner's, 1967.

_____."On the Origin of Polyalphabetic Substitution." *Isis* 71.1 (1980): 122–7.

Karvouni, Maria."Il ruolo della matematica nel *De re aedificatoria* dell'Alberti." *Leon Battista Alberti*. Ed. Joseph Rykwert and Anne Engel. Milan: Electra, 1994. 282–91.

Katz, M. Barry. *Leon Battista Alberti and the Humanist Theory of the Arts*. Washington, DC: University Press of America, 1977.

Kircher, Timothy."Dead Souls: Leon Battista Alberti's Anatomy of Humanism." *MLN* 127.1 (2012): 108–23.

_____. *Living Well in Renaissance Italy: The Virtues of Humanism and the Ironies of Leon Battista Alberti*. Tempe: Arizona Center for Medieval and Renaissance Studies, 2012.

Kittler, Friedrich."Perspective and the Book." *Grey Room* 5 (2001): 38–53.

Koenigsberger, Dorothy. *Renaissance Man and Creative Thinking: A History of Concepts of Harmony, 1400–1700*. Hassocks: Harvester, 1979.

Landino, Cristoforo."Proemio al Commento dantesco." *Scritti critici e teorici*. Ed. Roberto Cardini. Vol. 1. Rome: Bulzoni, 1974. 120.

Maccagni, Carlo."Leon Battista Alberti e Archimede." *Studi in onore di Luigi Bulferetti* 3 (1987): 1069–82.

Mancini, Girolamo. *Vita di Leon Battista Alberti*. Florence: Sansoni, 1882.

Mandosio, Jean-Marc. "La classification des sciences et des arts chez Alberti." *Leon Battista Alberti: Actes du Congrès Internationale de Paris, 10–15 april, 1995*. Ed. Francesco Furlan et al. Vol 2. Turin: Nino Aragno, 2000. 643–704.

Maraschio, Nicoletta. "Il plurilinguismo quattrocentesco e l'Alberti." *Alberti e la cultura del Quattrocento: Atti del convegno internazionale del Comitato Nazionale VI centenario della nascita di Leon Battista Alberti, Firenze: 16–18 dicembre, 2004*. Ed. Roberto Cardini and Mariangela Regoliosi. Vol 2. Florence: Polistampa, 2007. 611–28.

March, Lionel. *Architectonics of Humanism: Essays on Number in Architecture*. Chichester: Academy Editions, 1998.

Marolda, Paolo. *Crisi e conflitto in Leon Battista Alberti*. Rome: Bonacci, 1988.

Marsh, David. Introduction. *Dinner Pieces*. By Leon Battista Alberti. Ed. and trans. David Marsh. Binghamton: Medieval & Renaissance Texts & Studies, 1987.

_____. "Poggio and Alberti: Three Notes." *Rinascimento* 23 (1983): 189–215.

_____. "The Self-Expressed: Leon Battista Alberti's Autobiography." *Albertiana* 10 (2007): 125–40.

_____. "So What?" Reply to Ingrid Rowland. *New York Review of Books*, 12 January 1995. Web.

Massalin, Paola, and Branko Mitrović. "L'Alberti ed Euclide." *Albertiana* 11–12 (2008): 165–247.

Mastrorosa, Ida. "Alberti e il sapere scientifico antico: Fra meandri di una biblioteca inter-disciplinare." *Leon Battista Alberti: La biblioteca di un umanista*. Ed. Roberto Cardini, Lucia Bertolini, and Mariangela Regoliosi. Florence: Mandragora, 2005. 133–50.

McLaughlin, Martin. "From Lepidus to Leon Battista Alberti: Naming, Renaming, and Anonymizing the Self in Quattrocento Italy." *Romance Studies* 31.3–4 (2013): 152–66.

_____. *Leon Battista Alberti: La vita, l'umanesimo, le opere letterarie*. Florence: Olschki Editore, 2016.

_____. "Leon Battista Alberti and the Redirection of Renaissance Humanism." *Proceedings of the British Academy* 167, 2009 Lectures (2010): 25–59.

_____. "Literature and Science in Alberti's *De re aedificatoria*." *Science and Literature in Italian Culture from Dante to Calvino*. Ed. Pierpaolo Antonello and Simon Gilson. Oxford: European Humanities Research Centre, 2004. 94–114.

Meister, Aloys. *Die Geheimschrift im Dienste der Päpstlichen Kurie Von Ihren Anfängen Bis Zum Ende des XVI. Jahrhunderts. Mit fünf kryptographischen Schriftafein*. Paderborn: F. Schöningh, 1906.

Mendelsohn, Charles J. "Bibliographical Note on the *De cifris* of L.B. Alberti." *Isis* 32 (1940): 48–51.

Michel, Paul-Henri. *Un idéal humain au XVe siècle: La pensée de L.B. Alberti*. Paris: Les Belles Lettres, 1930.

Mulas, Alessandra. "Felice Feliciano e Leon Battista Alberti." *Leon Battista Alberti tra scienze e lettere: Atti del convegno organizzato in collaborazione con la Société internationale Leon Battista Alberti (Parigi) e l'Istituto italiano per gli studi filosofici (Napoli), Genova,*

19–20 novembre 2004. Ed. Alberto Beniscelli and Francesco Furlan. Genoa: Accademia Ligure di Scienze e Lettere, 2005. 309–26.

Onians, John. "Alberti and the Neuropsychology of Style." *Leon Battista Alberti e il Quattrocento: Studi in onore di Cecil Grayson e Ernst Gombrich: Atti del convegno internazionale, Mantova, 29–31 ottobre 1998*. Ed. Luca Chiavoni, Gianfranco Ferlisi, and Maria Vittoria Grassi. Florence: Olschki, 2001. 239–50.

Pesic, Peter. "Secrets, Symbols, and Systems: Parallels between Cryptanalysis and Algebra, 1580–1700." *Isis* 88.4 (1997): 674–92.

Petrucci, Armando. "L'Alberti e le scritture." *Leon Battista Alberti*. Ed. Joseph Rykwert and Anne Engel. Milan: Electra, 1994. 276–81.

Ponte, Giovanni. *Leon Battista Alberti: Umanista e scrittore*. Genoa: Tilgher, 1981.

Rosenheim, Shawn James. *The Cryptographic Imagination: Secret Writing from Edgar Allan Poe to the Internet*. Baltimore: Johns Hopkins University Press, 1997.

Rowland, Ingrid. "Character Witnesses." *New York Review of Books*, 1 December 1994. Web.

_____. Reply to David Marsh. *New York Review of Books*, 12 January 1995. Web.

Sacco, Luigi, ed. and trans. *Un primato italiano: La crittografia nei secoli XV e XVI*. Rome: Istituto Storico e di Cultura dell'Arma del Genio, 1958.

Salani, Teresa Poggi. "La grammatica dell'Alberti." *Studi di Grammatica Italiana* 20 (2001): 1–12.

Schneider, Laurie. "Leon Battista Alberti: Some Biographical Implications of the Winged Eye." *Art Bulletin* 72.2 (1990): 261–70.

Shoptaw, John. "Lyric Cryptography." *Poetics Today* 21.1 (2000): 221–62.

Simonetta, Marcello. "Federico da Montefeltro architetto della Congiura dei Pazzi e del Palazzo di Urbino." *Francesco di Giorgio alla corte di Federico da Montefeltro: Atti del convegno internazionale di studi: Urbino, Monastero di Santa Chiara, 11–13 ottobre 2001*. Ed. Francesco Paolo Fiore. Florence: Olschki, 2004. 81–102.

_____. "Federico da Montefeltro contro Firenze. Retroscena inediti della congiura dei Pazzi." *Archivio storico italiano* 161 (2003): 261–84.

Singh, Simon. *The Code Book: The Evolution of Secrecy from Mary Queen of Scots to Quantum Cryptography*. New York: Doubleday, 1999.

Strasser, Gerhard F. "The Rise of Cryptology in the European Renaissance." *The History of Information Security: A Comprehensive Handbook*. Ed. Karl de Leeuw and Jan Bergsta. Boston: Elsevier, 2007. 277–325.

Tinti, Paolo. "Pagine come pietre." *Lettere in libertà: Dalle iniziali miniate ai graffiti, alfabeti, segni, immagini*. Ed. Roberta Cristofori and Grazia Maria De Rubeis. Parma: Museo Bodoniano, 2007. 57–66.

Tristano, Caterina. "Il modello e la regola: Teoria e pratiche di scrittura di Leon Battista Alberti." *Leon Battista Alberti: La biblioteca di un umanista*. Ed. Roberto Cardini, Lucia Bertolini, and Mariangela Regoliosi. Florence: Mandragora, 2005. 39–49.

Vagnetti, Luigi. "Considerazioni sui *Ludi Matematici*." *Studi e documenti di architettura* 1 (1972): 173–259.

Watkins, Renée. "The Authorship of the *Vita Anonyma* of Leon Battista Alberti." *Studies in the Renaissance* 4 (1957): 101-12.

———. "L.B. Alberti in the Mirror: An Interpretation of the *Vita* with a New Translation." *Italian Quarterly* 30.177 (1989): 5–30.

———. "L.B. Alberti's Emblem, the Winged Eye, and His Name, Leo." *Mitteilungen des Kunsthistorischen Institutes in Florenz* 9 (1960): 256–8.

Weyl, Hermann. "The Mathematical Way of Thinking." *The World of Mathematics*. Ed. James Roy Newman. Vol. 3. New York: Simon and Schuster, 1956. 1832–51.

Williams, Kim, Lionel March, and Stephen R. Wassell, eds. and trans. *The Mathematical Works of Leon Battista Alberti*. Basel: Birkhäuser, 2010.

Ycart, Bernard. "Alberti's Letter Counts." *Literary and Linguistic Computing* 29.2 (2014): 255–65.

2a. Luca Pacioli: *De Divina proportione* (chronological order)

Pacioli, Luca. *De Divina proportione*. Venice: Paganini, 1509. Houghton Library, Harvard University, Typ 525.09.669.

———. *De Divina proportione*. Venice: Paganini, 1509. Biblioteca Nazionale di Firenze, Nencini, 2.8.8.16.

———. *De Divina proportione*. Venice: Paganini, 1509. Riccardiana, 10244 and SEDE. Ed.R.120.

———. *De Divina proportione*. Venice: Paganini, 1509. Vatican Library, Urb. Lat. 257 [s.XVI].

———. *Divina proportione: Die Lehre vom Goldenen Schnitt*. Ed. and trans. Constantin Winterberg. Vienna: Carl Graeser, 1889.

———. *De Divina proportione*. Ed. Aldo Mieli. Trans. Ricardo Resta. Buenos Aires: Editorial Losada, 1946.

———. *De Divina proportione*. Facsimile Reprint. Manuscript held at the Biblioteca Ambrosiana di Milano, ms 170 sup. Ed. Augusto Marinoni. Milan: Silvana, 1982.

———. *Pacioli's Classic Roman Alphabet*. 1933. Ed. Stanley Morison. New York: Dover, 1994.

———. *De Divina proportione: Ristampa anastatica dell'edizione del 1509*. Ed. Fabio Massimo Bertolo. Sassari: Scriptorium, 1998.

———. *De Divina proportione*. Facsimile Reprint. Manuscript held at the Bibliothèque de l'Université de Genève, n. 210. Sansepolcro: Aboca Museum, 2009.

2b. Luca Pacioli: Other Works and Critical Studies Consulted

Angelini, Alessandra. "Luca e Leonardo nelle lettere capitali del *De Divine Proportione*." *Luca Pacioli a Milano*. Ed. Matteo Martelli. Brera: Accademia di Belle Arti di Brera e Biblioteca del Centro Studi "Mario Pancrazi," 2014. 125–42.

Ascarelli, Fernanda. *La tipografia cinquecentina italiana*. Florence: Sansoni, 1953.

Azzolini, Monica. "Anatomy of a Dispute: Leonardo, Pacioli and Scientific Courtly Entertainment in Renaissance Milan." *Early Science and Medicine* 9.2 (2004): 115–35.

Baldasso, Renzo. "Portrait of Luca Pacioli and Disciple: A New Mathematical Look." *Art Bulletin* 92.1–2 (2010): 83–102.

Bartolozzi, Margherita, and Raffaella Franci. "La teoria delle proporzioni nella matematica dell'abaco da Leonardo Pisano a Luca Pacioli." *Bollettino di storia delle scienze matematiche* 10 (1990): 3–28.

Benedetti, Roberto. *Feliciano, Petrarca e gli altri: Geometrie illustrate e poesia nel manoscritto Trieste, Biblioteca Civica "A. Hortis," Petr. I.5*. Udine: Vattori, 2004.

Bertieri, Raffaello. "Gli studi italiani sull'alfabeto nel Rinascimento: Pacioli e Leonardo da Vinci." *Gutenberg Jahrbuch* (1929): 269–86.

Biggiogero, Giuseppina Masotti. "Luca Pacioli e la sua *Divina proportione*." *Istituto Lombardo* (1960): 3–30.

Boeckeler, Erika. "Building Meaning: The First Architectural Alphabet." *Push Me, Pull You: Physical and Spatial Interaction in Late Medieval and Renaissance Art*. Ed. Sarah Blick and Laura D. Gelfand. Vol. 1. Leiden: Brill, 2011. 149–96.

_____. "The Dramatization of the Alphabet in the Renaissance." PhD dissertation in Comparative Literature, Harvard University, 2007.

_____. "Painting Writing in Albrecht Dürer's Self-Portrait of 1500." *Word & Image* 28.1 (2012): 30–56.

Boncompagni, Baldassare. "Intorno alle vite inedite di tre matematici scritte da Bernardino Baldi." *Bullettino di bibliografia e di storia delle scienze mathematiche e fisiche* 12 (1879): 352–438, 863–72.

Bressanini, Dario, and Silvia Toniato. *I giochi matematici di Fra' Luca Pacioli: Trucchi, enigmi e passatempi di fine Quattrocento*. Bari: Dedalo, 2011.

Bringhurst, Robert. *The Elements of Typographic Style*. Version 3.1. Vancouver: Hartley & Marks, 2005.

Brown University Library. *Roman Types: Examples from the First Twenty-Five Years of Printing in Italy*. Providence: Annmary Brown Memorial Library, 1960.

Bruschi, Arnaldo, et al., eds. *Scritti rinascimentali di architettura*. Milan: Il Polifilo, 1978.

Caro, Annibale. *Opere*. Ed. Stefano Jacomuzzi. Vol. 2. Turin: Unione Tipografico-Editrice Torinese, 1974.

Carpo, Mario. "The Making of the Typographical Architect." *Paper Palaces: The Rise of the Renaissance Architectural Treatise*. Ed. Vaughan Hart with Peter Hicks. New Haven: Yale University Press, 1998. 158–69.

Casamassima, Emanuele. *Trattati di scrittura del Cinquecento italiano*. Milan: Il Polifilo, 1966.

Catich, Edward M. *The Origin of the Serif: Brush Writing and Roman Letters*. Davenport, IA: Catfish Press, 1968.

Chappell, Warren, and Robert Bringhurst. *A Short History of the Printed Word*. 1970. Vancouver: Hartley & Marks, 1999.

Chastel, André. *Musca depicta*. Milan: Franco Maria Ricci, 1984.

Ciapponi, Lucia. "A Fragmentary Treatise on Epigraphic Alphabets by Fra Giocondo da Verona." *Renaissance Quarterly* 32.1 (1979): 18–40.

Ciocci, Argante. *Luca Pacioli e la matematizzazione del sapere nel Rinascimento*. Bari: Cacucci, 2003.

Cohen, Matthew A. "How Much Brunelleschi? A Late Medieval Proportional System in the Basilica of San Lorenzo in Florence." *Journal of the Society of Architectural Historians* 67.1 (2008): 18–57.

Comboni, Andrea. "Rarità metriche nelle antologie di Felice Feliciano." *Studi di Filologia Italiana: Bollettino Annuale dell'Accademia della Crusca* 52 (1994): 65–92.

Contin, Duilio. "Il *De Divina proportione* di Luca Pacioli: Rassegna bibliografica sui mano-scritti e sull'opera a stampa." *Antologia della Divina proportione di Luca Pacioli, Piero della Francesca e Leonardo da Vinci*. Ed. Duilio Contin, Piergiorgio Odifreddi, and Antonio Pieretti. Sansepolcro: Aboca Museum, 2010. 37–48.

Contin, Duilio, Piergiorgio Odifreddi, and Antonio Pieretti, eds. *Antologia della divina proporzione di Luca Pacioli, Piero della Francesca e Leonardo da Vinci*. Sansepolcro: Aboca Museum, 2010.

Convegno internazionale straordinario per celebrare Fra' Luca Pacioli: Venezia, Centro Zitelle, 9–12 aprile 1994. Milan: IPSOA, 1995.

Cresci, Giovanni Francesco. *Essemplare di più sorti lettere*. Rome: Antonio Blado, 1560.

Davies, Martin. "Humanism in Script and Print in the Fifteenth Century." *The Cambridge Companion to Renaissance Humanism*. Ed. Jill Kraye. Cambridge: Cambridge University Press, 1996. 47–62.

Davis, Margaret Daly. "Luca Pacioli, Piero della Francesca, Leonardo da Vinci: Tra 'Propor-tionalità' e 'Prospettiva' nella *Divina proportione*." *Piero della Francesca tra arte e scienza: Atti del convegno internazionale di studi, Arezzo, 8–11 ottobre 1992, Sansepolcro, 12 ot-tobre 1992*. Ed. Marisa Dalai Emiliani and Valter Curzi. Venice: Marsilio, 1996. 355–62.

Drucker, Johanna. *The Alphabetic Labyrinth: The Letters in History and Imagination*. New York: Thames and Hudson, 1995.

Dürer, Albrecht. *Underweysung der Messung, mit dem Zirckel un Richtscheyt, in Linien Ebnen und gantzen Corporen*. Nuremberg: [s.n.], 1525.

Duso, Elena Maria. "Un nuovo manoscritto esemplato da Felice Feliciano." *Lettere Italiane* 50.4 (1998): 566–86.

Eisenstein, Elizabeth. *The Printing Press as an Agent of Change: Communications and Cultural Transformations in Early Modern Europe*. 2 vols. Cambridge: Cambridge University Press, 1979.

Etienne, Noémie. "Rassegna bibliografica sui contenuti del Codice di Ginevra." *Antologia della Divina proportione di Luca Pacioli, Piero della Francesca e Leonardo da Vinci*. Ed. Duilio Contin, Piergiorgio Odifreddi, and Antonio Pieretti. Sansepolcro: Aboca Museum, 2010. 63.

Falbo, Clement. "The Golden Ratio: A Contrary Viewpoint." *College Mathematics Journal* 36.2 (2005): 123–34.

Fanti, Sigismondo. *Theorica et practica de modo scribendi fabricandique omnes literarum species.* Venice: Giovanni Russo, 1514.

Feld, M.D. "Constructed Letters and Illuminated Texts: Regiomontanus, Leon Battista Alberti, and the Origins of Roman Type." *Harvard Library Bulletin* 28.4 (1980): 357–79.

Feliciano, Felice. *Alphabetum romanum.* 1463. Vatican Library, ms Vat. Lat. 6852.

Field, J.V. "Rediscovering the Archimedean Polyhedra: Piero della Francesca, Luca Pacioli, Leonardo da Vinci, Albrecht Dürer, Daniele Barbaro, and Johannes Kepler." *Archive for History of Exact Sciences* 50.3–4 (1997): 241–89.

Folkerts, Menso. "Luca Pacioli and Euclid." *The Development of Mathematics in Medieval Europe: The Arabs, Euclid, Regiomontanus.* Aldershot: Ashgate, 2006. 219–31.

Franci, R., and L. Toti Rigatelli. "Towards a History of Algebra from Leonardo of Pisa to Luca Pacioli." *Janus* 72 (1985): 17–82.

Frings, Marcus. "The Golden Section in Architectural Theory." *Nexus Network Journal* 4.1 (2002): 9–32.

Fumagalli, Giuseppe. *Lexicon Typographicum Italiae.* 1905. Florence: Olschki, 1966.

Gamba, Enrico. "Pittura e storia della scienza." *La ragione e il metodo: Immagini della scienza nell'arte italiana dal XVI al XIX secolo.* Milan: Electra, 1999. 43–53.

Giusti, Enrico, and Carlo Maccagni, eds. *Luca Pacioli e la matematica del Rinascimento.* Florence: Giunti, 1994.

Goldschmidt, E.P. *The Printed Book of the Renaissance: Three Lectures on Type, Illustration, and Ornament.* 1950. Cambridge: Cambridge University Press, 2010.

Gray, Nicolete. *Lettering on Buildings.* London: Architectural Press, 1960.

————. "Sans Serif and Other Experimental Inscribed Lettering of the Italian Renaissance." 1960. Seattle: Letter Perfect, 1997.

Graziadio, Francesca. "'De lorigine delle letter de ogni natione': La costruzione geometrica di Luca Pacioli." *Fontes* 11–12 (2003): 95–125.

Hart, Vaughan. Introduction. *Paper Palaces: The Rise of the Renaissance Architectural Treatise.* Ed. Vaughan Hart and Peter Hicks. New Haven: Yale University Press, 1998.

Herz-Fischler, Roger. *The Shape of the Great Pyramid.* Waterloo, ON: Wilfrid Laurier University Press, 2000.

Honsell, Furio, and Giorgio Bagni. *Luca Pacioli: "De viribus quantitatis." Curiosità e divertimenti.* Sansepolcro: Aboca Museum, 2009.

Huntley, H.E. *The Divine Proportion: A Study in Mathematical Beauty.* New York: Dover, 1970.

Huylebrouck, Dirk. "De Divino Errore." 17 December 2013. arXiv:1311.2858 [math.HO]. Web.

————. "Lost in Triangulation: Leonardo da Vinci's Mathematical Slip-Up." *Scientific American,* 29 March 2011. Web.

————. "Observations about Leonardo's Drawings for Luca Pacioli." 12 November 2013. arXiv:1311.2855v1 [math.HO]. Web.

Bibliography

Jeger, Isabelle. "Description matérielle du manuscrit 210." *Antologia della Divina proportione di Luca Pacioli, Piero della Francesca e Leonardo da Vinci*. Ed. Duilio Contin, Piergiorgio Odifreddi, and Antonio Pieretti. Sansepolcro: Aboca Museum, 2010. 31–5.

Jori, Alberto. "Nel segno dell'armonia cosmica: La casa del Mantegna e le teorie di Luca Pacioli: Il codice segreto della 'divina proportione.'" *Civiltà Mantovana* 27.5 (1992): 151–87.

Kapr, Albert. *The Art of Lettering: The History, Anatomy, and Aesthetics of the Roman Letter Forms*. Trans. Ida Kimber. New York: Saur, 1983.

Kemp, Martin. *Leonardo da Vinci: The Marvelous Works of Nature and Man*. 1981. Oxford: Oxford University Press, 2006.

Kernan, Alvin. *Printing Technology, Letters and Samuel Johnson*. Princeton: Princeton University Press, 1987.

Knight, Stan. *Historical Scripts: From Classical Times to the Renaissance*. 2nd ed. New Castle, DE: Oak Knoll Press, 2003.

Knuth, Donald. "The Letter S." *Digital Typography*. Stanford, CA: Center for the Study of Language and Information, 1999. CSLI Lecture Notes No. 78. 263–84.

———. "Mathematical Typography." *Digital Typography*. Stanford, CA: Center for the Study of Language and Information, 1999. CSLI Lecture Notes No. 78. 19–65.

Mackinnon, Nick. "The Portrait of Fra Luca Pacioli." *Mathematical Gazette* 77.479 (1993): 130–219.

Magnaghi-Delfino, Paola, and Tullia Norando. "Le Geometrie ricostruite delle lettere capitali di Luca Pacioli." *Luca Pacioli a Milano*. Ed. Matteo Martelli. Brera: Accademia di Belle Arti di Brera e Biblioteca del Centro Studi "Mario Pancrazi," 2014. 143–65.

———. "Luca Pacioli's *Alphabeto Dignissimo Antiquo*: A Geometrical Reconstruction." *Proceedings of the 14th Conference of Applied Mathematics*. Bratislava: Slovak University of Technology, 2015. 1–20.

Marcon, Susy. "Vale feliciter." *Lettere Italiane* 40.4 (1988): 536–56.

Mardersteig, Giovanni. *Scritti sulla storia dei caratteri e della tipografia*. Milan: Il Polifilo, 1988.

Marinoni, Augusto. Introduction. *Luca Pacioli: De Divina proportione*. Milan: Silvana, 1982.

———. Introduction. *De viribus quantitatis*. Ed. Augusto Marinoni. Transcription by Maria Garlaschi Peirani from Codex 250, Biblioteca Universitaria di Bologna. Milan: Ente Raccolta Vinciana, 1997.

Marinoni, Augusto, ed. *Scritti Letterari*. By Leonardo da Vinci. Milan: Rizzoli, 1987.

Markowsky, George. "Misconceptions about the Golden Ratio." *College Mathematics Journal* 23.1 (1992): 2–19.

Martelli, Matteo, ed. *Luca Pacioli a Milano*. Brera: Accademia di Belle Arti di Brera e Biblioteca del Centro Studi "Mario Pancrazi," 2014.

Mattesini, Enzo. "La lingua nel *De divina proportione*." *Antologia della Divina proportione di Luca Pacioli, Piero della Francesca e Leonardo da Vinci*. Ed. Duilio Contin, Piergiorgio Odifreddi, and Antonio Pieretti. Sansepolcro: Aboca Museum, 2010.

_____."Luca Pacioli e l'uso del volgare." *Studi Linguistici Italiani* 22 (1996): 145–80.

Mazziotti, Edvige. "Tecnicismi matematici nella 'Divina proportione' di Luca Pacioli." *Contributi di filologia dell'Italia Mediana* 9 (1995): 55–81.

McCarthy, Patricia, et al. "Pacioli and Humanism: Pitching the Text in *Summa Arithmetica*." *Accounting History* 13.2 (2008): 183–206.

Meiss, Millard. "Toward a More Comprehensive Renaissance Paleography." *Art Bulletin* 42.2 (1960): 97–112.

Mitchell, Charles. "Felice Feliciano Antiquarius." *Proceedings of the British Academy* 47 (1961): 197–221.

Montecchi, Giorgio. *Itinerari bibliografici: Storie di libri, di tipografi e di editori.* Milan: F. Angeli, 2001.

Morison, Stanley. *Calligraphy 1535–1885: A Collection of Seventy-Two Writing-Books and Specimens from the Italian, French, Low Countries and Spanish Schools, Catalogued and Described.* Milan: La Bibliofila, 1962.

_____. *Early Humanist Script and the First Roman Type.* London: Bibliographical Society, 1943.

_____. *Politics and Script: Aspects of Authority and Freedom in the Development of Graeco-Latin Script from the Sixth Century B.C. to the Twentieth Century A.D.* 1957. Ed. Nicolas Barker. Oxford: Clarendon Press, 1972.

Mosley, James. *Trajan Revived.* Birmingham: J. Moran, 1964.

Moyllus, Damianus. *The Moyllus Alphabet.* 1483. Verona: Bodoni, 1927.

Negri, Maria Paola. "Luca Pacioli e Daniele Gaetani: Scienze matematiche e retorica nel Rinascimento." *Annali della Biblioteca Statale e Libreria Civica di Cremona* 45 (1994): 111–44.

Nuovo, Angela. *Alessandro Paganino (1509–1538).* Padua: Editrice Antenore, 1990.

Ogg, Oscar. *Three Classics of Italian Calligraphy: An Unabridged Reissue of the Writing Books of Arrighi, Tagliente and Palatino.* New York: Dover, 1953.

Ohm, Martin. *Die reine Elementar-Mathematik.* Berlin: Jonas, 1835.

Ong, Walter. *Orality and Literacy: The Technologizing of the Word.* London: Methuen, 1982.

Orfei, Luca. *Alfabeto delle maiuscole antiche romane.* 1586. Milan: Il Polifilo, 1986.

Osley, A.S., ed. *Scribes and Sources: Handbook of the Chancery Hand in the Sixteenth Century.* London: Faber and Faber, 1980.

Pacioli, Luca. *Arithmetica et geometria.* Autograph Manuscript. Vatican Library, Vat. Lat. 3129 [s.XV] ff 1–396.

_____. *De ludo scachorum.* Fondazione Palazzo Coronini Cronberg, ms 7955. Facsimile. Sansepolcro: Aboca Museum, 2007.

_____. *De viribus quantitatis.* Transcription by Maria Garlaschi Peirani from Codex 250, Biblioteca Universitaria di Bologna. Milan: Ente Raccolta Vinciana, 1997.

_____. *Euclidis megarensis.* Venice: Alessandro Paganini 1509.

_____. *Summa de arithmetica, geometria, proportioni et proportionalita.* Venice: Paganino de Paganini, 1494.

_____. *Tractatus De Computis et Scripturis*. Ed. Alda Barella and Flavio Dezzani. Turin: Genesi, 1992.

Palatino, Giovanni Battista. *Breve et utile discorso delle cifere*. Rome: A. Blado, 1547.

_____. *Libro nuovo d'imparare a scrivere tvtte sorte lettere antiche et moderne di tvtte nationi, con nvove regole misvre et essempi: Con vn breue & vtile trattato de le cifere*. Rome: Giunta, 1540.

Parkes, M.B. *Pause and Effect: An Introduction to the History of Punctuation in the West*. Berkeley: University of California Press, 1993.

Pérez-Gómez, Alberto. "The Glass Architecture of Fra Luca Pacioli." *Architectura: Zeitschrift für Geschichte der Baukunst* 28.2 (1998): 156–80.

Petrucci, Armando. Introduction. *Alfabeto delle maiuscole antiche romane*. By Luca Orfei. Milan: Il Polifilo, 1986. ix–xx.

_____. *La scrittura: Ideologia e rappresentazione*. Turin: Einaudi, 1986.

Pieretti, Antonio. "Luca Pacioli: La matematica come paradigma universale del sapere." *Antologia della Divina proportione di Luca Pacioli, Piero della Francesca e Leonardo da Vinci*. Ed. Duilio Contin, Piergiorgio Odifreddi, and Antonio Pieretti. Sansepolcro: Aboca Museum, 2010. 11–18.

Quaquarelli, Leonardo. "Felice Feliciano letterato nel suo epistolario." *Lettere Italiane* 46.1 (1994): 109–22.

Reynolds, L.D., and N.G. Wilson. *Scribes and Scholars: A Guide to the Transmission of Greek and Latin Literature*. Oxford: Clarendon Press, 1974.

Rhodes, Dennis. *Studies in Early Italian Printing*. London: Pindar Press, 1982.

Richardson, Brian. *Print Culture in Renaissance Italy: The Editor and the Vernacular Text, 1470–1600*. Cambridge: Cambridge University Press, 1994.

_____. *Printing, Writers, and Readers in Renaissance Italy*. Cambridge: Cambridge University Press, 1999.

Rider, Robin. "Shaping Information: Mathematics, Computing, and Typography." *Inscribing Science: Scientific Texts and the Materiality of Communication*. Ed. Timothy Lenoir. Stanford: Stanford University Press, 1998. 39–54.

Riva, Franco. "Rassegna bibliografica comparativa: Il Codice della Biblioteca Universitaria di Ginevra, il Codice della Biblioteca Ambrosiana di Milano e la versione a stampa del 1509." *Antologia della Divina proportione di Luca Pacioli, Piero della Francesca e Leonardo da Vinci*. Ed. Duilio Contin, Piergiorgio Odifreddi, and Antonio Pieretti. Sansepolcro: Aboca Museum, 2010. 129–30.

Rossi, Attilio. *Alphabeto dignissimo antico di Luca Pacioli*. Milan: Silvana, 1960.

Rowland, Ingrid. "Abacus and Humanism." *Renaissance Quarterly* 48.4 (1995): 695–727.

Ruano, Ferdinando. *Sette alphabeti di varie lettere formati con ragion geometrica*. Rome: Valerio & Luigi Dorico, 1554.

Schneer, Cecil J. "The Renaissance Background to Crystallography." *American Scientist* 71.3 (1983): 254–63.

Shaw, Paul, ed. *The Eternal Letter: Two Millennia of the Classical Roman Capital*. Cambridge, MA: MIT Press, 2015.

Sparrow, John. *Visible Words: A Study of Inscriptions in and as Books and Works of Art*. Cambridge: Cambridge University Press, 1969.

Stevelinck, Ernest. "The Many Faces of Luca Pacioli: Iconographic Research over Thirty Years." *Accounting Historians Journal* 13.2 (1986). Web.

Susini, Giancarlo. *The Roman Stonecutter: An Introduction to Latin Epigraphy*. Ed. E. Badian. Trans. A. M. Dabrowski. Oxford: Blackwell, 1973.

Taylor, Robert Emmett. *No Royal Road: Luca Pacioli and His Times*. Chapel Hill: University of North Carolina Press, 1942.

Tiller, Elisabeth. "'Peroché dal corpo umano ogni mesura con sue denominazioni deriva': Paciolis *De divina proportione* (1509) und die mathematische Aneignung des Körpers." Berlin: Humboldt University, 29 September 2011.

Tinto, Alberto. *Il corsivo nella tipografia del Cinquecento: Dai caratteri italiani ai modelli germanici e francesi*. Milan: Il Polifilo, 1972.

Torniello, Francesco. *Opera del modo de fare le littere maiuscole antique*. Milan: Gotardo da Ponte, 1517. Ed. Giovanni Mardersteig. Verona: Bodoni, 1970.

Tory, Geoffroy. *Champ fleury*. Paris: G. Tory & G. Gourmont, 1529.

Trovato, Paolo. *L'ordine dei tipografi: Lettori, stampatori, correttori tra Quattro e Cinquecento*. Rome: Bulzoni, 1998.

Ulivi, Elisabetta. "Documenti inediti su Luca Pacioli, Piero della Francesca e Leonardo da Vinci, con alcuni autografi." *Bollettino di storia delle scienze matematiche* 29.1 (2009): 15–160.

————. "Luca Pacioli: Una biografia scientifica." *Luca Pacioli e la matematica del Rinascimento*. Ed. Enrico Giusti and Carlo Maccagni. Florence: Giunti, 1994. 21–79.

Ullman, B.L. *The Origin and Development of Humanistic Script*. Rome: Edizioni di Storia e Letteratura, 1960.

Updike, Daniel B. *Printing Types: Their History, Forms, and Use*. 2nd ed. 2 vols. Cambridge, MA: Harvard University Press, 1951.

Vasoli, Erminio Cesare. "Il Rinascimento italiano: L'ambiente storico e culturale in cui è maturato il pensiero pacioliano." *Convegno internazionale straordinario per celebrare Fra' Luca Pacioli: Venezia, Centro Zitelle, 9–12 aprile 1994*. Milan: IPSOA, 1995. 3–9.

Verini, Giovanni. *Luminario: Liber elementorum litteram*. Toscalano: Alessandro Paganini, 1526.

Wardrop, James. "Civis Romanus Sum: Giovanbattista Palatino and His Circle." *Signature* 14 (1952): 3–39.

Wolff, Ferdinand. *Lehrbuch der Geometrie*. Berlin: Reimer, 1830–45.

Zapf, Hermann. "Typographie des caractères romains de la Renaissance." *Cahiers GUTenberg* 37–8 (2000): 44–52.

Zeising, Adolf. *Der goldene Schnitt*. Halle: Engelmann, 1884.

_____. *Neue lehre von den proportionen des menschlichen körpers, aus einem bisher uner-kannt gebliebenen, die ganze natur und kunst durchdringenden morphologischen grundgesetze entwickelt und mit einer vollständigen historischen uebersicht der bisherigen systeme begleitet.* Leipzig: R. Weigel, 1854.

3a. Niccolò Tartaglia: "Quando chel cubo" in *Quesiti et inventioni diverse* (chronological order)

Tartaglia, Niccolò. *Quesiti et inventioni diverse.* Venice: Venturino Ruffinelli, 1546.

_____. *Quesiti et inventioni diverse.* Venice: Nicolo de Bascarini, 1554.

_____. *Quesiti et inventioni diverse: Riproduzione in facsimile dell'edizione del 1554.* Ed. Arnaldo Masotti. Brescia: La Nuova Cartografica, 1959.

3b. Niccolò Tartaglia: Other Works and Critical Studies Consulted

Altieri Biagi, Maria Luisa. *Galileo e la terminologia tecnico-scientifica.* Florence: Olschki, 1965.

Angelini, Annarita. *Simboli e questioni: L'eterodossia culturale di Achille Bocchi e dell'Hermathena.* Bologna: Pendragon, 2003.

Besana, Luigi. "La Nova Scientia di Nicolò Tartaglia: Una lettura." *Per una storia critica della scienza.* Ed. Marco Beretta, Felice Mondella, and Maria Teresa Monti. Milan: Cisalpino, 1996. 49–71.

Bombelli, Raffaele. *Algebra.* Bologna: Giovanni Rossi, 1579 [1572].

_____. *L'algebra.* 1569; 1572. Milan: Feltrinelli, 1966.

Bortolotti, Ettore. "I contributi del Tartaglia, del Cardano, del Ferrari, e della Scuola Matematica di Bolognese alla teoria algebrica delle equazioni cubiche." *Studi e memorie per la storia dell'università di Bologna* 9 (1926): 55–108.

Bovarini, Leandro. *Del moto.* Perugia: Vincenzo Colombara, 1603.

Bruno, Giordano. *De triplici, minimo et mensura.* Frankfurt: Johann Wechel & Peter Fischer, 1591.

Caravaggio, Pietro Paolo. *In Geometria male restaurata.* Milan: Ludovico Monti, 1650.

Cardano, Girolamo. *Ars magna.* 1545. *Opera omnia.* Ed. Charles Spon. Lyon: Huguetan & Ravaud, 1663.

Casalderrey, Francisco Martín. *Cardano y Tartaglia: La aventura de la ecuación cúbica.* Madrid: Nivola, 2009.

_____. *Cardano y Tartaglia: Las matemátics en el Renacimiento italiano.* Madrid: Nivola, 2000.

Cocchetti, Carlo. "Brescia e la sua provincia." *Grande illustrazione del Lombardo-Veneto.* Vol. 3. Ed. C. Cantù. Milan: Corona e Caimi, 1858.

Cossali, Pietro. *Origine, trasporto in Italia, primi progressi in essa dell'algebra: Storia critica di nuove disquisizioni analitiche e metafisiche arricchita.* 2 vols. Parma: Reale Tipografia, 1797–9.

Bibliography

De Pace, Anna. *Le matematiche e il mondo: Ricerche su un dibattito in Italia nella seconda metà del Cinquecento*. Milan: FrancoAngeli, 1993.

_____. "Semantic Differences of 'Simplicity' in the Definition of the Scientific Status of Mathematics." *Acme: Annali della Facoltà di Lettere e Filosofia dell'Università degli Studi di Milano* 52.2 (1999): 31–61.

del Rosso, Paolo. *La fisica*. Paris: Le Voirrier, 1578.

Feldmann, Richard W., Jr. "The Cardano-Tartaglia Dispute." *Mathematics Teacher* 54.3 (1961): 160–3.

Favaro, Antonio. "A proposition della famiglia di Niccolò Tartaglia." *Commentari dell'Ateneo di Brescia per l'anno 1919* (1920): 3–7

_____. *Per la biografia di Niccolò Tartaglia*. Rome: Ermann Loescher & C., 1913..

Franci, Raffaella, and Laura Toti Rigatelli. *Storia della teoria delle equazioni algebriche*. Milan: Mursia, 1979.

Freguglia, Paolo. "Niccolò Tartaglia e il rinnovamento delle matematiche nel Cinquecento." *Cultura, scienze e tecniche nella Venezia del Cinquecento: Atti del convegno internazionale di studio Giovan Battista Benedetti e il suo tempo*. Ed. Antonio Manno. Venice: Istituto Veneto di Scienze, Lettere ed Arti, 1987. 203–16.

Gabrieli, Giovanni Battista. *Nicolò Tartaglia: Invenzioni, disfide e sfortune*. Siena: Università degli Studi di Siena, 1986.

_____. "Niccolò Tartaglia matematico bresciano." *Commentari dell'Ateneo di Brescia per l'anno 1999* (2002): 323–45.

Gavagna, Veronica. "L'insegnamento dell'aritmetica nel *General trattato* di Niccolò Tartaglia." *Atti della giornata di studio in memoria di Niccolò Tartaglia: Nel 450° anniversario della sua morte, 13 dicembre 1557, 2007*. Ed. Pierluigi Pizzamiglio. Brescia: Commentari dell'Ateneo di Brescia, 2007. 101–38.

_____. "La soluzione per radicali delle equazioni di terzo e quarto grado e la nascita dei numeri complessi: Del Ferro, Tartaglia, Cardano, Ferrari, Bombelli." 2012. Web.

_____. "*Radices Sophisticae, Racines Imaginaires*: The Origins of Complex Numbers in the Late Renaissance." *The Art of Science: From Perspective Drawing to Quantum Randomness*. Ed. Rosella Lupacchini and Annarita Angelini. New York: Springer, 2014. 165–90.

Guilbeau, Lucye. "The History of the Solution of the Cubic Equation." *Mathematics News Letter* 5.4 (1930): 8–12.

Gutman, Kellie O. "Quando Che'l Cubo." *Mathematical Intelligencer* 27.1 (2005): 32–6.

Hamon, Gérard, and Lucette Degryse. *Niccolò Tartaglia: Mathématicien autodidacte de la Renaissance italienne*. Paris: Hermann, 2010.

Hellman, Hal. *Great Feuds in Mathematics: Ten of the Liveliest Disputes Ever*. Hoboken: John Wiley & Sons, 2006.

Katscher, Friedrich. "How Tartaglia Solved the Cubic Equation: Tartaglia's Poem." *Loci* (August 2011). Mathematical Association of America. Web. 2013.

Kichenassamy, Satyanad. "Continued Proportions and Tartaglia's Solution of Cubic Equations." *Historia Mathematica* (2015). 15 April 2015. Web.

Kloyda, Sister M. Thomas A. Kempis. "Linear and Quadratic Equations 1550–1660." *Osiris* 3 (1937): 165–92.

Lem, Stanisław. "Love and Tensor Algebra." *The Cyberiad: Fables for the Cybernetic Age*. 1967. Trans. Michael Kandel. New York: Seabury Press, 1974. 51–3.

Maracchia, Silvio. "Su alcuni possibili autografi di Niccolò Tartaglia." *Rendiconti* 94 (1960): 42–6.

_____. "Tartaglia e la sua 'regola general.'" *Commentari dell'Ateneo di Brescia per l'anno 1998* (2002): 273–87.

Masotti, Arnaldo. Introduction. *Quesiti et inventioni diverse: Riproduzione in facsimile dell'edizione del 1554*. By Niccolò Tartaglia. Brescia: La Nuova Cartografica, 1959.

Mengoli, Pietro. *Via regia ad mathematicas*. Bologna: Vittorio Benacci, 1655.

Montagnana, Massimo. "Nicolò Tartaglia quattro secoli dopo la sua morte." *Archimede* 10 (1958): 135–9.

Olivo, Alberto. *Sulla soluzione dell'equazione cubica di Niccolò Tartaglia*. Milan: Annibale Frigerio, 1909.

Parshall, Karen H. "The Art of Algebra from Al-Khwarizmi to Viète: A Study in the Natural Selection of Ideas." *History of Science* 26.2 (1988): 129–64.

Piotti, Mario. *La lingua di Niccolò Tartaglia: Un puoco grossetto di loquella: "La Nova scientia" e i "Quesiti et inventioni diverse."* Milan: LED, 1998.

Pizzamiglio, Pierluigi, ed. *Atti della giornata di studio in memoria di Niccolò Tartaglia: Nel 450° anniversario della sua morte, 13 dicembre 1557, 2007*. Brescia: Commentari dell'Ateneo di Bresciam, 2007.

_____. *Niccolò Tartaglia nella storia: Con antologia degli scritti*. Brescia: EDUCatt, 2012.

Rivolo, Maria Teresa. "I metodi di estrazione di radici quadrate e cubiche nel medioevo e nel Rinascimento." *Conferenze e seminari/Associazione subalpina Mathesis: Seminario di storia delle matematiche T. Viola*. Ed. E. Gallo, L. Giacardi, and C.S. Roero. 1995–6. 59–74.

Rothman, Tony. "Cardano v Tartaglia: The Great Feud Out of Bounds." 9 August 2013. arXiv:1308.2181 [math.HO]. Web.

Saiber, Arielle. "Niccolò Tartaglia's Poetic Solution to the Cubic Equation." *Journal of Mathematics and the Arts* 8.1–2 (2014): 68–77.

Schulz, Phillip. "Tartaglia, Archimedes and Cubic Equations." *Australian Mathematical Society Gazette* 11.4 (1984): 81–4.

Serfati, Michel. "Le secret et la règle." *La recherche de la vérité*. Ed. Marc Barbut et al. Paris: ACL-Les Éditions du Kangourou, 1999. 31–71.

Stedall, Jacqueline. *From Cardano's Great Art to Lagrange's Reflections: Filling a Gap in the History of Algebra*. Zürich: European Mathematical Society, 2011.

Tamborini, Massimo. *De cubo et rebus aequalibus numero: La genesi del metodo analitico nella teoria delle equazioni cubiche di Girolamo Cardano*. Milan: FrancoAngeli, 1999.

Tartaglia, Niccolò. *General trattato di numeri et misure*. Venice: Curzio Troiano dei Navò, 1556–60.

_____. *Nova scientia inventa da Nicolo Tartalea*. Venice: Stefano Nicolini da Sabbio, 1537.

_____. *Nova scientia inventa da Nicolo Tartalea con una gionta al terzo libro*. Venice: Nicolo de Bascarini, 1550.

_____. *Ragionamenti de Nicolo Tartaglia sopra la sua travagliata inventione*. Venice: Nicolo de Bascarini, 1551.

_____. *Regola generale da sulevare con ragione e misura non solamente ogni affondata nave ma una tone solida de mettallo intitolata la travagliata inventione*. Venice: Nicolo de Bascarini, 1551.

Tartaglia, Niccolò, ed. and trans. *Euclide Megarense acutissimo philosopho, solo introduttore delle scientie mathematice*. 1543. Venice: Giovanni Bariletto, 1569.

_____, ed. and trans. *Euclide Megarense Philosopho*. Venice: Venturino Ruffinelli, 1543.

_____, ed. and trans. *Opera Archimedis Syracusani*. Venice: Venturino Ruffinelli, 1543.

Tartaglia, Niccolò, and Lodovico Ferrari. *Cartelli di sfida matematica: Riproduzione in facsimile delle edizioni originali 1547–1548*. Ed. Arnaldo Masotti. Brescia: Ateneo di Brescia, 1974.

Tiraboschi, Girolamo. *Storia della letteratura italiana*. Vol. 7. Modena: Società Tipografica, 1777.

Toscano, Fabio. *La formula segreta: Tartaglia, Cardano e il duello matematico che infiammò l'Italia del Rinascimento*. Milan: Sironi, 2009.

4a. Giambattista Della Porta: *Curvilineorum elementorum libri duo* and *Elementorum curvilineorum libri tres* (chronological order)

Della Porta, Giambattista. *Curvilineorum elementorum libri duo*. Naples: Antonio Pace, 1601.

_____. *Elementorum curvilineorum libri tres: In quibus altera geometriae parte restituta, agitur de circuli quadratura*. Rome: Bartolomeo Zannetti, 1610.

_____. *Elementorum curvilineorum libri tres: Edizione nazionale delle opere di Giovan Battista Della Porta*. Ed. Veronica Gavagna and Carlotta Leone. Naples: Edizioni Scientifiche Italiane, 2005.

4b. Giambattista Della Porta: Other Works and Critical Studies Consulted

Altieri Biagi, Maria Luisa. "Appunti sulla lingua della commedia del '500." *Atti del convegno sul tema: Il teatro classico italiano nel '500, Roma 9–12 febbraio 1969*. Rome: Accademia Nazionale dei Lincei, 1971. 253–300.

_____. *Galileo e la terminologia tecnico-scientifica*. Florence: Olschki, 1965.

Amabile, Luigi. *Il Santo Officio della inquisizione in Napoli, narrazione con molti documenti inediti*. Città del Castello: S. Lapi, 1892.

Balbiani, Laura. *La "Magia Naturalis" di Giovan Battisa Della Porta: Lingua, cultura e scienza in Europa all'inizio dell'età moderna.* Bern: Lang, 2001.

————. "La ricezione della *Magia naturalis* di Giovan Battista Della Porta: Cultura e scienza dall'Italia all'Europa." *Bruniana & Campanelliana* 5.2 (1999): 277–303.

Belloni, Gabriella. *"Criptologia" di Giovan Battista Della Porta: Conoscenza magica e ricerca scientifica in G.B. Della Porta.* Rome: Centro Internazionale di Studi Umanistici, 1982.

Bolzoni, Lina. "Retorica, teatro, iconologia nell'arte della memoria del Della Porta." *Giovan Battista Della Porta nell'Europa del suo tempo: Atti del convegno Giovan Battista della Porta, Vico Equense-Castello Giusso, 29 settembre–3 ottobre 1986.* Ed. Maurizio Torrini. Naples: Guida, 1990. 337–85.

Buonincontro, Marina. "Teatro, scienza e memoria nella commedia di Giambattista Della Porta." *Annali Istituto Universitario Orientale, Napoli, Sezione Romanza* 32.2 (1990): 167–86.

Candela, Elena. "Un caso di esasperato plurilinguismo in commedia." *Annali Istituto Universitario Orientale, Napoli, Sezione Romanza* 32.2 (1990): 503–22.

Clubb, Louise George. *Giambattista Della Porta, Dramatist.* Princeton: Princeton University Press, 1965.

Colangelo, Francesco. *Racconto istorico della vita di Gio. Battista Della Porta filosofo napolitano: Con un'analisi delle sue opere stampate.* Naples: Fratelli Chianese, 1813.

Della Porta, Giambattista. *La carbonaria.* Venice: Gervaso Antonio Somasco, 1606.

————. *De furtivis literarum notis vulgo de ziferis.* Naples: Giovanni Maria Scotto, 1563.

————. *De furtivis literarum notis vulgo de ziferis.* Naples: J.B. Subtilem, 1602.

————. *De furtivis literarum notis vulgo de ziferis libri III.* London: John Wolfe, 1591.

————. *De telescopio.* Ed. Vasco Ronchi and Maria Amalia Naldoni. Florence: Olschki, 1962.

————. *Della magia naturale del signor Gio. Battista Della Porta Napolitano libri XX.* Trans. Pompeo Sarnelli. Naples: Antonio Bulifon, 1677.

————. *Magiae naturalis, sive, De miraculis rerum naturalium libri IIII.* Antwerp: Christopher Plantin, 1560.

————. *Magiae naturalis sive de miraculis rerum naturalium libri IV.* Naples: Matthiam Cancer, 1558.

————. *Magiae naturalis libri XX.* Naples: Apud Horatium Saluianum, 1589.

————. *Natural Magick.* London: Thomas Young and Samuel Speed, 1658.

————. *Physiognomia.* Vico Equense: Giuseppe Cacchio, 1586.

————. *Pneumaticorum libri tres,* bound with *Curvilineorum elementorum libri duo.* Naples: Io. Iacobum Carlinum, 1601.

————. *La tabernaria.* Ronciglione: Domenico Domenici, 1616.

————. *La trappolaria.* Bergamo: Comin Ventura, 1596.

————. *Le zifere o della scrittura segreta.* Ed. Raffaele Lucariello. Naples: Filema, 1996.

De Morgan, Augustus. *A Budget of Paradoxes.* 1872. *The Encyclopedia of Eccentrics.* La Salle: Open Court, 1974.

Drake, Stillman. *The Unsung Journalist and the Origin of the Telescope*. Los Angeles: Zeitlin & Ver Brugge, 1976.

Eamon, William. "Markets, Piazzas, and Villages." *The Cambridge History of Science Vol. 3: Early Modern Science*. Ed. Katharine Park and Lorraine Daston. Cambridge: Cambridge University Press, 2006. 206–23.

_____. *Science and the Secrets of Nature: Books of Secrets in Medieval and Early Modern Culture*. Princeton: Princeton University Press, 1994.

Eamon, William, and Françoise Paheau. "The Accademia Segreta of Girolamo Ruscelli: A Sixteenth-Century Italian Scientific Society." *Isis* 75.2 (1984): 327–42.

Findlen, Paula. "Jokes of Nature and Jokes of Knowledge: The Playfulness of Scientific Discourse in Early Modern Europe." *Renaissance Quarterly* 43.2 (1990): 292–331.

_____. *Possessing Nature: Museums, Collecting, and Scientific Culture in Early Modern Italy*. Berkeley: University of California Press, 1994.

Fiorentino, Francesco. *Studi e ritratti della rinascenza*. Ed. Luisa Fiorentino. Bari: Laterza, 1911.

Fornari, Cesare. *Di Giovanni Battista Della Porta e delle sue scoperte: Discorso*. Naples: Fratelli de Angelis, 1871.

Gabrieli, Giuseppe. *Il carteggio linceo della vecchia accademia di Federico Cesi (1603–1630)*. Rome: Accademia Nazionale dei Lincei, 1938.

_____. *Contributi alla storia della Accademia dei Lincei*. 2 vols. Rome: Accademia Nazionale dei Lincei, 1989.

_____. "Giambattista Della Porta, Notizia Bibliografica dei suoi mss. e libri, edizioni, ecc. con documenti inediti." *Rendiconti della R. Accademica Nazionale dei Lincei* s.6a.8 (1932): 206–77.

Gavagna, Veronica. "Magia e matematica negli *Elementorum curvilineorum libri tres* di Giovan Battista Della Porta." *Sezione di Didattiva e Storia della Matematica* (2001): 1–22.

Gavagna, Veronica, and Carlotta Leone. Introduction. *Edizione Nazionale delle opere di Giovan Battista Della Porta Vol. 11: Elementorum curvilineorum libri tres*. By Giambattista Della Porta. Naples: Edizioni Scientifiche Italiane, 2005. ix–xxxiii.

Genta, Felice. *Dopo la denigrazione di G.B. Della Porta: Comunicazione letta nell'assemblea generale della Comunità artigiana dei fotografi della provincia di Napoli nella tornata del 31 gennaio 1928*. Naples: Fratelli Ciolfi, 1928.

Granese, Alberto. "L'edizione delle commedie." *L'edizione nazionale del teatro e l'opera di G.B. Della Porta: Atti del convegno, Salerno, 23 maggio 2002*. Ed. Milena Montanile. Pisa: Istituti Editoriali e Poligrafici Internazionali, 2004. 97–102.

Greco, Carmelo. "Scienza e teatro in G.B. Della Porta." *Letteratura e scienza nella storia della cultura italiana: Atti del IX Congresso A.I.S.L.L.I.: Palermo-Messina-Catania, 21–25 aprile 1976*. Palermo: Manfredi, 1978. 429–51.

Hofmann, Joseph E. "Über das unmittelbare Nachwirken der Portaschen Quadratur krummlinig begrenzter ebener Figuren." *Archives internationales d'histoire des sciences* 26 (1954): 16–34.

Bibliography

_____."Über Portas Quadratur krummlinig begrenzter ebener Figuren." *Archives internationales d'histoire des sciences* 23–4 (1953): 193–208.

King, Henry C. *The History of the Telescope.* London: Griffin, 1955.

Kodera, Sergius."Giambattista Della Porta." *The Stanford Encyclopedia of Philosophy.* Summer 2015. Ed. Edward N. Zalta. 19 May 2015. Web.

_____."Giambattista Della Porta's Histrionic Science." *California Italian Studies* 3.1 (2012): 1–27. Web.

_____."The Laboratory as Stage: Giovan Battista della Porta's Experiments." *Journal of Early Modern Studies* 3.1 (2014): 15–38.

Loria, Gino."The Physicist J.B. Porta as a Geometer." *Bulletin of the American Mathematical Society* 22.7 (1916): 340–3.

Lucariello, Raffaele. Introduction. *Le zifere o della scrittura segreta.* By Giambattista Della Porta. Ed. Raffaele Lucariello. Naples: Filema, 1996.

Marcolongo, Roberto. *Memorie sulla geometria e la meccanica di Leonardo da Vinci.* Naples: S.I.E.M, 1937.

_____."Su due opere poco conosciute di Luca Valeria e G.B. Porta." *Rivista di fisica, matematica e scienze naturali* 10 (1936): 177–81.

Montanile, Milena, ed. *L'edizione nazionale del teatro e l'opera di G.B. Della Porta: Atti del convegno, Salerno, 23 maggio 2002.* Pisa: Istituti Editoriali e Poligrafici Internazionali, 2004.

Muraro, Luisa. *Giambattista della Porta mago e scienziato.* Milan: Feltrinelli, 1978.

Napolitani, Pier Daniele."La matematica nell'opera di Giovan Battista Della Porta." *Giovan Battista della Porta nell'Europa del suo tempo: Atti del convegno Giovan Battista della Porta, Vico Equense-Castello Giusso, 29 settembre–3 ottobre 1986.* Ed. Maurizio Torrini. Naples: Guida, 1990. 113–66.

Novalis. *Schriften.* Vol. 2. Berlin: G. Reimer, 1837.

Paolella, Alfonso."La presenza di Giovan Battista Della Porta nel *Carteggio Linceo.*" *Bruniana & Campanelliana* 8.2 (2002): 509–21.

Pesetti, Nada."Tipologie e linguaggio nelle commedie di Giovambattista Della Porta." *Studi di filologia e letteratura* 4 (1978): 127–46.

Piccari, Paolo. *Giovan Battista Della Porta: Il filosofo, il retore, lo scienziato.* Milan: FrancoAngeli, 2007.

Piccinini, Guido Maria. *Profilo di Giovan Battista Porta.* Naples: G. Genovese, 1964.

Pullini, Giorgio."Stile di transizione nel teatro di Giambattista della Porta." *Lettere Italiane* 8.3 (1956): 299–310.

Rak, Michele."Modelli e macchine del sapere nel teatro di Giovan Battista della Porta." *Giovan Battista della Porta nell'Europea del suo tempo: Atti del convegno Giovan Battista della Porta, Vico Equense-Castello Giusso, 29 settembre–3 ottobre 1986.* Ed. Maurizio Torrini. Naples: Guida, 1990. 391–415.

Reeves, Eileen. *Galileo's Glassworks: The Telescope and the Mirror.* Cambridge, MA: Harvard University Press, 2008.

Bibliography

Rienstra, Miller Howard. "Giovanni Battista Della Porta and Renaissance Science." PhD dissertation, University of Michigan, 1963.

Rosen, Edward. *The Naming of the Telescope*. New York: Henry Schuman, 1947.

Saiber, Arielle. "Flexilinear Language: Giambattista Della Porta's *Elementorum curvileorum libri tres*." *Annali d'italianistica* 23 (2005): 89–104.

Shumaker, Wayne. *The Occult Sciences in the Renaissance: A Study in Intellectual Patterns*. Berkeley: University of California Press, 1972.

Silvestri, Paolo. "Aspetti del comico linguistico nel teatro di Giambattista Della Porta." *Annali Istituto Universitario Orientale, Napoli, Sezione Romanza* 35.2 (1993): 629–48.

Sirri, Raffaele. "L'artificio linguistico di G.B. Della Porta." *Annali Istituto Universitario Orientale, Napoli, Sezione Romanza* 21 (1979): 59–112.

————. "L'artificio linguistico di G.B. della Porta: Le tragedie." *Annali Istituto Universitario Orientale, Napoli, Sezione Romanza* 20 (1978): 307–57.

————. *L'attività teatrale di G.B. Della Porta*. Naples: Libreria De Simone, 1968.

————. "Invenzione linguistica e invenzione teatrale di G.B. Della Porta." *Annali Istituto Universitario Orientale, Napoli, Sezione Romanza* 29.2 (1987): 255–77.

————. "Teatralità del teatro di G.B. Della Porta." *L'edizione nazionale del teatro e l'opera di G.B. Della Porta: Atti del convegno, Salerno, 23 maggio 2002*. Ed. Milena Montanile. Pisa: Istituti Editoriali e Poligrafici Internazionali, 2004. 69–82.

Snyder, Jon. *Dissimulation and the Culture of Secrecy in Early Modern Europe*. Berkeley: University of California Press, 2009.

Spampanato, Vincenzo. *Quattro filosofi napolitani nel carteggio di Galileo*. Portici: E. Della Torre, 1907.

Squarotti, Giorgio Bàrberi. "Della Porta o il teatro del mondo." *Giovan Battista Della Porta nell'Europa del suo tempo: Atti del convegno Giovan Battista della Porta, Vico Equense-Castello Giusso, 29 settembre–3 ottobre 1986*. Ed. Maurizio Torrini. Naples: Guida, 1990. 439–67.

Tateo, Francesco. "Sul linguaggio scientifico di Giambattista della Porta." *Giambattista della Porta in edizione nazionale: Atti del convegno di studi*. Ed. Raffaele Sirri. Naples: Istituto Italiano per gli Studi Filosofici, 2007. 47–60.

Torrini, Maurizio. "Della Porta scienziato." *L'edizione nazionale del teatro e l'opera di G.B. Della Porta: Atti del convegno, Salerno, 23 maggio 2002*. Ed. Milena Montanile. Pisa: Istituti Editoriali e Poligrafici Internazionali, 2004. 1–8.

Torrini, Maurizio, ed. *Giovan Battista della Porta nell'Europa del suo tempo: Atti del convegno Giovan Battista della Porta, Vico Equense-Castello Giusso, 29 settembre–3 ottobre 1986*. Naples: Guida, 1990.

Trabucco, Oreste. "Nell'officina di Giovan Battista Della Porta." *Bruniana & Campanelliana* 7.1 (2001): 269–79.

Valente, Michaela. "Della Porta e l'Inquisizione. Nuovi documenti dell'Archivio del Sant'Uffizio." *Bruniana & Campanelliana* 5.2 (1999): 415–34.

Vasoli, Cesare. "L'analogia universale: La retorica come semeiotica nell'opera del Della Porta." *Giovan Battista della Porta nell'Europa del suo tempo: Atti del convegno Giovan Battista della Porta, Vico Equense-Castello Giusso, 29 settembre–3 ottobre 1986.* Ed. Maurizio Torrini. Naples: Guida, 1990. 31–52.

5. Other Works Consulted

Affò, Ireneo. *Vita di monsignore Bernardino Baldi da Urbino.* Parma: Carmignani, 1783.

Andersen, Kirsti, and Henk J.M. Bos. "Pure Mathematics." *The Cambridge History of Science Vol. 3: Early Modern Science.* Ed. Katharine Park and Lorraine Daston. Cambridge: Cambridge University Press, 2006. 679–723.

Arbizzoni, Guido. "Sperimentalismo poetica di Bernardino Baldi." *Seminario di studi su Bernardino Baldi Urbinate, 1553–1617.* Ed. Giorgio Cerboni Bairdi. Urbino: Accademica Raffaello, 2003. 19–35.

Baldi, Bernardino. *Cronica de' matematici overo epitome dell'istoria delle vite loro.* Urbino: Angelo Ant. Monticelli, 1707.

_____. *De verborum Vitruvianorum significatione.* Augsburg: Johannes Praetor, 1612.

_____. *Gli epigrammi inediti: Gli apologhi e le ecloghe.* Ed. Domenico Ciàmpoli. Lanciano: R. Carabba, 1914.

_____. *Heronis ctesibii belopoeeca.* Augsburg: Davidis Franci, 1616.

_____. *L'invenzione del bossolo da navigare: Poema inedito.* Ed. Giovanni Canevazzi. Livorno: Raffaello Giusti, 1901.

_____. *Lettere.* Ed. Amadio Ronchini. Parma, 1873.

_____. *Versi e prose scelte di Bernardino Baldi.* Ed. Filippo Ugolini and Filippo-Luigi Polidori. Florence: Le Monnier, 1859.

_____. "La vita di Commandino." *Giornale de' Letterati d'Italia* 19 (714): 140–85.

_____. *Le vite de' matematici: Edizione annotata e commentata della parte medievale e rinascimentale.* Ed. Elio Nenci. Milan: FrancoAngeli, 1998.

_____. *Vite inedite di matematici italiani.* Ed. Enrico Narducci. Rome: Tipografia delle scienze matematiche e fisiche, 1887.

Balducci, Sanzio. "Annotazioni linguistiche alla *Cronica de Matematici* di Bernardino Baldi." *Seminario di studi su Bernardino Baldi Urbinate, 1553–1617.* Ed. Giorgio Cerboni Bairdi. Urbino: Accademica Raffaello, 2003. 87–110.

Becchi, Antonio, ed. *Q.XVI: Leonardo, Galileo e il caso Baldi, Magonza, 26 marzo 1621.* Trans. Sergio Aprosio. Venice: Marsilio, 2004.

Berra, Claudia. "La musa didascalica di Bernardino Baldi." *Bernardino Baldi studioso rinascimentale: Poesia, storia, linguistica, meccanica, architettura: Atti del convegno di studi di Milano, 19–21 novembre, 2003.* Ed. Elio Nenci. Milan: FrancoAngeli, 2005. 9–23.

Biagioli, Mario. *Galileo, Courtier: The Practice of Science in the Culture of Absolutism.* Chicago: University of Chicago Press, 1993.

_____. "The Social Status of Italian Mathematicians 1450–1600." *History of Science* 27.1 (1989): 41–95.

Biliński, Bronislaw. *Prolegomena alle "Vite dei matematici" di Bernardino Baldi: Manoscritti Rosminiani-Celli già Albani-Boncompagni.* Wrocław: Zakład Narodowy Imienia Ossolińskich, 1977.

_____. *La vita di Copernico di Bernardino Baldi dell'anno 1588 alla luce dei ritrovati manoscritti delle "Vite dei matematici."* Wrocław: Zakład Narodowy Imienia Ossolińskich, 1973.

Blair, Ann, and Anthony Grafton. "Reassessing Humanism and Science." *Journal of the History of Ideas* 53.4 (1992): 535–83.

Boas, Marie. *The Scientific Renaissance, 1450–1630.* New York: Harper & Row, 1962.

Bowen, James, ed. *Civilization of Europe, Sixth to Sixteenth Century.* London: Methuen & Co., 1975. Vol. 2 of *A History of Western Education.*

Branca, Vittore, et al., eds. *Letteratura e scienza nella storia della cultura italiana: Atti del IX Congresso A.I.S.L.L.I.: Palermo-Messina-Catania, 21–25 aprile 1976.* Palermo: Manfredi, 1978.

Brann, Eva. *The World of the Imagination: Sum and Substance.* Savage, MD: Rowman & Littlefield, 1991.

Brumbaugh, Robert S. *Plato's Mathematical Imagination: The Mathematical Passages in the Dialogues and Their Interpretation.* Bloomington: Indiana University Press, 1954.

Buchanan, Scott. *Poetry and Mathematics.* New York: The John Day Company, 1929.

Butterworth, Brian. *The Mathematical Brain.* London: Macmillan, 1999.

Byers, William. *How Mathematicians Think: Using Ambiguity, Contradiction, and Paradox to Create Mathematics.* Princeton: Princeton University Press, 2007.

Cajori, Florian. *A History of Mathematical Notations.* 1928–9. New York: Dover, 1993.

Campbell, Mary B. *Wonder and Science: Imagining Worlds in Early Modern Europe.* Ithaca: Cornell University Press, 1999.

Caro, Annibale. *Apologia de gli Academici di Banchi di Roma, contra M. Lodovico Castelvetro da Modena.* Parma: Viotto, 1558.

Cassirer, Ernst. *The Individual and the Cosmos in Renaissance Philosophy.* 1927. Trans. Mario Domandi. Philadelphia: University of Pennsylvania Press, 1972.

Clagett, Marshall, ed. *Archimedes in the Middle Ages.* 10 vols. Madison: University of Wisconsin Press, 1964–84.

_____, ed. *Critical Problems in the History of Science: Proceedings.* Madison: University of Wisconsin Press, 1959.

Cochrane, Eric. "Science and Humanism in the Italian Renaissance." *American Historical Review* 81.5 (1976): 1039–57.

Conley, Tom. *The Self-Made Map: Cartographic Writing in Early Modern France.* Minneapolis: University of Minnesota Press, 1996.

Crescimbeni, G.M. *La vita di Bernardino Baldi, abate di Guastalla.* 1704. Ed. Ilaria Filograsso. Urbino: Quattroventi, 2001.

Crombie, A.C. *Augustine to Galileo: The History of Science, A.D. 400–1650*. London: Falcon Press, 1952.

Daniel, Daniel F. "Math and Metaphor." *Bridges: Mathematical Connections in Art, Music, and Science: Conference Proceedings*. Ed. Reza Sarhangi. Arkansas City: Gilliland, 1998. 225–36.

Dehaene, Stanislas. *The Number Sense: How the Mind Creates Mathematics*. New York: Oxford University Press, 1997.

Delazer, Margarete, et al. "Language and Arithmetic – a Study Using the Intracarotid Amobarbital Procedure." *NeuroReport* 16.12 (2005): 1403–5.

Devlin, Keith J. *The Math Gene: How Mathematical Thinking Evolved and Why Numbers Are Like Gossip*. New York: Basic Books, 2000.

Drake, Stillman, and I.E. Drabkin. *Mechanics in Sixteenth-Century Italy: Selections from Tartaglia, Benedetti, Guido Ubaldo, & Galileo*. Madison: University of Wisconsin Press, 1969.

Duhem, Pierre. *Le système du monde: Histoire des doctrines cosmologiques de Platon à Copernic*. 10 vols. Paris: A. Hermann, 1913–59.

Dunham, William. *Journey through Genius: The Great Theorems of Mathematics*. New York: John Wiley & Sons, 1990.

Ferraro, Giovanni. *Bernardino Baldi e il recupero del pensiero tecnico-scientifico dell'antichità*. Alessandria: Edizioni dell'Orso, 2008.

Folkerts, Menso. *The Development of Mathematics in Medieval Europe: The Arabs, Euclid, Regiomontanus*. Aldershot: Ashgate, 2006.

Freguglia, Paolo. *La geometria fra tradizione e innovazione: Temi e metodi geometrici nell'età della rivoluzione scientifica, 1550–1650*. Turin: Bollati Boringhieri, 1999.

Gärdenfors, Peter. *Conceptual Spaces: The Geometry of Thought*. Cambridge, MA: MIT Press, 2000.

Garin, Eugenio. *L'educazione in Europa, 1400–1600: Problemi e programmi*. Bari: Laterza, 1976.

————. *Scienza e vita civile nel Rinascimento italiano*. Bari: Laterza, 1965.

Garzoni, Tomaso. *La piazza universale di tutte le professioni del mondo*. 1585. Ed. Paolo Cherchi and Beatrice Collina. 2 vols. Turin: Einaudi, 1996.

————. *Theatro de' vari e diversi cervelli mondani*. Venice: Paolo Zanfretti, 1583.

Gavins, Joanna, and Gerard Steen, eds. *Cognitive Poetics in Practice*. London: Routledge, 2003.

Glaz, Sarah. "Poetry Inspired by Mathematics: A Brief Journey through History." *Journal of Mathematics and the Arts* 5.4 (2011): 171–83.

Glimp, David, and Michelle R. Warren, eds. *Arts of Calculation: Numerical Thought in Early Modern Europe*. New York: Palgrave, 2004.

Grafton, Anthony. *Defenders of the Text: The Traditions of Scholarship in an Age of Science, 1450–1800*. Cambridge, MA: Harvard University Press, 1991.

_____. "The Importance of Being Printed." *Journal of Interdisciplinary History* 11.2 (1980): 265–86.

_____. "The New Science and the Traditions of Humanism." *The Cambridge Companion to Renaissance Humanism.* Ed. Jill Kraye. Cambridge: Cambridge University Press, 1996. 203–23.

Greenblatt, Stephen. *The Swerve: How the World Became Modern.* New York: W.W. Norton, 2011.

Grendler, Paul. *Schooling in Renaissance Italy: Literacy and Learning, 1300–1600.* Baltimore: Johns Hopkins University Press, 1989.

_____. *The Universities of the Italian Renaissance.* Baltimore: Johns Hopkins University Press, 2002.

Hadamard, Jacques. *An Essay on the Psychology of Invention in the Mathematical Field.* New York: Dover, 1954.

Hallyn, Fernand. *The Poetic Structure of the World: Copernicus and Kepler.* 1987. Trans. Donald M. Leslie. New York: Zone, 1993.

Harlaar, Nicole, et al. "Mathematics Is Differentially Related to Reading Comprehension and Word Decoding: Evidence from a Genetically Sensitive Design." *Journal of Education Psychology* 104.3 (2012): 622–35.

Hay, Cynthia, ed. *Mathematics from Manuscript to Print, 1300–1600.* Oxford: Clarendon Press, 1988.

Hayles, N. Katherine. *Chaos and Order: Complex Dynamics in Literature and Science.* Chicago: University of Chicago Press, 1991.

_____. *Writing Machines.* Cambridge, MA: MIT Press, 2002.

Heath, Thomas. Introduction. *Euclid: The Thirteen Books of the Elements.* Ed. and trans. Thomas Heath. 3 vols. New York: Dover, 1956.

Heninger, S.K., Jr. *Touches of Sweet Harmony: Pythagorean Cosmology and Renaissance Poetics.* San Marino: Huntington Library, 1974.

Hersey, George. *Pythagorean Palaces: Magic and Architecture in the Italian Renaissance.* Ithaca: Cornell University Press, 1976.

Høyrup, Jens. *The Founding of Italian Vernacular Algebra.* Roskilde: Roskilde University, 1999.

_____. *Measure, Number, and Weight: Studies in Mathematics and Culture.* Albany: SUNY Press, 1994.

Hunt, Katherine, and Rebecca Tomlin. Introduction. *Numbers in Early Modern Writing.* Special issue of *Journal of the Northern Renaissance* 6 (2014): 2–11.

Jackendoff, Ray. *Foundations of Language: Brain, Meaning, Grammar, Evolution.* Oxford: Oxford University Press, 2002.

James, William. Rev. of *Lectures and Essays* (1879), by W.K. Clifford. *Collected Essays and Reviews.* London: Longmans, Green, and Co., 1920. 138.

Johnson, Mark. *The Body in the Mind: The Bodily Basis of Meaning, Imagination, and Reason.* Chicago: University of Chicago Press, 1987.

Kasner, Edward, and James Newman. *Mathematics and the Imagination*. New York: Simon and Schuster, 1940.

Kline, Morris. *Mathematical Thought from Ancient to Modern Times*. 3 vols. Oxford: Oxford University Press, 1972.

Koyré, Alexandre. *From the Closed World to the Infinite Universe*. Baltimore: Johns Hopkins University Press, 1957.

————. "Galileo and Plato." *Journal of the History of Ideas* 4 (1943): 400–28.

Kristeller, Paul Oskar. *Renaissance Thought: The Classic, Scholastic, and Humanist Strains*. New York: Harper & Row, 1961.

Kuhn, Thomas. *The Copernican Revolution: Planetary Astronomy in the Development of Western Thought*. Cambridge, MA: Harvard University Press, 1957.

Laird, W.R. "Archimedes among the Humanists." *Isis* 82.4 (1991): 628–38.

Lakoff, George, and Rafael Núñez. *Where Mathematics Comes From: How the Embodied Mind Brings Mathematics into Being*. New York: Basic Books, 2000.

Le Lionnais, François, ed. *Great Currents of Mathematical Thought*. 1962. Trans. R.A. Hall and Howard G. Bergman. 2 vols. New York: Dover, 1971.

Libri, Guillaume. *Histoire des sciences mathématiques en Italie: Depuis la renaissance des lettres jusqu'à la fin du dix-septième siècle*. 4 vols. Paris: J. Renouard, 1838–41.

Lohmar, Dieter. "Non-Language Thinking in Mathematics." *Axiomathes* 22.1 (2012): 109–20.

Long, Pamela O. "Humanism and Science." *Renaissance Humanism: Foundations, Forms, and Legacy*. Ed. Albert Rabil, Jr. Vol. 3. Philadelphia: University of Pennsylvania Press, 1988. 486–512.

Luminet, Jean-Pierre, ed. *Les poètes et l'univers*. Paris: Le Cherche Midi, 1996.

Mancosu, Paolo, et al., eds. *Visualization, Explanation and Reasoning Styles in Mathematics*. Dordrecht: Springer, 2005.

Massey, Irving. *The Neural Imagination: Aesthetic and Neuroscientific Approaches to the Arts*. Austin: University of Texas Press, 2009.

La matematica antica su CD-rom: Una iniziativa del Giardino di Archimede per la storia della matematica. Ed. Enrico Giusti. Florence: Giardino di Archimede, 2001–. CD-ROM. 60 discs to date.

Mazur, Barry. *Imagining Numbers: (Particularly the Square Root of Minus Fifteen)*. New York: Farrar, Straus, and Giroux, 2003.

Mazzio, Carla. "The Three-Dimensional Self: Geometry, Melancholy, Drama." *Arts of Calculation: Numerical Thought in Early Modern Europe*. Ed. David Glimp and Michelle R. Warren. New York: Palgrave, 2004. 39–65.

Mazzotta, Giuseppe. *Cosmopoiesis: The Renaissance Experiment*. Toronto: University of Toronto Press, 2001.

Menninger, Karl. *Number Words and Number Symbols: A Cultural History of Numbers*. Trans. Paul Broneer. Cambridge, MA: MIT Press, 1969.

Moretti, Franco. *Graphs, Maps, Trees: Abstract Models for a Literary Theory.* London: Verso, 2005.

Moss, Jean Dietz. "Rhetoric, the Measure of All Things." *MLN* 119.1 (2004): 56–65.

Moyer, Ann. "Renaissance Representations of Islamic Science: Bernardino Baldi and His Lives of Mathematicians." *Science in Context* 12.3 (1999): 469–84.

Napolitani, Pier Daniele, and Pierre Souffrin, eds. *Medieval and Classical Traditions and the Renaissance of Physico-Mathematical Science in the 16th Century.* Turnhout: Brepols, 2001.

Narducci, Enrico. "Vite inedite di matematici italiani scritte da Bernardino Baldi." *Bullettino di bibliografia e di storia delle scienze matematiche e fisiche* 19 (1886): 335–406, 437–89, 521–640.

Nenci, Elio, ed. *Bernardino Baldi studioso rinascimentale: Poesia, storia, linguistica, meccanica, architettura: Atti del convegno di studi di Milano, 19–21 novembre, 2003.* Milan: FrancoAngeli, 2005.

Netz, Reviel. "The Aesthetics of Mathematics: A Study." *Visualization, Explanation and Reasoning Styles in Mathematics.* Ed. Paolo Mancosu, Klaus Frovin Jorgensen, and Stig Andur Pedersen. Dordrecht: Springer, 2005. 251–94.

————. "Linguistic Formulae as Cognitive Tools." *Pragmatics & Cognition* 7.1 (1999): 147–76.

Osler, Margaret. *Reconfiguring the World: Nature, God, and Human Understanding from the Middle Ages to Early Modern Europe.* Baltimore: Johns Hopkins University Press, 2010.

Osserman, Robert. *Poetry of the Universe: A Mathematical Exploration of the Cosmos.* New York: Anchor Books, 1995.

Peterson, Mark. *Galileo's Muse: Renaissance Mathematics and the Arts.* Cambridge, MA: Harvard University Press, 2011.

Pinel, Philippe, and Stanislas Dehaene. "Beyond Hemispheric Dominance: Brain Regions Underlying the Joint Lateralization of Language and Arithmetic to the Left Hemisphere." *Journal of Cognitive Neuroscience* 22.1 (2010): 48–66.

Pinker, Steven. *The Language Instinct: How the Mind Creates Language.* New York: HarperPerennial, 1995.

Piotti, Mario. "I giudizi linguistici di Bernardino Baldi." *Bernardino Baldi studioso rinascimentale: Poesia, storia, linguistica, meccanica, architettura: Atti del convegno di studi di Milano, 19–21 novembre, 2003.* Ed. Elio Nenci. Milan: FrancoAngeli, 2005. 115–26.

Plato. *Dialogues of Plato.* Ed. and trans. B. Jowett. London: Macmillan and Co., 1892. 5 vols.

Poulet, Georges. *The Metamorphoses of the Circle.* Trans. Carley Dawson and Elliott Coleman. Baltimore: Johns Hopkins University Press, 1966.

Pullman, Howard W. "The Relation of the Structure of Language to Performance in Mathematics." *Journal of Psycholinguistic Research* 10.3 (1981): 327–38.

Rabil, Albert, Jr, ed. *Renaissance Humanism: Foundations, Forms, and Legacy.* Philadelphia: University of Pennsylvania Press, 1988.

Raimondi, Ezio. *Scienza e letteratura.* Turin: Einaudi, 1978.

Ramachandran, V.S., and William Hirstein. "The Science of Art: A Neurological Theory of Aesthetic Experience." *Journal of Consciousness Studies* 6 (1999): 15–51.

Randall, John Herman, Jr. *The School of Padua and the Emergence of Modern Science*. Padua: Antenore, 1961.

Reiss, Timothy. *Knowledge, Discovery and Imagination in Early Modern Europe: The Rise of Aesthetic Rationalism*. Cambridge: Cambridge University Press, 1997.

Rhodes, Neil, and Jonathan Sawday, eds. *The Renaissance Computer: Knowledge Technology in the First Age of Print*. London: Routledge, 2000.

Riccardi, Pietro. *Biblioteca matematica italiana dalla origine della stampa ai primi anni del secolo XIX*. 3 vols. Modena: Soliani, 1870–86.

Rider, Robin. "Early Modern Mathematics in Print." *Non-Verbal Communication in Science Prior to 1900*. Ed. Renato G. Mazzolini. Florence: Olschki, 1993. 91–113.

Rose, Paul Lawrence. "Humanist Culture and Renaissance Mathematics: The Italian Libraries of the Quattrocento." *Studies in the Renaissance* 20 (1973): 46–105.

———. *The Italian Renaissance of Mathematics: Studies on Humanists and Mathematicians from Petrarch to Galileo*. Geneva: Droz, 1975.

———. "Rediscovered Manuscripts of the *Vite de' Matematici* and Mathematical Works by Bernardino Baldi (1553–1617)." *Rendiconti della Classe di scienze fisiche, matematiche e naturali*, 8th ser. 56.3 (1974): 274–9.

Rossi, Paolo. *La nascita della scienza moderna in Europa*. Bari: Laterza, 1997.

Rotman, Brian. *Mathematics as Sign: Writing, Imagining, Counting*. Stanford: Stanford University Press, 2000.

Saiber, Arielle. *Giordano Bruno and the Geometry of Language*. Burlington: Ashgate, 2005.

———. "Middle Ages and Early Renaissance." *The Routledge Companion to Literature and Science*. Ed. Bruce Clarke with Manuela Rossini. London: Routledge, 2011. 423–37.

Saiber, Arielle, and Henry Turner. Introduction. "Mathematics and the Imagination." Ed. Arielle Saiber and Henry Turner. Special isssue of *Configurations* 17 (2009): 1–18.

Sarton, George. *Six Wings: Men of Science in the Renaissance*. Bloomington: Indiana University Press, 1957.

Schatzberg, Walter, Ronald A. Waite, and Jonathan K. Johnson, eds. *The Relations of Literature and Science: An Annotated Bibliography of Scholarship, 1880–1980*. New York: Modern Language Association of America, 1987.

Schwartzman, Steven. *The Words of Mathematics: An Etymological Dictionary of Mathematical Terms Used in English*. Washington, DC: Mathematical Association of America, 1994.

Semenza, Carlo, et al. "Is Math Lateralized on the Same Side As Language? Right Hemisphere Aphasia and Mathematical Abilities." *Neuroscience Letters* 406 (2006): 285–8.

Senechal, Marjorie. "Mathematics and Narrative at Mykonos." *Mathematical Intelligencer* 28.2 (2006): 24–33.

Serrai, Alfredo. *Bernardino Baldi: La vita, le opere, la biblioteca*. Milan: Sylvestre Bonnard, 2002.

Bibliography

Serres, Michel, Josué V. Harari, and David F. Bell. *Hermes: Literature, Science, Philosophy*. Baltimore: Johns Hopkins University Press, 1981.

Settle, Thomas B. "Egnazio Danti and Mathematical Education in Late Sixteenth-Century Florence." *New Perspectives on Renaissance Thought: Essays in the History of Science, Eductation and Philosphy: In Memory of Charles B. Schmitt.* Ed. John Henry and Sarah Hutton. London: Duckworth, 1990. 24–37.

Shapiro, Stewart. *Philosophy of Mathematics: Structure and Ontology.* New York: Oxford University Press, 1997.

Siekiera, Anna. "L'ingegno e la maniera di Bernardino Baldi." *Saggi di letteratura architettonica da Vitruvio a Winckelmann.* Ed. Francesco Paolo di Teodoro. Vol. 1. Florence: Olschki, 2009. 299–312.

Sinisgalli, Rocco. "Bernardino Baldi e la Scuola di matematica di Urbino." *Seminario di studi su Bernardino Baldi Urbinate, 1553–1617.* Ed. Giorgio Cerboni Bairdi. Urbino: Accademica Raffaello, 2003. 251–67.

Smith, Barbara Herrnstein, and Arkady Plotnitsky, eds. *Mathematics, Science, and Postclassical Theory.* Durham, NC: Duke University Press, 1997.

Steinschneider, Moritz. "Vite di matematici arabi tratte da un'opera inedita di Bernardino Baldi." *Bullettino di bibliografia e di storia delle scienze matematiche e fisiche* 5 (1872): 429–534.

Strong, Edward. *Procedures and Metaphysics: A Study in the Philosophy of Mathematical-Physical Science in the Sixteenth and Seventeenth Centuries.* Berkeley: University of California Press, 1936.

Tang, Yiyuan, et al. "Arithmetic Processing in the Brain Shaped by Cultures." *PNAS* 103.28 (2006): 10775–80.

Thorndike, Lynn. *A History of Magic and Experimental Science.* 8 vols. New York: Columbia University Press, 1934–58.

Turner, Henry S. *The English Renaissance Stage: Geometry, Poetics, and the Practical Spatial Arts 1580–1630.* Oxford: Oxford University Press, 2006.

Turner, Mark. *The Literary Mind.* New York: Oxford University Press, 1996.

Van Egmond, Warren. "The Contributions of the Italian Renaissance to European Mathematics." *Symposia Mathematica* 27 (1983): 51–67.

Vasari, Giorgio. *Le vite.* 3 vols. Florence: Giunti, 1568.

———. *Lives.* Trans. Gaston Du C. De Ver. London: Philip Lee Warner, 1912–14.

Vasoli, Cesare. *Magia e scienza nella civiltà umanistica.* Bologna: Il Mulino, 1976.

Volpi, Mirko. "Bernardino Baldi lirico." *Bernardino Baldi studioso rinascimentale: Poesia, storia, linguistica, meccanica, architettura: Atti del convegno di studi di Milano, 19–21 novembre, 2003.* Ed. Elio Nenci. Milan: FrancoAngeli, 2005. 25–53.

Westman, Robert S. "On Communication and Cultural Change." *Isis* 71.3 (1980): 477.

Whitrow, G.J. "Why Did Mathematics Begin to Take Off in the Sixteenth Century?" *Mathematics from Manuscript to Print, 1300–1600.* Ed. Cynthia Hay. Oxford: Clarendon Press, 1988. 264–9.

Wolfe, Jessica. *Humanism, Machinery, and Renaissance Literature*. Cambridge: Cambridge University Press, 2004.

Zarnhofer, Sabrina, et al. "The Influence of Verbalization on the Pattern of Cortical Activation during Mental Arithmetic." *Behavioral and Brain Functions* 8.13 (2012): 1–15.

Zaccagnini, Guido. *Bernardino Baldi nella vita e nelle opere*. Pistoia: Soc. An. Tipo-Litografia Toscana, 1908.

Index

References to figure captions are indicated by the letter f.